Much Maligned Monsters

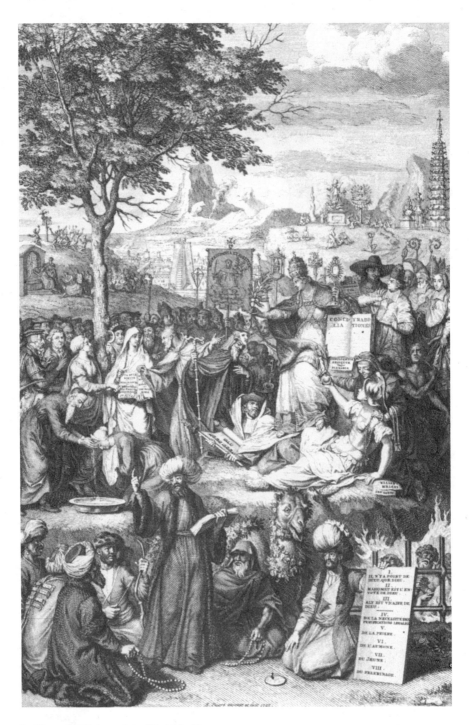

1. View of Religions of the World in Picart

Much Maligned Monsters

A HISTORY OF EUROPEAN REACTIONS
TO INDIAN ART

BY

PARTHA MITTER

With a new Preface

THE UNIVERSITY OF CHICAGO PRESS
Chicago & London

The University of Chicago Press, Chicago 60637
The University of Chicago Press, Ltd., London

99 98 97 96 95 94 93 92 6 5 4 3 2 1
ISBN 0-226-53239-9 (paperback)

Library of Congress Catalogin-in-Publication Data

Mitter, Partha.
 Much maligned monsters : a history of European reac-
tions to Indian art / by Partha Mitter.
 p. cm.
 Originally published: Oxford : Clarendon Press, 1977.
 Includes bibliographical references and index.
 1. Art, Indic—Public opinion. 2. Public opinion—
Europe.
 I. Title.
 N7428.M53 1992
 709'.54—dc20 91-47595
 CIP

TO MY PARENTS

Contents

List of Plates

Unless otherwise stated the photographs are provided by the respective libraries and museums mentioned above. For giving me much help with regard to obtaining photographs of some of the material thanks are due to Miss Helen Angus (Victoria & Albert Museum), Mr. P. Rawlings (University Library, Cambridge), Mr. Duncan Robinson (Fitzwilliam Museum, Cambridge), and Mr. Nicholas Turner (British Museum).

Preface to the 1992 Edition

IT is beyond the scope of the present paperback edition to undertake an extensive revision of the text. That must await a future edition. What this occasion offers me is an opportunity to reflect upon the profound changes in our thinking since the publication of *Much Maligned Monsters* in 1977. Then, the currently popular subject of colonial discourse had not yet seen the light of day. Much has happened since. The established discipline of literary criticism was dealt a severe jolt by Edward Said's challenging work *Orientalism,* which inspired a steady stream of academic works that dissected with remarkable single-mindedness the racial and cultural stereotyping of non-Europeans in colonial fiction. The concept of discourse entered the domains of literary studies and historical thought; those who used it were intent on destroying the epistemic certainty of these disciplines and their claims to scientific objectivity. The new subject, critical theory, stirred up a lively debate about the privileged position of the Enlightenment notions of a logocentric universe—the very ideas that lay at the heart of Western representations of non-Western societies.[1]

This 'postmodernist' era of dissolving certainties following the collapse of universal canons prompts me to take stock of my own thoughts and clarify my own particular approach to the discourse of Orientalism. As I see it, my own contribution has been not only to trace misrepresentations of Hindu art throughout history but, more importantly, to challenge the validity of applying Western classical norms for appreciating ancient Indian art. If there is a plethora of literary and artistic representations of the Other, few scholars, as far as I can gather, have taken on the task of systematically questioning the dominance of Victorian taste. And yet, unlike the more obvious negative Western images of the black or the Oriental, the Victorian hierarchy of taste regarding the contrast between the 'high' art of the salon and the 'low' decorative art of India is more ingrained and lies far below the surface. Above all, nineteenth-century Western notions of artistic progress and the superiority of mimesis in art transformed Indian taste during the colonial era, with the consequent loss of indigenous values. Of course, even today non-European societies are held by the grip of European cultural values.

xiii

The question is, can we afford to hold on to such monolithic canons when the world is shrinking and there is an ever-growing need to recognise cultural diversity?[2]

What *Much Maligned Monsters* attempts to do is to question the dominance of the Western classical canon by showing it to be the product of a specific historical and cultural situation rather than one with a timeless and universal quality. The core of the book deals with the reception of Hindu sculpture and architecture in the nineteenth century, 'the imperial meridian,' to borrow the title of a recent work. This was when the British Raj embarked on a reconstruction of India's past in an effort to cope with the complexities of the conquered territory. After all, the secret of political control lay in a sound knowledge of the subject people. James Fergusson and other archaeologists of the period have placed us in their debt for their painstaking collection and classification of data on Indian antiquities (see chaps. 3 and 6). Let us not forget that if today we are able to scan the distant horizon of Indian art with any assurance, this is because we stand on the shoulders of these pioneer scholars.

But for all their success in codifying the past of Indian art, their writings suffered from being imprisoned within the Victorian framework. These nineteenth-century historians claimed to approach Hindu art and architecture with an unbiased objectivity, with an innocent eye, no less. It was this innocence that gave them the confidence to view the design of the south Indian temple gateways (*gopura*) as a form of solecism—not just in bad taste but wrong in principle. But as E. H. Gombrich has taught us in another context, the 'innocent eye' is an illusion, for what we see is coloured by our cultural expectations.[3] To put it slightly differently, when the West turned its cultural mirror toward the Other, what it saw reflected in it was its own Self. To return to Fergusson and his contemporaries, when they claimed to be neutral and scientific in their descriptions of Hindu temples, they missed the 'hidden agenda' of their discourse. The unstated assumption in this case was the purported universality of the classical canon. The particular innocent eye of the last century was the token of a failure—the failure of Western Europe to come to terms with the Hindu art of India. But why, pray, must the West attempt to understand Indian art, demanded a distinguished reviewer as he vented his spleen in a well-known journal.[4] To answer the question: the reason is an intellectual one, for Hindu art tells us a great deal about the dominant values of the West—when other exotic and distant arts, notably Far Eastern art, are assimilated more easily within Western culture, why does Hindu sculpture and architecture continue to pose problems of understanding?

Few European writers can put the Western viewpoint more succinctly than the two great nineteenth-century thinkers Hegel and Ruskin (see

chaps. 4 and 5). Hegel posits an unacceptable polarity between the supreme abstraction of Hindu philosophy and 'its gross manifestation' in Hindu idols, the earliest and the most extreme example of uncontrolled imagination in art and thought. Ruskin complains that Indian art never depicts a natural fact. If it represents a living creature, it represents it under some distorted or monstrous form. What both of them had in mind here was what Winckelmann called 'noble simplicity and quiet grandeur,' a perfect taste as epitomised by Greek art. What they overlooked was the fact that Hindu art belonged to an entirely different world of imagination, one that did not correspond to the classical ideal.

Such responses bring out with great clarity the clash of two antithetical artistic norms, as Hindu art becomes a foil for testing Western rationality. And nowhere is this conflict more poignant than in the pages of early travel accounts where Hindu gods masquerade as pagan monsters. Unable to classify these exotic images by any known categories, European travellers fell back upon their own cultural preconceptions, thereby lending credence to the dictum that the human mind comes to terms with the unknown by means of the known. These travellers had been taught by the Church that all non-Christian religions were demonic, but the essential definition of a 'monster' as irrational also played a part in this clash of taste. In time, greater familiarity replaced initial European ignorance of Indian society. But as we journey through the centuries, from the first travellers and ethnographers to colonial officials, 'picturesque' travellers, philosophers, critics, and art historians, we are regaled at each new turn with redefinitions and reassertions of dominant values of the West as it confronted the essential otherness of Hindu art.

Although engrossing, our interest in European interpretations of Hindu art might have remained on the level of exoticism, were it not for the fact that they continue to exert an unfortunate influence on us. Indian art history and architectural history as modern disciplines are the creations of colonial archaeologists, and within them lurk these archaeologists' claims of value-free scholarship. It was while purporting to be an objective historian that Fergusson became convinced that Hindu art was 'written in decay,' a conviction he sought to prove by appealing to the nineteenth-century doctrine of degeneration through racial mixture. It is simply that his European sensibility found south Indian decoration 'overornate,' hence decadent. A believer in the teleological view of art history, he offered the concept of a continuous decline in the case of Indian art from its golden age of Buddhism. The technological simplicity of Buddhist art was taken by him to be the pinnacle of elegant taste in India and any deviation from it was declared to be decadent. The consequence of this was the distortion of the chronology of Indian art, devised on the basis of an extraneous element, namely classical taste,

rather than on internal evidence.[5] A close examination of the history of Indian architecture makes clear that the later Hindu temples, with their rich and complex decorations, were the logical culmination of the objectives set by earlier Hindu builders and designers. What was possible to realise with the technological perfection attained in the tenth century was not possible in the early Buddhist era. The Indian love of richness rather than simplicity is also evident from Sanskrit literature, where ornament plays a central role. But as recently as 1991 historians are still in the grip of the Western architectural canon, unsure how to fit later Hindu temples into their chronological framework, in which the Gupta period is viewed as the 'golden age.' This framework necessarily consigns the post-Gupta period to decadence.[6] The revolution in chronology will entail not just minor tinkering but a transformation of outlook. This is not easy, but a beginning has to be made, and my own work on European interpretations of Indian art will, I hope, go some way toward it by focusing on the culturally determined claims of European art history.

<div align="right">P. M.</div>

Brighton
October 1991

NOTES

1. Said, E. W. *Orientalism,* Routledge and Kegan Paul, London, 1978. Two pioneering works may also be mentioned: R. Schwab's classic *La Renaissance Orientale* (Payot, Paris, 1950) and B. V. Street's *The Savage in Literature* (Routledge and Kegan Paul, London, 1975). Following Foucault, the new theorists identified the European knowledge system as the special preserve of the white middle-class male, who used it as a tool for controlling marginal groups. For the most clear exposition of these ideas see Gates, H. L., *Race, Writing & Difference,* University of Chicago Press, Chicago, 1986; Inden, R., 'Orientalist Constructions of India,' *Modern Asian Studies,* 20, 3, 1986, pp. 401–46; Todorov, T., *La Conquête de l'Amérique: La question de l'autre,* Editions de Seuil, Paris, 1982; Parker, R. and Pollock, G., *Old Mistresses: Women, Art and Ideology,* Routledge, London, 1981; Nochlin, L., 'The Imaginary Orient,' *Art In America,* May, 1983, pp. 120–29 and 180–91; Kabbani, R., *Devise and Rule: Europe's Myths of the Orient,* Macmillan, Basingstoke, 1986. See also Szyliowicz, I. L., *Pierre Loti and the Oriental Woman,* Macmillan, Basingstoke, 1988; Alloula, M., *The Colonial Harem,* Manchester University Press, Manchester, 1987. I would like to thank Peter Dronke and Rodney Needham for their valuable comments on this Preface.

2. Recently the journal *Artificial Intelligence and Society* has taken up these issues; see also Mitter, 'Should Artificial Intelligence Take Culture into Consideration?,' in *Artificial Intelligence for Society,* ed. Gill, K. S., John Wiley and Sons, Chichester, 1986, part 3, article 9, pp. 101–10. And see Mitter, 'Can We Ever Understand Alien Cultures?,' *Comparative Criticism,* ed. Shaffer, E. S., vol. 9, Cambridge University Press, Cambridge, 1987, pp. 3–34, and editor's introduction, pp. xiii–xxii.

3. Gombrich, E. H. *Art and Illusion,* Phaidon, 1960, pp. 250–51.

4. Naipaul, V. S., 'Indian Art and Its Illusions,' *The New York Review of Books,* XXVI, 4, 22

March 1979, pp. 6–9. In contrast, Francis Haskell in his review analysed most sensitively the particular Western failure ('Under Western Eyes'), *Times Literary Supplement*, no. 3958, 3 February 1977, p. 124.

5. See Mitter, 'Western Bias in the Study of South Indian Aesthetics,' *South Asian Review*, VI, 2, January 1973, pp. 125–36; 'The Aryan Myth and British Writings on Indian Art and Culture,' in *Literature and Imperialism*, ed. Moore-Gilbert, B., Roehampton Institute, London, 1983, pp. 69–92. On the relationship betwen evolutionary theories and notions of degeneration, see Pick, R., *Faces of Degeneration*, Cambridge University Press, Cambridge, 1989.

6. There are, of course, individual works of great sensibility, such as James Harle's *Temple Gateways of South India*, Bruno Cassirer, London, 1963, but what I am talking about here are the general Western assumptions that continue to live on in recent works. To give an example: the beautifully produced and scholarly account of Indian architecture by Tadgell, C., *The History of Architecture in India*, Architecture, Design and Technology Press, London, 1990.

Preface

THE reception of Indian art in Europe presents a curious paradox. On the one hand, it still remains a misunderstood tradition in the modern West, whose aesthetic qualities are yet to be properly appreciated. On the other hand, possibly no other non-European artistic tradition has been responsible for so much discussion among intellectuals from the very end of the Middle Ages. It therefore offers a striking case study of the cultural reactions of a particular society to an alien one. And nowhere can this clash of the two essentially different, even antithetical, cultural and aesthetic values be better studied than in European interpretations of Hindu sculpture, painting, and architecture. Indo-Islamic architecture or Mogul painting did not present any serious problems of assimilation for the European, as they reflected a taste that could be understood in the West. Accordingly, collections of Mogul paintings began at an early period. On the other hand, there is very little in literature to indicate whether they had much effect on prevailing tastes and interests, apart from being objects of curiosity. The great Rembrandt was exceptional in his appreciation of their aesthetic qualities. In contrast to Indo-Islamic art, although very little Hindu art was collected before the nineteenth century, travellers, ethnographers, philosophers, and the literati in general showed an almost obsessive interest in it. In short, the problem of accommodating multiple-limbed Indian gods in the European aesthetic tradition became the leading intellectual preoccupation as early as the sixteenth century.

India had meant a great deal to Europeans since the time of Alexander, but the actual knowledge about it had become confused in the final days of the Roman empire and had given rise to certain myths. These myths about India could not but influence the way Indian art was seen in the West. Arguably, Indian art presented a test case for the Western understanding of India, because its aesthetic standards differed so much from those of the classical West. In the early period of European explorations of Asia, travellers saw Hindu sacred images as infernal creatures and diabolic multiple-limbed monsters. This early attitude may not be entirely unexpected; what is remarkable is that the attitude persisted even into the modern period, though different critics sought to evaluate these alleged monstrosities in different ways. A further

aspect of Indian art which presented problems of assimilation, the eroticism connected with certain cults and images, was responsible for numerous speculations in the eighteenth century. The end of the century was marked by the discovery of the wealth of Sanskrit literature and Indian philosophy which went hand in hand with increasing archaeological explorations of the subcontinent. However, even in the nineteenth century, the new accession of information was generally fitted into an earlier framework. Thus, Hegel saw in the supposedly formless images of Indian art an expression of Indian mentality which was identified by him as dreaming consciousness. A new aspect of Indian art came into focus with the growing Victorian concern with the industrial arts and decorative ornament. Ruskin approved of the sense of colour and form of the native Indian craftsmen but abhorred Indian sculpture, painting, and architecture as representing unchristian ethos. It was only with the general revolt against the classical tradition that the search for alternative values led from the appreciation of medieval European art to the praise of the Indian tradition which was exalted for its spirituality. The examination of these attitudes strongly suggests that the Western world still has to find a way to appreciate the values of Indian art in its own context and in its own right.

As is clear from the above, my work deals primarily with Hindu art and architecture and to a lesser extent with Buddhist and Jain art. It is based mainly on printed sources with relevant references to early collections. The work is also about people, about how they felt and expressed themselves. Therefore importance has been attached to the actual language used by authors in different periods. For that reason contemporary English translations of authorities have been preferred to my own. Only in cases where the translation is in serious disagreement with the original have I provided my own interpretation. In the case of Sanskrit words standard diacritical marks have been used. Indian place-names have been rendered in current forms. Arabic numerals within square brackets in the text indicate the numbers of the plates.

The present work grew out of my doctoral thesis for the University of London. My debt of gratitude to friends and acquaintances to whom I have turned for assistance and advice has grown over the years. However, I cannot hold them responsible for views expressed or errors made. I should like to thank Mr. and Mrs. W. G. Archer, M. Jean Adhémar, Professor K. A. Ballhachet, Professor C. R. Boxer, Mr. G. Brans, Dr. J. G. De Casparis, Mr. D. F. Cook, Professor L. D. Ettlinger, Miss K. Geiersberger, Dr. Richard Gombrich, Mr. B. Gray, Dr. J. Harle, Dr. A. Harvey, Mr. J. Irwin, Professor M. Jaffé, Professor O. Kurz, Dr. B. Pereira, Mrs. Caroline Pillay, Professor J. M. Plumley, Dr. Chiara Settis, Dr. Elinor Shaffer, Mrs. Helena Shire, Mr. Robert

Skelton, Dr. G. Steiner, Dr. E. Timms and Dr. W. Zwalf for their generous assistance.

I derived considerable benefit from the seminars I held with Dr. F. R. Allchin of the Oriental Faculty, Cambridge in formulating my ideas about Ruskin, Havell and Coomaraswamy. My thanks are also due to Mr. Simon Digby for letting me consult his unpublished dissertation on European reactions to India. I have received assistance from the staff of the Dept. of Oriental Antiquities in the British Museum, the Victoria and Albert Museum, the Ethnographic section of the Nationalmusaeet, Copenhagen, the Etnografiska Museet, Stockholm, the Rijksmuseum and the Tropenmuseum, Amsterdam, and the Volkenkunde Museum, Leiden. In connection with the last museum I wish to thank especially Dr. P. H. Pott for his kindness. Thanks are also due to the staff of the Bibliothèque Nationale, Paris, the Bodleian Library, Oxford, the Senate House Library and the library of the School of Oriental and African Studies, University of London. I am grateful to the staff of the Warburg Institute library and especially to Mr. J. B. Trapp for his kind assistance on all occasions. I wish to thank the staff of the University Library, Cambridge, most warmly for their constant readiness to help and especially for the excellent copies of illustrations made by the photographic department. To Mr. Roger Ferguson I owe a debt of gratitude for patiently preparing the index.

I am grateful to the University of London for providing financial support in the first three years of research and to the Central Research Fund of the university for providing generous travel grants. I am also grateful to Churchill College, Cambridge, for offering me a Research Fellowship in the fourth year of my research.

To the President and Fellows of Clare Hall, who have shown generosity to me not only by granting me a handsome stipend during the tenure of my Fellowship in the College but in every other way, I wish to express my deep appreciation. I should like to take the opportunity here to thank Mr. Peter Dronke and Mrs. Ursula Dronke, Dr. Deborah Howard, and Dr. M. Lapidge of Clare Hall for their helpful suggestions and the stimulating discussions I have had with them.

It is difficult for me to express in a few words how much the work owes to Professor Sir Ernst Gombrich. His constant inspiration, unstinting support, and admirable patience are deeply appreciated. Finally, a special fond word for Swasti who shared with me the excitement of producing the book from the very beginning.

Clare Hall, Cambridge P.M.
May 1973

Abbreviations

Arch.	*Archaeologia* (journal of the Society of Antiquaries, London).
As. Res.	*Asiatic Researches* (journal of the Asiatic Society of Bengal).
Bibl. Nat.	Bibliothèque Nationale, Paris.
BSOS	*Bulletin of the School of Oriental Studies*, London.
DNB	*Dictionary of National Biography.*
Hobson-Jobson	*Hobson-Jobson, A Glossary of Anglo-Indian Colloquial Words and Phrases*, ed. Yule, H., and Burnell, A. C., London, 1903 (new edn.).
JWCI	*Journal of Warburg and Courtauld Institutes*, London.
OED	*Oxford English Dictionary.*
TLSB	*Transactions of the Literary Society of Bombay.*
TRAS	*Transactions of the Royal Asiatic Society of Gt. Britain and Ireland.*

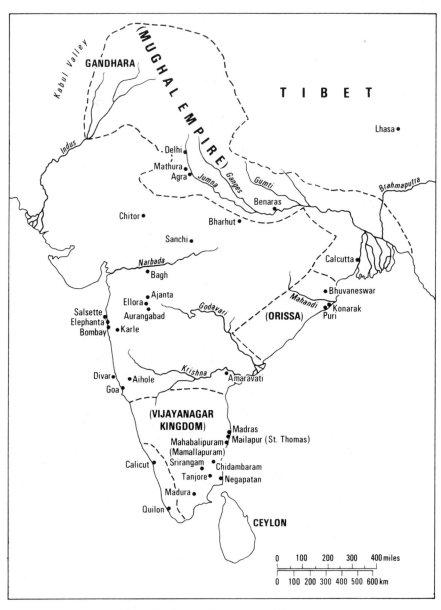

Map of India showing major architectural
sites visited by Europeans

. . . they descanted with great Prolixity . . . of the Troglodytes, the Himantopodes or Crump-footed Nation, the Blaemiae People who wear their Heads in the middle of their Breasts, the Pygmies, the Cannibals, the Hyperborei . . . the Aegipans with their Goat's-feet, and the Devill and all the others: every individual word of it by Hear-say.

I am much mistaken if I do not see among them Herodotus, Pliny, Solinus, Berosus, Philostratus, Pomponius Mela, Strabo, and God knows how many other Antiquaries.

And so inquisitive they are [the French], that they will be stark staring mad at those who come out of strange countries, unless they bring a whole budget full of strange stories, calling them dolts, blockheads, ninnyhammers, and silly oufs.

RABELAIS

Indian Art in Travellers' Tales

AT the very end of his classic study of the profound influence which the discovery of Indian civilization had on Europe in the nineteenth century, Raymond Schwab noted with regret one dark spot which stained the general picture. Virtually none of the Romantic admiration for all the different facets of Indian culture had ever included an aesthetic appreciation of the visual arts. This was all the more curious when one took into account the reception of Far Eastern art from the eighteenth century onwards. Searching for an answer to this perplexing question Schwab suggested that the chief reason for this may lie in the fact that until recently the quality of Indian art offered to the European was uniformly poor and generally lacked any aesthetic merit whatever. One cannot deny the truth of his suggestion. And yet it does not answer the whole question, for the problem is with us even today. In spite of the existence of important collections of Indian art in museums all over Europe it is still a neglected subject. Moreover, while it is true that before the nineteenth century the isolated examples of Indian sculpture or painting languishing in various cabinets of curiosities in Europe could not compare with splendid collections of Chinese art, it is none the less arguable that Indian art of high quality was not entirely unknown to Westerners.[1] Since the end of the Middle Ages people from the West had been visiting Indian temples, which they seldom failed to scrutinize with great care because of a certain curiosity value attached to them. But both European visitors to India and those who remained behind were generally agreed on one thing: the great difficulty of coming to terms with Hindu art.

Why did Hindu art, and the treatment of Hindu figure sculpture and iconography in particular, present such problems of assimilation? In order to seek the answer to this question it is necessary to go beyond the eighteenth and nineteenth centuries and back to the end of the Middle Ages, because in essence that was when attitudes were formed and the germs of later reactions firmly planted. The period from the middle of the thirteenth to the end of the seventeenth century may be regarded as

the formative phase in the reception of Indian art. Several important features of the formative phase may be noted here. First of all, throughout the greater part of this long period ideas about Indian art were much the same and they were mainly derived from existing travel accounts. The early travellers formed an especially privileged class. The number of people who had either the financial means or the opportunity to undertake a long and difficult overland journey or a sea voyage to India was very small indeed. Therefore these fortunate few had the sole privilege of disseminating information about Indian art on their return. Naturally they also had an overwhelming share in forming the early Western image of Indian art. It does not surprise us that these travellers believed in the essential truthfulness of their reports, which were of course unquestioningly accepted by their contemporaries. Yet, as a comparison of actual Indian sculptures with their early descriptions reveals at once, the early travel accounts were far from being objective or truthful. This is not to say that there was a deliberate conspiracy, for that would have made our task somewhat easier. It is simply that early travellers preferred to trust what they had been taught to expect instead of trusting their own eyes. The outcome of this was the universal use of certain popular European stereotypes for delineating Indian gods, whether in literature or in the graphic medium. The most famous of all stereotypes was that of monsters, presented in books as authentic portraits of Indian gods. The typical reactions of an early Western traveller were bound to reflect certain prejudices stemming from his Christian background as well as from a clash of tastes involving two very different traditions, which were further reinforced by a total ignorance of Hindu iconography. But more important still, the 'preconceptions' which underlay early interpretations of Indian gods were largely derived from certain influential medieval traditions. Alongside these reactions one also notices the gradual emergence of a counter-tendency: the readiness on the part of the traveller to praise certain formal aspects of Indian art, the treatment, for instance, of figure sculptures and the combination of a certain grandeur in the total conception of Hindu temples with a wealth of exquisite details. Curiously enough, the appreciation of formal aspects did not necessarily lead to a corresponding interest in iconography. These two somewhat contradictory threads continued to exist together and were often interwoven in the descriptions of a particular traveller. It was only in the middle of the seventeenth century that the dichotomy was to a large extent resolved. With the rise of scientific interest in different forms of paganism there was a demand for information about Indian mythology on the one hand and for authentic pictures of Indian gods on the other. Both these developments helped to dissolve the age-old monster tradition. Although one occasionally comes across vestiges

2

of monster myths in books issued in this period, they had lost their old magic and were already on the way out.

i. MUCH MALIGNED MONSTERS

The celebrated Venetian traveller Marco Polo was the first known European to mention Indian gods. In the history of explorations he holds a unique position, for his travels mark the beginnings of that great transformation which was to overtake the medieval *imago mundi*. The full implications of his discoveries were not, however, realized in his lifetime. It is even ironical in retrospect that his remarkably objective descriptions of Asia only served to earn him the nickname 'il milione' from contemporaries. Prior to Marco Polo, Western ideas about Asia consisted of a whole tradition of myths and fables which combined some truth with much fiction. It was only when travellers beginning with Marco Polo returned to Europe with factual reports of their explorations that a new dimension of realism entered medieval conceptions of the fabulous East. The story of Marco's wide travels in the East, dictated in 1298 to Rusticiano or Rustichello of Pisa in the prison at Genoa, was largely responsible for arousing European interest in the manners and institutions of the distant peoples of Asia.[2] Undoubtedly, Marco Polo's first love was China, so that he had relatively little to say about India. There is none the less a passage among his descriptions of the people of south India which deserves our attention. The passage describes a certain idolatrous practice prevailing on the Coromandel coast of India:

they have certain abbeys in which are gods and goddesses to whom many young girls are consecrated; their fathers and mothers presenting them to that idol for which they entertain the greatest devotion. And when the nuns [monks tr.] of a convent desire to make a feast to their god, they send for all those consecrated damsels and make them sing and dance before the idol with great festivity.[3]

We have no evidence whether the statement was based on personal experience or whether Marco Polo was only repeating what he may have heard. Its chief importance lies elsewhere, for it provided a great medieval illuminator and his associates with the inspiration for a painting on the subject. The painting entitled *Danse des servantes ou esclaves des dieux* [2] occurs in one of the most renowned fourteenth-century manuscripts, *Le Livre des merveilles*. This illuminated manuscript, which is one of the first to treat secular subjects and which contains 265 paintings illustrating the travels of Marco Polo, Odoric of Pordenone, Sir John Mandeville, Hayton, and other popular travellers, once belonged to the Duc de Berry. It is now the prized possession of the Bibliothèque Nationale, Paris.[4] The painting, based on Marco Polo's description of

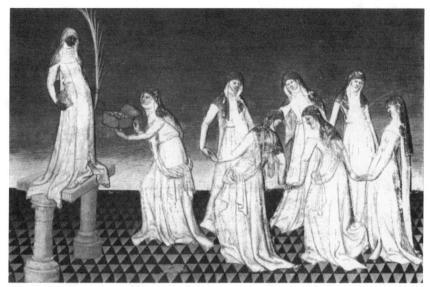

2. Devadāsīs of Coromandel in *Livre des merveilles*

the consecrated Indian maidens of the Coromandel coast, was executed by the workshop of the Boucicaut Master, considered to be one of the finest late medieval painters.[5] It is a very early if not the first European illustration of an Indian religious scene showing an idol.

If the caption had not clearly stated the subject of the picture, it would have been impossible for us to recognize it as Indian. There is hardly any physical resemblance between these blonde nuns and Indian *devadāsīs* or consecrated maidens, or between this dark-skinned effigy and Indian images. Therefore, unless one is prepared to dismiss this strange, hybrid product as an aberration on the artist's part, it calls for an explanation. And that explanation must take into account the problem of visual stereotypes in Western pictorial tradition and their special role in the portrayal of Indian gods in Europe. It was precisely in the context of stereotypes in art that Professor Gombrich drew our attention to a curious phenomenon in a famous early printed book, the *Liber Cronicarum*, popularly called *Nuremberg Chronicle* (1493). In it the illustrator claimed to depict a large number of different cities in the world such as Damascus, Ferrara, Milan, and Mantua, when in fact all he simply did was to substitute a different caption for each city while retaining one single pictorial formula for all of them. Since it is inconceivable that all these cities were identical, the fact is that 'neither the publisher nor the public minded whether the captions told the truth. All they were expected to do was to bring home to the reader that these names stood for cities.'[6] Apart from the fact that the standards of accu-

4

racy demanded from the information contained in a picture were low because people were not often in a position to verify them against facts, the example reflects a widespread tendency which goes back to the Middle Ages. The tendency is clearly seen in the use by medieval artists of certain pre-existing 'stereotypes' or 'schemata' whenever they sought to represent the objective world. This they did instead of attempting to represent their own visual impressions of the outside world. The particular medieval practice is, however, only an exaggerated and more extreme form of what is a principle of universal validity. Whenever we attempt to understand something unfamiliar we proceed from the known to the unknown. The human mind is able to record its impressions of the external world only by first classifying the received information under a general category and the initial generalized 'schema' serves as the essential framework for this. In the field of art, when artists choose to represent a new subject, a pre-existing general formula serves as the starting-point which may then be modified and adapted in the light of the actual individual subject. But the problem arises when the artist is not able to adapt his schema because either he lacks the relevant schemata or his starting-point is too far removed from his motif. To us Wolgemut's depiction of different cities is not convincing simply because being too far from his motifs he was not able to adapt his initial schema for a city, which thus came to stand for all these cities.[7]

To return to Boucicaut, in whom we clearly see the principle in operation. This great French master must have been excited by the passage in Marco Polo which gave him a unique opportunity to try his skill at such a novel subject. Yet his main disadvantage was that he lacked a suitable schema corresponding to the subject, as he had no personal experience of India. It was inevitable that Boucicaut relied entirely on Marco Polo's description. The problem before him was the method to be chosen for translating a purely literary description into a visual image. The particular solution he reached, which he no doubt felt would be meaningful to his audience, was to follow the text faithfully. The Venetian traveller had mentioned nuns in charge of abbeys in south India ('nonnain do mostier'). He had also implied that the function of Christian nuns and Indian consecrated maidens was the same. The logical outcome was the picture of Indian nuns dancing before a nun-like idol. The utter incongruity of the whole situation hits us with great force. Yet the incongruity becomes apparent only because we, with our access to fuller facts, are in a position to judge that because Boucicaut was too remote from his theme he essentially lacked a convincing schema to represent the scene. However, the fact of the matter is that this sort of hybrid representation, namely putting European clothing on an Indian subject, was a constant feature of the early Western image of

Indian gods. It was only with the increase of factual knowledge about India in the seventeenth century that artists were able substantially to modify their original schemata, leading to a corresponding improvement in the portrayal of Indian gods. We must bear in mind that the main purpose of the Boucicaut painting was to illustrate a sensational and exotic theme in order to render the text all the more vivid. Since the primary aim was not to impart objective information about Indian gods, it did not really matter if the depiction was factually correct or not.[8]

The case of the 'dancing nuns' of Coromandel is an isolated one and the subject did not receive any further treatment from artists. Far more widespread were the stereotypes of monsters which fill the pages of travel accounts, masquerade as Indian gods, and dominate Western imagination until well into the second half of the seventeenth century. These so-called Indian idols had not the slightest connection with Buddhist or Hindu iconography. Their origin and ancestry were entirely European. Yet travellers insisted that they were Indian and they were accepted as such by their readers. The reasons for the belief widely held by travellers that Indian gods were demons and monsters must be sought in the two powerful traditions that shaped the beliefs and attitudes of the people in the Middle Ages.

The first tradition is a secular one and concerns the medieval literary tradition regarding monsters and marvels of the East derived from classical sources. The decline of the Roman Empire and the subsequent period of unrest and chaos had led to the disruption of contacts between India and the West. The primacy of Islam in the Near and Middle East from the ninth century onwards created a further insuperable barrier. As a result India survived throughout the greater part of the Middle Ages in myths and legends which ultimately went back to the Greek authors Herodotus, Ctesias, and Megasthenes, although transmitted by Pliny and Solinus.[9] Equally influential was the *Romance of Alexander* attributed to Callisthenes, which had numerous medieval derivatives.[10] While this text claimed to be a factual narrative of Alexander's adventures in the East, it was really a collection of fantastic stories and supposed marvels Alexander had encountered in India. Yet nothing illustrates better the prevailing mentality than the fact that pseudo-Callisthenes passed as real history in the Middle Ages and that Pliny with his uncritical assortment of supernatural stories was the most popular of classical writers.[11] Medieval works dealing with the marvels of the East, particularly the encyclopedias, whose main sources for supernatural fiction about India were Pliny and Solinus, wielded great authority all over Europe throughout the Middle Ages. It is under the influence of texts such as these that travellers to the East went in search

6

of and actually believed they had discovered the marvels they had read about since their youth. Wittkower describes the hold of such texts on European imagination in connection with a typical tract:

'Marvels of the East' determined the western idea of India for 2000 years . . . and made their way into natural science and geography, encyclopaedias and cosmographies, romance and history, into maps, miniatures and sculpture. They gradually became stock features of occidental mentality . . . their power of survival was such that they did not die altogether with the geographical discoveries and better knowledge of the East but lived on in pseudo-scientific dress up to the 17th and 18th centuries.[12]

Although in the time of Marco Polo direct communication between India and the West was restored again, the resultant new knowledge did not bring about a noticeable change of attitudes. For the myths about fabulous creatures had created a precarious balance between fantasy and truth in the minds of travellers. It was in this credulous state that travellers visited India, so that their reports consisted of 'a curious mixture of solid observation and fabulous tradition. These men went out to distant countries with a preconceived idea of what they would find . . . their imagination was fed from childhood with stories of marvels and miracles which they found because they believed them.'[13] A particularly influential medieval text called *Marvels of the East* described, among other wonders, Indian monsters which it had inherited from diverse classical sources through Pliny, Solinus, and pseudo-Callisthenes.[14] The Greeks themselves had constructed an elaborate universe consisting of strange and fantastic beings. A number of these belonged to classical mythology, such as Satyrs, Centaurs, Sirens, and Harpies. But the Greeks had also rationalized their instinctive fears 'in another, non-religious form by the invention of monstrous races and animals which they imagined to live at a distance, in the East, above all in India'.[15] This feature of the classical tradition was brought into focus by Baltrusaitis, who described Greco-Roman society as being 'two-faced'. One side of it showed the world of gods and humanity and all that was heroic and noble, affirming a powerful and life-giving principle. The other world was inhabited by fantastic creatures of complex and remote origin.[16]

The Middle Ages, which never lost touch with antiquity, thus received a large number of monsters from this source. Among the many composite and strange creatures medieval authors describe, I am particularly concerned with the multi-armed monsters, as they bear a physical resemblance to Indian gods. What at once fascinates and repels us about a monster is the fact that it goes against what is considered 'natural', in other words rational to us. One of the definitions of a monster given in

7

the *Oxford English Dictionary* is that it is something unnatural. To the Greeks therefore this would be the very opposite of their idea of a universe of rational beings and ideas. This view of monsters influenced nineteenth-century criticisms of Indian gods as being monstrous. In the last century, when classical ideals of order and rationality were especially favoured by art critics, Indian gods with their many arms were regarded as monstrous because they defied all idea of rationality. This modern view of the monster as standing for irrationality can be easily understood. But it is not so easy to reduce to a clear and logical pattern the attitude of the people in the Middle Ages. No doubt one of the reasons why Indian gods were brought within the category of monsters was that they were looked upon as unnatural. Yet people did not think of monsters entirely in these terms; it may in fact be argued that there was no such clear distinction in their minds between the realms of imagination and actuality. Monsters were real living creatures with supernatural powers living in distant lands, but they too paid homage to the Christian God, as seen in the famous portals of Vézelay. In fact this question had been settled by St. Augustine, who had ingeniously suggested that if monsters did exist they did so by virtue of the Divine Will.[17] In this way monsters could be conveniently accommodated in the Christian order of the universe.

A famous example of this compromise between classical and Christian ideas was Isidore of Seville, who epitomized the whole medieval encyclopedic tradition. Qualifying Varro's statement that 'portents' or 'prodigies' were born contrary to nature, Isidore had argued in his *Etymologies* that they were contrary to what nature was understood to be. He had further defined prodigies as existing by virtue of some bodily size beyond the measure of common men, including superfluous members.[18] But the most revealing feature in Isidore is the existence side by side as monsters of creatures drawn from mythology and from anomalies of obstetric literature.[19] This demonstrates most clearly the curious ambiguity of meaning in Isidore, and for that matter in all medieval authors, between the monster as a figment of the imagination and as a living creature.

Isidore's monsters were in the main of classical descent, but the most striking fact is that in the thirteenth century the West rediscovered these many-armed prodigies, not in the pages of antique authors, but in travel accounts. While no doubt travellers themselves like other people in the Middle Ages were acquainted with the monsters in popular late antique handbooks like Solinus, Marco Polo's description of the idols of Zipangri or Chipangu (Japan) was primarily responsible for the reappearance of many-armed monsters in literature and art.[20] And it is no less significant that these monsters were already recognized as being

of Indian origin as early as the thirteenth century. Baltrusaitis cites Thomas of Cantimpré (1201–1263/80), who mentioned 'La manière et les faitures des monstres des hommes qui sont en Orient et le plus en Inde', in his popular *De Naturis Rerum*. In the German translation of Cantimpré by Megenberg, called *Book of Nature* (1475), in the *Bestiary* of Ghent (1479), and finally in the influential *Nuremberg Chronicle* (1493), the many-armed idols were consigned to the 'category of abnormal beings.[21] Once again one notices the blurring of distinctions between the living and the imaginary, and this ambiguity about Indian gods persisted throughout the early period.

Whatever else, the 'classical' monsters of India were considered harmless in the Middle Ages. Yet Indian gods acquired malevolent attributes later in travel literature. It thus becomes necessary to introduce the second influential tradition, which is religious in nature and deals with medieval conceptions of hell, the field of demonology, and the imagery connected with Antichrist in Apocalyptic literature.

From the earliest date the Christian Church had taught that all pagan religions were invented by the devil. Originally this attitude had grown up in connection with classical gods. In late medieval painting demons instead of idols were often shown standing on antique columns.[22] Even more interesting is the fact that the real existence of pagan gods was assured in a peculiar way in the Middle Ages. Many of the Fathers had agreed not only that the pagan gods were demons, but that these demons were the forces still alive and active in the Christian sublunary world, that attacked souls and tempted them. The whole early medieval 'psychology of sin' was bound up with this.[23] St. Augustine sanctioned the idea that demons persuaded the ancients to false belief. Some of the most virulent attacks on pagan gods are to be found in St. Augustine's *De Civitate Dei*, where he argued that devils presented themselves to be adored, but that they were no gods but wicked fiends and most foul, unclean and impotent spirits.[24]

In early Christian iconography the devil commonly appeared as a serpent or a beautiful man.[25] It was only around the year 1000 of the Christian era that hideous and frightening characteristics of the devil began to take shape. Since pagan gods had already been reduced to the level of evil spirits, there was nothing to prevent artists from borrowing some of their features in order to create a more convincing image of the devil. Indeed, some of the attributes of the devil, such as goat-beard, cloven hooves, and shaggy lower limbs, came from the classical Pan or from satyrs.[26] But Satan and his host of demons were composite creatures reflecting other traditions as well. For instance the wings and claws of the demonic host were derived from the dragon of the Apocalypse. There existed a close link between hell imagery and apocalyptic literature

in the medieval period. It has been shown not only that the legend of Antichrist in the Revelation has many parallels with the old Babylonian dragon myth, but that in some early Christian writers Antichrist was actually identified with the dragon that came up from the sea. Although the early Church tradition wavered between the interpretation of Antichrist as a human agent of the devil and the devil himself,[27] in popular imagination in the Middle Ages this subtle doctrinal distinction was frequently ignored.[28] This can be seen very clearly in art and literature, where there was constant interchanging of the features of the apocalyptic dragon with those of demons from other traditions.

Thus by the late medieval period an elaborate and in many ways frightening imagery of demons and hell had grown up, consisting of elements from diverse sources. The point to bear in mind here is that the two traditions, the classical one of the monstrous races and the Christian one of demons, converged at some stage in medieval history. The process may have been slow and gradual. While we are able to see its outcome in art and literature, it is not possible to give a precise date for this convergence. The meeting of the classical and the Christian tradition was made easier by St. Augustine's assertion that pagan gods were mortal just like other creatures and subject to the same Divine Will which they were powerless to contravene. There is also the famous instance of the satyr in the wilderness who had confessed to St. Antony that he too was mortal.[29]

In short, classical monsters and gods, Biblical demons and Indian gods were all indiscriminately lumped together with congenital malformations under the all-embracing class of monsters. An indication of this ambiguity is to be seen in an illustration from a German text of Hrabanus Maurus where classical prodigies mingle happily with the dragon of the Apocalypse.[30] In this twilight region it is difficult to say with certainty where the line was drawn between the world of facts and that of the imagination. The indiscriminate and eclectic interest in monsters from diverse sources goes a long way to explain the consistent use of the stereotypes of demons and monsters to represent Indian gods. They were taken by travellers to be simply another variant of the multi-limbed pagan monsters and prodigies known to exist in the East. In this section I propose to trace the adventures of Indian gods in Europe in the guise of different monsters. In the course of their adventures they continuously acquired new attributes and characteristics from the literary tradition of classical monsters and Christian demonology, gaining in richness of detail here or in credibility there, as each new traveller published his account.

The friar Odoric of Pordenone, who visited a number of places in south India between 1316 and 1318, gave a much fuller report of its

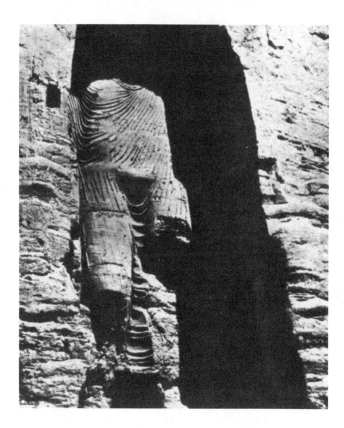

inhabitants and their customs than did Marco Polo. He was the first traveller to leave a description of a monstrous idol in the form of half-man and half-ox. This monster at Quilon in south India gave responses out of its mouth and demanded the blood of forty virgins to be given to it.[31] However, the most dramatic moment in his narrative arrived when the pious monk proceeded to describe his horrific experience while crossing the Valley Perilous, situated by the river of delights. Corpses lay scattered in the area and marvellous music could be heard there. To quote Odoric:

And so great was the noise thereof that very great fear came upon me . . . And at one side of the valley, in the very rocks, I beheld as it were the face of a man very great and terrible, so very terrible indeed that for my exceeding great fear my spirit seemed to die in me . . . I dared not come nigh that face, but kept at seven or eight paces from it.[32]

The question is, what had Odoric actually seen? His modern English editor is quite convinced that Odoric's description was based on actual experience, though somewhat exaggerated by his excited imagination. Yule also points out that the gigantic face might have been suggested by the great rock-cut Buddha figures of Bamian in Afghanistan [3]. This

11

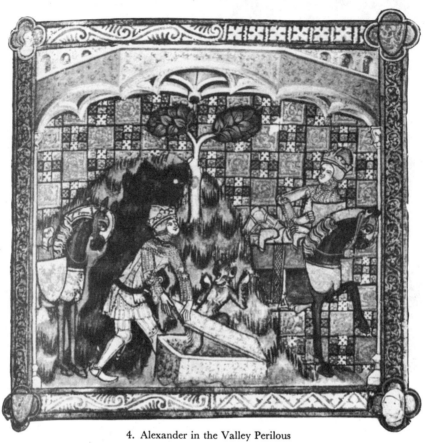

4. Alexander in the Valley Perilous

argument is further supported by the fact that travellers have often reported hearing strange noises in the valley to the north of Kabul. Other scholars have placed the Valley Perilous in the Khotan area of Central Asia on account of the colossal images and the sounds produced by nature in the desert.[33] All this strongly suggests that Odoric took the colossal Buddha figure to be the devil.

Odoric's conviction that he had encountered the devil in the Valley Perilous is based on a respectable medieval tradition. The *Alexander-Romance* of pseudo-Callisthenes tells in one version the story of Alexander's adventure with devils in the Valley Perilous situated near India. The following explanation is provided for the accompanying illustration: 'Ensi com li diables enseigna Alixandre le sentir pour isir hors don vael preileus [perilleus] [4].'[34] Judging by the immense popularity of the *Alexander-Romance* we may be sure that Odoric was acquainted with the episode and had accepted it as a fact. His expectation of seeing Indian monsters had been raised by the widely diffused fabulous tradition. The colossal sculptures which made such a strong impression on

12

5. Odoric in the Valley Perilous

him merely confirmed what he had known all along from literature. Appropriately, his remarkable experience found a place among the illustrations in *Le Livre des merveilles*. Here, seen through a crack in the valley of hell, are a number of damned souls held in the grip of a winged devil [5].[35]

Odoric's story received further embellishments in the fictitious travels of Sir John Mandeville who conveniently inserted it in the second part of his book. In order to add an air of authenticity to his part in the story he claimed to have travelled in the area in the company of two monks. Mandeville gave a frightening description of the devil's head and placed the valley of perdition by the river Physon, near the island of Milles-trozothe or Mistorak in Armenia, which he described as the evil-smelling mouth of hell [6]. His reference to the river Physon and to Armenia leaves us in no doubt that he identified this valley as the area on the periphery of the Earthly Paradise. In medieval traditions the Earthly Paradise was generally placed in the East.[36] Modern scholarship leaves us in no doubt that Mandeville had never been out to the East and had conveniently appropriated Odoric's account for his purposes. Nevertheless, there is little evidence to show that his contemporaries ever seriously questioned his honesty, so great was his reputation. Compared with

13

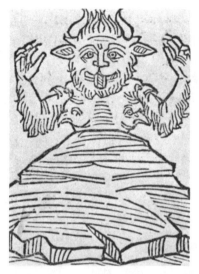

6. Devil's head in 1482 German edition of Mandeville

7. Devil's head in 1484 German edition of Mandeville

him even Marco Polo's influence was negligible on the succeeding generations. As Mandeville's influence on his age was profound, he was able to give Odoric's description of the Valley Perilous an assured place in Western imagination for a number of generations.[37] Many of Mandeville's monsters were incorporated in the *Nuremberg Chronicle* and later in the sixteenth century in Sebastian Münster's influential *Cosmographia*. The German translation of Mandeville by Otto von Diemeringen (1484) contains a truly horrific picture of the devil's head in the Valley Perilous [7].[38]

Another well-known illustration of Mandeville's version of the Valley comes from *Le Livre des merveilles* [8]. In this fourteenth-century painting pilgrims go through the 'valley of the devil' praying while demons torment damned souls, presided over by the figure of Satan whose sinister head can be seen through a crack in the valley.[39] Other paintings from the workshop of the Boucicaut Master on the subject of Indian idolatry include one on human sacrifice taking place in Quilon in front of an idol which bears a striking resemblance to Martikhora, the composite monster described by Ctesias [9].[40] Finally there is a picture in the *Livre des merveilles* which prepares the ground for the famous sixteenth-century stereotype for Indian gods in Varthema. The picture from the French workshop for the first time assigned horns and goat-head to an Indian god which had until now been the common features of the devil [10].[41]

14

8. Mandeville in the Valley Perilous

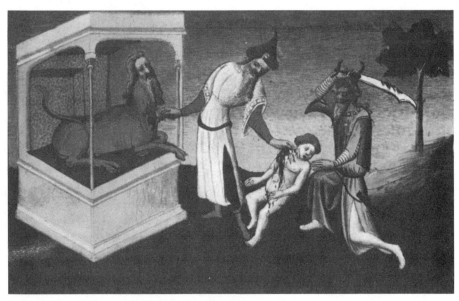

9. Sacrifice to Indian god in *Livre des merveilles*

10. Horned Indian gods in *Livre des merveilles*

By the middle of the fourteenth century the West had become ac-
quainted with Indian gods, but their general portrayal was still vague
and ill defined. It was only in 1510 with the publication of Varthema's
Itinerario that the Western image of Indian gods received an entirely new
and sharp definition. The sixteenth century witnessed a sudden increase
in Indian travels as well as the publication of travel reports. Varthema's
influence on his age was twofold: it affected both literature and the
pictorial tradition relating to Indian gods. There is no doubt that Var-
thema was able to reach a wide audience because of the introduction
of the printing press which helped in the rapid diffusion of knowledge
over a large area.

The Bolognese Ludovico di Varthema, whose travels took him to
south India between 1503 and 1508, gave a description of the religion
prevailing in the area in his *Itinerario*. His famous statement about the
king of Calicut was that, while the king ultimately believed in God, he
was at the same time guilty of adoring the devil. The term for God in
the region, Varthema said, was Tamerani. But notwithstanding his faith
in God, the ruler paid respect to the devil, known as Deumo in these
parts.[42] Contemporaries paid serious attention to Varthema's remark,
for Calicut's political importance to European traders was considerable

16

in the sixteenth century. The description of the devil adored in the potentate's chapel is quoted here in full because it helps us to understand subsequent interpretations of Indian gods:

... And the king of Calicut keeps this Deumo in his chapel in his palace, in this wise; this chapel is two paces wide in each of the four sides, and three paces high, with doors covered with devils carved in relief. In the midst of this chapel there is a devil made of metal, placed in a seat also made of metal. The said devil has a crown made like that of the papal kingdom, with three crowns; it has also four horns and four teeth with a very large mouth, nose, and most terrible eyes. The hands are made like those of a flesh-hook and the feet like those of a cock; so that he is a fearful object to behold. All the pictures around the said chapel are those of devils, and on each side of it there is a Sathanas seated in a seat, which seat is placed in a flame of fire, wherein are a great number of souls, of the length of half a finger and a finger of the hand. And the said Sathanas holds a soul in his mouth with the right hand, and with the other seizes a soul by the waist.[43]

The description is not at all easy to interpret. There exists in Hinduism a whole range of attitudes from the belief in an abstract, *Upanisadic* supreme Deity to simple animism on the village level. For Varthema it was not so difficult to translate the Hindu monistic concept of Godhead into the Christian one. Yet when he confronted actual Hindu gods he did not hesitate to follow the medieval tradition in calling them devils. After all, had not the Church Fathers taught that all pagan gods were demons and devils? Deumo, the south Indian name for the devil, according to Varthema, may have been derived from *deva*, used to denote minor gods in that area. Tamerani or *tamburan* is a title of honour among the Nayars but there exists a minor deity called Peria Tamburan of a fierce character. However, the point to remember is that, according to Varthema, it was Deumo and not Peria Tamburan who was installed in the king's chapel in the form of the devil. It is possible that the Italian had made up his picture of the Calicut ruler's chapel on the basis of his experience of local folk deities, but even that knowledge was confused as is evident from the garbled account of Tamerani and Deumo. Local elements might well have gone into Varthema's Deumo, although one must remember that it would have been unusual for a folk deity to have been in the royal chapel even if one assumes that he was allowed to see it.[44] On the other hand, it becomes increasingly clear from a close look at Varthema's Indian god that its ancestry is European. His description of Sathanas surrounded by the devils of hell owed a great deal more to medieval European hell imagery than to an Indian tradition. The account was simply lifted from popular pictures of hell, where the towering figure of Satan was often shown sitting in the middle and devouring sinners while his attendant creatures tortured the damned. The great

17

fresco at the Campo Santo in Pisa, executed by Francesco Traini in 1350, at once comes to mind.[45] This frightening picture of what awaited the sinners in hell must have had a powerful effect on people in the late Middle Ages, and even in the sixteenth century Varthema probably felt the impact of paintings such as these. The fact that to Varthema Indian gods could not be anything but demons is attested in two further passages. In one he described the sculptures on the walls of the palace at Calicut as 'devils carved in relief'.[46] In the other he referred to the figures of Śiva and Pārvatī on a certain type of coin as 'two devils stamped upon one side of them'.[47]

It was not in Italy but five years later in Germany that an illustrated edition of Varthema was put out.[48] In the matter of popular prints on topical subjects or illustrations accompanying travel reports the Germans were the undoubted leaders in the sixteenth century. The publishers, moreover, had the services of outstanding artists. For his illustration of the idol of Calicut, the Augsburg artist Jorg Breu[49] turned to a stereotype that closely corresponded to the description in Varthema, since he did not have access to an actual Indian image. His task was made very simple by Varthema's substitution of a European devil for an Indian god. Dutifully he produced a woodcut which was no different from the popular woodcuts of the devil [11]. Also it is not impossible that he may have turned to Traini for his inspiration.

When examined closely, the Deumo of Varthema reveals further new features, for it is a composite monster, drawing upon several different traditions. First of all, the papal triple crown worn by the Sathanas of Calicut reminds one immediately of the tradition of popes in hell, and the most notable one in Dante.[50] In the case of Varthema it is difficult to say whether he was following a satirical tradition or not, but he must have been familiar with these traditions. The creature's three crowns, four teeth, and four horns remind us distinctly of the dragon of the Apocalypse. No doubt the Apocalyptic dragon had seven heads, ten horns, and seven diadems, but in the Revelation these numbers had a special mystic significance.[51] Yet the play upon the numbers three and four is so striking that it cannot be easily dismissed. Also one only needs to remember that the dragon symbolized pagan empires of the East.[52] Therefore for Varthema it was natural to think of pagan India in these terms. In keeping with this tradition the artist chose to represent the Deumo with claws rather than cloven hooves. The claws were the contribution of the Apocalyptic dragon to the medieval configuration of the devil. The shaggy lower limbs were of course derived from the classical satyr which had by now become the stock attribute of the devil.

The second illustration of the Deumo receiving sacrifice is a more straightforward devil-figure with horns like the one we encountered in

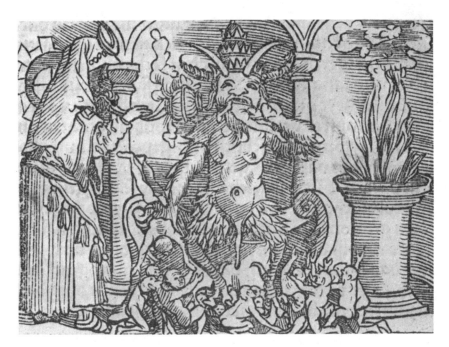

11. Idol of Calicut in Varthema's *Itinerario*

Livre des merveilles [10]. However, here it has claws instead of cloven hooves for its feet [12].[53]

The Deumo of Varthema set the tradition of demons adored in India in literary accounts and in illustrations. Varthema's work ran into numerous editions and was translated into all the major European languages. His particular portrait of Indian gods thus made its way into the works of subsequent travellers, most of whom were either directly or indirectly indebted to him. When Martin Fernandez de Figueroa published his *Conquista de las Indias* in 1512 subsequent to his visit to India between 1505 and 1511, he did not forget to summarize Varthema's description of the devil of Calicut.[54] While the picture of anti-Christian demons posing as Indian gods continued to haunt the pages of travellers, each traveller began to enrich the tradition by adding elements from his own experience in India as well as from his knowledge of the medieval demonological iconography. The descriptions inevitably gained in conviction as circumstantial details from the traveller's own experience were added to them. From the end of the sixteenth century to the beginning of the next the first group of Englishmen arrived in India. Some of them have left us their impressions of Hindu gods. By 1577 the average educated Englishman had read Richard Eden's

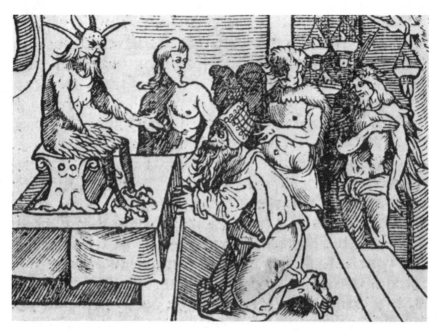

12. Calicut Idol receiving Sacrifice

translation of Varthema even if he did not have access to the earlier Latin one.[55] Ralph Fitch, travelling between 1583 and 1591, was the first Englishman to report that the Hindu idols in Bijapur looked like the devil.[56] But clearly the idols of Benaras, the holy city of the Hindus, merited detailed treatment:

Here . . . they have their images standing, which be evill favoured, made of stone and wood, some like lions, leopards, and monkeis; some like men and women, and pecocks; and some like the devil with foure armes and 4 hands . . . And in divers places there standeth a kind of image . . . they call Ada . . . This Ada hath foure hands with clawes . . . They have in some of these houses their idoles standing, . . . Many of them are blacke and have clawes of brasse with long nayles, and some ride upon peacockes and other foules which be evill favoured . . . none with a good face.[57]

There is, however, a new departure here. While agreeing with Varthema, Fitch provided the additional factual information that each Hindu deity was symbolically associated with a particular animal. William Finch, who followed him in the years 1608–11, saw in the Mughal emperor Akbar's gallery in his palace 'pictures of Banian dews [*deva*] or rather divels, intermixt in most ugly shape with long hornes, staring eyes, shagge haire, great fangs, ugly pawes, long tailes, with . . . horrible dif-

20

formity and deformity . . .'[58] If we searched within the Hindu pantheon we would be hard put to it to find such a monster. The Western demonic tradition is far too obvious here to require further comment. Perhaps the word dew (*deo*), whose initial letter is the same as that of the devil, reinforced this line of argument. Apart from equating these gods with devils, Finch elsewhere had also described 'pagods, which are stone images of monstrous men feareful to behold'.[59] The learned priest Edward Terry came to India as a chaplain to Sir Thomas Roe, King James's emissary to the court of Jahangir. Terry pointed out that the notorious idolaters,[60] the Hindus, were divided into many sects. No doubt the words of the early Fathers were uppermost in his mind when he wrote 'but that I know Satan (the father of division) to be the seducer of them all.' He also agreed with the prevailing view that Hindu images of worship were 'made in monstrous shapes'.[61]

The second important link in the chain of stereotypes for Indian gods was J. H. van Linschoten, who arrived in India in 1583 and lived there for five years. His *Itinerario* brought out in 1596 contained engravings by Joannes and Baptista à Doetechum based on his own sketches.[62] He made a point of visiting the rock-hewn monuments in the neighbourhood of the Portuguese possessions on the west coast of India. These monuments, which were to become some of the supreme examples of 'the sublime and the picturesque' architecture of the late eighteenth century, were then only beginning to acquire renown.[63] It is evident from Linschoten's remarks that Salsette made a strong, even frightening, impression on him:

The Pagodes and Images are many and innumerable throughout the Orientall countries . . . By the town of Bassaym . . . there lyeth an Island called Salsette. There are two of the most renowned Pagodes, or temples, or rather holes wherein the Pagodes stand in all India . . . Images therein cut out of the [very] rockes of the same hill, with most horrible and fearefull [formes and] shapes . . . all the chambers . . . are al full of carved Pagodes, of so fearefull, horrible and develish formes [and shapes] that it is [an abomination to see]. The other temple . . . with so evill favored and uglie shapes, that to enter therein it would make a mans hayre stand upright.[64]

Linschoten came across another monstrous Indian god in a village in the south which was

so mishaped and deformed, that more monstrous was never seene, for it had many hornes, and long teeth that hung out of his mouth down to the knees, and beneath his Navel and belly it had an other such like face, with many hornes and tuskes . . . Upon the head thereof stoode a [triple crown] Myter, not much unlike the Popes triple crown, so that in effect it seemed [to be like the monsters described] in the 'Apocalips'.[65]

21

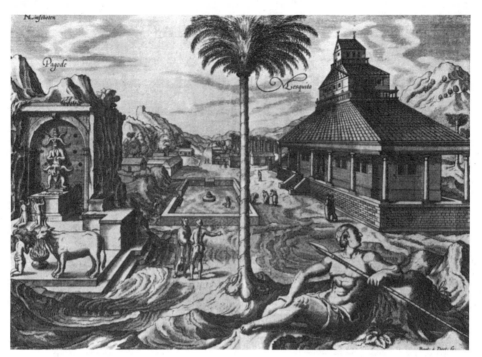

13. Linschoten's *Idolum Indorum Pagodes*

The two descriptions were combined by Baptista à Doetechum to produce the curious illustration [13] of *Idolum Indorum Pagodes, & Templa Mahumetanorum.*[66] The print was expected to offer a general picture of non-Christian faiths. The pagode is a square rock-hewn temple consisting of a façade with a Romanesque round arch resting on two shallow columns. Presumably this was the rock-temple of Salsette. The paraphernalia of Hindu worship such as a bathing tank and a sacred cow were thoughtfully added. In the niche of the temple, on a pedestal, stands a monster which is close in spirit to the Deumo of Varthema with its horns and tusks. Deumo's connection with the dragon of the Revelation was only implied in the Italian traveller. In Linschoten this was made explicit in the above passage. If we accept that the second head of the monster issues from his belly, it can then be easily traced back to the gastrocephalic monsters of the Middle Ages.[67] Linschoten's Indian monster was considered important enough to be mentioned by the Jesuit historian Du Jarric.[68]

Among the early seventeenth-century travellers, the gentleman traveller Sir Thomas Herbert carried on the tradition of Indian monster-gods. His 'Picture of an Indyan merchant or Bannyan with his idol' shows a composite monster whose direct antecedent is the 'pagode' of Linschoten [14].[69] Herbert's monster, however, has much more pro-

22

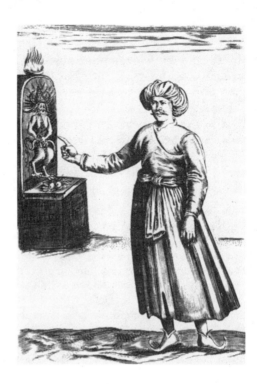

14. Herbert's picture of Indian Bannyan with Idol

nounced and pendulous breasts. When Sir Thomas felt like conveying a vivid impression of idolatry to his audience he did not hesitate to reproduce Varthema's description of the demon of Calicut more or less verbatim:

In Calicut . . . their King adores the Dieuill (whom they call the Deumo) the chappell where this monster sits is uncouered, and in height about three yards. As they goe in, the wooden entrance is engrauen with hellish shapes. Within their beloued Deumo is imperously inthronized vpon a brazen mount. His head is aduanced with a rich Diadem, from his head issue foure great hornes (such as haue the Rams of Persia) his eyes glaring, mouth like a Port Cullis, beautified with foure tuskes, his nose ugly flat, his looke terrible, hands like clawes, has Lions thighs and legs, and feet not unlike Monkey: and besides this Grand Pagod are lesser Deumoes glistering like Glowormes, Some of which are pictured devouring soules.[70]

We may grant that for Herbert with his classical education it was not possible to come to terms with the many-armed Indian gods. But the point at issue is not that he was critical of these images, but that he preferred to reproduce the impressions of his predecessors instead of presenting examples from his own experience. One can give no better instance of the curious persistence of monster stereotypes. Herbert had earlier brought up the subject: 'I have seene some of their Pagothes or Idols, in wood resembling a man, painted with sundry colours, his legs

23

stradling, very wide, under him two lampes, not always burning. In other Fanes (temples) they have three or fiue great Pagods, to which they pray, though they be misshapen and horrible.'[71]

During the period 1638–40 Johann von Mandelslo went out to the East as the ambassador of the Duke of Holstein. His *Communication on India*, published by Adam Olearius in 1647, acquired much popularity in its time. Although Mandelslo was quite ready to appreciate the beautiful architectural details of Hindu temples, he none the less subscribed to the age-old tradition of monster-gods:

They are indeed of a belief, that there is but one God . . . yet does not this perswasion hinder, but that they worship the Devil . . . The Figure under which they represent him is dreadful to look on. The Head, out of which grows four Horns, is adorn'd with a triple Crown, after the fashion of a *Tiara*. The countenance is horribly deformed, having coming out of the Mouth two great Teeth, like the Tusks of a Boar, and the Chin set out with a great ugly Beard. The Breasts beat against the Belly, at which the Hands are not absolutely joyned together, but seem negligently to hang down. Under the Navil, between the Two Thighs, there comes out of the Belly another Head, much more ghastly than the former, having two Horns upon it, and thrusting out of the Mouth a filthy Tongue of extraordinary bigness. Instead of Feet it has Paws, and behind, a Cows-tail.[72]

Not only did Mandelslo tread the ground made familiar by Varthema and Linschoten, but he had yet another distinct medieval tradition in mind, when he compared the teeth of the devil-god to the tusks of a wild boar. In medieval literature the wild boar with its fierce tusks was presented as an evil-mouthed sinner who served Antichrist.[73] Mandelslo concluded with the description of 'Pagodes (temples) . . . which look more like Caves and Holes of darkness than Places of Devotion, there being nothing to be seen on the Walls of them, but the Figures of Beasts and Devils. Notwithstanding which these poor wretches pay their Devotions with more respect and zeal than is observed in most Christian Churches.'[74]

Three Frenchmen who visited India in the second half of the seventeenth century achieved great fame in contemporary Europe. The jeweller, Jean-Baptiste Tavernier, who made six voyages to the East, was personally felicitated by Louis XIV.[75] Tavernier, who met the other two Frenchmen, Thévenot and Bernier, during his extensive travels in India, gave a detailed description of Puri, Benaras, and Mathurā, three of the greatest Indian temples, in his book dated 1676. In the Jagannātha temple in Puri he found 'Niches fill'd with . . . idols; the greatest part whereof represent most hideous monsters, being all of different colours.'[76] Similarly he found in Mathurā 'Round the *Duomo*'s [dome] are niches fill'd with the figures of daemons.'[77] It is clear from the next

passage that the symbolic images of gods were in the main objectionable: 'Some with four arms, some with four legs, some with men's heads upon bodies of Beasts, and long tails that hang down to their thighes: There are an abundance of Apes; and indeed it is an ugly sight to behold so many deform'd spectacles.'[78] Inside too he saw a *ratha* or chariot covered with painted 'calicut' depicting 'the shapes of Devils'.[79]

Young Jean Thévenot, the nephew of Melchisedec Thévenot, the French equivalent of the Italian Ramusio and the English Purchas, did not live to see the publication of his travel book in 1684. He was unlike Tavernier, an admirer of Indian temples, particularly Ellora.[80] Yet he could not help remarking that the Pagodes at Masulipatan were 'so full of the lascivious Figures of Monsters, that one cannot enter them without horror.'[81]

When the noted physician and philosopher François Bernier's Dutch editor chose to portray Hindu worship in 1699, he took the simple expedient of inserting a devil-figure in his illustration [15] of a Gentile and his wife.[82] There was no need for further elucidation since for a long time the average reader had learnt to expect the devil whenever the subject of Indian gods came up. Bernier, a disciple of Gassendi, had himself mentioned 'a stately engine of wood, as I have seen of them in many other places of the Indies, with I know not how many extravagant figures, almost such as we are wont to paint Monsters with two heads or bodies, half man and half beast, or gigantic or terrible heads, Satyrs, Apes or Divels'.[83]

It was in accord with this prevailing sentiment that Jan Nieuhof observed in 1682 that 'not far from the city [Nagapatan] is a *Pagode* ... call'd *Tzina*, the Pinacle of which reaches to the very Clouds, the Inhabitants believe that it was built by the Devil, and that in one Night... In the Suburbs to the North ... you see many Idols of a terrible aspect, made only of Clay.'[84]

The account of monstrous gods of India is brought to a close here with two Englishmen whose works exemplify the amazing persistence of this tradition. In the work of John Ovington the epithet 'monstrous' became imbued with a new meaning which foreshadowed late eighteenth-century romantic attachment to Elephanta and other cave-temples. Significantly the word monstrous was applied to the scale of sculptures.

Of these Gigantick Figures, some had six Arms, and others three Heads, and others of such vast Monstrosity, that their very Fingers were larger than an ordinary Man's leg.[85]

Ovington felt that he was obliged to explain the reasons for this interest in the 'monstrous': 'This variety of pleasant and monstrous Images, I lookt upon as no other than the several Objects of the Gentiles worship,

25

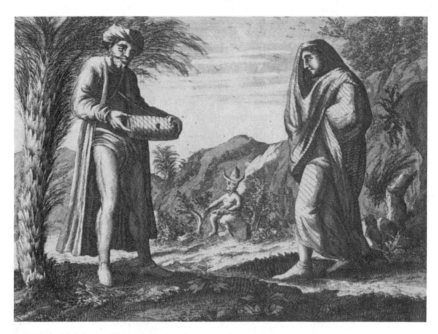

15. Hindu idol in the Dutch edition of Bernier

as each Adorer's Fancy led him to his several God, either of Terror or Delight.'[86]

The learned Dr. Fryer of Cambridge, whose statement that 'Eliphanto' was named after the 'monstrous' stone elephant supported Ovington's equation of 'monstrosity' with huge size, none the less continued the earlier tradition. In 1672, he saw in Madras a Gentile pagode (temple), 'where is supposed to be hid their Mammon of Unrighttuousness . . . the outsides [of which were filled with monstrous figures.]'[87] He too felt the need to explain why Indian gods were 'cut in horrid Shapes, the reason of which . . . though I should allow the diversity of Creatures in all Orders of the World, hath no other aim but to represent the Divinity, by whatsoever Image, yet I cannot imagine such Deformities could ever be invented for that end'.[88]

With Dr. Fryer one may conveniently bring to a close the account of monster stereotypes that were used for the depiction of Indian gods. For while travellers continued to mention occasionally devil-worship in India even beyond the seventeenth century, by this time the original impetus had lost its force and was being increasingly replaced by more scientific attitudes to Hinduism. Although Indian gods had been identified with demons as early as the fourteenth century their definitive shape was given by Varthema whose direct and indirect influence was to be

26

felt in virtually all subsequent travellers. The reasons for such wide diffusion of Varthema's *Itinerary* were not only that he was published in translation in all major European languages but also because great compilers of travels and cosmographists did not fail to include his Deumo of Calicut in their works. In Italy, the first volume of Ramusio printed in 1550 contained Varthema's account.[89] In the same year the learned doctor of Basle, Sebastian Münster, brought out the last of the great cosmographies, which not only included Varthema's description but carried an illustration as well [16].[90] The royal cosmographer of France, André Thévet, did not lag far behind, as he too provided the description of the Calicut idol in his *La Cosmographie universelle* (1575).[91] Mention has already been made of Richard Eden's English translation of Varthema (1577).[92] Doubtless Varthema was widely quoted even in the

16. Idol of Calicut in Münster's *Cosmographia*

seventeenth century. As late as 1667, when the monster tradition was well on the way out, we find Varthema's description of the Deumo of Calicut quoted *in extenso* by the influential comparative mythologist, Athanasius Kircher, in his *China Illustrata*.[93]

There now remain two notable exceptions to the monster tradition without a mention of which my account will not be complete. While discussing medieval mythographic tradition Professor Seznec drew our attention to the extent to which classical gods had survived in the Middle Ages in disguises borrowed predominantly from the Orient. This had given rise to a heterogeneous mythographic tradition during the medieval period. The medieval interest in exotic mythologies and Oriental cults declined sharply in the Renaissance when the classical forms of antique gods were restored to them. However, there was a revival of interest in exotic mythologies from the middle of the sixteenth century, encouraged no doubt by the growing Egyptomania.[94] Following the Greeks themselves the Renaissance Neoplatonists had accepted Egyptian hieroglyphs as a mysterious sacred language which contained the profound secrets of ancient religion.[95] The mythographic manuals published between 1548 and 1556 as iconographic guides to practising artists show this interest in exotic cults. Of the manuals, *The Images of*

27

the Gods by Vincenzo Cartari was the most popular and had won the approval of Lomazzo, the theoretician of the Mannerist period. Continuing the syncretic tradition Cartari and others had claimed to treat 'tutti i dei della gentilità'. Cartari's chief concern was to present a whole 'barbaric pantheon' while showing a nominal interest in classical gods.[96]

An event of considerable importance, which contributed to the widening of Western intellectual horizon, took place in 1615, when Lorenzo Pignoria added the descriptions of Indian, Japanese, and Mexican gods in Cartari's *Images*.[97] Pignoria's place in history is assured as a forerunner of eighteenth-century scholarship in comparative religion and mythology. He belonged to the circle of enlightened Humanists such as Charles Fabri de Peiresc and Girolamo Aleandro who not only collected exotic idols and read about them in travel reports but were actively engaged in studying the parallels between different forms of paganism and in trying to form a universal theory of religion. Despite their limitations it is refreshing to see that they did not reject exotic non-European religions out of hand. Pignoria's own comparative method consisted in tracing all religions back to Egypt which was accepted by him as the centre of diffusion.[98] Pignoria's edition of Cartari provided the illustration of an Indian god based on two separate sources [17]. At the end of 1553 an anonymous Jesuit father sent back reports from Goa about a statue with three heads, three legs, and three hands, belonging to the temple on the island of Elephanta. This statue is none other than the famous Śiva Maheśamūrti figure at Elephanta [84]. In 1560 the Jesuit Ludovico Fores sent information about the elephant-headed god Ganissone (Gaṇeśa).[99] These two reports were combined by the engraver Ferroverde to create a symbolic image which fitted very well with the general tenor of Cartari's book with its collection of strange, ancient Near Eastern gods. Pignoria had accepted that these gods 'composés d'homme et de bête—qu'on voit dans les temples hindous et telle de statues Japonaises, voire un certain serpent symbolique, lui paraissent venir tout droit des bords du Nil'.[100] It was in accord with his interest in symbolic images that Pignoria wished to learn its secrets, and he expressed regret that the Jesuit fathers had not explained its meaning. Indian gods with their remoteness from the general European scene could hardly make a lasting impression in this period. None the less it is important to recognize this early and in many ways unusual interest in the meaning of Indian images, prompted no doubt by the prevailing obsession with baffling allegories and abstruse symbolism.

Finally, the Humanist Pietro della Valle's attitude to many-armed Indian gods represented an age-old Western tradition regarding symbolic images, which found its most elaborate exposition in Neoplatonic thought. His travels, published in the years 1657–63 in the form of

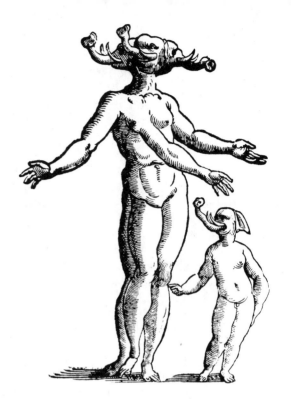

17. Indian gods in Cartari's *Images*

letters to his friend Mario Schipano, included a traditional description of devil-worship in an Indian temple.[101] But this Roman patrician was a cultivated man and a Humanist and had moreover shown interest in Oriental philosophy and religion in a number of letters. A friend of Kircher's and possibly Pignoria's, he was also the first traveller to direct the attention of scholars to Assyrian cuneiform inscriptions. We can therefore understand why he took an active interest in Hindu rites and beliefs and even expressed the desire to inquire from the Brahmans at Goa what the seemingly bizarre Hindu iconography meant.[102] He was quite convinced that Indian images contained rational and profound truths behind their 'monstrous' exterior. It was in this frame of mind that he spoke of the gods in a temple in the city of Cambay:

One there was which had many Arms on a side, and many Faces and this they . . . call'd *Brachma*, one of their chief false Deities. Another had the head of an Elephant and was call'd *Ganescio* . . . Some of the Idolets sat upon Sundry Animals, as Tygers and the like, and even upon Rats; of which things the foolish and ignorant Indians relate ridiculous stories. But I doubt not that, under the veil of these Fables, their ancient Sages (most parsimonious of the Sciences, as all Barbarians ever were) have hid from the vulgar many secrets, either of Natural or Moral Philosophy, and perhaps also of History . . . and I hold for certain that all these so monstrous figures have secretly some more rational significations, though expressed in this uncouth manner.[103]

29

Della Valle's conviction that these 'so monstrous figures have secretly some more rational significations' stemmed from a well-established Western tradition regarding the symbolic image. As Professor Gombrich has shown, two essentially different attitudes prevailed towards images in the Christian church in the Middle Ages. In the first tradition, called by him the Aristotelian, the function of the image was didactic because it was used to teach the Sacred Word to the illiterate as a visual complement to the Scriptures. Since the danger of idolatry was always there, the Church exhorted its followers not to take the image literally, but only as standing for a higher idea. Symbols of this kind were easily comprehensible for they were a sign language that gave visual form to canonical ideas. Side by side there existed an alternative but equally important Neoplatonic tradition of an essentially mystical approach to the image, formulated in the texts attributed to Dionysius the Areopagite.[104] The author, a Christian Neoplatonist, justified the existence of certain gross and 'inappropriate' symbolism in the Bible by suggesting two ways of approaching the Divine. In the first, the celestial hierarchy was presented in a 'positive' manner in terms of beautiful beings. Here Dionysius was recalling Plato's doctrine that it was the recognition of beauty that formed the precious link between our mortal world and the higher spiritual one. In Christian terms the analogy of beauty was one of the means for the comprehension of the ways of the Divine. Yet, as Dionysius pointed out, there was an inherent danger in the use of sensible form for a spiritual idea, as these beautiful beings could be taken literally as god-like men. Therefore, in order to prevent this confusion, a 'negative' approach of 'inappropriate' symbols was used in the Scriptures. A famous instance of this was Ezekiel's vision of four enigmatic animals representing four evangelists.[105] The very monstrosities of these images prevented them from being accepted as real and stimulated the mind to seek a higher spiritual significance. To quote Professor Gombrich, 'To the profane these enigmatic images conceal the holy arcanum of the supernatural; to the initiate, however, they serve as the first rung of the ladder through which we ascend to the Divine.'[106] This symbolic interpretation of the monstrous and the enigmatic goes back however to early Greek history. With the rise of natural philosophy the idea gained ground, in connection with the interpretation especially of coarse and obscene myths about gods, that ancient poets, Homer and Hesiod, had presented profound spiritual ideas through the means of symbol and allegory. The idea rests on the conviction that Nature revealed herself only to those who were able to appreciate her ways, but to the vulgar she turned her enigmatic and monstrous side. This doctrine, with its elevation of the status of the initiated, not only affected ancient mystery cults, but also Neoplatonism

and ultimately Christianity as well.[107] When efforts were made to re-
concile classical philosophy with Christianity, it was argued that, while
undeniably God had chosen the Revelation to make the idea of mono-
theism known to man, pagan philosophers, who were close to the period
of the Creation, were also allowed to share in this knowledge. The sages
however hid their knowledge behind the veil of allegory so that it was
not prematurely profaned. This view of mysterious symbols, whose long
history I have outlined here, saw a powerful revival in the Renaissance
Neoplatonists who regarded Egyptian hieroglyphs not as a proper langu-
age but as cryptographs containing the secrets of ancient Eastern
sages.[108] It was precisely this powerful tradition that della Valle followed
when he claimed to see some rational significations behind the 'mon-
strous' Indian gods. Della Valle's serious concern with the meaning of
Indian religion is confirmed by his modern editor. Underlying the
writings of this Italian traveller there is a deeper vein of thought which
attempts to penetrate the mystery surrounding the outer semblance of
Hinduism.[109] Equally remarkable is the way in which della Valle anti-
cipated eighteenth-century syncretists in not only identifying Indians
as Pythagoreans, but tracing common worship of Isis and Osiris in
Egypt and India, and finally comparing many-limbed and animal-
headed Hindu gods with the gods Janus, Jupiter-Ammon, and Anubis.
It does not come as a surprise, therefore, that he was also one of the first
Europeans to make a distinction between a higher philosophical form
of Hinduism and the superstititous cults of the multitude.[110]

ii. WONDERS OF ELEPHANTA

What makes the travel reports fascinating reading is that, while the
iconography of Indian art was uncomprehendingly received as the re-
pository of esoteric wisdom or the outcome of demonic religion, early
travellers did not hesitate to reflect on the architectural grandeur of
Hindu temples and the delicate craftsmanship of the surface sculptures
on them. Also, if in some cases the meaning of certain sculptures eluded
the travellers, their form rarely failed to please them. This counter-
tendency only goes to show that, however limited it might have been,
the appreciation of the beautiful architectural details or the treatment
of the human figure pointed the way to a proper aesthetic appreciation
of Indian art. The grand conceptions of the excavated temples of Western
India were especially admired. It may be argued that architecture, lack-
ing the emotional and cultural connotations of figure sculpture, is
generally far easier to come to terms with. Architecture may even be
called a neutral subject compared with figure sculpture, because the
human form may embody not only what a particular civilization regards
as beautiful but the whole ethos of that society. My point at once

becomes clear if we consider the importance attached to the representation of the nude in Western art.[111] Here very clear and specific rules were evolved as to what could be represented and what could not be. In the same way, when we look at Indian sculpture, we become at once aware that certain clearly defined principles were equally at work in the depiction of the human figure. It was the conflict of two different but clearly defined standards of beauty that proved such a stumbling-block for the early travellers. On the other hand, they were ready to appreciate the skill involved in the excavations of rock-temples or the delicate craftsmanship of the architectural details. The admiration of the early Europeans was accompanied by a steady growth in the documentation of information regarding Indian temple architecture, including some notable early efforts at measuring certain monuments. These attempts paved the way for a more systematic documentation of the knowledge of Indian architecture in the eighteenth century. Early travellers conveyed their impressions of Indian architecture by way of analogy with famous examples drawn from European architecture. The method was close in spirit to the stereotypes of monsters used for Indian gods. What they did not appreciate they described by analogy with known examples. What they did appreciate they felt they could best describe by drawing an analogy with what the average European knew very well. A good example is the sixteenth-century traveller who called the style of sculpture in a south Indian temple 'romanesque'.[112] This kind of comparison, which ignored the essential differences between Indian and European traditions, arose because travellers were not clearly aware of cultural differences. The lack of a clear idea of cultural differences was also to be noticed in early descriptions of non-European societies. Travellers frequently described a piece of sculpture or architecture as being in the 'antique' style simply because that piece happened to coincide with their own aesthetic values. From discovering 'antique' works in India to linking them with Alexander's visit to the country was a small step and this was taken with regard to western cave temples.[113]

Obvious as the limitations of this comparative method were, it none the less rendered a useful service. It sustained the interest of the reader by offering him a visual analogy which formed a bridge between the familiar and the unfamiliar. As far as architecture was concerned literary descriptions seldom found their illustrators, which was a great contrast to the 'monster' gods. But then it was usually the strange and the sensational that took the fancy of the engravers. Monster stereotypes far outnumber other descriptions of Indian gods. We shall, however, come across occasional descriptions where Indian gods are not treated as monsters.

The same friar Odoric who was the first known European to talk about monstrous idols of India spoke admiringly of 'a certain wonderful

32

18. Golden Indian god in Odoric's travels

idol, which all the provinces of India greatly revere and which is as big as St. Christopher is commonly represented by the painters, and it is entirely of gold'.[114] St. Christopher, one of the best-known saints of the Middle Ages who offered special protection to pilgrims, was most frequently depicted on a grand scale on the outsides of churches. Taking his cue from Odoric, who not only described the idol as wonderful but had compared him with St. Christopher, the illuminator of *Livre de merveilles* this time gave a human form to the Indian god [18].[115] The fifteenth-century Italian Niccolo Conti mentioned temples for Indian gods built 'very similar to our own, with interiors containing paintings of figures and idols of the height of sixty feet'.[116] Until the sixteenth century the descriptions are very general and suffer from a lack of precision, thus making it impossible for us to identify any temple with certainty. Nor did the travellers see much of India. For instance, immediately after his brief visit to the western coast of India Odoric embarked for China. Conti too is very sparse with incidental details about the places he visited.

It is only in the sixteenth century that the descriptions gain in richness of detail and from the statements of travellers it is often not difficult to identify the temples. A remarkable document bearing witness to the early appreciation of the sculptures of western Indian cave temples comes from the collection of travels edited by Ramusio. It is a letter

written by the Florentine Andrea Corsali from India to the Duke Giuliano de' Medici in 1515 in which he deplored the destruction of an Indian temple on the island of Divar by the Portuguese. The passage is worth quoting in full for the contrast it makes to the reactions of Varthema:

In this land of Goa and the whole of India there are numerous ancient edifices of the pagans. In a small island nearby called Divari, the Portuguese in order to build the land of Goa have destroyed an ancient temple called Pagoda, which was built with a marvellous artifice, with ancient figures of a certain black stone worked with the greatest perfection, of which some still remain standing in ruins and damaged because the Portuguese do not hold them in any esteem. If I could obtain one of these sculptures thus ruined, I would have sent it to your lordship, so that you may judge in what great esteem sculpture was held in antiquity.[117]

It was probably because Corsali belonged to Florence which played such a leading role in the rise of new Humanism that he was able to overcome the prejudice which an average traveller betrayed in his response to Indian sculpture. I have no doubt that Corsali shared the Renaissance enthusiasm for classical art and regarded it as the highest achievement that human beings could aspire to in art. Therefore, the classical world, he felt, had something to do with the sculptures at Divar and it was not without reason that he had 'antiquity' in mind when describing this temple. Corsali's account had impressed the royal cosmographer Thévet (1575) so much that his description of antique statues and medals included an appreciative account of 'belles medalles d'une certaine pierre noire, si bien & proprement elabourees, & en telle perfection, que les meilleurs tailleurs du nostre temps se trouveroient es bahis d'imiter chose si parfaite que ces dites medalles' from Dinari.[118]

An event of considerable importance took place in the wake of the Portuguese occupation of western Indian coastal areas in the sixteenth century. The cave temples near Bombay and Goa, notably Elephanta, Kānheri, and Mandapeswar, thus came to the notice of Europeans. Initially these temples suffered in the hands of religious zealots as attempts were made to convert them into Christian churches. From G. P. Maffei (1588), the official historian of Jesuit missions, we learn that after purging one of the temples at Elephanta of all previous profanations Father Antoine had dedicated it to God.[119] Presumably the building was aesthetically pleasing enough to be consecrated to God so long as it could be cleansed of its pagan associations. In the midst of unrelenting Jesuit hostility there are occasional grudging tributes to Elephanta. Father Gasper reported that many monuments of skill and magnificence were to be seen in India.[120] Maffei himself remarked about temples 'which are able to compete in magnificence with the most superb of

34

ancient Rome'.[121] Later the Jesuit historian, Du Jarric (1608), also praised 'Temples fort somptueux & magnifiques'.[122] Two major secular Portuguese writers attested to the fine sight these monuments offered when they first saw them and to the fact that they showed signs of rapid deterioration on account of neglect and wilful damage. Garcia da Orta remarked that Elephanta was a fine sight when he first arrived from Portugal in 1534, but it was fast becoming the pasture ground of local cattle,[123] while Couto lamented the imminent destruction of 'one of the most beautiful things in the world'.[124] After suffering initially from the depredations of Portuguese soldiers, they began to attract men of letters who took the opportunity offered by Portuguese explorations of these areas to visit them. The cave temples lend themselves easily to romanticization because of their grand conception and massive scale, of the interplay of light and shadow within and without them, and finally on account of the wonderful visual dialogue between the simplicity of the total conception and the richness of decorative details. These visitors in the age of Humanism who brought with them certain powers of observation and a breadth of vision were at once struck by the imagination and skill involved in excavating these enormous temples of such delicate craftsmanship. It was a certain sense of wonder which they tried to convey in their writings. It was they who spread the news that these monuments were some of the greatest wonders of the world.

Elephanta and other cave temples in the vicinity might have already been known to Europeans in the fifteenth century, but we have definite evidence that the Portuguese botanist Garcia da Orta paid a visit to it in 1534. He was the first European to record his impressions of this monument. He was so impressed with it that he did not consider it improper to insert a short description of the temple in his otherwise purely scientific account of the medicinal herbs of India. We also learn from him that the Portuguese had already given currency to its present name of Elephanta and that to Indians it was known as Pory (Gharapuri). The name Elephanta originated from the large sculpture of an elephant that stood at the entrance to the temple but has now disappeared. Orta, who regarded Elephanta as the 'the best of all' the pagodas he knew, wrote as follows:

Another pagoda, the best of all, is on an island called Pori, which we call the Isle of the Elephant . . . On the walls, all round, there are sculptured images of elephants, lions, tigers, and many human images, some like Amazons, and in many other shapes well sculptured. Certainly it is a sight well worth seeing and it would appear that the devil had used all his powers and knowledge to deceive the gentiles into his worship. Some say it is the work of the Chinese when they navigated to the land. It might well be true seeing that it is so well worked.[125]

Orta also mentioned visiting Kānheri but left no account of it.[126]

The next visitor to Elephanta was the statesman João do Castro, a remarkable man and Renaissance personality with wide-ranging interests and accomplishments.[127] Castro's navigational diary *Roteiro de Goa até Dio* reflects a deep feeling of wonder on his part at the sight of the huge and magnificent temple at Elephanta, for he was thoroughly overwhelmed by the great 'boldness' of manner in which the whole edifice was hewn out of the hard, solid rock. A work of such magnitude and artifice, he declared, could not have been produced by mortals and it must be regarded as one of the wonders of the world. He was convinced that such imagination which went beyond the bounds of nature was not lawful. As a Humanist Castro was convinced that unless one was confident that men were capable of such feats the unbelievable edifice must appear to be the product of spirits and diabolical agents. In exasperation he confessed the loss of words to describe fully the remarkable monument with all the stories represented on the walls and all the gods depicted. But here Castro was being modest for what he did was an essential prerequisite for the study of architecture. There is strong suggestion that this man, who was endowed with a scientific bent of mind and an outstanding gift of observation, was also acquainted with Humanist principles and methods of studying architecture. In order to understand the general plan and the distribution of parts in Elephanta, which was considered by him to be in Roman style, he carried out measurements of the temple and made detailed studies of columns and figures. This was the first attempt on record to measure an Indian monument. *Roteiro* thus forms one of the most valuable early documents in our study. Castro was so impressed by the sculptures that he stated that 'Indeed the proportions and symmetry with which each figure and everything else is made it would be worth the while of any painter to study it even if he were Apelles'.[128]

Castro also described with precision three of the major pieces of sculpture at Elephanta. While it is too much to expect a knowledge of Hindu iconography in this early period, Castro's accurate description of the figure upholding the ceiling with two arms helps us to identify it at once as the great Śiva Andhakāsuravadha image [54]. Likewise, he mentioned the Śiva Maheśamūrti figure as a man with three faces [84]. The androgynous Śiva Ardhanārīśvara image with a single breast was taken by him to be the Amazon of classical mythology [50]. This last identification introduced a long and celebrated tradition which was still firmly imbedded in eighteenth-century literature until the correct identification on the basis of Sanskrit finally laid it to rest.[129] Castro found Salsette even more impressive and left an equally detailed account of it.[130]

19. Thévet's illustration of Idol in Elephanta

Information about Elephanta had also reached the West through Jesuit sources in 1553 and 1560, which then received wide circulation in Pignoria's edition of Cartari.[131] In Thévet's cosmography too, not only do we find a long account of Elephanta and its statues 'de grandeur incroyable', but an illustration [19] of this particular monument with an idol.[132] Although the picture was based on a literary description the artist did not portray the Indian god as a monster. The reason may lie in the fact that Thévet sought to trace the imprint of Classical Antiquity in the art of Elephanta. In this Thévet was of course following the suggestion of the sixteenth-century traveller Corsali. In the work published in 1590 by Gasparo Balbi, Elephanta was identified as an antique Roman temple ('un tempio de Romani antico'). Somewhat inconsistently he added that it was built by Alexander to mark the end of his military advance into India.[133] On the other hand horror mingled with involuntary admiration for the unknown pagan sculptor's skill in Linschoten's description:

37

... and round about the wals are cut and formed, the shapes of Elephants, Lions, Tigers ... Amazones and [many] other [deformed] things of divers sorts, which are all so well [and workmanlike] cut, that it is strange to behold. It is thought that the Chinos [which are verie ingenious workemen] did make, when they used to traffique in the countrie of India.[134]

When we turn from Linschoten to the major Portuguese historian Diego do Couto we immediately sense the great difference in personality. Couto's appreciation sums up the whole attitude of the Humanists of the period to this monument. His active career spanned a period of fifty years in India during which time he gradually came to appreciate the splendours of the cave temples of Salsette and Elephanta.[135] Although part of his interest stemmed from curiosity about what he must have regarded as strange and mysterious monuments, his descriptions often reveal unusually perceptive aesthetic judgements and a keen eye for details. In the seventh Decade of his *Asia*, completed and published at the beginning of the seventeenth century and containing valuable descriptions of the cave temples, Couto uncritically reproduced an unreliable story that Kānheri caves contained a subterranean passage which went as far as Agra.[136] But he did note that

in the centre of this Island there exists that wonderful Pagoda of Canari, thus called from its being supposed to have been the work of the Canaras. It is constructed at the foot of a great Hill of Stone of light grey colour; there is a beautiful Hall at its entrance, and in the yard that leads to the front back door, there are two human figures engraved on the same stone, twice as big as the Giants exhibited on the Procession of the Corpus Christi feast in Lisbon, so beautiful, elegant, and so well executed, that even in Silver they could not be better wrought and made with such perfection.[137]

The conclusion he reached was that Kānheri 'may certainly be reckoned one of the wonders—and perhaps the greatest in the world'.[138]

As was the case with his predecessors Castro and Orta, Elephanta was given the pride of place in the Decade. He took elaborate measurements of the 'remarkable' and 'stupendous' temple, remarking that it was laid on a north-to-south axis.[139] About the sculptures he made the general remark that 'not only the figures looked very beautiful, but the features and workmanship could be very distinctly perceived, so that neither in silver or wax could such figures be engraved with greater nicety, fineness or perfection.'[140] Here we see something approaching aesthetic judgement which took into account the peculiar qualities of Indian sculpture, with its emphasis on rich ornamentation. Couto took enormous pains to go through the sculptural panels on every single wall in the main temple which were then described with great precision and care. Of course he had no knowledge of Hindu icono-

graphy apart from identifying the elephant-headed god at Elephanta as the Hindu god Gaves (*sic* for Gaṇeśa).[141] Yet it is remarkable that major Śaiva figures are clearly recognizable from his descriptions. The large Śiva Naṭarāja figure was mentioned.[142] Although earlier Castro had spoken of the Andhakāsura image, Couto gave a fuller description of it including its 'curious and beautiful crown on the head'.[143] The elaborate plastic treatment of Śiva's matted hair with beautiful jewels set in it especially fascinated Couto who mentioned it admiringly on several occasions.[144] As a person familiar with classical mythology, like Castro he was quick to identify the Ardhanārīśvara Śiva as an Amazon: 'The ancients believed this idol to have been half man and half woman, because it has only one breast like the ancient Amazons.'[145] His most important contribution was to leave an account of the great Maheśa-mūrti group, generally regarded as the highest achievement of the Kālācuri period:

From the pavement of this chapel issued a body from the waist upwards of so enormous size, that it fills the whole vacuum in length and breadth of the chapel: it has three large faces, the middle one looks to the north, the second to the west, and the other to the east. Each of these faces has two hands, and on the neck two large necklaces, wrought with considerable perfection. The figures have on their heads three very beautiful crowns.[146]

Finally, from Couto we learn that the Elephanta interior was covered with a fine coat of lime and bitumen composition which 'made the Pagoda so bright, that it looked very beautiful and was worth seeing'.[147] The colours have faded since in Elephanta, and only Couto's testimony remains to tell us how splendid it looked in the sixteenth century.

Elephanta, Kānheri, and Mandapeswar continued to be visited by Europeans in the seventeenth century. *Le Voyageur curieux* (1664), the posthumous work of an unknown author, contains an account of Elephanta in which the temple is claimed to be the work of Alexander.[148] The Englishman Ovington (1696) was specially fascinated by the animal sculpture in Elephanta: 'Here likewise are the just dimensions of a Horse Carved in Stone, so lively with such a Colour and Carriage and the shape finisht with that Exactness, that many have Fancyed it, at a distance, a living Animal, than only a bare Representation.'[149] From the following passage we have the information that he too was engaged in determining the size and measurements of Elephanta: 'Elephanta . . . cut out of the very Heart of a hard Rock, whose Dimensions are about an Hundred and Twenty Foot Square, and in Height about Eighteen . . . sixteen Pillars of Stone Cut out with much Art and Ingenuity, whose Diameters are Three Foot and an Half, design'd as it were for the support of this Weighty Building.'[150] Ovington admired the composition and arrangement of the columns and figures at

Elephanta, for he mentioned 'thus Beautified with these lovely Columns and curious Arches, are Figures of . . . Men . . . Twelve or Fifteen Foot high, in just and exact Symetry, according to the Dimensions of their various Statures'.[151] Neither did he ignore the treatment of expressions in the figures, for he wrote 'Here are some taking an Amiable Charming Lady by the chin, and there the horrid Prospect of others hewing in pieces little children; and generally above the Heads of all, are abundance of diminutive Folk hovering in the Air, represented with chearful aspects and lively Figures.'[152] He put forward a religious explanation to account for the excellence of the sculptures by suggesting that 'These Figures have been Erected not barely for displaying the Statuary's skill, or gratifying the Curiosity of the Sight, but by their admirable Workmanship were more likely design'd to win upon the Admiration, and thereby gain a kind of Religious Respect from such Heathens as came near them.'[153]

The Cambridge man, Dr. Fryer, who was over-fond of making obscure and learned allusions, curiously described Kānheri as

all cut out of a Rock; where is presented *Vulcan's* Forge, supported by mighty Colosses, bellied in the middle with two Globes. Next a Temple with a beautiful Frontispiece not unlike the *Portuco* of St *Paul's West* Gate: within the porch on each side stand two monstrous giants, two Lesser and one Great Gate give a noble Entrance . . . Beyond this [is a] . . . Place of Audience 50 ft Square, all bestuck with Imagery, well Engraven according to old Sculpture . . . More aloft stood the King's Palace, large, stately and magnificent.[154]

According to Fryer Elephanta too was a 'miraculous Piece hewd out of solid stone; it is supported with Forty two *Corinthian* Pillars, being a Square, open on all sides but towards the *East*; where stands a statue with three Heads, crowned with strange Hieroglyphics.'[155] He noted with regret about Kānheri that the Portuguese 'strive to erace the remainders of this *Herculean* Work, that it may sink into oblivion of its Founders'.[156]

The last and the most famous early description of Kānheri is to be found in the work of the Italian Gemelli-Careri (1700) who claimed to be the first European to discover it, appearing thus to be unaware of the works of Castro, Orta, and Couto.[157] It is, however, certainly true that he was the first traveller to make a serious study of its dimensions, the accuracy of which has stood the test of time.[158] It was entirely in keeping with the spirit of the period that he took it to be the work of Alexander: 'The Pagod or Temple of the *Canarin*, . . . is one of the greatest wonders in Asia, as well because it is look'd upon as the Work of *Alexander* the Great, as for its extraordinary and incomparable Workmanship, which certainly could be undertaken by none but *Alexander*.'[159]

European discovery of the other great rock-hewn temple site in west-

40

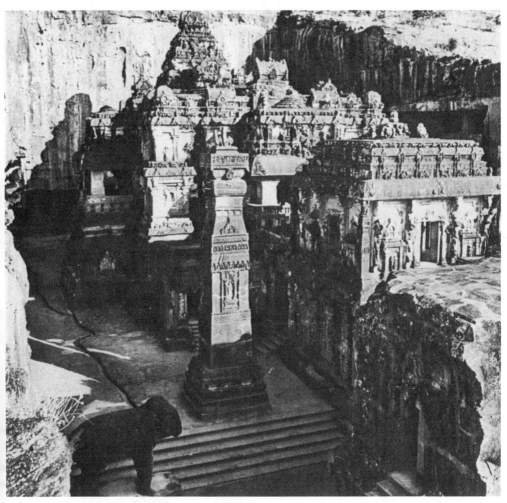

20. Kailāsa temple at Ellora

ern India, Ellora, had to wait until the late seventeenth century when Jean Thévenot decided to visit it because it was so well known all over India. Unlike the temples near Goa the difficulty of reaching it might have discouraged early Western travellers who were still unfamiliar with the interior of India. Thévenot could only spend two hours there and with the limited time at his disposal he was only able to give approximate measurements of the main buildings and sculptures. However, not only did he note that 'Everything there is extremely well cut, and it is really a wonder to see so great Mass in the Air, which seems so slenderly underpropped, that one can hardly forbear to shiver at first entering into it',[160] but he managed to supply a detailed account of the general design of Kailāsa temple [20], by analysing each of its three

41

main architectural parts.[161] Neither did he leave out the sculptural groups, noting in passing that on a high platform rested a gigantic idol with his head as big as a drum but the rest 'in proportion'. The great *dhvajasthambha* at Kailāsa which stands to this day was described as 'a Pyramide [lovely pyramid according to him] or Obelisk larger at the basis than those of Rome, but they are not sharp pointed'.[162] After remarking on the unusual three-storied Buddhist building generally called 'Tin Thal' Thévenot concluded:

If one consider that number of spacious Temples, full of Pillars and Pilasters, and so many thousands of Figures, all cut out of a natural Rock, it may be truly said, that they were works surpassing human force, and that at least [in the age wherein they have been made] the Men have not been altogether Barbarous, though the Architecture and Sculpture be not so delicate as with us.[163]

Domingo Paes, who has left us a valuable account of the great Hindu kingdom of Vijayanagar which he visited in the early sixteenth century, stopped on the way to examine

. . . the city of Darcha [Dharwar?] which has a monument such as can seldom be seen elsewhere . . . a Pagoda . . . so beautiful that another as good of its kind could not be found within a great distance . . . it is a round temple made of a single stone, the gateway all in the manner of joiners' work, with every art of perspective. There are many figures of the said work, standing out as much as a cubit from the stone, so that you see on every side of them, so well carved that they could not be better done—the faces as well as all the rest; and each one in its place stands as if embowered in leaves; and above it is in the Romanesque style, so well made that it could not be better. Besides this, it has a sort of lesser porch upon pillars, all of stone, and the pillars with their pedestals so well executed that they appear as if made in Italy.[164]

However, even more magnificent sights were awaiting him in Vijayanagar which he toured with a fellow Portuguese, Figueroa, as guests of the king Krsnadeva Rāya. Everywhere he went he found rows of fine houses, usually one-storied and flat-roofed, and broad and beautiful streets.[165] Admiringly he wrote that the city was as large as Rome and very beautiful to the sight.[166] Architectural remains confirm the glowing tribute paid by Paes to this splendid city.[167] He saw outside the city very beautiful pagodas, the chief among which was the temple of Viṭṭhalasvāmin which was begun by Krsnadeva Rāya and is considered one of the finest examples of Vijayanagar architectural style.[168] He also confirmed the rich polychrome effect these temples made, and described polychrome sculptures in temples in general. From him we learn that the palace contained sculptural panels on the walls representing various dancing postures which were a kind of *aide mémoire* to the dancers attached to the court.[169] The palace walls also carried paintings with

scenes painted 'like life' representing everyday subjects, including exotic ones like the arrival of the Portuguese in the kingdom.[170]

Although reports about the cave temples near Bombay far outnumbered those from other areas, the rest of India, including the north, began to be explored from the sixteenth century onwards as well. The cave temples were mostly visited by the Portuguese or those who happened to arrive in Goa in Portuguese vessels. Those who took the overland route went through well-known places in the north. Thus in the late sixteenth century the first English travellers visiting India provide us with much information about the architecture of the north, laying special stress on the splendour and wealth of the temples. Fitch saw 'very many faire houses'[171] along the water in Benaras, while Withington agreed that Baroda was a 'little cittye, yet of fyne buyldings'.[172] William Finch mentioned, among other antiquities, 'a very faire tanke' in Ajmer, 'three faire Pagodes richly wrought with inlayd workes, adorned richly with jewels' in Merta,[173] and finally the 'faire' city of Bayana.[174] Edward Terry, the chaplain to Sir Thomas Roe, King James's emissary to Jahangir, described the temple of Nagarkot as 'most richly set forth, both scaled and paved with plate of pure gold'.[175]

During his stay in India between 1614 and 1619, Roe travelled up north to Chitor in Rajasthan which had been sacked by the Mughals in Akbar's time. Roe however noted that the ruined city still contained a 'toombe of woonderfull magnificence . . . 100 churches all of carved stone', and a magnificent city gate.[176] He then proceeded to Todah where he saw 'many excellent woorkes of hewed stone about yt excellently cutt, many tancks, arches, vawlted, and discents made, lardge and of great depth'.[177] He was particularly charmed by a delicate grove nearby, full of 'little temples and altars of pagods and gentilliticall idolatrye, many . . . wells, tancks and summer houses of carved stone, curiously arched; so that I must confesse a banished Englishman might have beene content to dwell there'.[178]

Although favourable accounts of buildings dominate the pages of travel literature, one occasionally comes across appreciations of sculpture as well. An early Jesuit missionary to Central Asia, Francisco de Azevedo, stopped at Joshimath in 1631 on the way to Alakānandā, the famous Hindu pilgrim spot. At Joshimath he saw 'in front of the main entrance of this pagoda . . . the statue of an angel [anjo in the Portuguese original] made of bronze, very splendid, and the whole very artistic, not only the statue itself but more specially the features'.[179]

The Jain temple of Cintāman in Ahmedabad built in 1638 came to the notice of two Europeans, Mandelslo and Thévenot. Mandelslo in fact paid a return visit to Ahmedabad to see 'the principal *Mosquey* of the Benjans, which without dispute is one of the noblest structures that

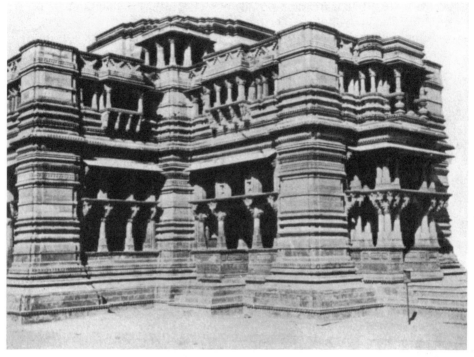

21. Govinda Deva temple at Mathura

can be seen . . . The *Mosquey* stands in the middle of a great Court . . . all about which there is a Gallery, much after the manner of our Cloysters in Monasteries . . .'[180] Confirming Mandelslo's view Thévenot mentioned its 'Cloyster furnished with lovely cells, beautified with Figures of Marble in relief'.[181] Thévenot's report covered a wide area on the subcontinent, including the mention of the three greatest temples. The ancient temple at Mathurā was described as 'the largest and fairest among the Pagodes of the Indies'.[182] It seems most likely that here he meant the temple of Govinda Deva [21] built in 1590. Although its sanctuary was destroyed by Aurengzeb's orders in the second half of the seventeenth century it still is by far the most impressive temple. Second in importance is the temple of Jugal Kishore which did not suffer the fate of the other one. Therefore it is equally possible that Thévenot had this one in mind.[183] It was especially the wealth of the temples that stirred his imagination, for he wrote about the temples of Benaras and Puri that 'nothing can be more magnificent than these Pagodes . . . by reason of the quantity of gold and many jewels, wherewith they are adorned.'[184] Thévenot agreed with Sir Thomas Roe about Chitor that

44

despite its present dilapidated state the hundred temples could still be distinguished and many antique statues were to be seen.[185] Travelling southwards Thévenot came across a temple in Sitānagar built with stone 'the same kind as the Theban'. He also stated that

it has a Basis five Feet high all round, charged with Bends and Wreaths, and adorned with Roses and Notchings, so finely cut as if they had been done in Europe. It hath a lovely Frontispiece with its Architreve, Cornish and Fronton, and is beautified with Pillars and lovely Arches, with the Figures of Beasts . . . and some with Figures of Men . . . in the middle of the Floor there is a great rose well cut.[186]

Next to the temple was a palace and on describing it he resorted to an analogy from European architecture. He wrote of 'the Architecture which is of a very good contrivance, and though it cannot absolutely be said to be of any of our orders, yet it comes very near the Dorick.'[187] In general he found in both ancient and modern buildings in India 'that the Architectors make the Basis, Body, and Capital of their Pillars, of one single piece'.[188]

As a jeweller Tavernier did not fail to notice or repeat stories of the lavish use of precious stones in the decoration of temples and images, particularly in the temple of Jagannātha at Puri.[189] He also described the temples of Benaras and Tirupati. The latter temple seemed like a town to him with its proliferation of temples of different sizes.[190] He got the impression from these temples that they were all cruciform buildings.[191] At Mathurā he most probably saw the Govinda Deva temple which he described as being in the form of a cross standing on an octagonal pedestal. This is a fairly precise description of the temples in late north Indian style in Mathurā.[192]

In the same period the Dutchman Nieuhof spoke appreciatively of 'the magnificent houses' in a south Indian city and the temple near Pulicat:

. . . the lofty and most ancient Pagode, call'd Tyripopeliri . . . at a little Distance from the Sea-shoar, . . . of which I had the Curiosity to take a full View. It is an ancient Structure, the front of which is adorn'd with many Statues Artificially cut in Stone. It is surrounded by a Wall with a Gallery on top of it, over which are placed a great Number of large Coffins, which rest upon Statues of divers Figures . . . The Walls are made of blue Stones, which are brought thither a vast way, out of the Country, and most Artfully joined together.[193]

Among the less celebrated temples mention was made in the 1650s by Peter Mundy of a temple in Jalor as 'the neatest and prettiest that I have yett seene of that sort of Coarse white marble'.[194] He also gave a longer account of a temple in ruins in the Sidhpur region:

45

Here is a Hindooe Dewra ruinated, it seems by Moores envieing its beautie, adorned on the outside with the best Carved worke that I have seene in India, verie spacious and high, yett not a handbreadth from the foote to the topp but was Curiously wrought with the figures of men and weomen etts. their fabulous stories. Now the said Edifice is defaced by the throweing downe the Copulaes, Arches and pillars thereof, breaking the Armes, Leggs and Noses of the said Images . . .[195]

A later contemporary, Thomas Bowrey (1669–79), preferred to talk in general terms about Indian temples:

Many, yea most of theire Pagods, are very Stately buildings of Stone of curious workman Ship of the Same, representing all Sorts of musick and dances to theire Gods, and are Surrounded with cloysters of marble, flat roofed with large and Exceedinge fine marble, Supported with Pillars of the Same, flagged below alsoe with marble, with walks to the great gate of the Pagod . . . The Entrance vizt. the Great gate of Some of these Pagods, I have often Observed, are most rare and Admirable worke, vizt. a man on horsebacke cut out in one Entire piece Set upon each Side one full as bigge or bigger than any naturall ones, all of marble, and, which is more rare, I have seen within Some of these great Pagods, a large Cart and 2 horses, with all theire appurtenances, cut out of an entire Stone.[196]

It might be convenient to end with Dr. Fryer, who not only remarked on the remarkable durability of the temples but even conceded that 'Their outsides shew Workmanship and Cost enough, wrought round with monstrous Effigies.'[197] In his typical obscure style, spiced with learned, mostly classical allusions, he spoke of Calicut: '. . . for the City that stood upon stilts, is tripped up, for down it is gone; and the Temple, whose Marble Pillars durst compare with those of *Agrippa's* in the *Roman Pantheon* is Topsy turvy.'[198] Indian sculpture too held its interest for him. He mentioned two temples in Pulparra in Surat which had been defaced by the Muslims 'with Images Antick enough, but of excellent durance and splendour'.[199] Time had not dealt so cruelly with one of them so that 'the lines of its ruined Beauty are still legible, though in old Characters.'[200] Two further temples were described as 'Large and of good Workmanship in Stone, after their Antick and Hieroglyphical Sculpture'.[201] Finally, he wrote with appreciation of an Indian god 'cut out of Excellent Black Marble, the height of a Man, the Body of an Ancient *Greek* hero, it had four Heads, and as many Hands . . . a Piece of Admirable Work and Antiquity.'[202]

The picture that emerges from these accounts of architecture and sculpture is clear. There was some measure of appreciation of Indian art and architecture, and however limited this might have been it none the less laid the foundations for a proper study of it in the eighteenth century, leading ultimately to the rise of Indian archaeology as

a scholarly discipline. There is a direct link between attempts made by early Europeans such as Castro or Couto to measure the monuments they visited and the extensive scientific surveys carried out by the English archaeologists in the late eighteenth century. Admittedly early travellers did not leave any sketches or ground-plans of the monuments they examined, or if they did these drawings are lost to us. For this period there exists a rare example in a set of drawings recently discussed by Professor Lach.[203] The Indian pagode or temple, from the hand of an anonymous European artist in *circa* 1540, is represented as a European church which is yet another instance of the use of familiar stereotypes for portraying the unfamiliar. This particular illustration has an additional interest. Unlike engravers in Europe who had to rely entirely on literary descriptions for their treatment of Indian subjects the artist at least was on the spot and yet he chose to depict a Hindu temple as if it were a European church.

Even in the absence of drawings from early visitors like Castro, Couto, or Thévenot, the manner in which they sought to collect information about Indian architecture and document it in their writings served a very useful purpose. These accounts form the most important early evidence for the study of Western attitudes to Indian architecture in the sixteenth and seventeenth centuries. The very fact that they were engaged in ascertaining the measurements and proportions of different parts of monuments like Elephanta suggests a concern with design and total conception. The current architectural theories must have had their influence on more intelligent observers,[204] and it is possible that they sought to discover the forms and proportions of Indian architecture in order to compare them with European examples they were familiar with. The fact that Western examples were never far from their minds is borne out by their almost obsessive use of analogies. Although the general importance of these travellers rests on their particular role in making Indian monuments familiar in the West and in investing them with a romantic aura, a number of them were not incapable of taking a serious interest in sculpture and painting. While one must not underestimate the value of these early notices their obvious limitations cannot for a moment be denied. In the first place, even the formal appreciation was limited in scope, as it tended to be reduced to an admiration for the workmanship involved in the decoration of architecture or the details of sculpture, except in very exceptional cases. Their formal appreciation also tended to divorce the treatment of sculptures from their iconography and see these sculptures in total isolation and out of their contexts. Historically speaking, two traditions grew out of travel reports, giving two essentially conflicting, if not outright contradictory, views about Indian art. According to the first, Indian art

consisted of nothing but irrational monsters and horrific demons. The other saw the elegance and grandeur of the temples as clearly proving their classical origins. Some even went so far as to find historical links with Alexander. In short, neither approach took into account the essential qualities of Indian art.

iii. PAGANISM REVEALED

The conflict between form and its meaning could not be resolved until people in the West were able to recognize the fact that the beautiful treatment of sculptures in temples was not extraneous to the iconographic programme developed for them. In other words, religious doctrines and mythological lores provided the main subject-matter for artists in India, as it did for religious art elsewhere. A new class of sources dating from the middle of the seventeenth century marks the beginnings of changing attitudes in the West towards alien societies and provides the essential key to the understanding of Indian iconography. These were the first systematic studies of Indian religious and mythological traditions in which the influence of a new scientific approach to societies was clearly felt. The mid-seventeenth-century curiosity about other societies was not, however, an entirely new phenomenon in the West. It was Herodotus who had initiated the study of comparative culture by posing two basic questions—what an alien society had in common with his own, and in what way one differed from the other. These two principles became the general guidelines for ethnographic studies from the Renaissance onwards. The sixteenth century saw a substantial widening of interest in non-European societies, for Humanists engaged in collecting information as assiduously as they amassed natural and artificial objects in their cabinets of curiosities.[205] In this interest in alien societies it was the religious practices that came first in importance. Interest in religion continued to grow until it reached its peak in the eighteenth century. In a very early work on paganism, *Omnium Gentium Mores, Leges, Ritus* (1520), the author Johannes Boemus had already raised the subject of Brahmans and their philosophy. He of course followed the tradition in deriving his information from classical sources, rather than from travellers.[206] The study of comparative culture came under the heading of 'cosmology' and included history and geography or 'ethnography'. These two subjects were the forerunners of modern anthropology. The special position of cosmology in the sixteenth century can be well gauged by the fact that every school of the period included it in its curricula.[207] While there is no doubt that a systematic account of Hinduism was not undertaken before the seventeenth century, travellers from the thirteenth century had been preparing the ground with their vivid descriptions of Hindu social

and religious practices. One must make this qualification, however, that most of their pages were taken up by sensational items like the *sati*, hook-swinging and ritual suicide under the wheels of the car of Jagannātha.[208]

The ancient reputation of Brahmans was mainly responsible for stimulating interest in Hinduism in the age of explorations. Next in importance from the traveller's point of view was the Hindu belief in transmigration. Hindus were in fact identified by Europeans as Pythagoreans on account of their belief in metempsychosis. The West came to know the Brahmans or gymnosophists through classical sources as being not only virtuous and wise, but as the ancient teachers of Plato and Pythagoras.[209] The medieval Brahman texts, the most notable one being that of Palladius, portrayed the gymnosophists as being thoroughly non-materialistic and possessing intuitive wisdom received directly from God.[210] In other words, Brahmans played a special role in the rise of medieval notions of 'primitivism'. Already in the fourth century the idea that Brahmans were the epitome of the instinctive Christian anticipated the later 'noble savage' idea of the eighteenth century. Patristic literature also sought to reconcile paganism with Christianity by highlighting scriptural and Hindu parallels on abstinence, specially vegetarianism. The supreme medieval example of abstinence was the Indian gymnosophist who gave rise to the legend of a pagan people in the East whose life was essentially Christian.[211]

On their arrival in India Europeans were elated by the fact that they had rediscovered the Brahmans of antiquity. This sense of rediscovery can be summed up in the words of Alexander Ross, who declared in his *Pansebia* (1653) that Brahmans were the descendants of the Brachmans of antiquity.[212] As far back as 1330 Friar Jordanus had noted that Indians were 'true in speech and eminent in justice'.[213] In the sixteenth century Duarte Barbosa could not help admiring the non-killing of living creatures by Banians,[214] while several generations after Sir Thomas Roe remarked that Pythagoreans (Banians) would 'not kyll . . . the virmine that bites them'.[215] Della Valle went so far as to claim that Pythagoras was foolishly adored as Brahmā in India.[216] Herbert regarded the religion of Brahmans or the Pythagorean sect of gymnosophists as 'rare and wonderfull, beyond apprehension . . . They will not feed on aught has bloud and life.'[217] This flattering view of Brahmans is also to be found in William Methwold, Antony Schorer,[218] Nieuhof,[219] and Bowrey.[220]

These aspects of Hinduism which Europeans came across in India made a favourable impression on them. On the other hand, zoolatry and the presence of zoomorphic gods in the Hindu pantheon presented serious problems of assimilation for the average traveller. From the very

49

beginning zoolatry was either plainly disliked or some justification was found for it, until a clear link could be established by the students of comparative religion between Indian and Egyptian or Biblical zoolatry. Marco Polo was the first European to report that Indians worshipped the ox because it was a creature of such excellence.[221] A similar explanation was provided by Jordanus,[222] while Odoric stated that the sacred cow was allowed to roam the public places as a consecrated animal.[223] Fitch regarded cow-worship as strange.[224] It was in connection with the Varāhavatāra image of Viṣṇu that Sir Thomas Roe said that Indians ascribed divinity 'to a piggs head in a church'.[225] Della Valle mentioned 'the idol of an ox' in a temple[226] and Methwold gave a somewhat garbled version of the animal incarnations of Viṣṇu.[227] But it was the Icelander Jón Ólafsson who furnished an elaborate description of the worship of a horned cow by an Indian king, and the elephant-headed god Gaṇeśa.[228]

It is evident from the preceding accounts of early travellers that there was no dearth of information about the Hindus, their beliefs and practices, even from the earliest period of European explorations. The information was, however, unsystematic and mainly concentrated on the sensational. Also, up to the seventeenth century, there had been very few attempts to present a coherent picture of Indian mythology to the Western audience, or to provide a clear outline of Hindu religious doctrines. The Jesuits might have produced such an account. The first known outstanding work on Hinduism was by Father Fenicio (1609). Unfortunately, this valuable account of the Indian gods came to be known in the West only in 1672 through the unscrupulous plagiarist Baldaeus. In any event, Fenicio was exceptional for his period.[229] The first printed work to foreshadow the mid-seventeenth-century ethnographic works was that by Henry Lord, called *A Display of Two Forraigne Sects in the East Indies* (1630). The two sects were the Hindus and the Parsees. The ostensible purpose and the tone of the tract were polemical, but this should not blind us to its importance. The high moral tone of Hinduism involving its avoidance of flesh and wine incensed Lord to such an extent that he resolved to expose the fallacy of a religion that had not been granted the Revelation.[230] In order to do this he resorted to the comparative method, established by Pignoria in the early seventeenth century. Turning to the ancient West he asserted that the Hindu abstinence from meat and wine was not an original inspiration, for it had been derived from Pythagoras and the ancient Egyptians.[231] More interesting is the rest of the tract dealing with Hindu history, law, customs, liturgy, and ceremonies. Lord gathered his facts from the *śāstras* as narrated by the Brahmans. In this first printed account of Hindu religious doctrines Lord followed an essential Biblical pattern in his arrangement of subjects under headings such as the

creation of the world, the first man and woman, the conflict of the classes, and the consequent destruction of the world by flood. Among other subjects he did not neglect to discuss the Hindu idea of God and also something peculiar to Hindu mythology, the conception of the aeons of the world.[232]

Lord's work reflected the current European interest in eye-witness accounts of the religious practices of pagans all over the world which began to arrive in the West through missionaries. Missionaries, both Catholic and Protestant, went out with the intention of converting the local population. At the same time they realized that in countries like China or India they had first to understand the religious systems of these societies, or they had little chance of succeeding against their sophisticated adversaries.[233] But missionaries in the seventeenth century had been taught to take a scientific interest in all subjects under the sun. Human institutions in general and paganism in particular came under the heading of natural history which had as much right to be studied as rocks, plants, and animals. The foundations of comparative religion were laid by Pignoria who belonged to the circle of Humanists with wide interests in other cultures. However, the study of human institutions began in earnest when Varenius formulated the essential principles of ethnology.[234] The empirical data provided by the missionaries encouraged scholarly interest in paganism leading eventually to the attack on the very basis of Christianity itself. It is in the light of these developments that one must judge the work of Rogerius, who made the most important contribution to Western knowledge of Hinduism, until the arrival of Sir William Jones on the scene.

Abraham Rogerius, a missionary from Holland, spent a period of ten years in the Dutch Indian possessions on the Coromandel coast. In Pulicut, where he was active between 1630 and 1640, he came to know a Brahman fugitive from Goa, who communicated to him the substance of Hinduism by drawing upon Vedic and Purāṇic literature. Portuguese was the common language between them and Padmanava rendered into Portuguese the verses of Bhatṛhari, the seventh-century Sanskrit poet, for the Dutch priest. This was then translated into Dutch by Rogerius, the very first adaptation of a Sanskrit work into a Western language.[235] The outcome of the co-operation between Padmanava and the Dutch pastor was *De Open Deure tot het verborgen heydendom*, published by Rogerius's widow in 1651. The title, which announces the opening of the door to the secrets of paganism, I think well conveys the enthusiasm with which the learned circles greeted the new accession of knowledge about Brahmanical faith. Throughout the greater part of the sixteenth century, whatever little knowledge about Hinduism the Jesuits at Goa acquired, was spent in proving how ridiculous and degrading Hindu

rites and mythology were.[236] In contrast, the growing conviction that there was every need to study pagan religions is clearly demonstrated by the opening remarks of Jacobus Sceperus, the editor of *The Open Door*. When he brought out the volume, instead of denigrating paganism in the usual sixteenth-century manner, he was able to defend the need to study Hinduism by actually offering theological arguments. According to him one should not conclude that paganism was so destitute of all fundamental laws of reason that the pagans in general lived without the awareness of God or religion. Admittedly God had let pagans go their own particular ways because of their original transgressions, but at the same time He had not left them totally ignorant of Himself.[237] In defence of the Hindus Sceperus was appealing here to the kind of argument already used in the case of the pagan classical philosophers. Whenever attempts had been made to reconcile Christianity with the classical heritage, the usual argument was that, while the most perfect instrument of divine Revelation was the Scripture, the early Greek philosophers had been allowed some share in this divine knowledge. On the other hand, ordinary pagans continued to be steeped in deep ignorance.[238] Sceperus reflected this tradition when he declared that to the class of pagan philosophers, namely Pythagoras, Anaxagoras, Plato, and the Stoics, who were endowed with some knowledge of God, must be added the Brahmans and gymnosophists. He refused to dismiss the Brahmans as mere pagans, for had they not been credited with extraordinary powers of judgement and with possessing a perfect form of knowledge and science? While they were esteemed even today for their intelligence, moderation, and modesty, Plato and Pythagoras were not ashamed to learn the basic tenets of their philosophy from the same Brahmans.[239] Sceperus not only pleaded for the Brahmans to be placed on the same footing as ancient Greek philosophers, but even the text of *The Open Door* drew constant parallels between Indian, ancient classical, and Old Testament religious practices.

De Open Deure, or *The Open Door*, is not only remarkably objective in its descriptions and reflects a certain fairness, but it is in general free from the missionary fanaticism or contempt for Hindu religion and literature evident in Jesuit accounts.[240] A scientific power of observation and accuracy informs the whole text, which sets out to deal with each topic step by step in a systematic and coherent manner. The range and scope of the book are admirable. The introduction states that until now authors had dealt with the external features of Hinduism and had not given much thought to its fundamental doctrines to which Rogerius had devoted his time and efforts in India. Therefore, in addition to the translation of an authentic Sanskrit text with Padmanava's help,[241] the Dutch missionary was now able to offer his European readers a coherent

52

account of Hindu mythology drawn from Vedic and Purāṇic sources. It must of course be pointed out that Rogerius took the south Indian versions of various Purāṇas to be prevalent throughout the whole of India, but this can be excused on the grounds that he had only limited access to information. On the other hand, the importance of the Purāṇas in providing iconographic programmes for Hindu temples cannot be overstated which, I think, speaks sufficiently for the importance of this pioneer ethnographer.[242]

The first section of *The Open Door* is devoted to Brahmans, their rights, privileges, and special position in the social hierarchy. For us more relevant is the discussion of the basic tenets of the Hindu faith, which includes an account of the cosmological system, Hindu ideas about God, the Creation, the four ages of the world, and its final dissolution. The importance attached to Hindu ideas about God, the Creation, and the dissolution of the world no doubt owes much to the same subjects in the Old Testament which preoccupied scholars in the seventeenth century. On the other hand, these subjects figure prominently in the incarnation legends of the Vaiṣṇava Purāṇas. From the general cosmological system Rogerius went on to the two principal gods, Śiva and Viṣṇu, whose followers were the most numerous among the Hindus. The roles played by the wives of Śiva and Viṣṇu and Śiva's children were discussed as equally the functions of the attendant animal deities associated with the major gods, such as Garuḍa or Nandi, the *vāhanas* or the carriers. Nor were the subordinate gods neglected.[243] Rogerius was convinced that it was not enough to talk about the fundamental philosophical principles. Since Hinduism was a living faith it was necessary to pay attention to the actual mode of worship and also to see how theological and mythological ideas were actually realized in sacred art. With this intention in mind he paid several visits to Hindu temples during his stay in Pulicut and the fruits of his observations were presented in a systematic manner.[244] He discovered that the major temples in the country were either dedicated to Śiva or to Viṣṇu, the sovereign deities of the two main sects. The temples built in honour of the sovereign deity were not only larger than the ones built for lesser gods but they also had reasonably high towers.[245] He further stated:

The *Pagodas* of *Wistnou* and *Eswara* are well built and higher than those which are built for lesser gods; they are of reasonable size, but those that I have seen are not so large as to compare with the churches in our cities: the edifices are not at all high but low and flat; but the towers are sometimes high, like, among others, the towers of the *Pagoda* near *Tegnepatram*.[246]

Many of the important temples of the south, namely Mādurā, Śri-rangam, Tirruvarur, and Tirupati, were mentioned. He found that, while Mādurā was not only the highest temple but was undoubtedly

the most beautiful, Śrirangam too was quite beautiful.[247] He was perceptive enough to comment on the functions of the ornament in Hindu temples and rightly described them as palaces where the gods retreated like 'grands seigneurs'.[248] He did not fail to note that the god Brahmā was not honoured with temples.[249] The threefold division of the south Indian temples was observed by him. The first part had a vault sustained by stone pillars, which was open to everyone and on all sides. There one usually saw images of animals, of elephants, bulls, and horses. Next followed the second part which was shut with a strong door, guarded by Brahmans. Lastly came the sanctum.[250] Rogerius, however, realized that it was not enough to give a general description of the temple, for it made sense only when the description could be set against its proper iconographic context. He therefore proceeded to give an account of the main iconographic features of a Hindu temple including the main images to be found in it. It is this certain knowledge of the function and the iconography of the sculptural images in Hindu temples that distinguishes the author of *The Open Door* from his predecessors. Even that unusually appreciative account of Elephanta by the historian Couto was totally lacking in any knowledge of iconography.[251] In a Vaiṣṇava temple, Rogerius wrote, the image of Viṣṇu was four-armed. In a Śaiva temple, on the other hand, the main image usually took the form of a *liṅga*. If the Śiva image was human, it was given three eyes. He also described the subordinate deities in the temples of Viṣṇu and Śiva, including the winged Garuḍa and Nandi, the respective animal attributes of the two gods.[252] The strength of Rogerius's text lay in the ability of the author to illustrate his literary descriptions with examples based on personal observation. Thus when he related the myth of Viṣṇu's boar incarnation he did not forget to mention the boar-headed image of Viṣṇu he had seen in the Adivarāha temple in Gingi.[253]

A spirit of scientific inquiry informs Rogerius's text in general. Yet what is striking is that old preconceptions preyed even on the mind of this remarkable man. There is no doubt that his book gave the first authentic picture of Hinduism in the West. But what one must remember is that he stood on the threshold of change and therefore represented both old and new traditions. It is therefore inevitable that he should subscribe to some extent to the prevailing monster tradition in this period of transition. He was clearly aware of the difference between gods and anti-gods in Hindu mythology when he identified *asuras* as demons.[254] Also when he stated that Indians worshipped the sovereign God, many lesser gods, and the devil,[255] he possibly meant by the devil the local folk-divinities of south India. On the other hand, one hears distinct echoes of Varthema in the above statement. For he not only regarded many-armed images as demonic, but had unequivocally

identified the deities Gaṅgā and Gaurnātha as embodiments of the devil.[256] Coming from a man of such acute observation it is all the more difficult to understand. In his general description of the second part of of the south Indian temple plan he had stated: 'Ordinarily there are [in the second part] very terrifying images: men with several heads and a number of arms: it is horrible to see such representations.'[257] Similarly elsewhere, after a long section on Gaṅgā and Gaurnātha, he observed: 'The image of this *Ganga* has one head and four arms . . . One finds everywhere *Pagodas* built for this particular devil.'[258]

These vestiges of the monster tradition in Rogerius do not, however, detract from the great importance of the work, which can be measured by comparison with a work issued two years after *The Open Door*. In 1653 François, Sieur de la Boullaye-le-Gouz, included a long section on the worship of Rāma in north India in his travel report. The account of the followers of Rāma was, however, only part of his general description of India. It was therefore sketchy and could not compare with Rogerius's comprehensive and painstaking investigation of Hindu doctrines. It is, none the less, important to note Boullaye-le-Gouz's approach. He made it a point to emphasize in his introduction that his main aim was to present the truth about Indian religious practices and not to please his readers with fiction.[259] He pursued this aim by narrating the story of Rāma from the epic *Rāmāyaṇa*, which was illustrated by him with popular Indian paintings.[260] He found the Hindu temples more beautiful than Jewish synagogues and Muslim mosques.[261] He further noted that these often contained images of Rāma with his wife Sītā in various postures. He also observed in this connection that Rāma had a crown on his head and not horns, as some previous authors had maintained.[262] Was Boullaye-le-Gouz attempting to correct here the misconception of early travellers who identified Indian gods as horned monsters? The old preconceptions had clearly no hold over him for he stated without any further speculation that the gods were depicted with four arms and hands.[263] His more famous contemporary, Bernier, had also given a valuable account of Hinduism.[264]

Far more ambitious work on universal paganism came from the pen of possibly the greatest polymath in history, the Jesuit Athanasius Kircher, generally regarded as one of the founders of the branch of learning called Egyptology.[265] In his monumental work, *China Illustrata* (1667), Kircher stated that all he did was to bring together the most curious and remarkable things not only from China but also from the neighbouring kingdoms, illustrating their antiquity and the superstitions by which they were so miserably enslaved.[266] The shower of abuse on paganism which greets the reader on virtually every page is misleading, and it must not blind us to the intrinsic value of Kircher's work. Admittedly

he did not come up to Rogerius's standards of objective reporting. Yet he was very different from the earlier Jesuit missionaries whose sole purpose in investigating the nature of Hinduism had been to prove the superiority of Christianity. While he professed to disapprove of paganism, Kircher was at the same time committed to presenting as much information about it as possible. As he himself admitted candidly, the greater part of the world practised idolatry.[267] He in fact belonged to the growing circle of ethnographers who were convinced of the need to study paganism because they held that the idea of God was immanent in all ancient religions, although Christianity was privileged to receive its most perfect expression. In this Kircher, a friend of Peiresc and Cardinal Barberini, was in accord with Pignoria and like him he took Egypt to be the centre of diffusion for all religions.[268] However, Kircher also anticipated eighteenth-century students of religion in his use of late antique Neoplatonic authors for the interpretation of Egyptian mythology.[269] Kircher's brand of cultural diffusionism, with its mixture of encyclopedic learning and superhuman industry with frequently a total lack of commonsense, has been ridiculed often enough. But what his critics overlook is that for the first time an attempt was made to evolve guidelines for the understanding of non-Christian religions instead of rejecting them as being unworthy of serious consideration. Indian mythology and religion gained from this as well because from now on parallels were to be increasingly sought between Indian mythology on the one hand and Egyptian and classical on the other. From *China Illustrata* we learn that it was in connection with his study of Chinese religions that Kircher developed an interest in the origins of idolatry and its subsequent diffusion. Retracing his steps he discovered that Chinese idolatry had originated in India, which in its turn had received the same practice from Egypt. When the Egyptian priests had been driven out by Cambyses, the ancient Persian monarch, they were forced to emigrate to India. Proceeding from this assertion Kircher further endeavoured to prove that the founder of idolatry and the belief in metempsychosis in India was Rāma who was none other than the Chinese Siequia or the Japanese Xaca. In his section on idolatry Kircher reproduced a garbled version of the spread of Buddhism in these countries.[270]

Clearly India fascinated Kircher, for he included a long section on it, paying a particularly glowing tribute to the grandeurs of the Mughal empire under Akbar [37], who was renowned for his might as well as for his wisdom.[271] His reading of missionary and travel reports indicated to Kircher that not only did the Indians observe the same customs as those followed by the Greeks and Egyptians, but they worshipped the very same gods, such as the Egyptian god Apis in Bengal. According to

the Jesuit scholar this fact was attested by Apollonius of Tyana who claimed to have seen the worship of gods such as Apollo and Dionysus in India.[272] It did not therefore surprise Kircher that there were still to be found people in India who followed the Egyptians in adoring the detestable Tiphon, the enemy of the human race. Significantly Kircher had interpreted Varthema's Deumo as the Indian Tiphon, but here this monstrous god was accommodated in Kircher's cosmological system as standing for the negative principle, a notion which attempted to interpret zoolatry allegorically.[273] The great reputation of Brahmans which went back to antiquity prompted the Jesuit to include an account of their religious doctrines. As the head of the Jesuit centre of learning in Rome he naturally had access to missionary reports on Asian religions and other related documents from the East. His chief informant on Hinduism was Father Heinrich Roth, a German compatriot and a friend of his. Roth, who was attached to the Agra mission, brought back to Rome an illustrated account of the ten incarnations of Viṣṇu.[274] This was included in Kircher's work along with a description of the cosmological myth which attributed the birth of the different sections of the Indian society from the different parts of Brahmā's body [25].[275] In *China Illustrata* also appeared for the very first time the Sanskrit *devanāgarī* script. The script was predictably taken by Kircher to be the sacred, arcane language behind which Brahmans kept concealed their esoteric religion.[276] Kircher was only applying here the mistaken idea he held about the Egyptian hieroglyphs, an idea that was kept alive until their decipherment.

In 1672 appeared another famous work on Hinduism, in fact the last major seventeenth-century contribution to the subject. The title of the English edition is worth quoting: *A True and Exact Description of the most celebrated East India coasts of Malabar and Coromandel . . . Ceylon (including descriptions of pagan temples, manners, ceremonies) . . . Also a most Circumstantial and Compleat Account of the Idolatry of the Pagans of the East Indies, the* Malabars, *Benjans, Gentires, Brahmans etc. Taken partly from their own* Vedam . . . *and Authentick manuscripts, partly from frequent Conversations with Priests and Divines, with the Draughts of the Idols, done after their Originals*. About the outstanding merit of the work there is no doubt. Only the authorship is in question. It appeared under the name of Philip Baldaeus, a missionary who spent a number of years on the southern coasts of India. It is only with the intervention of modern scholarship that we know that a substantial portion of the work was plagiarized from the treatise on Hinduism by the Jesuit Jacopo Fenicio. But that is not all. There are reasons to believe that Baldaeus himself did not translate Fenicio's Portuguese text into Dutch. He was guilty of a further fraudulent act. The Dutch artist Philip Angel had in his possession an

illustrated work on Hindu mythology entitled *Devex Avataars*, which he had given as a present to the Dutch governor of Batavia [28]. As the tutor to the governor's son, Baldaeus had access to this text which he subsequently published under his own name, failing to mention either Fenicio or Angel. The evidence suggests that this text is none other than the Dutch version of Fenicio's work which was probably translated by the artist Angel.[277]

Even compared with Rogerius's treatise on Hinduism the *Seita dos indios orientais* was a remarkable work, and it was all the more so considering that it was completed by Fenicio in 1609. He is, however, considered here with the late seventeenth-century authors and not in the early part of the century because it was through Baldaeus that this work received the widest dissemination in learned circles, although sections from Fenicio had already appeared in Faria y Sousa's work published between 1666 and 1675.[278] However dishonest he might seem to us for his complicity in stealing from Fenicio and possibly from Rogerius, the authority of Philip Baldaeus was unquestioned among contemporaries. Although his claim in the title of the book to have interviewed Brahmans sounds suspiciously like Rogerius's account, his English translator, Churchill, has this to say about Baldaeus:

What relates to the Idolatry of these *Pagans*, we are convinc'd by his own Testimony, that besides the opportunity he had of visiting their *Pagodes*, or Temples (a thing rarely allow'd there) one of their most learned *Brahmans* liv'd with him . . . from whom . . . he learn'd the most Secret Recesses of their Religion . . . much beyond what Abraham Royerius (who writ upon the same Subject) can pretend to upon that account.[279]

Putting aside the question of Baldaeus's own credibility, the emphasis on accurate and authentic information in Churchill underlines the intellectual approach of the period. Churchill further pointed out that earlier works on paganism were defective primarily because they were full of errors and fabulous relations so that 'it is no wonder if the most curious in History have conceiv'd a very indifferent opinion if not an entire aversion to them.'[280]

In response to the growing demand for information about non-Christian religions, Baldaeus offered a short introduction to the Malabar language and discussed the social practices of the Brahmans and other classes of Hindus in south India. But it was Fenicio's relation of Hindu cosmological and mythological systems based on the *Purāṇas* that formed the most important part of his narrative. It included Hindu notions about the creation of the world, the four ages (*yuga*) of the world, the origin and transmigration of souls, and consent regarding the existence of God. For us the most interesting section is the one on Hindu theogony

divided into two parts, and including myths about Śiva and deities associated with him, myths relating to his children, and a very detailed account of the ten incarnations of Viṣṇu.[281] Baldaeus was convinced that 'under these ten transformations are hid the chief Mysteries of the Pagan Religion on both sides of the *Ganges*.'[282]

The description of temples in the south in Baldaeus was possibly the only original contribution he made, and it differed from Fenicio's description of them. Baldaeus wrote:

In the choice of the Places [for temples], and manner of Building, they follow rather their Instinct or pretended Inspiration, than any general Rule . . . These *Pagodes* are on the Coast of *Malabar* most commonly built of Marble, and on the Coast of *Coromandel*, of very large square stone; such is the most celebrated *Pagode* at *Rammanakojel*, a vast Structure . . . of which I have been an eye-witness myself . . . The *Pagodes* of the *Malabars* are generally cover'd with Copper, adorn'd with Balls gilt on the top; within and without stand their Idols with many Heads and Arms, surrounded on sides with Serpents. The *Pagode* is enclosed by a Brick-wall, for the reception of the People, who don't enter the *Pagode*, but perform their Worship in the Court . . . Hence it is that the Gates are well guarded, being commonly either of Marble or covered with Brass, with the Figures of Elephants, Tygres, Bears, and Lyons upon them.[283]

The most impressive work of this genre was written a little over forty years after Baldaeus, in 1713, by the Royal Danish missionary, Bartholomaeus Ziegenbalg, at Tranquebar in south India. Although the work falls outside our period, because it had been virtually forgotten for many years until it was published for the first time in 1867 by Protestant missionaries in India, it certainly deserves our attention. In Ziegenbalg we have a missionary who refused to go along with the prevailing attitudes and show how the Word of God had been distorted by the Hindus. Instead he wanted his readers to make up their own minds with the help of his straightforward, factual, and matter-of-fact presentation of Hinduism. Since the intention of this enlightened man was not to indulge in fanciful speculations or in the denigration of Hinduism, he took care to be as objective as possible by reproducing faithfully the substance of the correspondence he had with Brahmans. Unfortunately, *Genealogy of the Malabar Gods*, a work of great usefulness even today, was not welcomed in the eighteenth century. The hostility of Ziegenbalg's colleagues prevented its publication, for it was pointed out that the duty of the missionaries was to extirpate Hinduism and not to spread heathenish nonsense.[284]

The appearance of works on Hinduism was accompanied by significant changes in the pictorial tradition. Instead of appealing to the imagination and concentrating solely on the sensational, as it was the case with early travellers with their general indifference to facts, the

new ethnographic tradition became committed to the presentation of authentic information on the basis of empirical evidence. This new departure was seen in illustrations of paganism, and Indian gods began rapidly to shed their previous monstrous guises as their own character and attributes were increasingly restored to them. Before the 1630s an authentic portrayal of Indian gods was extremely rare. An exceptional case has however been recently noted by Lach. It is a drawing, most probably by a European, of the three gods, Brahmā, Viṣṇu, and Śiva, which reached the West in *circa* 1540.[285] But unlike the universally known monster stereotypes this particular picture remained unknown until the twentieth century. The first noticeable change came in 1630 when William Marshall at least attempted to depict Indian gods as faithfully as it was within his means on the title-page to Henry Lord's tract on the Hindus and Parsees [22]. Presumably the engraver Marshall based his Indian gods on Lord's description, but he also dutifully added a devil-figure to stand for an Indian god on the same title-page.[286] Despite this curious blend of truth and fiction, his engravings do have an air of authenticity. He was also responsible for the title-page and illustrations [14] in the 1638 edition of Herbert's travels.[287] In Rogerius's *Open Door* the monster stereotype was finally discarded. The Indian gods on the title-page were of poor quality but they were certainly of Indian inspiration [23]. An attempt was made by the engraver to offer a comprehensive picture of Hinduism, its religious practices on the one hand and its sacred images on the other. A Hindu temple is represented at the top of the page, flanked on two sides by two Indian gods, one of whom is clearly recognizable as the elephant-headed Gaṇeśa.[288] Next to appear were Boullaye-le-Gouz's illustrations to the *Rāmāyaṇa* [24], based on popular Indian religious paintings.[289]

The god Brahmā and the cosmological myth of his creation of the different classes of men from different parts of his body were illustrated in Kircher with a European figure whose body was marked by circles to indicate these classes [25]. The picture, Kircher claimed, was similar to the image of Brahmā to be found in temples.[290] The picture entitled *Pagodes Indorum Numen*, occurring on two separate occasions, including once in the company of a Tibetan ancestor cult, is no Indian god [26].

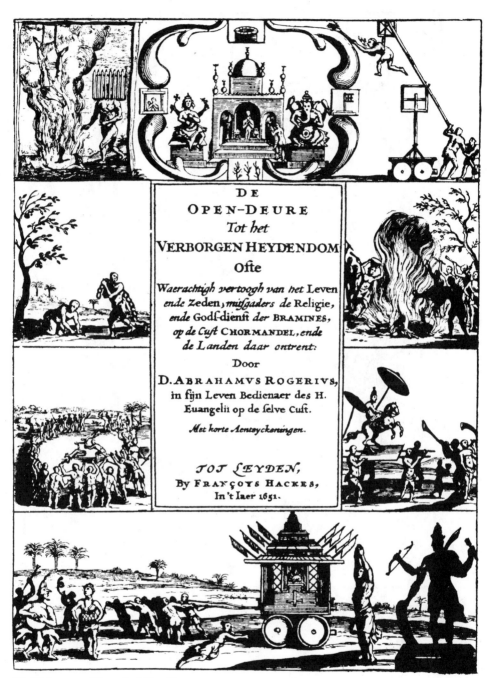

DE
OPEN-DEURE
Tot het
VERBORGEN HEYDENDOM
Ofte

Waerachtigh vertoogh van het Leven
ende Zeden, *mitsgaders de* Religie,
ende Godf-dienft *der* BRAMINES,
op de Cuft CHORMANDEL, *ende*
de Landen daar ontrent:

Door

D. ABRAHAMVS ROGERIVS,
in fijn Leven Bedienaer des H.
Euangelii op de felve Cuft.

Met korte Aenteyckeningen.

TOT ℒℰYDℰN,
By FRANÇOYS HACKES,
In 't Iaer 1651.

23. Title-page of Rogerius' *Open Door*

24. Boullaye-le-Gouz's illustrations to the *Rāmāyana*

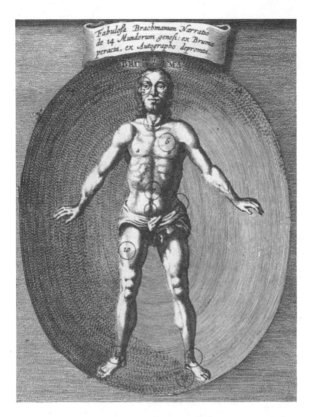

25. Indian cosmic deity in *China Illustrata*

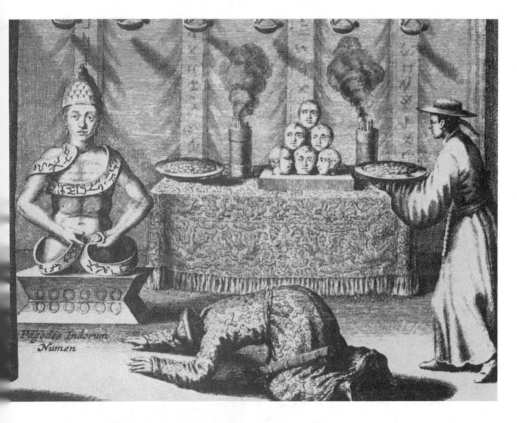

Kircher did not offer any explanation, but the very fact that this god was presented once as part of Tibetan worship, and later as illustration of the Indian deity adored by the Chinese and Japanese, suggests that it is a Buddha image. After all, the Japanese god Xaca and the Chinese Siequia in Kircher are none other than Buddha Sākyamuni. Moreover, not only does the god Pagodes have some similarities with the seated Buddha image, however crudely drawn, but the other god Menipe must be a garbled version of the Buddhist chant *Om mani padme hum*.[291] The most authentic pictures of Indian gods were the series of popular Indian religious paintings [27] sent by Father Roth to illustrate his story of the ten incarnations of Viṣṇu, which were faithfully reproduced by Kircher.[292]

Particular stress was laid on the accuracy of Baldaeus's prints by his English editors, the Churchills:

We have made it our chiefest care to give you an exact Delineation of the before-mention'd Draughts [of their idols] in the best Copper Plates . . . with all imaginable exactness according to true Originals, contrary to what is practis'd by many, who study to represent matters of this kind, rather according to their own Fancy than to Truth.[293]

No doubt they are more convincing than their predecessors [28]. However, while every care was taken in the first two pictures to depict the attributes of the gods Śiva and Gaṇeśa faithfully, the total effect is disappointing. Not only are the features poorly rendered, but with their enormous size these gods seem to threaten their followers rather than give them reassurance. The whole atmosphere of terror is increased by the tiny scale of the worshippers in comparison with the two gods.[294] On the other hand, Angel's collection of paintings [29] representing the ten incarnations of Viṣṇu reproduced in Baldaeus [30] are authentic Indian and superior to the ones in Kircher on the same subject.[295]

In the following decades the prints of Indian inspiration in Rogerius, Kircher, and Baldaeus received the widest dissemination in literate circles through the medium of books. Olfert Dapper's *Asia* (1672) featured Angel–Baldaeus prints of the ten incarnations of Viṣṇu as well as pictures from Kircher and Rogerius. The flat treatment of the Indian paintings of Angel was modified by the engraver by shading the figures in the Western manner and by dramatic chiaroscuro. The next year John Ogilby put out the same prints in his unacknowledged translation of Dapper.[296] It was, however, in 1723 that the engraver Bernard Picart brought together in his magnificent volumes all that was known in the West about Indian gods. *Cérémonies et coutumes religieuses des tous les peuples du monde* [1], an encyclopedia of contemporary paganism in all parts of the globe, reproduced the works of the major

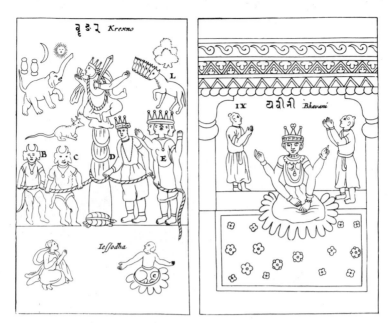

27. Incarnations of Viṣṇu in *China Illustrata*

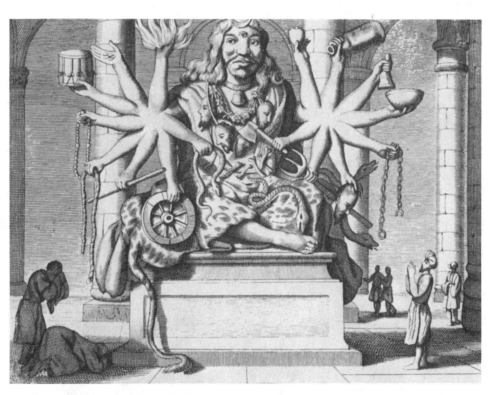

28. Portrait of Śiva in Baldaeus' work

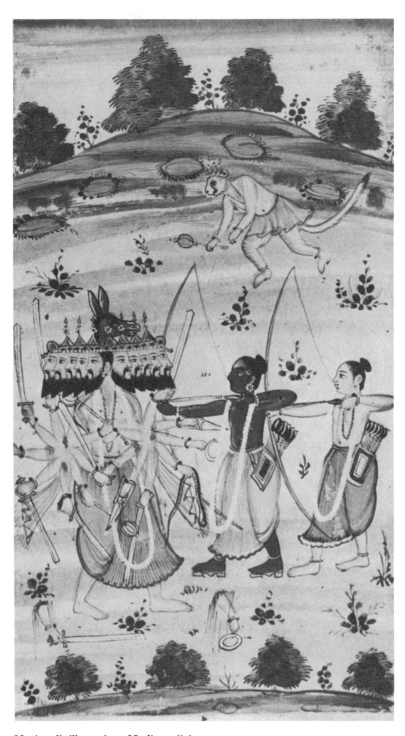

29. Angel's illustration of Indian religion

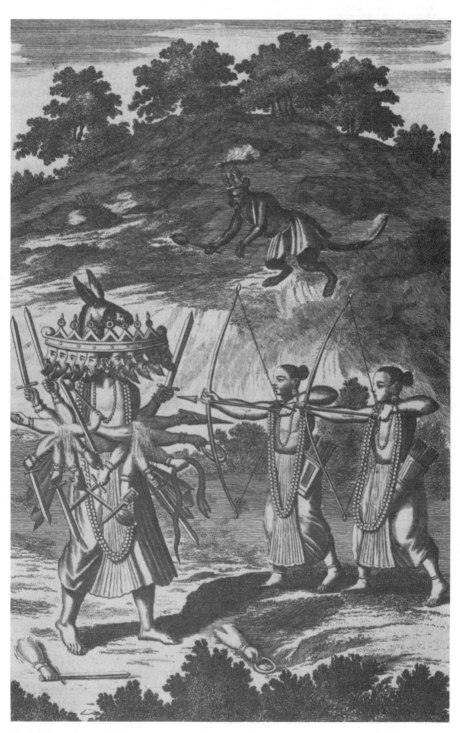

30. Baldaeus' copy of Angel

31. Picart's copy of Indian miniature

32. Vignette in Picart showing Banian god

ethnographers and travellers and also their illustrations [31, 32, 33, 34, 35].[297] But even before the publication of this work, as Lightbown shows, Picart engraved some Indian miniatures from the collection of G. A. Baldini for Chatelain's *Atlas historique*.[298]

The period from Henry Lord to Bernard Picart witnessed the dissolution of the monster stereotypes and the emergence of authentic images of Indian gods. The incidental details too, such as the human figure and the dress in these illustrations, had become convincing. For this change, the reproduction in books of Indian miniatures on secular subjects was largely responsible. The process had actually started in the

68

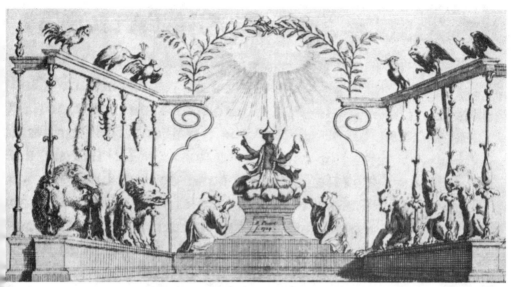

33. View of Indian yogis and idol in Picart

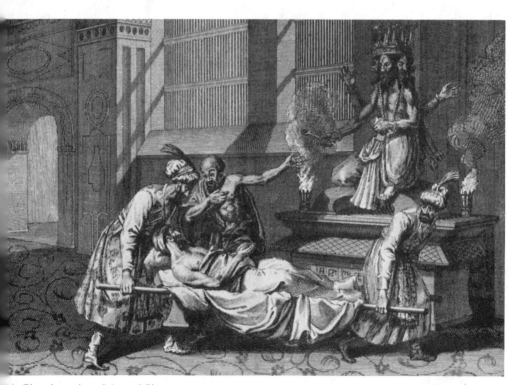

4. Picart's version of the god Iśvara

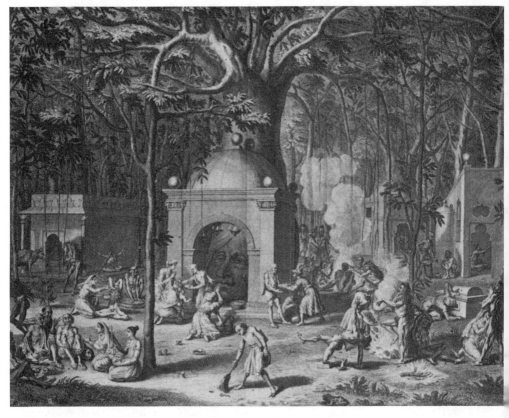

35. Vignette in Picart showing Hindu god

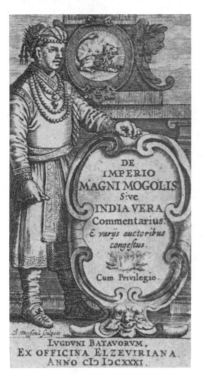

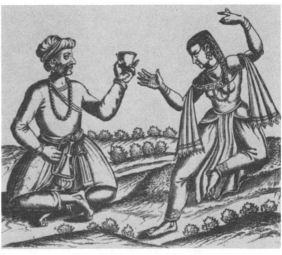

37. Copy of Indian miniature in Herbert's travels

36. Jahangir's portrait on De Laet's cover

38. Akbar's portrait in *China Illustrata*

39. Aurengzeb against 'Chinese' architectural background in Valentyn's work

second decade of the seventeenth century, when Renold Elstrack issued an engraving of the Mughal emperor Jahangir, based on a miniature now lost.[299] The same emperor appeared in Purchas in 1625. The print was in fact a combination of two Mughal paintings, one of which was by the famous Mughal painter Manohar.[300] Early, too, is the portrait of the same emperor [36] in Johannes de Laet's *De Imperio Magni Mogolis sive India Vera* (1631).[301] William Marshall, who was responsible for the illustrations in the 1638 edition of Herbert's travels, did an engraving [37] called 'A man and Woman of Industant' from an Indian miniature brought back by Herbert.[302] The portrait [38] of the emperor Akbar in *China Illustrata* was also based on a Mughal miniature.[303] A set of Golconda miniatures, which came into the possession of the Burgomaster of Amsterdam, Nicolaes Witsen, was reproduced in his *Noord en Oost Tartarye* (1692).[304] The most numerous Mughal miniatures occur, however, in *Oud en Oost-Indien* (1724). In this work by François Valentyn miniature portraits [39] accompanied the account of the Timurid Mughal dynasty.[305]

CHAPTER II

Eighteenth Century
Antiquarians
and Erotic Gods

BY THE third decade of the eighteenth century much information about
Indian gods had been received in Europe through missionary and
secular efforts, as a growing number of ethnographers sought to present
an authentic picture of Hindu religion and mythology by drawing upon
Indian literary sources and popular paintings. This new development
inevitably led to the dissolution of the long-standing monster tradition,
for no longer could Hindu gods be regarded as thoroughly incompre-
hensible and bizarre. In short, their acceptance was made easier by the
popularity that comparative studies of religion enjoyed in this period.
Scholars who speculated on universal paganism, and investigated myths
of different nations of the world, did so in the belief that all religions
had spread from one single original source. It was this conviction that
encouraged antiquarians to equate classical and Indian gods in a
syncretistic manner. The names of Pignoria and Kircher at once come
to mind as the most famous seventeenth-century advocates of this ap-
proach. There was, however, a dramatic increase in interest in com-
parative religion during the second half of the eighteenth century,
when a large number of antiquarians began to make use of the available
ethnographic material for their grandiose theories of universal religion.
Indian gods were inevitably drawn into the orbit because of the great
reputation of India in antiquity, and the eighteenth-century *érudits*
knew their classics well. The new concern with comparative mythology
brought about changes in the interpretations of Indian art. In this
century scholars had become increasingly aware of the importance of
sexual imagery in ancient classical religion, whether it was present in
myths or in sacred art. With the publication of accounts of sexual cults
and of erotic art of India, they realized for the first time that their
experience in the classical field was not an isolated one, but reflected a
widespread tendency to be found in most ancient and contemporary
religions. Therefore, when these scholars began to investigate the nature

73

of sexual motivation in ancient religious art they at once noticed the parallels between the erotic art of India and the classical West. In fact, as a study of the late eighteenth-century antiquarians suggests, not only did these scholars believe the erotic content of ancient religion and the representation of sexual organs in sacred art to be worthy of serious consideration, but they also brought with them a certain liberal spirit which went against the prevailing Christian prejudice. Their willingness to accept Indian erotic art on its own terms was certainly far in advance of the puritanical reactions to it in Victorian times.

Early travel reports contain hardly any reference to the erotic elements in Indian temple sculptures. The severe criticism of pagan practices by Christian Fathers, and especially their allegorizations of the more sensual elements in classical mythology, tended to make men in the Middle Ages forget that sensuous and religious experiences were not incompatible in antiquity. Here one must make the qualification, however, that the Fathers' criticisms also had the opposite effect, for their attacks showed precisely that pagan religions were full of sensuous experience.[1] In any event, the prevailing religious atmosphere in the Middle Ages discouraged the representation of the naked human body. If the nude was represented at all, its sensual appeal was greatly minimized. Small wonder then that Indian erotic sculptures failed to make a strong impression on the average traveller. Some however made a passing reference to them. One of the earliest was the Russian Athanasius Nikitin, who reported in the fifteenth century that, 'Budhs [gods] are naked, without anything on their hinder parts, and the wives of Boot and their children are also sculptured naked.'[2] Two hundred years later Mandelslo noticed in a Jain temple, 'Statue, white or black, representing a Woman naked, sitting and having her legs lying cross under her.'[3] Others however expressed unqualified hostility. Della Valle encountered figures at Ahineli representing 'dishonest actions. One was of a Woman. Another was of a Man and a Woman kissing, the Man holding his Hands on the Woman's Breasts, and sundry such representations fit indeed for such a Temple.'[4] He concluded from his experience that Indian gods were always represented nude and that numerous figures in indecent postures were to be seen inside temples.[5] Equally severe was the author of an anonymous seventeenth-century Dutch tract: 'some with extraordinary human figures, with many arms and heads, others, animal bodies with human heads, or animal heads with human bodies—with much immodest, heathen-style, fornication and other abominations carved or painted thereon . . . in various pagodas.'[6] In the same period the erotic sculptures at the temple in Puri were described by Bowrey as 'Engraven . . . Shapes of men and women dancinge, as alsoe many hideous Shapes of Satyrs'.[7] Even to Thévenot, the

74

temples at Masulipatan appeared to be 'so full of lascivious Figures of Monsters, that one cannot enter them without horror'.[8] Finally, in 1724 Alexander Hamilton spoke about the temple of Gopasvāmī in the Ganjam district of Orissa: 'Around his Temple and on the Coach are carved Figures of Gods and Goddesses in such obscene Postures, that it would puzzle the Covent Garden Nymphs to imitate.'[9]

In view of these reactions the early attitude to the representation of the *liṅga* (the phallus of Śiva) is especially interesting. Although early travellers had occasionally noticed the *liṅga* image of Śiva, its stylized depiction generally prevented them from recognizing it as specifically phallic. The Portuguese historian Couto was observant enough to identify its phallic character as early as the sixteenth century,[10] as della Valle was to do so in the next.[11] But as late as 1661, John Burnell, describing Mihesh (Maheśa) as a 'black stone like a hatter's block', failed to recognize it.[12] On the other hand, a contemporary, Peter Mundy, who clearly knew the meaning of the *liṅga* image, preferred to interpret it allegorically: 'I went into it, where, in the midle, on a place elevated, is a stone in forme like a Hatters blocke . . . plaine and un-wrought . . . The meaneinge of that plaine blunte forme . . . was That it represented the head of Mahadeus viril member . . . Perhapps con-servation as well as genneration is thereby implyed.'[13]

These early references to the erotic elements in Hinduism had not attracted a great deal of attention in the West, perhaps because they were taken to be the products of an abominable pagan culture. But this state of affairs began to change very rapidly in the seventeenth century. Ever since the Renaissance it had been tacitly acknowledged in certain intellectual and artistic circles that art enjoyed a special licence in re-presenting the nude body and even erotic subjects. On this view, the nudity of Indian sculpture could not itself make it a subject of condem-nation. Classical scholarship, moreover, had learned to accept the motto *naturalia non sunt turpia*[14] and had begun to regard even the representa-tion of sexual organs in art as an object of legitimate antiquarian study. The earliest Humanist and antiquarian interest in the overt sexual imagery of antique art may have closely followed in the wake of the seventeenth-century mania for collecting classical gems, intaglios, and other minor art objects. Many of these antique gems showed subjects ranging from Greco-Roman phallic gods to scenes from exotic cults such as that of Mithra or of the gnostic Abraxas (alternatively, Abrasax). These had no doubt served in ancient times as cult objects and objects of private devotion with special protective and healing powers. Lumi-naries like Rubens and his friend the French Humanist and antiquarian N. C. F. de Peiresc were passionate collectors of these erotic gems. Peiresc had in his collection some hundred such gems. His contemporary Louis

75

40. Phallic figure in Agostini's *Le gemme antiche figurate*

Chaduc too was an avid collector of these engraved amulets and had even compiled an illustrated catalogue for his collection.[15] Peiresc had presented four such antique gems to Rubens, three of which were clearly phallic in character.[16] In his letter of acknowledgement to the antiquarian, Rubens discoursed at length on the idea that the snail stood for the vulva in antiquity, an idea shared by Chaduc.[17] Rubens and others of his generation were preoccupied with the specific question of what these phallic amulets meant and with the more general question of the symbolic meaning of images. In this they shared the intellectual curiosity of the Humanists of the Barberini circle, notably Pignoria and Kircher, with whom they were closely associated.[18] Nor was the Catholic Church immune to these interests. Between 1644 and 1646 a priest, J. B. Casalius, brought out a treatise on the sexual rites of the ancient Egyptians.[19] It was however in 1657 that Leonardo Agostini, the antiquarian to Pope Alexander VII, became the first author to dare illustrate a large number of Priapic cults of antiquity. The engravings of precious stones in his *Le gemme antiche figurate*, depicting ithyphallic forms of classical and exotic gods, Priapic sacrifices, and gnostic gems known as Abraxas,[20] testify to a more factual approach to classical myths, an approach increasingly freed from allegorical justifications [40]. Whether the interest in the phallic rites of antiquity was purely antiquarian is somewhat doubtful and consequently these authors must be approached with some caution. One readily agrees with Manuel that 'when the fine art of engraving was used to illustrate in book form purported antique gems on which pagan deities were portrayed in postures shocking to Christian sensibilities a primary purpose of the publication was doubtless pornographic, but these works also served to heighten the sensual image of antiquity.'[21]

The interest of the above authors was still confined to the classical world, although this world was admittedly far more sensual and down to earth than the one exalted in the Renaissance. The frank depiction of sexual organs underlined the extent to which 'obscene' rites formed

part of ancient classical religions. The question of sexual imagery in classical religion was however made much more real for the literati by the growing knowledge of the sexual and fertility rites practised by pagan societies of their own times. In other words, this knowledge tended to reinforce the newly emerging picture of antiquity. Frequently one set of knowledge complemented the other: an obscure practice mentioned in the Old Testament might be understood by referring to its modern counterpart in a newly discovered nation in Asia, Africa, or America. In these developments, which ultimately led to the modern study of comparative religion,[22] India occupied the foremost place in the interest of scholars. Not only did India figure prominently among the nations known to the Greeks and Romans, but it was even possible to trace among the Indians the continuity of a number of practices which they had retained since ancient times. A case in point is the Indian *liṅga* cult. Often missionaries and ethnographers sought to comprehend phallic rites mentioned in ancient Hebrew and classical texts by comparing them with the particular Indian cult. These comparisons, however indirectly, none the less contributed to a favourable reception of Indian art, especially its erotic aspects. For not only was the role of the sensuous elements in Indian sacred sculptures given due recognition, but antiquarians became acutely conscious of the parallels between ancient classical and Indian representations of sexual organs and other erotic subjects in religious art. Increasingly, from the mid-seventeenth century onwards, efforts were made, with the help of a syncretistic approach, to interpret Indian iconography and the erotic kernel of Hinduism. In the process of coming to terms with Hinduism, these scholars began to consider a number of Hindu gods as being essentially none other than the particular Indian forms of certain ancient Egyptian and classical gods. Kircher, for instance, had cited the case of Apollonius of Tyana, who had found that the very same Greek gods were adored by the ancient Indians.[23] Syncretism, or the tendency to equate the functions of gods of widely differing cultures, was certainly not unique to this period: the way had been shown by the ancients themselves. In identifying classical and Hindu gods, the late seventeenth- and eighteenth-century antiquarians did no more than to revive a system of syncretism in wide use among late antique authors, especially among the Neoplatonists.[24]

The following extracts illustrate the first European attempts at symbolic and philosophical interpretations of Indian *liṅga* worship. It was in the *Open Door* of Rogerius that the *liṅga* was described as the *membrum virile*, whose editor further compared it with the image of the phallus carried in Rome on certain feast days, as related by St. Augustine.[25] Baldeaus, on the other hand, was surprised to learn that '*Brahmans* have

77

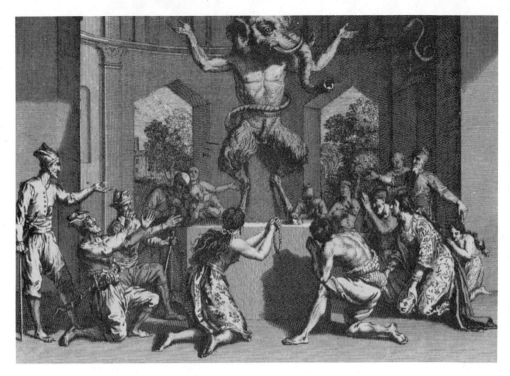

41. Phallic Sinhalese divinity of wisdom in Picart's *Coutumes*

a very odd Opinion of the Creation of the World . . . finding that all living Creatures were procreated by the carnal Copulation of Men and Women, they reverenced this Quivelinga, as the Original of all created things.'[26] None the less he did not neglect to remark on the similarity of the *liṅga* cult to the Greek adoration of the god Priapus and the ancient Hebrew veneration of Baal Phegor.[27] Commenting on the passage, Picart offered further justification for phallic worship. His suggestion, that nothing expressed better the fecundity of nature than the union of the two sexes and 'the vigour of Priapus', clearly anticipated certain late eighteenth-century theories about fertility cults.[28] Elsewhere, too, Picart was tempted to seek out the phallic gods of India. Again, in a manner that clearly foreshadowed the later syncretistic antiquarians, the French engraver equated the functions of the Indian god Gaṇeśa, the god of wisdom, with those of the classical Pan, by ascribing an ithyphallic and goat-like character to Gaṇeśa [41]. His particular identification was not entirely unwarranted, for this elephant-headed Hindu god has some phallic associations.[29]

Eighteenth-century scholars like La Créquinière went to India in search of parallels between classical and Old Testament practices on the one hand and Indian ones on the other as every one of them was convinced that the existing bewildering variety of religions in the world had

78

sprung from an original one. La Créquinière's work, translated into English by the famous Deist John Toland, was written with the purpose of tracing the parallels between ancient Hebrew and Hindu practices, for he believed that the Jews had colonized India. He was therefore able to come to the conclusion that 'We find among the Indians, Temples dedicated to Priapus, tho' under several different Names; and we may say, that they are much refin'd above the infamous Postures, wherein the Egyptians, Greeks and Romans have Represented him.'[30]

Another noted syncretizing antiquarian was the librarian to the king of Prussia, Mathurin Veyssière de la Croze, remembered today mainly for his contributions to Coptic grammar and Egyptology. He wrote a book called *History of Christianity in the Indies* (1724) in which the *liṅga* worship was described as essentially the worship of Osiris and Bacchus. The identification of Osiris as Bacchus was nothing unusual, since these two chthonic gods had been presented as identical by Herodotus as far back as the fifth century B.C.[31] By the time of Plutarch the Egyptian god had been fully assimilated into the classical pantheon. Osiris, the central figure in one of the popular mysteries prevailing in late antiquity, was also the main inspiration behind the very influential syncretistic treatise by Plutarch, *De Iside et Osiride*. Much of the information about Osiris and Osirian myths in the modern period down to the eighteenth century came from Plutarch, and thus it was nothing exceptional for La Croze to rely on the Roman author.[32] The important point here is that not only did La Croze revive the late antique syncretizing tradition, but he also extended its scope in order to bring the Indian god Śiva within it. The reasons advanced for the identification of Śiva with Osiris were as follows: apart from the fact that these gods were associated with phallic cults, Śiva was endowed with more than two eyes, comparable to the many eyes of Osiris. La Croze possibly derived the information of Osiris' multiple eyes from Plutarch. Continuing, he then proceeded to derive the word 'Isouren' (Īśvara = Śiva) from Isiris, the name for Osiris that occurs in the late antique author, Eusebius. Here, by an ingenious diffusionistic argument, La Croze was able to suggest a historical connection. He also found links between Isura (Īśvara) and the famous archaeological object, the Isiac table, reproduced in Pignoria's *Mensa Isiaca*. According to the antiquarian the object held by the thirty-six decans in Pignoria's book must be identified as the Indian *liṅga*.[33] La Croze, who, like Pignoria and Kircher, saw ancient Egypt as the centre of diffusion, conceded that the Egyptians were probably responsible for originating and subsequently spreading phallic cults to other parts of the world, since he could recall the statement in Herodotus that Priapism had been brought over by Melampus from Egypt to Greece.[34] So too Jablonski dealt in 1750 with the licentious rites

79

practised in ancient Egypt in his *Pantheon Aegyptiorum*. The learned treatise drew the expected parallels between phallic cults from Egypt and India.[35]

These two sets of evidence relating to erotic cults, one classical and the other contemporary pagan, helped to bring about a new awareness of ancient religion. But there occurred an event of singular importance which suddenly brought into sharp focus the whole problem of sexual symbolism in ancient paganism. This was the discovery of Herculaneum by the scholarly world. Although excavations had begun in earnest as early as 1738, on account of restrictions placed by the king of Naples the discovery was not made public until the year 1757.[36] Therefore, if in the period of Agostini in the previous century the few isolated cases of Greco-Roman *Priapi* could still be dismissed as exceptions or as aberrations, the sheer number of phallic objects revealed in the excavations of Herculaneum left no doubt as to the unrepressed sexuality of Classical Antiquity.[37] With this startling revelation the change in the eighteenth-century attitude to ancient heritage was complete. From now on, the problem before all the major writers on comparative religion was to search for ways and means to integrate all this new knowledge from the past and from contemporary pagan societies within a framework of general principles. The process, begun some 150 years before with Pignoria, received further impetus in the speculations of Kircher.[38] But in the late eighteenth century it was the sexual motivation of all religions which held the undivided attention of a large number of antiquarians.

Before proceeding to examine how the new archaeological and ethnological material was handled by the eighteenth-century savants, certain problems need to be considered. The eighteenth-century scholars, without exception, were convinced that the sexual imagery of ancient classical and Indian sacred art could only be allegorically interpreted, because, they claimed, that was how the ancients themselves had explained the representation of sexual organs in their religion. However, there is no evidence to justify their claim. The fact of the matter is that, while rejecting the traditional moralization of licentious classical myths and the sexual imagery of classical art, the eighteenth-century antiquarians themselves offered an essentially allegorical explanation of a different kind. In this situation we may legitimately ask what the ancients actually felt in these matters. In other words, what was the relationship between Eros and religion in antiquity, in so far as these are revealed in artistic remains? Greco-Roman art with an explicit sexual message consisted of vase-paintings, small phallic objects for religious purposes, and large ithyphallic sculptures which were displayed and carried in procession during Dionysiac and Priapic festivities.[39] While it is easy to see that these objects had some connection

80

with sacred rites, their precise function is more difficult to determine. In fact, no one has as yet offered a convincing explanation of the sexual imagery in either ancient Western or Indian art. Hans Licht, who studied the role of sex in classical society, viewed the existence of phallic objects in ancient religion in terms of the prevailing ideals regarding the propagation of children. Since the Greeks considered the reproduction of the species as a sacred duty, it was natural for them to revere the sexual organs and to accept them for their role in the reproductive process in nature. To put it differently, hedonism and ethics were not in conflict.[40] No one can pick a quarrel with this reasonable statement. But when Licht went on to qualify his statement an ambivalence stemming from his Christian background became at once apparent. According to him, these phallic cults did not represent a gross immorality but were in the highest degree moral conceptions of the sexual act. The objection may be raised here that Licht assumed, quite without justification, that ancient pagans had, in an imperfect and confused way, anticipated Christian values. He also added that the Greeks treated the sexual organs 'with an almost religious reverence as the mystical instruments of propagation, as the symbols of nature, life-producing and inexhaustibly fruitful . . . Thus the phallus becomes a religious symbol; the worship of the phallus in its various forms is the naive adoration of the inexhaustible fruitfulness of nature and the thanks of the naturally sensitive being for the propagation of the human race.'[41]

Two questions may be raised here: were the ancient Greeks aware of the sort of morality Licht imputes to them, and did they accept sexual organs in a symbolic sense, as he would have us believe? It is vital to raise these two related questions because from the very earliest period of Christian history attempts were made to allegorize the particularly obscene aspects of Greek religion in order to render them acceptable. The eighteenth century was of course heir to this long allegorizing tradition. But even Licht, writing in our own period, fell prey to this mode of interpretation. In answer to Licht, I should like to suggest here that it is virtually impossible to say categorically how the ancients regarded the representation of sexual organs. The fact that the Greeks, like many ancient and primitive peoples, ascribed supernatural powers to the process of reproduction is beyond doubt. What is not clear is whether the phallic objects were accepted as symbols standing for a higher idea, or as straightforward representations. The ambiguity is due in part to the very nature of a visual symbol, the reaction to which may contain a number of elements on different levels which defy logical analysis.[42] Moreover, the semantic distinction between 'symbolic' (thing regarded by general consent as recalling something by association) and 'real' (thing which stands only for itself) may not have been clearly

formulated in antiquity. Rather than look for the meaning of the 'obscene' representations themselves, it may be more useful to consider what function they had and what purpose they served. It is possible that the phallus or the *cteis* may have had a magical character in antiquity, containing or simulating like a relational model some of the powers active in the universe, and evoking for the worshipper a multitude of supra-rational associations. W. L. Hildburgh has shown in an interesting article that phallic pendants were commonly used in ancient Rome to ward off the evil eye.[43] This Roman practice reflects a very widespread belief in the protective power of the sexual organs against the malevolent forces of nature, perhaps because of their connection with life and reproduction. However, in as much as the pagan classical gods were assimilated in European philosophical thought, it became necessary to seek hidden meanings in the 'obscene' images, behind which ancient sages had hidden profound truths in order to prevent their profanation. It is well known that early Fathers had made use of allegory to gloss over improper tales of classical gods, but the process can in fact be seen long before in early Greek philosophers, who sought to create a distance between them and the grosser manifestations of religion.[44]

While it is impossible to state with certainty what the precise ancient classical attitudes to the phallic rites were, all the evidence strongly suggests that the allegorical interpretations of the eighteenth-century students of religion were based to a large extent on Neoplatonic writers of late antiquity, whose writings had pronounced mystical overtones. The comparisons made by the savants of the eighteenth century, between Hindu, classical, and Near Eastern gods, reflect the growing popularity of syncretism. The eighteenth-century syncretism was in essence a modern revival of certain interpretations made by Hellenistic and Roman authors of late antiquity, in which the distinct features of gods of different religions, often disparate, were blended, to render them indistinguishable. It was in the Hellenistic period that foreign Oriental gods such as Isis, Serapis, and Cybele were accepted into the classical pantheon. The Orphic tradition of instructing ordinary people in higher metaphysical and ethical ideas, through the medium of already existing popular myths, may have contributed to the growth of universality and syncretism, which eventually paved the way for Christian monotheism.[45] Dionysus, a god originally belonging to a primitive Thracian cult, was taken over by the followers of Orpheus, and the myths concerning his sufferings were made central to the Orphic mystery.[46] Syncretism found its most elaborate exposition in literature, and the authors of the syncretistic works, the late antique Neoplatonists, made extensive use of the corpus of Orphic hymns.[47] It was in this atmosphere that Plutarch

composed his syncretistic work on the mysteries of Isis and Osiris, the most famous example of this genre of writing. Small wonder that classically educated eighteenth-century antiquarians sought to comprehend Indian gods through the device of an already existing syncretism. Where the modern authors departed from their ancient predecessors was in their inclusion of Hindu gods, leading to a significant expansion of the mythological horizon. The new syncretism had a very important effect on European appreciation of Indian iconography: now the unfamiliar Indian pantheon could be brought within a known frame of reference, and could be discussed in a language familiar to the *érudits* all over the West. Hinduism, whose religious rites did not perhaps appear so very unlike the classical ones, readily provided the sought-for analogies. This analogical thinking was greatly encouraged by the celebrated essay 'On the Gods of Greece, Italy and India', written in 1784 by Sir William Jones, highly regarded by his contemporaries for his erudition in the field of Oriental studies.[48]

It is significant that, in the late eighteenth century, the classical god most frequently identified with Indian gods, notably with Śiva and Brahmā, happened to be Bacchus or Dionysus. On the one hand, this was due to the almost exclusive use by the antiquarians of the Neoplatonic treatises of late antiquity, in which Bacchus was the supreme deity, as he was in both Orphic and Dionysiac mysteries.[49] On the other hand, the ancient account of the Indian journey of Dionysus easily lent itself to such an interpretation of Hindu gods. In the nineteenth century, E. Schwanbeck had traced the classical tradition which equated Bacchus and Śiva. When Macedonians arrived in India, they were led in the true Greek fashion to identify Śiva with their own Dionysus. Their task had been made easier because it was stated in Euripides that Bacchus had made extensive travels in the East.[50] Alexander's invasion of India gave a new lease of life to this tradition, and from Megasthenes we have the story that the god Dionysus overran the whole of India with a considerable army, but had to retire to the heights of Mount Meros on account of the excessive heat of the plains. As a result of this expedition, Indians came to worship this god who taught them the art of wine-making.[51] We must therefore remember that these classical allusions to India were constantly in the minds of the eighteenth-century students of religion. As early as 1704 La Créquinière had observed that Hindu religious practices were precious remains of antiquity, while Hindu theology was very different from that of the ancient pagans.[52] This early recognition of the similarities as well as the differences between India and the ancient West was disregarded by later writers, when in a true syncretistic fashion the essential differences between ancient Western and Indian gods were thoroughly obliterated.

83

Nevertheless, during their intensive explorations of the classical and Biblical literature of the past and of contemporary treatises on ethnography and comparative religion, late eighteenth-century students of religion indeed discovered a significant phenomenon: the intimate connection between sexual imagery and fertility in many ancient and primitive religions. Not only did their writings foreshadow modern interpretations of primitive religion in terms of fertility-magic, which attain their culmination in Frazer's *Golden Bough,* but their new approach helped them to look at Hindu religion and religious art with a new vision and from a wider perspective. To this school of comparative religion, universal 'fertility' became the keynote of its interpretation of mythology. 'Fertility' itself was interpreted by the late eighteenth-century students of religion on several different levels that can be clearly distinguished in their works: on the level of agricultural fruitfulness symbolized by the phallus or *cteis,* or their complementary symbolic forms in other spheres, such as the sun and the stars; fertility was also taken to represent creativity, as part of the cycle of life, death, and rebirth; and finally, the phallus as a creative symbol was made the carrier of a more profound and mystical idea with reference to the connection between sacred and profane love.

The leading writers to discuss these problems were Pierre-Sylvain Maréchal, Pierre-François Hughes, called d'Hancarville, Richard Payne Knight, and Charles Dupuis. With the exception of Knight, all were French and consequently nourished on the prevailing anticlericalism and radical free-thinking of the Enlightenment. The English scholars were in general relatively unaffected by this intellectual milieu and its militant attitude to the established Church, except Knight, who is said to have been much more European in outlook than his English contemporaries. Maréchal, an unrepentant atheist, was responsible for publishing between 1780 and 1803 a twelve-volume work devoted to the finds at Herculaneum, with engravings by F. A. David.[53] Coming not long after the restrictions against the publishing of Herculaneum material had been removed, the profusion of erotic subjects in the work must have caused a great sensation in the learned circles. There is some evidence of Maréchal's interest in India in his treatise on the voyages of Pythagoras.[54]

The next two antiquarians were closely associated with the English Society of Dilettanti, a body founded in 1734 in order to influence English taste in art and to further classical scholarship. The Society, a leading force in the Neoclassical movement, had among its members the famous Charles Townley, a great collector of antiquities, whose collection enriched the British Museum after his death.[55] It is therefore all the more exciting to learn that he was the first European known to

have acquired an Indian erotic sculpture group apart from possessing a number of other pieces.[56] He was clearly interested in erotic art, for, when in 1784 Pierre-François Hughes, called d'Hancarville, arrived in London, he immediately found an enthusiastic patron in Townley. His theories on ancient religion deeply impressed both Townley and Knight, who took the responsibility for communicating them to the Society of Dilettanti.[57] Hancarville, who was certainly a major influence behind Knight's *Worship of Priapus*, himself published from London two works on a sexual theme, the first *Veneres et Priapi* (1784), and the second, and more serious, *Recherches sur l'origine, l'esprit et les progrès des arts de la Grèce* (1785).

Richard Payne Knight, the most influential member of the Society of Dilettanti in his time, is also the most colourful of the four authors. He was renowned for his aesthetic and antiquarian writings and his essay on the picturesque made an interesting contribution to aesthetic theory. His collection of antiquities is now the pride of the British Museum.[58] Knight visited Italy many times during his life. His Sicilian journal was deemed important enough to be translated by the young Goethe.[59] As Professor Pevsner shows, Knight's writings evince a deep concern with the content of works of art and less with their aesthetic value. That is perhaps why Knight turned his attention to Indian art which formed an important part of his collection, though little known. As we shall see, he was primarily interested in the meaning of Indian art. Pevsner also suggests that Knight's approach to ancient religion was 'psychoanalytical', and that his own religion was a broad pantheism, with a penchant for the mystery religions of the Orient, Greece, and India.[60] This English antiquarian's perhaps unjustified notoriety rests on his *Discourse on the Worship of Priapus, and its Connexion with the Mystic Theology of the Ancients* (1786), which was withdrawn within a few years after publication because of a scurrilous attack on it by a contemporary satirist, T. J. Mathias.[61] This is surprising because Knight's European contemporaries had already published works of a far more sensational nature without receiving any opprobrium, as it was rightly pointed out by the 1865 editor of *Priapus*.[62] The truth of the matter is, the freedom to write on sexual subjects, proclaimed so widely in the Enlightenment and Revolutionary France, had not made much impact on English society. Twentieth-century scholars are not agreed on the merit of the book. It was, Pevsner argues, surprisingly original for its time and anticipated certain modern approaches to archaeology and philology,[63] whereas Manuel considers it as nothing more than an addition to eighteenth-century pornographia.[64] The truth probably lies somewhere between the two, as the man himself was in the words of Pevsner 'a mixture of Caylus and Casanova, scholarship and hell-fire club tradition'.[65]

By far the best-known spokesman for the new interpretation of ancient religion in terms of sexual symbolism was Charles Dupuis, a leading intellectual, philosopher, and politician in the period of the French Revolution. Influenced by the ideas of Lalande, Dupuis in his philosophical system sought to trace all religions back to a common source, and to see the origins of all human beliefs in the worship of the sun and the stars on the one hand and the sexual organs on the other. A complete exposition of his universal system is to be found in the monumental seven-volume *Origine de tous les cultes ou la religion universelle* (1795). He was honoured with the offer of the Chair of Literature at Berlin by Frederick the Great. He became the French Commissioner of Public Instruction in 1790 and was a founding member of the French Institute.[66] Dupuis's treatise on universal religion was a manifestly anticlerical doctrine which enthusiastically extolled the virtues of paganism.[67]

Now, to turn to the contribution made by the four men to the understanding of Indian erotic art. According to these writers, especially Dupuis, the iconography of ancient classical and Indian erotic art was based on the same fundamental ideas as expressed in their mythology, ideas that were kept concealed from the ordinary superstitious populace. Both art and myth spoke allegorically and enigmatically of the fundamental 'causes' and were essentially the twin expressions of the same religious experience. The doctrine stated in two forms, one literary and the other artistic, was in principle a constant interplay of polarities, as exemplified in human sexuality and its projection in nature.[68] Interpretations of ancient mythology, least of all its allegorical interpretation, were nothing unique to the period, since they had been going on for over a century. What was specifically novel about the allegorizing school of Dupuis and its contribution to the reception of Indian erotic art was its consistent use of ancient Western and Indian erotic art for illuminating certain ancient myths. More important still, the learned discourses of Dupuis and others on ancient mythology were constantly illustrated with examples from classical and Indian art. They were thus the first scholars to make serious attempts to gain knowledge about Indian art not only from literary sources but from among the few known examples of Indian sculpture and painting in European collections.

All four of them discussed in some detail the implications of the phallus in ancient religion, and its creative function as reflecting the creative process in nature; they also compared the Greek and Egyptian forms of phallic worship with their purported Indian counterparts. Sylvain Maréchal in his *Antiquités d'Herculanum* drew parallels between the *Priapi* discovered in that city and the Indian *linga*. He further explained that the '*Priape Tétragone*' found in Herculaneum was to be identified with the image of *linga*, connected with the cult of the god

42. Hindu temple in Townley Collection

Rudra. His example of the tower of the temple of Maddol near Goa as an image of *liṅga* was derived from the work of the celebrated traveller and Orientalist, Anquetil-Duperron.[69] Although Maréchal's work was not primarily on comparative religion, he nevertheless considered these parallels between Classical Antiquity and India illuminating, and took this opportunity to discuss the universality of sexual symbolism in ancient religions. He was convinced that the respect paid to the phallus in Greece and Rome and to the *liṅga* in India proved that the cult of the phallus was not a local and isolated phenomenon. In fact, people all over the world, including the Manicheans, had portrayed nature in this manner.[70] Pierre-François d'Hancarville, in *L'Origine et les progrès des arts de la Grèce*, expounded the view that the Priapic cult was diffused over a wide area. He saw this as a reflection of ancient attempts to explain life and fertility as the creative activity of the heavenly Progenitor, but he made the god Bacchus in particular responsible for the transmission of these ideas to the Indians. His illustration of the *liṅga* came from the miniature Hindu temple in the Townley collection [42].

Charles Townley's little Hindu temple, said to have come from the Rohilla country in northern India, was presumably shipped to England after the area was taken over by the East India Company.[71] In *A Discourse on the Worship of Priapus*, Richard Payne Knight remarked, while discussing ancient phallic rites, that the image of the creative or generative attribute known as the *linga* still occupied the central and innermost recesses of Hindu temples.[72] Charles Dupuis, who had based his thesis of a universal religion on the interaction between the active and passive principles of nature, declared that the display of male and female sexual organs in the Cabirian rites at Samothrace expressed a grand cosmogonic idea. To him, the Indian *linga* represented the same philosophic idea in the form of the union of the two great 'causes of nature'.[73] From the reports of travellers Dupuis gathered that not only was the *linga* frequently represented in Hindu temples, but that the Indian sect of *lingāyats* always carried a small phallus around their necks, as was done by the followers of certain classical phallic gods.[74]

In these writings, the creative or life-affirming principle represented by the phallus was also by extension seen revealed in other forces in nature and the cosmos. The sun, adored by all primitive people for its connection with life, and in a very direct way with all vegetable life, became for the late eighteenth-century antiquarians the supreme example of the creative principle, in fact, the centre and origin of all creation. Not only the sun, but the whole planetary world was held to express sexual symbolism, and both Dupuis and his learned contemporary Antoine Court de Gébelin claimed to have discovered solar and astronomical notions behind a large number of ancient myths. Furthermore, Dupuis saw solar symbolism as complementing and not contradicting the essential concern of phallic rites with fertility. It was this conviction that led Dupuis to explain Apollo, Christ, and Buddha as allegorical representations of the sun.[75] Dupuis and Gébelin may have found support for their ideas in ancient sources, where the phallic and vegetation deity Dionysus was also associated with the sun. The most systematic treatment in antiquity of solar origins of religion is to be found in Macrobius' *Saturnalia*, in which text Dionysus, Apollo, and other Greco-Roman gods were presented as aspects of the sun and also the generative Cause of all forms of life.[76] Antiquarians of this period, including Dupuis, were indebted to Macrobius, although they were not always willing to acknowledge it. The universality of solar worship was taken for granted by them. It did not therefore surprise Sylvain Maréchal to read in Philostratus' life of Apollonius of Tyana that ancient Indian painters depicted the sun mounted on a chariot drawn by griffins.[77] Dupuis noted that, a century before, Kircher had drawn attention to Apollonius' statement that sun worship was one of the

43. Indian moon god from a set of old missionary paintings

oldest practices in India.[78] Payne Knight described ancient obelisks as solar symbols,[79] and Hancarville identified the Andhakāsura Śiva figure [54] on the island of Elephanta as Bacchus in the form of the 'nocturnal' sun, because this Hindu god appeared to conceal himself behind the veil represented in the sculpture.[80] Dupuis, who saw sexual symbolism mirrored in the whole of the planetary world, claimed to have discovered temples to the moon god among Indian paintings deposited in the Bibliothèque Nationale [43]. In this period, among the paintings depicting Hindu gods and Indian religious scenes known to have existed in Paris, four sets can be clearly identified. Of these, the oldest was a volume of paintings executed by missionaries. Dupuis' description of the temple to the moon god was derived from a picture in this volume. There is evidence, however, that Dupuis knew other volumes as well.[81] Two further instances of Indian astral symbolism were given by Dupuis. From his reading of the traveller Sonnerat, he concluded that the temple called the Seven Pagodas in Māmallapuram was consecrated to the seven planets. Moreover, the symbolic use of the number seven strongly reminded him of the seven enclosures in the temple of Jerusalem.[82] The other example of the thirty-six headed Indian astronomical deity [55] was gathered from the publication of the astronomer Le Gentil who had visited India in 1761–72.[83]

From the celestial sphere, the antiquarians then moved on to the animal world. Here, they held the bull to be the most important symbol

89

of generation and fecundity, as the sun was in the heavens. It is of course a fact that in primitive societies the bull has always been revered for symbolizing power and male sexuality, and for its association with vegetation. The late eighteenth-century savants, however, found the association between the bull and the vegetation god Bacchus especially significant. The further task of equating Bacchus with Indian Śiva was made easier for these *érudits* since both these divinities had the bull as their emblem. Modern philology confirms that the association between Bacchus and the bull goes back to remote antiquity. The religion of Dionysus as it prevailed in Hellenic Greece had its origins in pre-Hellenic Thrace, where he was worshipped from most ancient times in the form of a bull. In pre-Hellenic Crete another chthonic god, sometimes described as Zeus Zagreus, the hunter, was identified by his followers with the bull. Later in the Hellenic period he was drawn into the mysteries of Dionysus by being syncretized with the old Thracian god, and ritual sacrifices of bulls came to form an integral part of Dionysiac orgies.[84] This association between Bacchus and the bull was fully recognized by Hancarville when he described the bull as the foremost symbol of creation,[85] and accepted as such by the Japanese, Chinese, and Indians.[86] Hancarville also seems to have discovered the Indian form of Bacchus in the god Brahmā, who was supposedly represented in Elephanta in the company of cows.[87] He also believed that Indians revered the bull as Darmadeve (*Dharmadeva*), whose image in a Surat temple was still painted red in the manner that Bacchus was painted red in ancient Greece and Rome.[88] Dupuis described Bacchus as the sun-god in the form of the ancient 'equinoctial' bull.[89] Knight gave an example of taurine Bacchus with a human face and a sun-emblem.[90] The Hindu reverence for cows was illustrated by Knight by referring to a piece of sculpture from Tanjore in south India [44]:

Both the bull and the cow are also worshipped at present by the Hindoos as symbols of the male and female, generative and nutritive powers of the Deity. The cow is in almost all their pagodas; but the bull is revered with superior solemnity and devotion. At Tanjour is a monument of their piety to him which even the inflexible perseverance, and habitual industry of the natives of that country could scarcely have erected without greater knowledge of practical mechanics than they now possess. It is a statue of a bull lying down, hewn with great accuracy, out of a single piece of hard granite . . .[91]

The theory of the generative and nutritive powers of the universe, another name for the active and passive principles of Dupuis, was further elaborated by Knight with examples from the East and the West. He put forward the notion that Hancarville's illustration of a piece of Japanese sculpture showing a bull breaking 'the egg of chaos', and the enigmatic Greek head with its tongue sticking out, could only

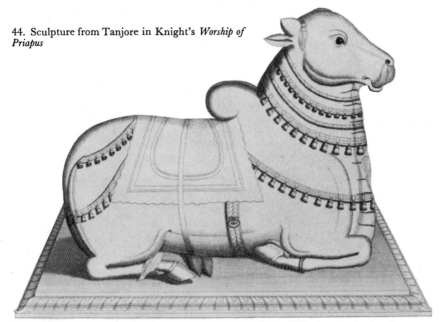

44. Sculpture from Tanjore in Knight's *Worship of Priapus*

be explained by referring to a very ancient Hindu sculptural group [45]. This remarkable erotic group from Elephanta was brought over to England on the man-of-war *Cumberland* and subsequently acquired by Charles Townley for his great collection of ancient art. He thus became the first European to possess a valuable example of Indian erotic art before the twentieth century [46, 47]. Knight explained the significance of the group as follows:

It contains several figures, in very high relief; the principal of which are a man and a woman, in an attitude which I shall not venture to describe, but only observe, that the action, which I have supposed to be a symbol of refreshment and invigoration, is mutually applied by both to their respective organs of generation, the emblems of the active and passive powers of procreation, which mutually cherish and invigorate each other.[92]

It was Dupuis who found other animals, particularly the goat, to be equally concerned with fecundity and vegetation. Recalling the role of the celestial goat as a beneficent agent in certain Greek and Egyptian rites, Dupuis turned his attention once again to the paintings of Indian gods in the Bibliothèque Nationale. In one, which according to the French *idéologue* represented one of the incarnations of Viṣṇu, the four-armed Sun-god held a little goat in one of his fingers. In another one [48], the god Isproun (Īśvara), shown descending to kill the demon Tiperant (Tripurā), also had in one hand a little goat. Finally, the picture of the god Iogui-Hisper (Yogī-Īswar = Śiva) represented him with a crescent moon on the forehead and a little goat in his hand [49].

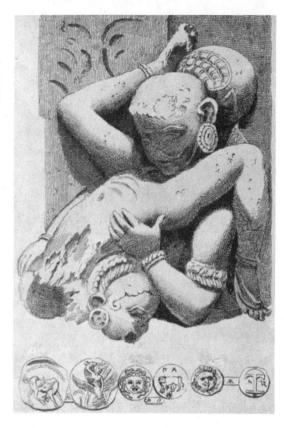

45. Detail from erotic fragment in Townley Collection and several Greek pieces including 'the enigmatic head with tongue sticking out' in Knight's *Worship of Priapus*

From these pictures Dupuis was left in no doubt that, although a particular painter or sculptor may have varied the treatment in accord with his own genius, this cosmogonic theme involving the goat was represented all over the world. In fact, the very same Egyptian goat-divinity was to be found in a cave in Ellora, as Anquetil had mentioned. Dupuis was convinced that there were some historical links between Egyptian and Indian cosmogonies, for did not the Indians themselves admit to the great antiquity of Ellora?[93]

All the late eighteenth-century students of religion to some extent, and Hancarville most of all, set up the phallic-vegetation deity Dionysus/ Bacchus as the most important creator god, and then traced his attributes in the Indian gods Śiva and Brahmā. They were encouraged in this by the knowledge that both Dionysus and Śiva have been associated with life, death, and resurrection. Hancarville's attempts to relate vegetation theories to higher metaphysical ideas were in fact based on notions that can be found in late antiquity. The evidence at our disposal seems to suggest clearly that sexual organs did not exist in ancient classical religion in their simple capacity as carriers of fertility. In fact, in the period of ascendancy of the mystery religions—when most of the

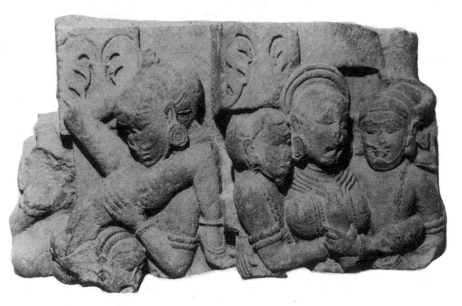

46. Erotic fragment from India, acquired by Townley, now in the British Museum

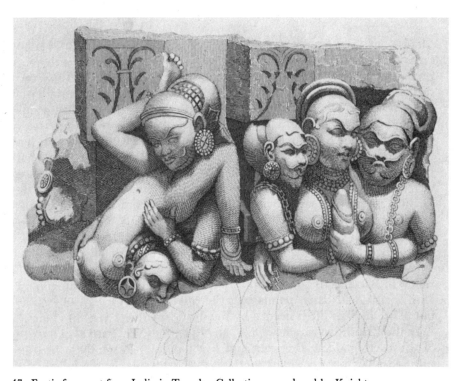

47. Erotic fragment from India in Townley Collection reproduced by Knight

48. Śiva destroying a demon, drawn by Sami

Hellenistic and Roman authors quoted by Knight, Hancarville, and Dupuis flourished—the original kernel of fertility symbolism had become submerged in more metaphysical ideas. The prime concern of Orphic religion, for instance, was to provide for its initiates a pleasant environment in the world of the dead. But the Orphics, instead of inventing new myths, used the pre-existing ones to teach their own doctrines. Central to Orphism were myths connected with creation and the renewal of life, particularly myths connected with the cosmogonic egg and the story of Dionysus as the victim of the Titans.[94] Conversely, the mysteries of Bacchus, specially popular in the Roman period, had borrowed the egg-symbol from the Orphics,[95] though they also had their own symbol of life's fruitfulness in the *liknon*, a basket of fruit and vegetables, with a phallus.[96] Dike, the chthonian deity, who in the Orphic mystery is said to mete out justice in the underworld, also appears on a very famous Bacchic monument in Italy.[97] The prominent place given in Orphic and Dionysiac cults to the death and the ascension of Bacchus from the region of the dead was poetically expounded by the Neoplatonist Proclus as a symbol of the world in its process of self-renewal. Bacchus frequently appears with phalli in Roman sarcophagi. In this case, as Nilsson points out, the phallus is not a sign of fertility but of life itself as life is needed by the dead when they arise in Hades.[98]

In the Eleusinian mysteries, too, an old agricultural festival in honour of the earth-goddess Demeter and her daughter Persephone became suffused with more complex metaphysical concepts, as the fortunes of

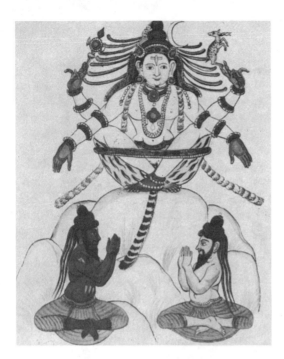

mother and daughter came to symbolize not only the seasons' cycle but the repetition of the eternal processes of life, death, and revival.[99] The inner mysteries of Eleusis were so well guarded that one can only speculate as to their content.[100] None the less, it is reasonable to assume that an exchange of ideas among these cults must have taken place, since none of them were mutually exclusive.[101] That connections among these mysteries may well have existed is evident from their reliance on a common mythological tradition.[102] In short, the three mystery cults, in stressing the dual fruitful-chthonian aspects of Persephone, at once an earth goddess and the queen of the underworld, and the twin aspects of Bacchus with the *liknon* and phallus as life's symbol and his depiction on ancient sarcophagi, reflected an intense preoccupation with the afterlife. However, in contrast to the unhappy Homeric world of the departed, the mystery religions promised a happy and pleasant afterlife.[103] At Eleusis, the sprouting corn, a symbol of eternal life, gave its initiates the confidence to face death, for the rulers of death's kingdom had become their friends through initiation.[104]

Hancarville was well aware of these beliefs held by the ancients. Having discussed the role of Bacchus as the guardian of life and vegetation, the French antiquarian proceeded to examine his role as the god of death. In this connection he pointed out that the Indian god of creation and preservation, who also had the bull as his symbol, also presided over death. The point was illustrated with the example of the common Hindu desire to hold the tail of a cow before taking leave of this world.

Hancarville praised the practice as being sound despite its apparent absurdity. His interpretation was that Hindus were well aware that the cow was the emblem of the god of life and death. Therefore they ensured tranquillity of the soul after death by means of this action.[105] It is clear that Hancarville's description of the state of the soul after death owed more to Greco-Roman mysteries than to any Hindu tradition. However, after having proved to his satisfaction the Hindu respect for the god of life and death in the form of a bull, he then sought confirmation of this practice in the classical world. Hancarville found the burial practice of the followers of Bacchus quite illuminating in this respect. Because the tombs were placed under the special protection of this god, not only was he called Chthonius but one even found frequent depictions of the attributes of Bacchus in Greco-Roman funerary urns. This must explain, Hancarville wrote, the existence of scenes of orgies, the representations of *Priapi*, and other obscene subjects on funerary vases.[106]

One needs to emphasize here that antiquarians like Hancarville did not rest content with drawing interesting and often apposite parallels between ancient Western and Indian practices but felt impelled to discover their one common origin, a persistent tendency among seventeenth- and eighteenth-century intellectuals. In search of these supposed common cultural and historical links, Hancarville turned his attention to the task of discovering the survivals of the Bacchic cult in India. Hancarville's main inspiration came from ancient accounts of the adventures of Dionysus in India, and his subsequent deification by the Indians. Hancarville was thus convinced that the twin aspects of life and death, combined in the image of the phallic god at Elephanta, unequivocally pointed to the dissemination of the doctrines of Bacchus in India. The figure, which he knew through the writings of the celebrated traveller Niebuhr and had identified as Bacchus, is none other than the well-known Śiva image in his role as the destroyer of the demon Andhaka [54].[107] At Elephanta, the French antiquarian wrote, this figure with six arms and an organ as prominent as that of the Priapus of the Greeks, represented the creator god among Indians. The deity also wore a garland of human skulls, a reminder of the destructive powers of the god. Like Bacchus he too had emblems such as bells and snakes near him and a veil behind him. While no one can deny for a moment Śiva's phallic-chthonic character, Hancarville's identification of this particular image as phallic was inaccurate, but part of the blame for this must rest on Niebuhr's misleading sketch [53].[108]

In addition to identifying the Elephanta Andhakāsura figure as Bacchus, Hancarville also presented the god Brahmā as another Indian version of the same classical deity. Brahmā was deified after his death in the year 3553 B.C. The Indians, he claimed, preserved Bacchic cere-

96

monies under different names. For the seemingly precise date of Brahmā's deification, Hancarville was indebted to the chronological speculations of the astronomer Jean-Sylvain Bailly, much respected in this period for his studies in the ancient history of Asia.[109] Knight, who accepted these interpretations, had also spoken of Bacchus and his powers over life and death.[110]

In the eighteenth-century writings on religion, the anthropological-allegorical doctrines were intertwined with a more mystical conception of sexual imagery in ancient fertility and sexual rites—the time-honoured connections between sacred and profane love. From a very early period in the history of Greek religious thought, earthly love was looked upon as a reflection of divine love, a notion sometimes expressed in mythopoeic terms. Thus the sensual aspects of ancient religion were interpreted as an essential step towards the union of the human soul with the divine. It is in this sense that sexual organs were regarded as divine, and containing in them higher spiritual truths under enigmatic forms. Even today there is no reason to dismiss this approach out of hand: the mystic association between love and religion appeared early in Orphic rhapsodists, who saw no reason to differentiate between creation and procreation, for they were essentially two kinds of love, one cosmic and the other human. With this belief in the unity of human and divine love, it was most appropriate that the Orphics chose Phanes-Eros as one of their major gods.[111] The primitive Cretan ritual involving the partaking of the sacrificed bull was transformed in the mysteries of Dionysus into a mystic union between god and man, as the bull became the god himself. In Orphism as well, the worshipper shared vicariously in the sufferings of Dionysus.[112] The Greek assumption of the fundamental unity behind the manifold phenomena of the world was reflected in the Orphic ideal of union with the Divine, an idea also shared by the initiates at Eleusis.[113] Farnell has no doubt that the inner core of Eleusis consisted of a mystical concept of kinship or oneness with the deities.[114] Orphic tenets had impressed Plato, in whose writings are to be found possibly the most delicate flowering of ideas connected with the nature of sacred and profane love.[115] Plato, who often expressed profound spiritual ideas through sexual images, presented love not as a mere intellectual idea, but more as an ideal blend of reason and desire. He saw a close relationship between erotic and religious impulses because for him love began in worship, but at the same time seeking a closer union with divinity.[116] Plato, who believed that love regained the soul's purity through the contemplation of beauty, uttered these remarkable lines in the *Phaedrus*: 'Such as one, as soon as he beholds the beauty of this world, is reminded of true Beauty, and his wings begin to grow; then is he fain to lift his wings and fly upward.'[117]

The eighteenth-century students of religion made consistent efforts to relate these mystical doctrines about sacred and profane love to androgynous divinities in ancient classical religion, and then searched for corresponding ideas in Hinduism. Their speculations were not unrelated to the facts of ancient Greco-Roman mythology. Not only were attempts made from the earliest times to relate bisexual deities to ideas of cosmic love, as certain ancient texts testify, but in Orphism at least the androgynous idea of a divine principle was deeply embedded from the very beginning. In Orphism, the androgynous god of love is one of the earliest recorded notions, and also one of the most profound. In Orphic theology, Phanes-Eros, who brought all things to light, was the primeval creator, *protogonos* or the first-born, and bisexual.[118] Plato's *Symposium* too speaks of a primeval androgynous god.[119] The antiquarians' concern with divine love and bisexuality can in part be explained by their great interest in Orphic texts. They were right to point out that divine androgyny was a feature common to a number of religions. What they did not stress enough was the fact that bisexuality may have carried other cosmogonic ideas as well. For instance, a case may be made that the bisexual image of the *liṅga* expressed what Eliade calls *coincidentia oppositorum*, rather than a *hieros gamos*. This would agree with a fundamentally dualistic view of the universe held by the Hindus.[120]

Notions of bisexuality indeed loom large in the writings of the eighteenth-century savants, who took the *liṅga* of the Śaivas to be a supreme example of divine bisexuality. Such a description of the Śiva *liṅga* as embodying an androgynous principle is to be found as early as 1724, in La Croze, who stated:

The Sovereign Being, containing all the principles of created beings from which all trace their origin of existence, embodies in himself the essence, the force, the reality of two sexes . . . One sees in this cult a profane mixture of the ceremonies belonging to the religion of Moses and the mysteries of Bacchus and Osiris.[121]

Clearly this account is fanciful, but it may yet be argued that the image of the *liṅga* combines 'the reality of the two sexes', since the dualism of the male Śiva and the female Śakti, the twin principles springing from the same source but in constant opposition, does play an important part in Śaivism. Moreover, the following interpretations of sacred bisexuality were in line with another ancient tradition, the belief in the existence of esoteric meanings hidden from the profane behind a bizarre exterior.[122]

The erotic bisexual figures in Herculaneum, mostly representing Hermaphrodites, were explained in allegorical terms by Maréchal. He made the further remark that these profound allegories and sublime hieroglyphs, which served to conceal the operations of nature from the vulgar, were eventually abused for reasons of social and political expe-

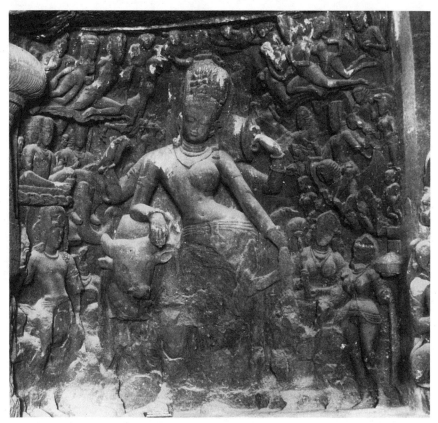

50. Śiva Ardhanārīśvara figure from Elephanta

diency.[123] While he was on the subject of Greek erotic cults, he did not neglect to mention that the Śiva *liṅga* offered the simultaneous sight of the union of two sexes.[124] Hancarville spoke of the particular Orphic hymn, in which Bacchus was qualified as male/female, and had the additional name 'queen of Priapus'; he also mentioned the feminine terracotta Bacchus belonging to Charles Townley.[125] On the Indian side, he found in the Judger Bede (Yajur Veda) of the Hindus the man/ woman epithet of Ruder (Rudra). According to the French savant, this androgynous Rudra was represented in Elephanta [50], and described by Niebuhr as an 'Amazon'.[126] Dupuis, the most forceful spokesman among the four of the view that nature revealed herself through monstrous symbols,[127] took to task the early Church Fathers for rejecting the allegorical interpretations of ancient classical phallic cults offered by the pagans themselves. It may be pointed out, however, that it was from the Fathers like Clement of Alexandria and Tertullian that Dupuis learned that at Eleusis the initiates invoked the sky and the earth, *la double force génératrice*, in an enactment of *hieros gamos*. Dupuis claimed that the consecration of the phallus and the *cteis*, at Eleusis and Samothrace,

was an expression of the same philosophical idea that was embodied in the *liṅga*, the idea of a marriage between the active and passive principles in nature.[128] In support of his view that Brahmans worshipped the active and passive 'Causes' of the universe, Dupuis cited the most celebrated ancient account of an Indian symbolic image. Basing himself on Bardesanes, Porphyry gave the remarkable description of a bisexual, Hindu creator deity, who held the sun on his male and the moon on his female side, who symbolized the whole universe and had the whole of nature portrayed around him.[129]

To Knight, however, fell the task of conducting a thorough investigation of the relations between sensual love and religion on the basis of artistic evidence. His firm belief in the symbolic nature of all ancient religions is evident from the very titles of his two major works, *A Discourse on the Worship of Priapus and its connexion with the Mystic Theology of the Ancients*, and an even more elaborate treatment of symbolism in *An Enquiry into the Symbolic Language of Ancient Art and Mythology*. Knight introduced *Worship of Priapus* with an apologetic for the existence of sexual imagery in ancient religious art:

Of all the profane rites of ancient polytheism this obscene rite was most attacked by Christians as contrary to the gravity and sanctity of religion, decency and good order in society, even the form seemed a mockery of all piety, fit to be placed in a brothel. But the forms and ceremonies of a religion are not always to be understood in their obvious sense; but are to be considered as symbolical representations of some hidden meaning, which may be extremely wise and just, though the symbols themselves, to those who know not their true signification may appear in the highest degree absurd and extravagant.[130]

As a concession to his Christian readers he added that superstition had taken over when the original meaning had been lost and that such was the case with phallic rites. Nothing could be more monstrous and indecent, if considered in its plain and obvious sense or as part of Christian worship, but if its original use was considered it was the natural symbol of a natural and philosophical system of religion.[131]

Knight's proposal in this connection, that one must turn to the corpus of Orphic texts in order to realize the true meaning of phallic rites in antiquity, rather than to Ovid, was not entirely unjustified. There exists indeed an intimate connection between love and metaphysics in Orphism.[132] One notices Knight's indebtedness to Orphic hymns in his description of Osiris and Bacchus as the 'first-begotten love', but, significantly, he also believed these gods to be phallic. Nor is there any doubt that he meant the Orphic god Phanes/Eros when he described the creator as combining in his person the active (male)/passive (female) principles, and possessing light as his prime attribute. Knight put forward the view that love was the mainspring of most ancient myths,

100

among which two images in particular made a deep impression on him: those of the classical Father of Night and of Osiris being embraced by the sun.[133] In all this, he did not forget to stress, there existed in ancient societies, side by side with superstitious religion based on fear for the vulgar, a form of secret and mystical religion which imparted divine truths by means of allegories and symbols. In Asia, and Egypt in particular, symbolical mode of worship seemed to him to have been of immemorial antiquity.[134] In a similar way, he argued, primitive Christians, during the Eucharist, worked themselves into fits of rapture and enthusiasm, love and benevolence.[135] The English antiquarian wrote that the Orphic epithet of 'Universal Generator' for the supreme deity was still in use among the Hindus, as in ancient Egypt the ithyphallic Osiris was part of a mystic cult.[136] Two kinds of bisexuality in Hinduism were distinguished by Knight.

First, the Śiva *liṅga*, an example of which existed close at hand in the miniature temple in the Charles Townley collection and previously mentioned by Hancarville [42]. The *liṅga* temple was the subject of the following comment:

The Hindus still represent the creative powers of the Deity by these ancient symbols, the male and female organs of generation . . . The first and greatest of these, the creative or generative attribute, seems to have been originally represented by the union of the male and female organs of generation which under the title of the lingam still occupies the central and most interior recesses of their temples or Pagodas.[137]

In 'Symbolical Language' he followed Hancarville in identifying the androgynous Ardhanārīśvara Śiva image in Elephanta [50] as the second example of bisexuality.[138]

According to Knight, the union of the two sexes in Hinduism was meant to express the creative powers of the deity. Elsewhere, in elaboration of this notion, he pointed out how the universal deity of the Hindus, being the cause of all motion, was equally the ultimate cause of all creation, preservation, and destruction.[139] This supreme deity of the Hindus, however, was neither Śiva nor Brahmā. In fact, for this description of the universal deity, Knight was able to draw upon a genuine Sanskrit text which had quite recently been made available in translation. Charles Wilkins's translation of the Vaiṣṇava text *Bhagavad-Gītā* was a momentous event in the history of Indology in the West, comparable in importance to Jones's translation of *Śakuntalā*. Wilkins's introduction to the *Gītā* lent support to Knight's view that there existed among the Hindus an exclusive and mystical religion, similar to that of ancient Greece: 'The Brahmans esteem this work to contain all the grand mysteries of their religion; and so careful are they to conceal it

101

from the knowledge of those of a different persuasion, and even the vulgar of their own'[140]

Two passages illustrate Knight's opinion about the mystical doctrine expounded in the *Gītā*. Quoting from Wilkins's translation on the nature of the supreme deity, who stated 'I am the Father and the mother of the world . . . among cattle I am the Kamdhook (*Kāma-dhenu*), I am the prolific Kandarp (*kandarpa*), the God of love . . .',[141] Knight, in a rare flight of poetic fancy, gives us his vision of the essential unity of Eastern and Western religious thought, a passionate outpouring of his own faith:

This is the doctrine inculcated, and very fully explained, in the Bagvat Geeta; a moral and metaphysical work lately translated . . . said to have been written upward of four thousand years ago. Kreshna or the Deity become incarnate in the shape of man, in order to instruct all mankind is introduced, revealing to his disciples the fundamental principles of the true faith, religion and wisdom; which are the exact counterpart of the system of emanations so beautifully described in the lines of Virgil before cited. We here find, though in a more mystic garb, the same one principle of life universally emanated and expanded and ever partially returning to be again absorbed in the infinite abyss of intellectual being.[142]

It is difficult to make a fair assessment of the four writers, since many of the problems they dealt with were purely topical in interest, not least their attacks on the established Church, although in their own period these authors, and Knight and Dupuis in particular, enjoyed considerable reputation in learned circles. Their 'pansexualism' has received the criticism of scholars as much as the uncritical use of literary and archaeological evidence.[143] Admittedly, the grandiose all-embracing systems of Dupuis and others seem somewhat fanciful to us. But this is not because they stressed the kernel of sexuality and fertility in ancient religion. It is only that we have come to suspect the view that one set of principles can explain the whole universe. In any event, whatever judgement we may form of their particular contribution to the study of ancient myths,[144] there is little doubt that they made several very valuable contributions to the reception of Indian art in the West.

First of all, it must be stressed, their interest in ancient art was iconographic rather than aesthetic. In this they belonged to the growing number of gentleman-humanists who were active all over Europe in the eighteenth century and were responsible for a new appreciation of ancient civilizations.[145] When we remember this it becomes easier for us to understand why *philosophes* like Dupuis were so preoccupied with symbolic art, including that of India. Recommending a more thorough investigation of the iconographic features of Indian art, Hancarville wrote:

The great resemblance that one can observe, between the figures and attributes of Bacchus and the figures carved by Indians at Elephanta, encourages the belief that one must explore the most ancient monuments of these people in order to discover the forms in which they had represented their ancient theological notions.[146]

He was convinced that it was through comparisons of the monumental remains that one was able to trace the development of motifs common to Greece and the East, subsequently lost during the rise of Christianity in the West, but still preserved in the East.[147] Similar encouragement to scholars to study Indian monuments was given by Knight, who held that symbolic multi-limbed gods existed not only in India but in ancient Greece as well:

This mode of representing the allegorical personages of religion with many heads and limbs to express their various attributes, and extensive operation, is universal in the East . . . and seems anciently not to have been unknown to the Greeks at least if we may judge by the epithets used by Pindar and other early poets.[148]

This particular interpretation of multi-armed gods amounted to a direct challenge to the prevailing prejudice against the images of Indian gods as being irrational. Like Hancarville before him Knight also favoured a comparative approach to the study of emblems in the art of different nations. Since all ancient nations had been closely related, the art of one could be profitably employed to explain another.[149] Despite the obvious shortcomings of this method, it at least encouraged scholars to take Indian art seriously, especially its iconography. It was Dupuis who, with even greater conviction, attacked the view that the symbolic Indian figures were monstrous. These figures, which had no corresponding types in nature, were more like a grammatical phrase made up of several different words. One could even, in effect, regard them as entire phrases in a hieroglyphic manner. They were not monstrosities except in the eyes of those who did not know how to interpret this ancient writing. Dupuis further stated that

All the temples of India, China and the isles of Asia are full of these monstrous figures, which I describe as phrases in hieroglyphic writing. The manuscript dealing with the metamorphoses of Viṣṇu, at the Bibliothèque Nationale, contains many examples of such allegoric figures that are meant to represent under the names of divinities, nature, its principal agents or personifications of natural causes.[150]

Dupuis and his contemporaries may thus be said to mark the beginnings of progressive European concern with the meaning and symbolism of Indian art, a subject dismissed in previous periods as being too bizarre to be worthy of scholarly inquiry. No less important for us is the fact

that one can trace direct links between them and later writers on symbolism, notably Creuzer and Hegel, who of course had a greater success in their interpretations of the symbolic content of Indian art.[151]

Finally, the other important contribution of these authors to the reception of Indian art in the West was to insist that the frank sexual imagery used by Indian sculptors and painters must be accepted as reflecting essentially different religious values, something which Christian Europe had hitherto been most reluctant to do. The late eighteenth-century students of religion had also sought to narrow the gulf in the Western mind that separated the classical from other societies, by setting Greco-Roman societies against a more realistic anthropological background, through their investigations of sexual motivation in sacred art. A liberal attitude in sexual matters, which all four authors reveal in their writings, was not an isolated phenomenon but in fact reflects the general intellectual climate, especially in France. In the late eighteenth century, anti-clericalism and free-thinking, encouraged by the Enlightenment, helped loosen the traditional hold of the Church, Protestant and Catholic alike. The whole process was further accelerated during the French Revolution. As Manuel has shown, two leading spokesmen of the age, Winckelmann and Diderot, had significantly stressed the connection between sensual love and religion, and had moreover adopted this insight as a key to the appreciation of ancient art. Diderot's glorification of the naked human form was typical of the period which had proclaimed freedom from social and political restraints.[152] It is this kind of atmosphere that bred avowed atheists like Maréchal, who were committed to the task of presenting paganism as a 'natural, noble, ancient religion at once dignified and appealing to the senses'.[153] Maréchal defended the inclusion of erotic subjects in *Antiquités d'Herculanum* by asserting that not only were the ancient Greeks very fond of representing the nude, but in Greece religious and social restraints never stood in the path of men of genius or of artistic progress.[154] Dupuis, another extreme anti-clerical, branded Christianity as a religion of terror, in contrast to simple, beautiful pagan religions.[155] In the same way, Knight could show preference for Hinduism, as being humane, liberal, and love-based, like all ancient religions.[156] The brief period of freedom and radicalism soon came to an end with the reimposition of puritanical values in the nineteenth century. Yet, what had been achieved was not negligible. The atmosphere which had allowed intellectuals to discuss sexual matters with openness, had also made it possible for them to achieve some measure of sympathy for Hindu erotic art, something which contrasts so favourably with the subsequent reassertion of Christian prejudice, especially in the Victorian period.

Orientalists, Picturesque Travellers, and Archaeologists

THE mythological speculations of Payne Knight, Dupuis, and others had led to a new appreciation of Indian art. While there is little doubt that their attitudes represented a radical departure from previous interpretations of Indian art, it must be emphasized at once that the new attitude was only possible because of the amount of reliable information available in the West in this period. For the sudden and in some ways dramatic improvement in the documentation concerning Indian art we must look to certain major changes in aesthetic outlook which were taking place in Europe. Among other things, two stand out in importance. First, the later part of the eighteenth century witnessed the emergence of several aesthetic movements which contributed to a new romantic awareness of the past and indirectly contributed to artistic revivals, notably the Greek and the Gothic. One of the lasting achievements of these revival movements was the inception and subsequent nurturing of scientific archaeology, and archaeology soon became the indispensable tool for the study of the past. The second important development was the phenomenon 'grand tour', which encouraged travels purely for the sake of visual and aesthetic pleasures. The area of travel was eventually extended to places outside Europe and as far afield as India and China. Another profound change was the intellectual revolution which came late in the eighteenth century with the European discovery of Sanskrit and other major Asian languages, not properly understood until then. These developments were of great significance for the reception of Indian art in that they marked the beginnings of a systematic approach to the collecting and recording of facts relating to Indian art and architecture and their dissemination mainly through widely read learned journals. It was this corpus of published material which provided antiquarians, philosophers, and other intellectuals with the valuable evidence for their interpretations of Indian art. Because of the peculiar importance of this type of evidence, it is

necessary to keep it separate from the more interpretative works of this period. The need to do this did not arise with regard to the travel reports of earlier periods simply because their authors were not able to maintain a clear distinction between objective reporting and subjective comments. It is only from the middle of the eighteenth century onwards that one can clearly discern the growth of two distinct traditions: one which undertook to record systematically all the relevant facts about Indian art, while the other engaged primarily in speculations about its nature and importance. A few words may be said concerning the sources to be dealt with here. First of all, four travellers are presented here because of their very special position in the eyes of their contemporaries on matters relating to Indian art and religion. Then comes the group of romantic travellers and professional artists whose ability to capture Indian architectural scenes with a certain charm and delicacy was largely responsible for starting a new romantic interest in Indian architecture, especially since it was presented for the first time in a manner that visually appealed to Europeans. Archaeologists, who follow, were able to apply the principles of the new science to Indian antiquities, principles which had already brought startling results in the field of Western archaeology. High among the fruits of British archaeological researches in India ranks the nineteenth-century discovery of the Ajanta caves, which brought to light the finest paintings from ancient India. Significantly, all three types of source deal predominantly with architecture and no doubt reflect prevailing tastes and interests. The final section seeks to indicate in general terms the extent to which information about Indian art was beginning to be diffused in European literature. This includes the works of authors whose main interests were Indian history and society as well as incidental notices in books not primarily devoted to India. The section is concluded with a brief outline of an event of great importance, although not sufficiently recognized at the time. This was the appearance in translation of parts of *Mānasāra* and several other Sanskrit aesthetic texts, the posthumous work of an Indian schoolteacher called Rám Ráz.

i. ANQUETIL-DUPERRON, NIEBUHR, LE GENTIL, AND SONNERAT

Incidental notices of Indian art continued to grow in number all through the eighteenth century along with descriptions of Hindu manners and customs. Yet, neither did the *lettres édifiantes* of the Jesuits add substantially to the excellent accounts of Rogerius, Fenicio-Baldaeus or Ziegenbalg, nor did the reports of travellers like Alexander Hamilton show any improvement on the works of their predecessors.[1] Despite the increase in knowledge there were no sustained efforts to present Hinduism in a systematic fashion. There was instead a proliferation of travel

106

accounts, containing much useful information, but treated in a haphazard manner, which did little to clarify the prevailing confused picture of Indian art. The situation did not see much change until the arrival of Anquetil-Duperron in India in the year 1754. During his lifetime Abraham-Hyacinthe Anquetil-Duperron was a controversial figure whose reputation received a severe blow from young William Jones's attack on his scholarly integrity.[2] Today, however, his place among the founders of Orientalism is assured. The arrival of Sanskrit texts and the diffusion of the knowledge of Indian literature in Europe have been described as the second Renaissance, 'la renaissance orientale'; the sense of discovery and the excitement were in many ways parallel to the first one. If one were to search for two key figures in *la renaissance orientale*, they would undoubtedly be Anquetil-Duperron and Sir William Jones. By the eighteenth century Sanskrit and ancient Persian texts had arrived in Europe but there was no one to decipher their scripts. It was Anquetil's determination to learn these Asian languages that took him to India with the blessings of the Académie des Inscriptions et Belles-Lettres. What he achieved was remarkable. The year 1771, which saw the appearance in translation of *Zend-Avesta*, also represents the initial date of the intellectual revolution; not only did the translation lay the foundation of comparative philology but it was also the first text not to take the Scriptures as its point of departure. Less sensational but equally important was Anquetil's subsequent translation of the *Upaniṣads*.[3] In the long introduction to the *Zend-Avesta* Anquetil gave an account of his extensive travels in India in search of inscriptions and also teachers to instruct him in ancient Asian languages. In it there are a number of passages devoted to art and architecture. From Arthur Waley we learn of his intention to make 'a complete iconographic survey of the rock-carvings'[4] at Ellora, but he was somewhat less than successful in this for he was not well served by his Brahman interpreters. Anquetil-Duperron's foremost interest was Sanskrit literature. It is therefore not surprising that Ellora 'interested him simply as a repository of Hindu mythology'.[5] Of all the Indian monuments he visited, Ellora received the greatest attention. He stated, 'as the Pagodas of Ellura had not been described except only summarily by Thévenot I intended to see everything in detail and to measure the dimensions.'[6] Very extensive and at the same time detailed measurements of all the caves and other architectural pieces, notably the Kailāsa temple [20], were taken by him and all the iconographical details painstakingly taken down. While his description took note of the presence of works belonging to Śaiva, Vaiṣṇava, and Jain religions, the account often showed confusion and betrayed a lack of familiarity with Indian mythology. A number of temples at Ellora were identified as the various tombs of the god Viṣṇu,

a story he had picked up from his interpreters.[7] The same Brahmans had assured him that the cave temples of Yogeswari, Mandapeswar, and Kānheri near Bombay were the work of Alexander.[8] Writing on Ellora Anquetil noted that the deities who appeared there were also to be seen in the Indian paintings deposited in the Royal Library in Paris.[9] He made a useful contribution to knowledge by identifying a Jain temple and the image of Pārśvanātha at Ellora.[10] Also interesting is his description of the image of 'Mendé', with the head of a kid; the description had later provided Dupuis with the evidence for the universal worship of the goat.[11] Very little was said by him about the style of art at Ellora except for one interesting remark. Significantly, Anquetil compared the style of the relief sculptures in Ellora with the medieval reliefs in the Notre Dame in Paris.[12] It was in about this period that people were again becoming conscious of medieval art, and they often made comparisons between Indian and medieval European art which appeared to them to have certain similarities. In this they were not far wrong for, indeed, the two traditions do have certain superficial similarities, especially if they are set against the classical tradition. Before ending his description of these caves the French savant urged the English to make a complete survey of them.[13]

The time at his disposal did not permit more than a cursory glance at Elephanta and Kānheri. Although he failed to identify the Ardhanārīśvara image at Elephanta, he did draw up accurate ground-plans for them.[14] At Kānheri he was thrilled to carry away a piece of sculpture from the celebrated Indian temple with the connivance of his guide. On his return he was to present this piece to le Comte de Caylus.[15] The ground-plans of Yogeswari, Mandapeswar, Elephanta, and Kānheri and the drawings of columns and *stupas* reproduced in the *Zend* [51] are reasonably accurate and do not compare unfavourably with present-day drawings.[16] Among other temples visited were the famous ones of Jagannātha at Puri in Orissa and Chidambaram in south India.[17] There was a tendency in Anquetil to see the *linga* represented everywhere. Accordingly, he identified several *stupas* in cave temples at Kānheri as the *linga* image.[18] The description of the tower of the temple of Maddol near Goa as being in the form of a *linga* was promptly accepted by the antiquarian Maréchal as proving the universality of the phallic cult.[19]

The second traveller to acquire a great reputation in contemporary learned circles was Carsten Niebuhr, a natural historian and scientist and the only survivor of a royal Danish scientific expedition to the East.[20] Apart from owning the Indian colony at Tranquebar, the Danes had shown an active interest in the East in the eighteenth century. Not only was the king of Denmark the only known ruler in Europe to possess several fine art objects from India in his collection, but he had actually

51. Ground-plans and other details of cave temples in *Zend-Avesta*

commissioned Sir William Jones to translate a Persian text. From Tranquebar was sent the important collection of south Indian bronzes to Copenhagen, which can still be seen in the Ethnographic Museum in that city.[21] Although Niebuhr was chiefly concerned with collecting specimens for the study of natural history, which were later to be published with great success, like other savants of the period he took a great interest in Indian religion and mythology. Also like the rest of Europeans of this time he faced the problem of not knowing Sanskrit, but owing to the lack of time all he could do was to reproduce several Indian scripts in the second volume of his travels (1778).[22] His reason for making three trips to Elephanta in order to draw and make note of all the different parts of the temple was that these would provide antiquarians with valuable information about ancient India.[23] As he must have been aware of the great upsurge of interest in antiquities in this period he was not to be disappointed in this expectation. His account and sketches of Elephanta were eagerly received by antiquarians like Hancarville. Niebuhr possibly knew of Anquetil's visit to Ellora. That is perhaps why he decided to concentrate on Elephanta. Of the two travellers, Anquetil, was more concerned with literary description of Hindu sculpture and architecture, while Niebuhr preferred to present

52. Sectional drawing of a column in Elephanta from Niebuhr's Travels

visual images of them. The outcome of Niebuhr's time spent in Elephanta was a remarkably accurate ground-plan, the measured sectional drawing of a column [52], and a series of important drawings of the main panels in the great Śiva temple.[24] These sketches became widely known in the late eighteenth century and provided the basis for many scholarly speculations. Although the drawings fail to convey the aesthetic quality of the figures at Elephanta, they, none the less, with their accurate details made a strong impression on scholars of the period. They certainly mark an advance on previous illustrations of Indian sculptures. The Ardhanārīśvara Śiva sketch impressed Knight and Hancarville, and the Andhakāsura figure [53, 54] became crucial evidence for the latter's identification of Bacchus and Śiva.[25] When it came to the question of iconography, the ignorance of Indian mythology presented him with serious problems, the kind of problems that Anquetil had faced before him. In fairness it should be emphasized, however, that he was always ready to admit his limited knowledge of Hinduism. In general, he preferred to give a euhemeristic explanation of Hindu gods, that is, that they were deifications of ancient heroes.[26] The elephant-headed Gaṇeśa was the easiest one to identify, whose mythological origins he gathered from the Indian ferrymen who took him to the island.[27] Being of Christian background he naturally took the great Maheśamūrti [55, 84] to represent a trinity of three major gods, Brahmā,

110

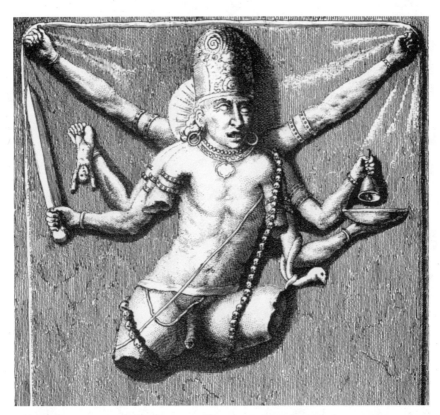

53. Niebuhr's sketch of the Andhakāsura Śiva figure at Elephanta

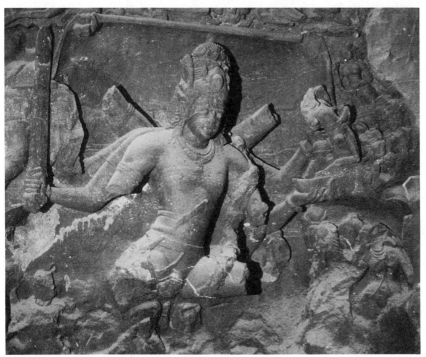

54. Andhakāsuravadha Śiva figure at Elephanta

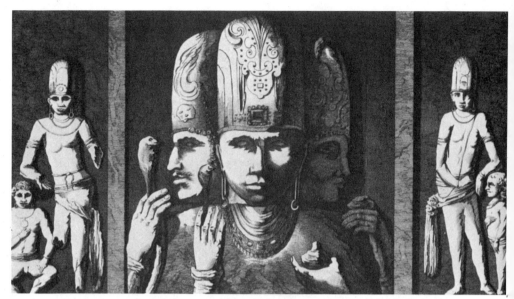

55. Niebuhr's sketch of Śiva Maheśamūrti at Elephanta

Viṣṇu, and Śiva. Of course, this tradition continued down to the time of Hegel.[28] The previous European interpretation of the Andhakāsura figure as representing the judgement of Solomon was rejected in favour of his Indian guides' equally fanciful view that it portrayed Kaṃsa of the Kṛṣṇa legend.[29] In describing Śiva Ardhanārī as an Amazon, Niebuhr was not adding anything new, for the tradition went back to the sixteenth century.[30] About the aesthetic quality of these sculptures Niebuhr had mixed feelings and sometimes it is not even clear what he meant. In one instance he referred to the 'belles figures' of Elephanta. In another, the main temple was praised as superb and magnificent.[31] In a further passage he sought to place Elephanta sculptures within an acceptable scale of values: 'In truth, they are not as beautiful as the bas-reliefs and statues of the Greek and Roman masters, but far superior to the design and arrangement of Egyptian figures, and besides, very beautiful in relation to their great antiquity.'[32] On the other hand, a somewhat contradictory view emerges in the following excerpt:

These monuments may not, truly speaking, be so good to look at as the great pyramids of Egypt, but they required no less labour and moreover a lot of skill . . . to excavate these rocks, to fashion such quantity of sculptures and above all to create such effect, far greater knowledge of design and sculpture was necessary than ever was possessed by Egyptians.[33]

Like Anquetil before him, the Danish naturalist urged the English to make a greater effort to study these remains of antiquity.[34]

112

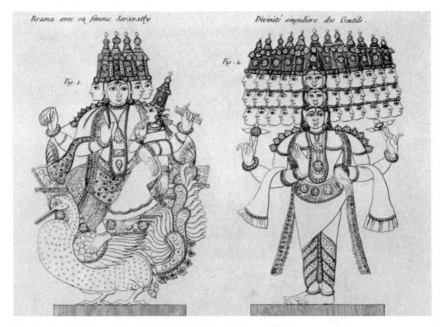

56. Le Gentil's illustration of Brahmā (left) and Viṣṇu (right)

The opportunity presented for observing the passage of the planet Venus brought the brilliant young member of the French academy of sciences, Le Gentil de la Galasière, to India in 1760, where he spent eight years recording his observations of natural phenomena.[35] The fruits of his researches were published in 1779, about ten years after his return, and were well received by savants, including Voltaire. Apart from the natural sciences, he treated Hindu zodiac and astronomical systems, religious manners on the Coromandel coast, and the architecture of the area. He was the first European to present a consistent picture of Hindu astronomy and one of the first to realize that Buddha was worshipped all over the Far East and South East Asia. His work mentioned the caves near Aurangabad, an early reference to this Buddhist site.[36] The picture of a remarkable allegorical Hindu deity with thirty-six heads presented by his interpreter, Maleappa, was reproduced in his work alongside another Hindu deity [56].[37] Dupuis used it to illustrate the symbolic gods of India. Various interesting features of south Indian temples were carefully investigated and types of building material noted. Le Gentil was particularly impressed by the manner in which huge blocks of granite were transported by the simplest means. He agreed that the arts had made no progress in India but that was no reason to dismiss them. Admittedly, Indians did not come up to the level of proficiency reached by Europeans but there was still much to admire in their art. He pleaded with his contemporaries to transfer to

113

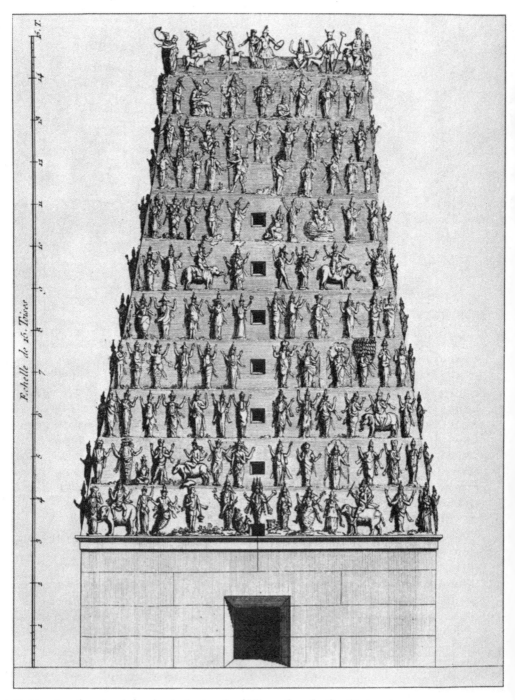

57. Drawing of a *gopura* belonging to the temple of Vilnour from Le Gentil's travels

Indian art at least part of the admiration generally lavished on Egyptian works.[38] In the final analysis what stands out in Le Gentil's account of Indian temples is his project for making exact measured drawings [57] of the *gopuras* belonging to the temples of Vilnour and Chincacol near Pondichery. This, as a scientist, he was well suited to do. The task would have presented some difficulties in ordinary circumstances, especially if the temple were still in use. Therefore, when the temple of Vilnour was temporarily abandoned by the resident priests at the time of Haidar Ali's invasion of the area, Le Gentil lost no time in putting his plan into operation. The freedom from interference was particularly useful to him because he now had access to the very top storey of the tower. With the help of several assistants he proceeded to take detailed measurements, including the elevation, of the different parts of the *gopuras* or gate-towers. Le Gentil, the first scholar to establish that Indians used the gnomon to orientate temples accurately, determined by measuring the Vilnour temple that its four sides faced the four cardinal directions with mathematical precision.[39] Part of the reason for the sudden upsurge of interest in the pyramidal *gopuras* in this period lay in the fact that the late eighteenth-century antiquarians were able to see a historical connection between them and the Egyptian pyramids. From his survey Le Gentil came to the following aesthetic conclusion:

The four faces [of the *gopuras*] were overloaded with ornament; these were not architectural ornaments, but figures carved in three-quarters relief, as in the portals of our Gothic churches . . . these works reveal the Indian ignorance of design . . . The figures which surround these pyramids are exactly similar in taste to those which are preserved in our Gothic churches, and the kind of mausoleum and stone sculptures seen here belong to the times which we call barbaric and Gothic.[40]

Note the significant comparison between Indian and Gothic styles made twice in this period by two savants, here and once before by Anquetil. The emerging Romantic interest in non-classical traditions helped travellers to look at Indian sculpture and architecture in a new light.

Pierre Sonnerat, celebrated traveller, natural historian, and savant, published in 1782 one of the most profusely illustrated and detailed accounts of Hindu religion and mythology that continued the tradition of Rogerius, Fenicio-Baldaeus, and Ziegenbalg. An early admirer of ancient Indian civilization as being the cradle of humanity and a fervent believer in the diffusionistic origins of religion, Sonnerat wielded great authority over his generation and was himself directly influenced by the speculations of antiquarians like Dupuis and Knight. Among the large number of illustrations in *Voyages aux Indes Orientales*, mention must be made of the important series of pictures relating to the iconography

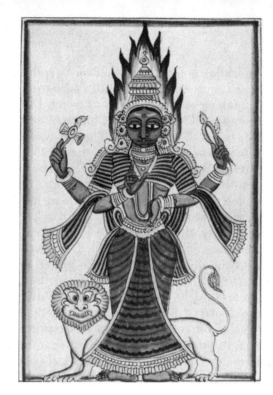

58. Siṁha-kālī figure drawn by Sami. The source of Sonnerat's pictures of Hindu deities

of Hindu gods and illustrating his text [58, 59], and an aerial view of a temple precinct on the Coromandel coast [60] with its four prominent tower-gateways or *gopuras*.[41] Sonnerat's opinion of Indian art was coloured by his particular view of Indian society: the contrast between the high civilization of 'a nation celebrated in antiquity' and the degenerate state of contemporary Indians. But in this India was the victim of her own historical situation. It was inevitable, concluded Sonnerat, that such an opulent country would become the bloody theatre of war.[42] Further on he stated that in 'India as well as among all the people of the East, the arts have made little or no progress', and for this despotic governments, the enervating climate, and innate conservatism were responsible. Was he here thinking of Winckelmann? The German art historian's reputation had already been established by this time.[43] First, the question of painting was taken up by Sonnerat. The absence in Indian painting of the technical advances made by Western art was criticized:

Painting is, and ever will be, in its infancy with the Indians. A picture where red and blue are predominant, with figures dressed in gold, is to them admirable. They do not understand the chiaro obscuro, the objects in their pictures have no relief, and they are ignorant of perspective . . . In a word, their best artists are no more than bad colourists. In their painted linens we only admire the brightness of the colours. . .[44]

116

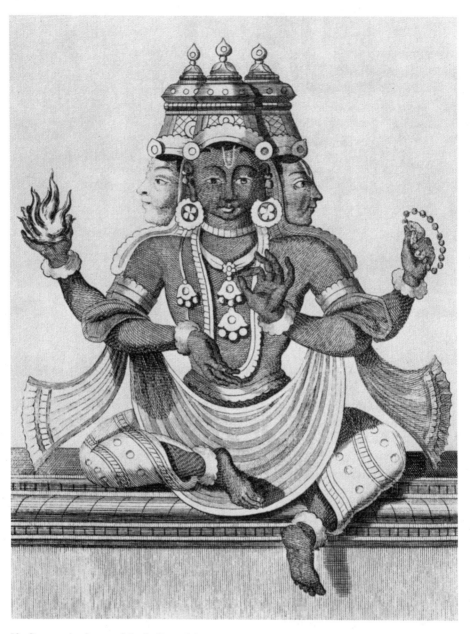

59. Sonnerat's picture of the Indian trinity

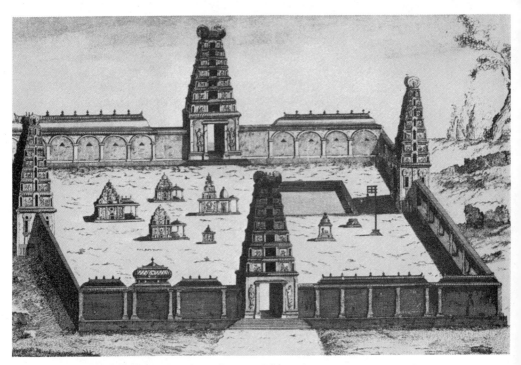

60. Sonnerat's picture of temple on Coromandel coast

Equally, the treatment of form in sculpture was deplored: Indian statues were 'badly designed and worse executed'. Arms and legs 'appear broke, heads that do not belong to the body, draperies stiff and slovenly'.[45] All these weaknesses stemmed from not attempting to imitate nature. Similarly, Indian architecture was

subject to no rules. The only monuments capable of giving an idea of their talents in this science are the great towers over the gates of their temples, and their stories are seen sometimes very high, and sometimes very low. The numerous columns which decorate the inside of their pagodas have no fixed proportion; some are very thick at the bottom and terminate like a cone, insensibly diminishing; others are very slender at the bottom and very large at the top. However, in my opinion, these temples have something more noble and majestic than those of the Chinese, or even of any other people on the face of the earth. Those enormous machines which crown the gates, the decorations within, and the thousand columns which surround the pagodas, inspire veneration, and announce an abode of the deity.[46]

Strong words indeed from a man who had great admiration for India. But as a 'progressivist' of the times,[47] he was convinced of the stagnant nature of contemporary Asian societies which had such a baneful effect on their art. The disintegration of the splendid Mughal empire was for Sonnerat the evidence for the decadent nature of Oriental despotism.

118

And also it was Winckelmann who had argued in favour of an inevitable and continuous progress of Western art as opposed to its absence in the Oriental countries.

Since the sixteenth century the immense size of the cave temples on the one hand, and the intricate details executed by Indian sculptors on their rock-surface on the other, had given rise to many speculations and aroused much wonder. It was felt that such demonstrations of strength were possible only by a world conqueror like Alexander with his unlimited resources and manpower. The feeling was also that monuments of such power and complexity must have taken many years to complete. But until the middle of the eighteenth century Westerners had not drawn the necessary conclusion that they were of great antiquity, antedating even the earliest pyramids of Egypt. In the eighteenth century certain developments brought to the fore the question of the age of these Indian monuments. The growing aesthetic interest in the colossal and the gigantic,[48] the essential ingredients in Burke's conception of the sublime, drew fresh attention to the cave temples of India, to the amount of patience required to build them, and inevitably to their antiquity. Another development which drew the attention of scholars to these monuments was the debate on the origin of societies. From the end of the seventeenth century a fierce controversy had been raging among intellectuals in which the opponents of Christianity engaged in discovering an ancient nation which preceded the Hebrew, in order to demonstrate that the Old Testament version of history was a corruption of more ancient and sublime notions. Originally the ancient Egyptians were given the place of honour but interest gradually shifted to other nations, including China. India's entry into the controversy was late in the eighteenth century, although earlier champions of India are not hard to find.[49] The four authors under review, especially Anquetil-Duperron and Sonnerat who had endorsed this controversy, agreed to come to the side of India. The question of the age of Elephanta and other Indian temples was settled in their minds not so much by historical evidence as by philosophical arguments. While these authors themselves were influenced by the debate on origins, they in their turn reinforced the arguments about India's antiquity by providing fresh evidence from their personal experience. Anquetil-Duperron remarked that these cave temples were the strongholds of some very ancient nation, that they involved a certain boldness of conception, the labour of many hands and many years, and were ranked among the wonders of the world.[50] The scientist Niebuhr was not much given to speculation. Yet India and especially the architecture on the isle of Elephanta had interested him essentially as the valuable remains of antiquity since Babylon and Nineveh no longer existed.[51] As it may be recalled, his illustration of

119

the Andhakāsura Śiva was accepted by Hancarville as a key evidence from the ancient period.[52] Part of the reason why Le Gentil took such a great interest in the *gopuras* was because he considered them to be some of the earliest pyramids in the world to be built. Like Voltaire he admired the ancient wisdom of the Indians and regarded them as the original nation, the cradle of humanity. The Egyptians, who had generally imitated the Indians, had naturally received their idea of the pyramids from them. The lack of a sense of design in Indian architecture, admitted by Le Gentil, was excused by him on the grounds that it belonged to the earliest period of human history.[53] It was, however, Sonnerat who had the greatest success in his efforts to sustain the image of India's great antiquity. He confessed that the origin of the Indians was lost in 'the obscurity of time'. Even in antiquity they were regarded as the primitive inhabitants of this earth. The sacred writings and fables of India demonstrated the greatness of Indian learning and went as far back as 4,800 years. India in her splendour had given religion, laws, and philosophy to other nations including the Greeks and Egyptians. But above all, it was the architecture of Salsette, Ellora, and Trevicaru which gave proof of India's great antiquity.[54] The view that India was even older than Egypt was sustained with further art-historical arguments:

The pyramids of Egypt, so much spoken of, are very feeble monuments, in comparison with the pagodas of Salcette and Illoura; the figures, the bas reliefs, the thousands of columns with which they are adorned, cut by a chisel in the same rock, indicate at least a thousand years of continual labour, and the depredations of time design, at least three thousand years existence. After this we shall not be surprised, that Indian ignorance attributes the first of these works to the gods, and the second to the genii.[55]

Of the examples of the oldest temples in India, the temple of the Seven Pagodas (Māmallapuram) was deemed by Sonnerat as one of the most ancient on account of its appearance, while he accepted the local literary tradition that the temple of Jagannātha in Orissa was unquestionably the oldest. From ancient texts Sonnerat had gathered that it was 4,883 years old.[56]

ii. THE SUBLIME, THE PICTURESQUE, AND INDIAN
 ARCHITECTURE

As travelling became increasingly simple for Europeans with the establishment of British power in India in the second part of the eighteenth century, there arrived on the scene an entirely new genre of travellers who were very different from their predecessors in tastes and interests. It was of course Indian antiquities which drew them to India, but in this they did not share Niebuhr's or Anquetil's enthusiasm for antiquarian scholarship. They came in search of 'sublime' and 'pictur-

esque' elements in Indian architecture and chose to visit and describe ancient monuments mainly for their visual and aesthetic qualities. The overwhelming majority of these travellers were British and contained some very competent artists among them, two of whom, the Daniells, were of outstanding merit. The finest products of the last two not only helped to change the prevailing conceptions about Indian architecture but were able to create a lasting image which distilled the very essence of romantic India. Clearly, the response of this generation to Indian architecture was in a large measure aesthetic and represented an important shift in European taste. One may well ask: what had brought about the change? To answer this question we must look at the emerging aesthetic movements in the eighteenth century—movements which had the twofold function of shaping romantic sensibilities on the one hand and of reducing the formalism and the rule of taste dominating classical art. The eighteenth century was a period of revivals and rediscoveries. The discovery, not only of ancient monuments in Greece but of those of the European Middle Ages as well, was bound to have serious consequences for art appreciation and aesthetic standards. Inevitably there was a substantial widening of aesthetic categories to keep pace with the new awareness of non-classical traditions. One of the consequences was that the academic and traditional concept of decisive rules in art was gradually replaced by the notion of the primacy of taste. Secondly, art critics of the period were willing to recognize qualities other than beauty as constituting important aesthetic criteria.[57] Beauty here did not mean something in the realm of abstraction and having a universal validity. When an eighteenth-century aesthetician spoke of beauty his contemporaries understood him perfectly—what was generally regarded as beautiful in art had been determined long ago in accordance with the classical canon. The apologists of this period were merely pleading that the framework of taste be so broadened as to accommodate criteria other than beauty. The first alternative to the category of beauty to emerge was the concept of the sublime. The notion was not entirely an eighteenth-century invention, for the late antique author Longinus had argued that the sublime in art evoked not a mere sensation of pleasure in the beholder but had the effect of carrying him away. When this idea was revived in the eighteenth century, it became linked with the growing interest in nature, as the word 'sublime' was applied to nature, even in its most fearsome aspects. The Earl of Shaftesbury was the first major writer of this century to raise sublime to the level where it was second only to beauty. Developing this new aesthetic category he further suggested that the feeling for sublime was aroused by the size of the subject. It had to be so large that the human mind failed to comprehend it. After him, two further qualities to the theory were added by Joseph Addison,

greatness and uncommon aspect. But the most definitive statement was made by Edmund Burke in 1757 when he placed sublime on the same level as beauty and made them the twin principal categories in art criticism. Not only was the sublime capable of arousing the strongest of emotions, but it had become a viable alternative to beauty in matters of taste. As to what were the essential ingredients of the sublime Burke had his answer: obscurity of the subject arousing fear induced by ignorance. The subject had also to express a certain power, greatness, and a dimension of infinite magnitude. The atmosphere of darkness, solitude, and silence enveloping the subject increased that feeling of terror.[58] It is easy to see why Burke's essay struck such a sympathetic chord in the minds of contemporaries. Already in the eighteenth century the Romantic concern with an essentially emotional response to a work of art was beginning to have an influence on art criticism. Moreover, sublime as an aesthetic notion provided the theoretical justification for the widespread cult of the colossal and the gigantic in architecture, as exemplified in Piranesi's work.[59]

The second influential aesthetic movement to emerge in the latter half of the eighteenth century was that of the 'picturesque', which may be properly described as belonging to the period of transition from classical formalism to 'romantic disorder'.[60] The movement had a more direct effect on practising artists than had the concept of the sublime and has been aptly described by Christopher Hussey as the nineteenth century's 'mode of vision'.[61] Although Sir William Temple, the Earl of Shaftesbury, and Addison can be regarded as its precursors, the movement gathered momentum only in the time of Richard Payne Knight, who had given evidence of an original and lively mind in other fields as well. The final shape to the theory of the picturesque was however given by Uvedale Price, a contemporary of Knight's. It was Price who took Burke's ideas further by suggesting 'picturesque' as the third category to accommodate subjects to which neither the term 'sublime' nor 'beautiful' could be properly applied. The picturesque too was an attack on classical notions of beauty as it advocated 'disorder' and 'irregularity' in landscape in both art and nature and suggested that even artificial rudeness was be preferred to order and neatness.[62]

To sum up the importance of the sublime and picturesque movements: by challenging the primacy of a notion of beauty developed in the period of the Renaissance, they narrowed down its definition and brought it into a sharper focus. Henceforth, not only was there to be an awareness of different non-classical traditions such as the Gothic, but certain specific features of classical taste and its difference from the non-classical were to be clearly recognized. It is not at all surprising that in the late eighteenth century both Anquetil-Duperron and Le

Gentil remarked on the similarity of Gothic and Indian art. This was the period when serious interest in medieval European art was beginning to be taken and the first thing to be noticed was its dissimilarity to classical art. The cave temples of Elephanta and Kānheri were admired by humanists like Castro as early as the sixteenth century as objects of wonder, but at the same time it was tacitly agreed that these monuments could not be regarded as beautiful in the classical sense.[63] The main points of admiration were their exquisite details or the grand total conception. It was only the change in taste in the eighteenth century, when men were taught to look for qualities other than beauty in works of art, that led them to take a fresh look at the visual beauties of Elephanta and other cave temples. If one were to recall the main features of sublime architecture in Burke's view—the infinitely enormous size of the subject with the surrounding darkness, silence, and solitude—it is easy to see how easily they fit the descriptions of the cave temples left from the time of the very first European visits to these sites. In addition the growing eighteenth-century mythology about their great age, which could not even be measured in terms of known history, made them the ideal subjects for the devotees of the sublime. The uncertainty surrounding the age of a particular monument gave it an additional qualification to be considered as a piece of sublime architecture. The aesthetics of the sublime encouraged people to approach works of art emotionally and in a romantic vein, without necessarily subjecting them to rational analysis. This stress on an emotional response, closely associated with the age of Romanticism, was to have an important effect on reactions to Indian architecture. Although it was a minor phase in the history of taste, the picturesque movement none the less encouraged travel solely for pleasure, a phenomenon which had started some fifty years before and came to be known as the Grand Tour. While searching for the existence of ideal scenes in nature, the picturesque traveller learned to isolate the visual properties of subjects from their other features and to enjoy them. But it was chiefly the rejection of classical formalism in favour of an irregular style that lent a peculiarly sharp edge to the picturesque traveller's appreciation of Indian architecture. As Hussey has shown, both Indian and Gothic architecture found equal favour in this period and it was largely accidental that Gothic was eventually accepted as the English national style.[64]

The first professional artist of some repute to arrive in India was William Hodges, famous as the draughtsman to accompany Captain Cook on one of his South Sea voyages. The publication of Indian sketches brought Hodges the coveted membership of the Royal Academy. Among his distinguished admirers were Reynolds and the great Humboldt.[65] He was a pioneer artist to work in aquatint, a medium

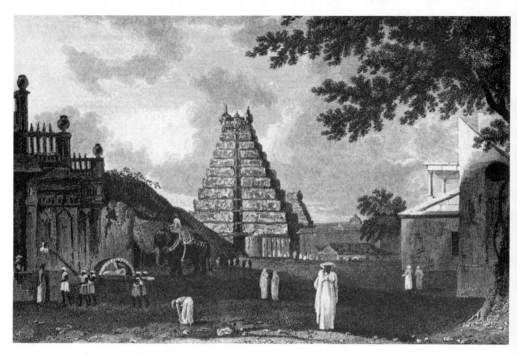

61. Hodges' view of the great pagoda at Tanjore

which lent itself well to the task of transferring watercolour sketches to print. The work that brought him recognition was *Select Views in India* (1786), a bilingual publication in French and English of a selection of coloured aquatint engravings based on drawings of ancient Indian monuments made by him between 1780 and 1783. Although concentrating on Muslim architecture, Hodges was able to offer some fine Hindu examples as well, such as the buildings on the Benaras waterfront, the temples at Deogarh in Bihar, and the great temple of Bṛhadīś-vara at Tāñjore.[66] The last two examples served to illustrate the development of Hindu architecture from the primitive stage to the more elegant. As a typical traveller of his time, Hodges felt obliged to give an account of his experience in India which appeared in print in 1793. From it, we learn, his motive for travel was to extend the knowledge of India in Europe by means of accurate drawings made on the spot, for so little was known about the country.[67] We also learn that his illustration of the Bṛhadīśvara temple [61] was based on a drawing by the artist Topping. Benaras especially appealed to Hodges because from the water the reputedly oldest city in the world appeared 'extremely beautiful', as the temples greatly embellished the banks.[68]

As a practising artist his remarks on matters of taste are extremely interesting. He was surprised to discover the Greek scroll motif in Hindu temple ornament and stated that it was 'curious to observe most

124

of the ornamental parts of Grecian architecture appearing in . . . Hindostan'.[69] An illustration of this was also provided by him. This discovery prompted him to undertake a comparison of classical and other styles in a pamphlet, in which he questioned the widely accepted primacy of classical art. While conceding the great excellence of Greek art, he none the less pleaded for greater tolerance towards other traditions. He declared:

Nor am I in the least prejudiced against its very eminent beauties and perfections: but why should we admire it in an exclusive manner; or, blind to the majesty, boldness, and magnificence of the Egyptian, Hindoo, Moorish and Gothic, as admirable wonders of architecture, unmercifully blame and despise them, because they are more various in their forms, and not reducible to the precise rules of the Greek hut, prototype, and column? Or because in smaller parts, perhaps accidentally similar, their proportions are different from those to which we are become familiar by habit.[70]

In this period of great archaeological activity, which changed prevailing ideas about classical Greece and Greek art, the rediscovery of the original form of the Doric column had led to a great deal of discussion.[71] The simplicity of the original Doric baseless column even became the focal point in any discussion on the excellence of Greek art. Hodges could not go against the tide of opinion by denying the excellence of the Greek column, and yet he refused to believe that the whole excellence of architecture depended upon it alone. Taking his arguments even further he advanced the notion that different environments and social customs of different nations were responsible for producing different artistic conventions, implying thereby that each tradition must be judged by its own standards [62]. The following statement by Hodges is revealing because, not only was a professional artist like him prepared to question traditional values, but to see such non-classical styles as the Hindu, Islamic, and Gothic in similar terms:

The several species of stone building . . . brought more or less to perfection, (I mean the Egyptian, Hindoo, Moorish, and Gothic architecture), instead of being copies of each other, are actually and essentially the same; the

125

spontaneous produce of genius in different countries, the necessary effects of similar necessity and materials; ... bred to more or less grandeur, elegance and perfection, in the Egyptian, Hindoo, and other artificial grottos and caverns.[72]

As an artist Hodges was also able to make valuable observations about Hindu art. He acknowledged the Indian skill in ornamenting buildings and admired some of the Hindu relief sculptures for 'their beauty of execution', which were 'finely drawn and cut with a peculiar sharpness'.[73] A particularly fine example in the collection of Townley seen by Hodges gave a striking proof of their ability in this form of art. Equally, the mythological figures cast in bronze demonstrated their perfect knowledge in the art of casting. But as a man with academic training he felt compelled to criticize Hindu sculpture and painting for their lack of concern with nature resulting in a failure to capture the likeness of subjects, a weakness common to the painter of ideal and symbolic themes.[74]

It has been remarked before that a permanent achievement of the two aesthetic movements was the creation of a new and significantly different image of Indian architecture for the European audience—an image deeply tinged with romantic nostalgia and a longing for distant and exotic landscapes. The movements encouraged the visit of artists to India who not only approached ancient Indian buildings with a new sensibility and vision but were able to convey that romantic feeling in their portrayal of ancient architecture. But if one were to choose the two most outstanding contributors to the new image they would undoubtedly be Thomas and William Daniell. They produced the finest European illustrations of Indian architecture for the nineteenth century as well as some of the finest specimens of book illustrations. They were to present to their contemporary audience the very quintessence of romantic India—something which was to be of lasting value in the nineteenth century. For the reproduction of Indian scenes the Daniells chose a then new medium, aquatint, used previously with much success by Hodges. The medium, which admirably suited the transfer to print of their delicate water colour renderings of Indian monuments, was raised to a new level of excellence in the Daniells' works. In fact one is able to trace the development of the aquatint medium in their works as their own styles of painting developed. Thomas Daniell, an artist of humble origins but possessing considerable talent and a great deal of ambition, embarked for the Eastern shores with his nephew William in 1788. Although they gave some consideration to China, it was India that drew them and was to hold their undivided attention. On their arrival in Calcutta, the centre of the English colonial society of the period, they set up their workshop with local assistants. The Daniells' ambition was to produce picturesque views of Indian antiquities for which there

existed a European market in India. Hodges with his coloured pictures of Indian antiquities had made a name both in Europe and among the English residents in India. And it was chiefly to rival and even to better his reputation that the Daniells engaged in turning out aquatints of the same subjects. In the event, they were to overshadow not only the achievements of Hodges but of all other contemporaries in the field.[75] From a mandatory book of travel, *A Picturesque Voyage to India*, published later in 1810, we learn something of their life in the East. Their intention, as they expressed it with an appropriate 'picturesque' phrase, was to take part in 'guiltless spoliation' in the interests of knowledge and to 'transport back picturesque beauties of those favoured regions'.[76] I think the entire spirit of the late eighteenth- and nineteenth-century picturesque is captured in these last words. Thomas Daniell and his nephew William journeyed from one end of the Indian subcontinent to the other in search of picturesque subjects with a substantial retinue of assistant staff. The result was an enormous output of drawings of great accuracy, made in part possible by their use of an early version of the camera obscura. Of the extensive areas covered by them in India, mention must be made of the temples of the south, represented with great accuracy and feeling for the first time, and the better-known western caves of Elephanta and the others in the vicinity. Kānheri and Elephanta were explored by the Daniells in collaboration with the artist, James Wales. Wales, in India from 1790 to 1795, undertook at the instance of Sir Charles Warre Malet to make a graphic record of Ellora in the years 1782–93. On his death in 1795 his drawings were handed over by Malet to Thomas Daniell. They appeared separately in 1816 with extensive ground-plans of Ellora apart from being included in Daniells' own *Oriental Scenery* [63].[77] When Thomas and William Daniell decided that they had gathered sufficient material in India they returned to England and subsequently set out to reproduce in aquatint a select number of their best works done in India. Between 1795 and 1808 appeared the magnificent volumes of *Oriental Scenery*. They were an instant commercial success and proved beyond doubt their superiority to the works of Hodges. The prints, which made the name Daniell a household word in the nineteenth century, were remarkable for their meticulous and accurate details and a certain delicacy of treatment. They brought Indian temples to Western viewers in a very dramatic manner by portraying famous monuments in their actual landscape setting. The reverberations of Daniells' publications were far and wide. It was on account of the great reputation for accuracy which the Daniells acquired that a contemporary, Lord Valentia, declared that they had drawn the number of pillars supporting the *Nandimaṇḍapa* at Tānjore [64] quite inaccurately.[78] Another contemporary, Forbes, readily acknowledged

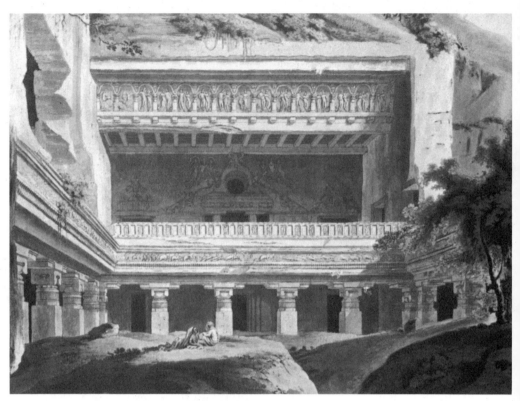

63. View of Ellora in *Oriental Scenery* of the Daniells

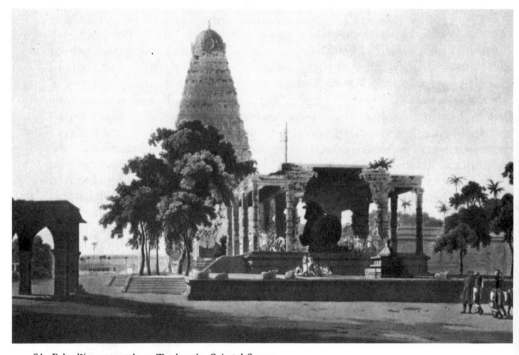

64. Bṛhadīśvara temple at Tanjore in *Oriental Scenery*

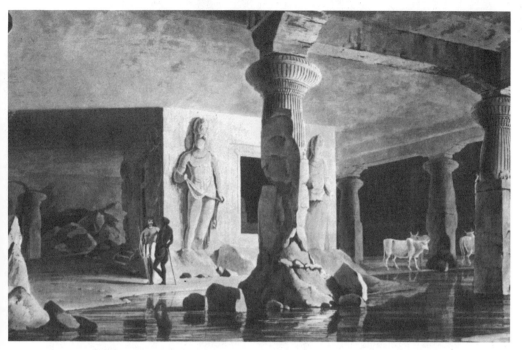

65. View of Elephanta in *Oriental Scenery*

that in order to get a correct impression of Elephanta one had only to look at their works [65]—works characterized by great accuracy and effect.[79] Daniells' illustrations were used by Pinkerton, the nineteenth-century compiler of travel accounts. But it was in Langlès's encyclopedic work that the prints of Thomas and William received the widest dissemination, for the French Orientalist spared no pains to make the most faithful copies of them [100]. Daniells' works continued to be issued as late as the 1830s in publications such as the popular *Oriental Annual* (1834).[80]

The influence of the two Daniells, especially the older Thomas, was felt in architecture. This aspect has been dealt with in the works of different scholars and therefore need only be noted in brief. It is a measure of the visual impact made by the Daniells that on their return they were asked to collaborate on the designing of Melchet Park and Sezincote, two famous country houses. Even more important, Humphrey Repton, a major figure behind the stylistic revolution in England which aimed to end the supremacy of the regular classical style, was thrilled to see the Indian prints in the *Oriental Scenery*. He subsequently used Indian motifs in his proposed design for the royal pavilion at Brighton, the first documented instance when Hindu architecture actually entered into the designing of a European building. It was only when Nash replaced Repton that the Islamic elements came to

129

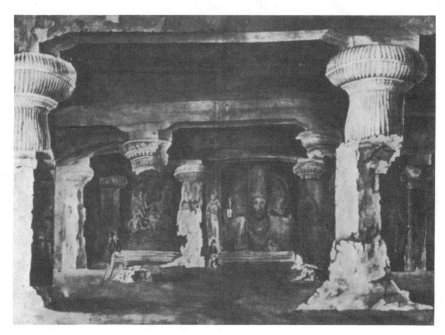

66. Elephanta interior by the brothers Bik

dominate the exterior of the Brighton Pavilion. Christopher Hussey points out that, when in Britain various irregular styles of architecture were receiving increasing attention, the Indian style was no less favoured than the Gothic. It was largely a matter of chance that eventually Indian architecture was not as influential as the Gothic. And no doubt much of the credit for this must go to Thomas and William Daniell.[81] Perhaps the finest tribute to their 'views' was paid by the great Turner: '"The East was clearly reflected as the moon in a lake" the artists had succeeded in increasing our enjoyment by bringing scenes to our fireside, too distant to visit, and too singular to be imagined.'[82]

In the early years of the nineteenth century the Dutch artists, the brothers A. J. and J.Th. Bik, had made a fine watercolour painting of the Elephanta interior when they stopped in India on their way to Java with Professor Reinwardt. Their watercolour painting is reproduced here [66] to illustrate a typical romantic treatment of Elephanta.[83]

The other English travellers who visited India at this time, including amateur artists, could not, of course, match the Daniells' achievements but they made no mean contribution. They were often able to describe a picturesque scene with feeling and imagination which they sometimes failed to convey with their brush. Of particular interest are the descriptions of day-to-day happenings full of local colour which were meti-

130

culously noted down in their diaries. The picturesque movement was in some respects responsible for the rise of a new social pastime, the picnic, and very soon the British in India began to regard ancient spots like Elephanta or Kānheri as an ideal setting for picnics. The new leisured pace of men of means was reflected in the peregrinations of Lord Valentia published in 1809. Of unusual interest are his notes kept of daily activities during his visit to the great *caitya* of Karle. Although from his account it appears that the route to Karle was already familiar to Europeans, this was the first recorded European exploration of the great Buddhist temple. Since Valentia had been accompanied by assistants he was able to have the whole building measured and the main inscriptions copied. He also had with him the artist Henry Salt, who made a fine and accurate drawing of the interior [67] with its prominent wooden ribs and rounded arches. Salt, later famous as a collector of Egyptian antiquities, made a large number of drawings during his visit to India with Valentia, many of which were reproduced in the latter's account. Apart from the drawing of the Karle interior a competent ground-plan was provided by Valentia, who communicated his discovery of this Buddhist chapel to the members of the Bombay Literary Society, a pioneer body devoted to Orientalism.[84] The experience at Karle stimulated Valentia to make further trips to the caves near Bombay. He was duly impressed with the Maheśamūrti at Elephanta which he felt had not been adequately conveyed in Niebuhr's sketch or the one in the *Asiatic Researches*.[85] In Tānjore, where the Viscount spent a few days as the guest of the ruler, he visited the great Bṛhadīśvara temple which he appreciatively described as 'the finest specimen of the pyramidal temple in India'.[86] He also readily admitted that the great temple was a very beautiful piece of architecture. It was here that he was proud to discover the Daniells' error in rendering the *Nandimaṇḍapa*. Before ending his visit he did not neglect to see the 'celebrated ruins' of Māmallapuram with Salt.[87]

The picturesque movement left its mark on the English middle-class literate woman who began to travel widely in the nineteenth century for personal edification. The establishment of the British in India which made it possible to travel in safety brought a number of educated women to the subcontinent. One of the first of these was Maria Graham, an amateur artist of some ability, though not perhaps coming up to professional standards. In her journal, published in 1812 and reissued the year after, Maria Graham stated that she was the first of the travellers who went out to India not for any specific scholarly or official reason but because she was interested in the country and until now no anthor had felt the need to treat its monuments and scenic beauty in a systematic manner.[88] The journal contains many interesting observations

131

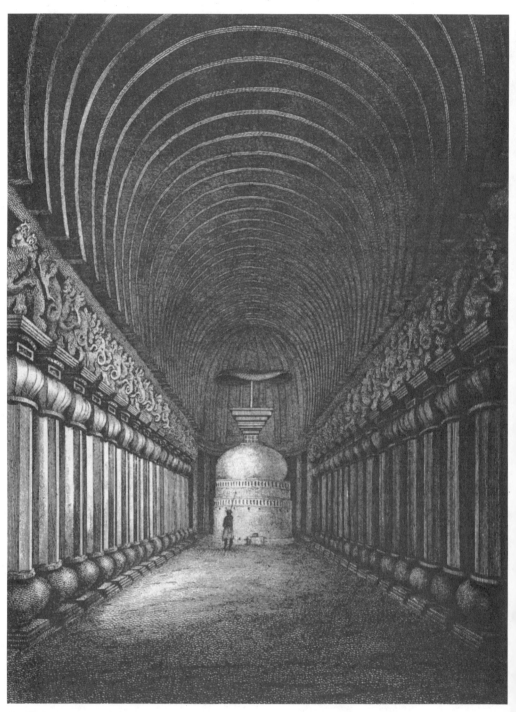

67. Karle interior in Valentia's travels

about the country. Written in an autographical vein, the account is full of her own emotional reactions to the ancient monuments as well as passages which seek to evoke the romantic atmosphere surrounding them. This personal style, a product of romanticism, continued to grow as the century wore on until we see its caricature in Seely's account of Ellora. Maria Graham's detailed account of her journey to Elephanta makes especially interesting reading. Making her way through the 'romantic passes' she came upon the main temple most unexpectedly and declared, 'I confess that I never felt such a sensation of astonishment as when the cavern opened upon me.'[89] She was here giving expression to what generations of visitors had felt on their very first view of the magnificent Śiva temple. The Englishwoman made sketches of the figures in the temple which she claimed (but with little justification) were superior to those of Niebuhr.[90] She did not omit to pay a visit to the newly discovered Karle *caitya*. She made a note of the wooden ribs of the hall and described it as almost like a Gothic cathedral. While she was careful to point out that the ribs terminated in a semicircle in the ceiling, they were curiously represented in the form of Gothic arches [68, 69] in the illustration in her journal.[91] The remains at Māmallapuram [70] and the roaring waves that lashed against its shores put Maria Graham in a philosophical mood:

The view of these objects, together with the loneliness of the place ... the distant roarings of the ocean, dispose the mind to meditate concerning the short duration of the monuments of human pride ... The monuments they have left now adorn a desert, which Nature, as if in scorn of man, seems to pride herself in decking with gay colours, ... whose Author can never be mistaken.[92]

Many years later she wrote the ambitious *Essays towards the History of Painting*, in which she took a polygenetic view that the arts had developed simultaneously in all ancient nations. The work was not startlingly original but certain aspects of it are of interest to us. Her Indian trip had made a lasting impression on her. As she reminisced: 'No one, who has seen the colossal head of the Trimurti, in Elephanta, can deny the grandeur, almost the sublimity, of that strange work; and the compartments of the same temple-cavern are examples of a gracious feeling of nature.'[93] Her conclusion was that Indian sculptures often showed a certain freedom, taste, and concern with naturalism, traits lacking in, for instance, the ancient art of Egypt. We also learn that when Flaxman was shown a drawing of Māmallapuram figures by her he too had shown an interest in these traits in Indian art.[94]

James Forbes spent over ten years in India at the end of which he produced two substantial volumes on the country and its culture. It is

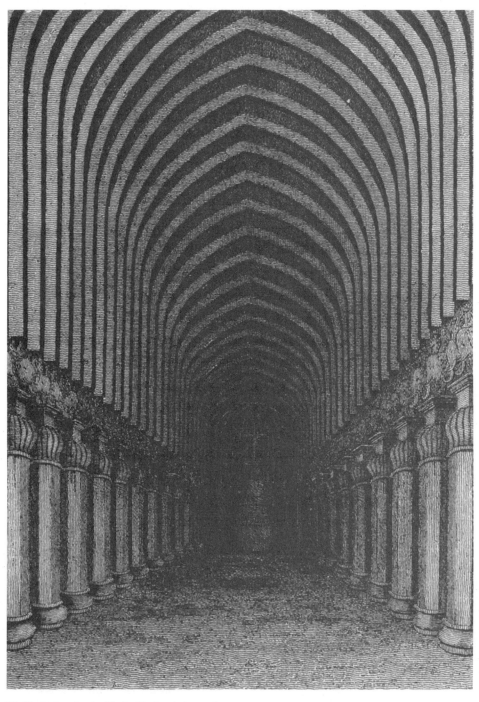

68. Karle interior in Maria Graham's journal

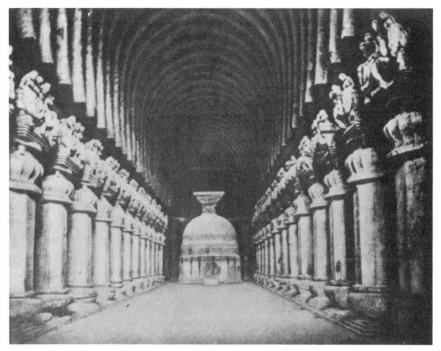

69. Interior of Karle caitya

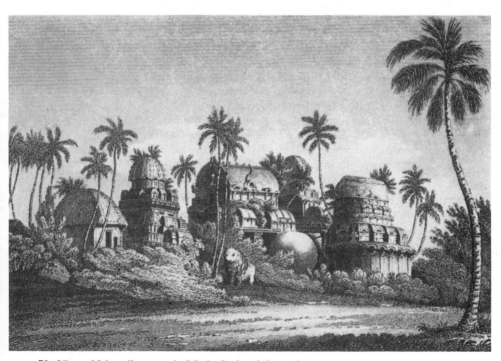

70. View of Māmallapuram in Maria Graham's journal

clear from his *Oriental Memoirs* (1813) that the cave temples of Elephanta and Salsette drew him for their 'picturesque' possibilities. The rock-temples had inspired poetry in this period, a famous example of which was Southey's *The Curse of Kehama*, published in 1810 and known to Forbes.[95] Therefore, the first thing that came to his mind on seeing Elephanta was a poem about the impermanence of vain glory and the inexorable march of time, the destroyer of all that was mighty.[96] Forbes visited Elephanta many times during his stay in western India and once spent four days there in order to make extensive drawings. With a somewhat unintended irony he complained elsewhere that the enjoyment of the 'picturesque' qualities of the Salsette caves could often be rudely interrupted by the presence of tigers in the area. About the Maheśamūrti at Elephanta he made the interesting remark that 'the general effect was heightened by the blueness of the light.'[97] The conclusion reached in his stylistic comparison between Salsette and Elephanta was that, while the earlier monument had a grander appearance, the Śiva temple was richer in sculptures. To add interest to the discussion Forbes provided a comparative drawing of columns belonging to these two monuments and one of the Elephanta temple [71]. But above all, there is in Forbes a most revealing account of a professional artist's reaction to Elephanta. He related the story about an eminent artist whom he accompanied to this cave temple:

I had been lavish in its praise; too much so, as I had reason to concede, on our arrival at the great temple . . . we remained for several minutes without speaking . . . at length, when more familiarized to the cavern, my companion still remained silent, I expressed some fear of having been too warm in my description and that, like most other objects, the reality fell short of the anticipated pleasure; he soon relieved my anxiety by declaring that, however highly he had raised his imagination, on entering this stupendous scene he was so absorbed in astonishment and delight as to forget where he was. He had seen the most striking objects of art in Italy and Greece, but never anything which filled his mind with such extraordinary sensations. So enraptured was he . . . that after staying until a late hour he reluctantly accompanied me . . .[98]

But at the same time, as the following passage shows, it was not the 'beauty' but the 'sublime' quality of Indian sculpture that impressed Europeans:

I do not wish to insinuate from this gentleman's surprize and delight in the caverns of the Elephanta, that he placed the Hindoo sculpture in competition with the Grecian temples and statues; it was the general effect which struck him. However these gigantic statues, . . . in the caves Elora and Salsette, may astonish a common observer, the man of taste looks in vain for proportion of form and expression of countenance.[99]

Brought up to believe the Apollo Belvedere and Laocoön to be the

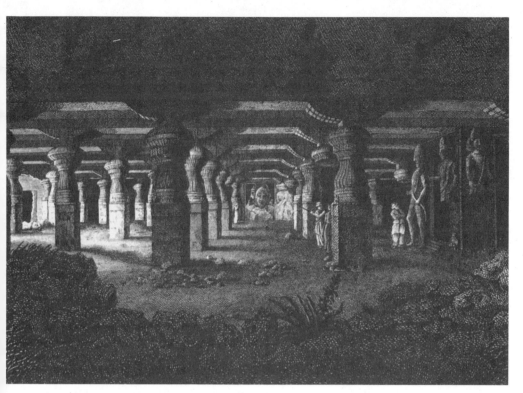

71. Forbes' view of Elephanta interior

supreme achievements in the history of art, Forbes simply failed to see
any beauty either of form or expression in the figures at Elephanta.

J. B. Seely's *The Wonders of Elora* (1824) represented the ultimate
apotheosis of this monument as the actual description got virtually
drowned in a rhetorical torrent of hyperboles and expletives like 'won-
der' and 'grand'. With regard to Ellora Seely did for the ordinary
literate public what Anquetil had done for scholars. Seely had succeeded
in establishing the reputation of his favourite monument Ellora in the
popular imagination to the extent that subsequent writers felt obliged
to come to the defence of other major monuments such as Elephanta
and Ajanta.[100] The romantic stage was already set as *The Wonders of
Elora* opened with an apposite quotation from Akenside, the poet asso-
ciated with the picturesque movement:

> Shall then this glory of the antique age,
> The Pride of men, be lost among mankind?[101]

The initial sections were devoted to Elephanta, and Karle with its
'noble vestibule and entrance'.[102] Seely also provided the interesting
information that the first rock-temple was often visited by pleasure
parties due to its close proximity to Bombay.[103] The pretty little village

137

of Ellora, a beautifully romantic spot, was however approached by the English officer with considerable emotion and although he was both tired and hungry he could not resist 'proceeding on at once to the glorious scene which awaited me at the eternal temples ... I at once rushed into the wonders and glories of these immortal works; but it is totally impossible to describe the feeling of admiration and awe excited on the mind upon first beholding these stupendous excavations.'[104] From the very long account of the various temples, especially of 'Keylas the Proud ... a mighty fabric of rock, surpassed by no relic of antiquity in the known world',[105] certain passages may be chosen for their special interest. In one an important comparison was made between Ellora and great European architectural masterpieces such as the Parthenon, the Pantheon, St. Peter's, and St. Paul's. In the case of European architecture everything could be explained in rational terms since they were essentially the products of science and labour. On the other hand, it appeared beyond belief that 'a temple ... with galleries, and an indescribable mass of sculpture and carving in endless profusion' could be fashioned out of a solid mountain of rock.[106] The whole sense of sublime mystery was reinforced in Seely's mind by the fact of its unknown origin and age. He was utterly convinced that the wonderful example of human endurance, skill, labour, and patience would endure long after the disappearance of contemporary wonders of architecture such as Fonthill and Blenheim.[107] His book, Seely hoped, would help to bring that just recognition to Ellora which was long overdue from learned antiquarians. His criticism in this context was that too much time had been spent by scholars on less wonderful antiquities of the West and the Near East, and especially on Egypt. It went to his credit that, in spite of his preoccupation with his own feeling of wonder in connection with Ellora, he was able to go beyond it and express an aesthetic appreciation of its architecture and sculpture in a number of places. At the end he could not resist asking the reader to intervene as he exclaimed—'Reader, is not this entire temple wonderful?'[108] An avowed romantic in his view of ancient India and the Hindus, Seely brought to a close his *Wonders of Elora* with a rhetorical question:

Where now is the whole mechanism of Elora's former splendour—the mystic dance, the beautiful priestesses, the innumerable midnight lamps, the choruses of hundreds of devoted victims, the responses of music, the shouts of fanatical fakeers, the solemn supplications of the graceful-looking Brahman of the 'olden day', clothed in long white vestments?[109]

Three other works of the same genre may be noted in brief. In Bishop Reginald Heber's widely read journal, published posthumously by his widow in 1827, there is the following appreciative account of Elephanta:

138

72. Bacon's impression of Puri

Though my expectations were highly raised, the reality much exceeded them, and that both the dimensions, the proportions, and the sculpture, seemed to me to be of a more noble character, and a more elegant execution than I had been led to suppose. Even the statues are executed with great spirit, and are some of them of no common beauty . . .[110]

Two points raised by him are of some importance: that the Maheśamūrti at Elephanta were the three forms of one god Śiva, and not of three different gods, and that the great antiquity of Elephanta was a myth. The statement showed that he was aware of recent archaeological discoveries.[111] The picturesque qualities of Māmallapùram reminded Heber of Southey's *Kehama*. He also found its sculptures superior to those of Elephanta.[112]

In 1837 Thomas Bacon brought out his *First Impressions* in which architecture was approached from the point of the picturesque effect it created [72]. In Konarak, the 'grouping of solid blocks of marble which have fallen from above' was considered to give a highly picturesque effect. Bacon had been asked to take charge of Caunter's *Oriental Annual* in the 1830s, the pictorial series which originally William Daniell contributed to but had later withdrawn from.[113]

Markham Kittoe's *Illustrations of Indian Architecture*, dated 1838,

139

contained among others a fine drawing of ruined columns, a northern Śaiva temple, and the temple of 'Kurkotak Nag' in Bundelkhand [73].[114]

iii. INDIA AND THE RISE OF SCIENTIFIC ARCHAEOLOGY

By archaeology two things are meant today: prehistoric archaeology, a legacy of the nineteenth century, which deals with cultural evolution and works closely with anthropology; and historic archaeology with its roots in classical archaeology, devoted to the study of the monumental remains of antiquity, mainly architecture of the past.[115] It was in essence the second which sparked off a concerted effort on the part of the English residents to explore Indian antiquities, to measure and document architectural monuments, and finally to present their researches in learned periodicals. The rise of scientific archaeology in the eighteenth century was so bound up with a profoundly changing conception of classical antiquity, expressed in the aesthetics of Neoclassicism and especially Winckelmann's romantic image of ancient Greece, that it is necessary to consider them together so that we may understand the inspiration behind such an extraordinary outburst of antiquarian activity in this period. The main points of the story may be briefly recapitulated here. The seeds of modern archaeology—the study and reclamation of the material remains of the past—had already been sown during the Renaissance in its conscious desire to revive the classical past, particularly the humanist need to discover the formal canons of Greco-Roman architecture. This did not as yet reflect a discriminating approach to antiquity for the interest was artistic and had the purpose of providing guidance to practising architects. In Pirro Ligorio (1513–83), the antiquary who applied scientific draughtsmanship to ancient monuments as well as carrying out excavations and restorations, one may discover an early archaeologist.[116] But the eighteenth century was the great age of archaeological explorations, marked by successive discoveries, beginning with Herculaneum in 1738 and Pompeii in 1748 and bringing the initial period to a close with the historic journey of Stuart and Revett to Athens in 1751. The establishment of proper archaeological methods in this century, attributed by J. M. Crook to Desgodetz, was carried further along in the accurate measurements and drawings of antiquities by English travellers. The English Society of Dilettanti, which we have had occasion to encounter, sponsored two publications, *Palmyra* (1753) and *Balbec* (1757), the outcome of Wood's journey. The work that brought lasting fame to the Society was, however, the series of magnificent drawings of *The Antiquities of Athens* executed by James 'Athenian' Stuart and Nicholas Revett.[117] The journey to Athens was undertaken in order to restore the pure form of Greek art for architects and had led to excavations, measurements, and

140

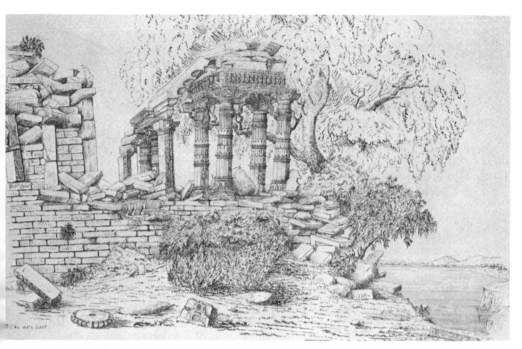

73. Temple of 'Kurkotak Nag' in Kittoe

the preparation of most exacting drawings by the celebrated duo.[118] Meanwhile, Girgenti and Paestum had come to the notice of the cognoscenti in the 1750s, although the tide did not turn until Richard Payne Knight was to 'discover' the latter's picturesque qualities in 1777.[119] Classical Greece and Rome were admired in this period not in the Renaissance humanist sense but as transformed by the Romantic sensibility. It was but a step from the adulation of early Greek order of architecture as being natural and reflecting primitive simplicity to the appreciation of the Gothic.[120] In Romantic consciousness the classical Greek and the Gothic were merely two sides of the same coin. Thus the second impetus to the rise of archaeology came from Romanticism and as costly journeys to distant lands were beyond the means of most people more attention began to be given to local antiquities, culminating in the Gothic Revival. The body which led this movement in Britain, the Society of Antiquaries,[121] was also involved with Indian antiquities in its early career until Indian studies in general were taken over by the Asiatic Society of Bengal. R. Gough, appointed director of the Society in 1771, brought out in 1785 an important comparative study of the cave-temples near Bombay based on the major existing accounts of these monuments.[122] To an antiquarian of the late eighteenth century Indian antiquities were as worthy of investigation as those of Britain or of Greece. The Renaissance image of Classical Antiquity no longer

141

continued to hold an absolute sway over him. In this respect, his position was very similar to his contemporary picturesque traveller who reflected a new attitude to Indian architectural remains.

These developments in Europe give us a valuable insight into the energy with which British residents in India engaged in intensive explorations of Indian antiquities from the middle of the eighteenth century onwards, laying in the process the foundations of modern Indian historical and art-historical scholarship. The methods followed by them, such as accurate and careful measurement of architecture, were learnt from precedents set in Europe and western Asia. An important feature of Indian archaeology was inherited from the British archaeological tradition in Europe. This may be described as an empirical and pragmatic approach to the subject. Instead of making aesthetic judgements and responding emotionally to artistic remains the authors felt that the way the facts were presented should be able to speak for themselves and let the reader draw his own conclusions.[123] The implications of this positivistic approach were seen at the end of the century in the works of archaeologists who felt qualified to speak authoritatively on the aesthetic quality of Indian art. It must also be mentioned that the quality of the remarkable drawings of Athenian antiquities by Stuart and Revett was not paralleled in the works of archaeologists in India. Admittedly, unlike in European architecture, these English archaeologists were not served by an already existing tradition. These limitations, it must be acknowledged at once, do not detract from the important achievements of the archaeologists in making available the vast corpus of material relating to Indian art and architecture which provided the essential data for subsequent interpretations of the subject.

The seventh volume of *Archaeologia* (1785), the journal of the transactions of the Society of Antiquaries, provides us with the earliest evidence for antiquarian interest in Indian architecture. In 1780 Captain Pyke's account of Elephanta, compiled some seventy years before, was presented by Alexander Dalrymple, the Orientalist, to the Society. Braving Maratha attack, Pyke with his men had taken measurements of the temple by candle-light. The drawings of sculptures, and possibly the earliest ground-plan of this temple, and diagrams of columns, including a sectional drawing, were reproduced in *Archaeologia* [74, 84]. The error in Dr. Fryer's computaton of the pillars was corrected and the myth which connected Alexander with Elephanta demolished, while Pyke himself may have started a fresh one by identifying the Andhakāsura Śiva group as the judgement of Solomon.[124] Dalrymple also reproduced some fine drawings of sculptures from Salsette [75] in the possession of Sir Ashton Lever, the famous collector of curiosities, ranging from live and stuffed birds to savage costumes. To the Society

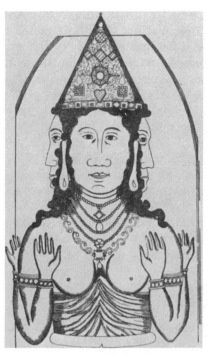

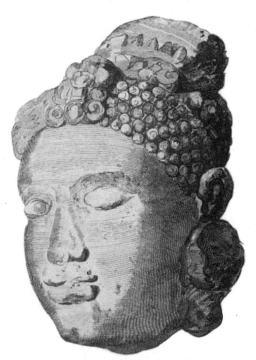

74. Pyke's sketch of Maheśamūrti at Elephanta

75. Indian sculpture in Sir Ashton Lever's collection

belonged a drawing based on pieces which were part of the booty brought back by Captain Allen on board the *Cumberland*, the most famous example of which was the Townley erotic group [47].[125] In the same year the antiquarian Smart Lethieullier's communication on Charles Boon, the governor of Bombay, was posthumously reported. Boon's account of temples on the isle of Salsette was written in order to explain measured drawings prepared during his years of office.[126]

A surgeon and Orientalist of some repute, William Hunter, invited in 1784 to read a paper to the Society on the 'Artificial Caverns in the Neighbourhood of Bombay', gave yet another account of measurements taken in Elephanta. Of great interest are his complimentary remarks on the ability of Indian sculptors to represent anatomical details accurately. As he stated, 'The people, whoever they were, who carved these statues have accurately observed and expressed successfully the form of the limbs, and the alterations that undergoes from muscular action or external impulse.'[127] No less important was his appreciation of 'a much more difficult part of the statuary's art . . . that which represents the effects of mental sensations on the human countenance'.[128] Traditionally Indian aesthetics attaches a great deal of importance to the

143

role of a wide range of emotions and their treatment in literature and art. Therefore, what Hunter reported here was not something that had suddenly appeared in this period. The difference was only in the way Indian sculpture was viewed in this period that stood on the threshold of Romanticism and Romantic aesthetics. Every age has its own special way of looking at a work of art and concentrates on certain aspects to the neglect of others. One period may consider the iconography as being most worthy of attention. In another, this aspect may be ignored in favour of design and form. The age of Romanticism, too, naturally imposed its own favoured criteria on art criticism. Not only was one to respond to a work of art emotionally but also the successful delineation of emotions was to be prized as one of its more important features. Hunter's eye, trained to look for the treatment of emotions in sculpture and painting, at once brought that particular aspect of Elephanta figures into focus. But he was only the first of a long line of visitors who were to dwell on the importance of the emotional quality in a work of art.

In one other respect Hunter stood at the head of a tradition. He argued a notion of evloution in Indian art in his assessment of Kānheri:

From the simplicity which reigns through the whole of the caves at Canara, and the total want of those monstrous figures which we meet with in the others; I think it probable that the former are the most ancient of the whole, and that the others have not been constructed till both the taste and the mythology of the people began to be corrupted.[129]

A crucial statement in the establishment of methodology for the study of architecture and sculpture of ancient India. Hence it is in need of close examination. In the first place, the argument betrays its teleological character—but only in an inverted sense, for there is a suggestion that art in India followed a path of downward 'progress' from a postulated 'golden age'. The Indian 'golden age' idea here belonged to a Western tradition, although the idea itself was common to many civilizations.[130] The notion was encouraged by the distinction made by scholars between the ancient, pristine, and philosophical form of Hinduism and its modern, vulgar corruption, which included monstrous cults, a trend that began with the first serious discussion of this religion. This distinction was now extended to art. First of all there was an implicit assumption here that Indian art must of necessity decline from a superior position rather than make progress. This had not as yet been clearly spelt out, but the whole attitude can be easily understood if we remember Winckelmann's argument for a clear and inevitable 'teleological' progress of Greek art which he contrasted with the corresponding lack of progress in Oriental art. By Oriental art he meant, of course,

Egyptian and Persian art.[131] But the moral of the story was not lost on later generations who applied the principle to all Eastern art.

Hunter's view of the peculiar evolution of Indian art and architecture was naturally subjective but it was given respectability by being provided with a theoretical framework. In the eighteenth century a much discussed doctrine was the 'evolutionary' principle of development from the simple to the complex. The notion, which betrayed the influence of the biological sciences and saw social developments as being parallel to the growth of organisms, had an able exponent in Sir William Jones.[132] It was seen at work in Greek art where the earliest was also the simplest.[133] As applied by Hunter to Kānheri its very simplicity was an indication of its early age. In this he was not far wrong as later researches on its probable date were to prove. Yet, one serious implication which followed from this interest in early Indian architecture and sculpture was to condemn the whole development of Hindu art as being corruptions of earlier forms. Hunter used a further argument to prove the antiquity of these caves—they were the work of a different race of people from the Indians.[134] This took care of the problem of different styles in various caves as well, for in the absence of evidence he could not argue for the evolution of a particular style through the ages.

In volume eight of *Archaeologia* (1787) there appeared Hector Macneil's letter on the picturesque beauties of Amboli (Yogeswari), Kānheri, and Elephanta, written four years before. Macneil, who had visited the caves in the company of friends, reported that they were the site of the British governor's annual parties of pleasure. Kānheri caves, 'monuments of genius and superstition . . . a spot as singular for the production of art as for the lonely romantic scenes',[135] were measured and traces of timber in the ceiling of the *caitya* noted. In denying that the main *caitya* hall in Kānheri was divided into two parts with a wooden floor in the middle, he made the aesthetic comment that this assumption on his part would fail to appreciate the achievement of the designers 'who have furnished us with such instances of taste and genius, as it would have destroyed the grandeur of the high hall'.[136] Not only did Macneil feel that Kānheri must be 'considered by the man of taste as an object of beauty and sublimity, and by the antiquary and philosopher as one of the most valuable monuments of antiquity',[137] but he got so carried away that he declared the ease, attitude, and symmetry of the female figures to be worthy of the genius of Michelangelo.[138] At the same time he sadly admitted that the ruined state of even such an instance of magnificence and beauty only went to prove 'the folly of human pride'. In the account of the measurements of Elephanta was included an important structural analysis of a column. Although he could not find any known order that corresponded to these columns, their heavy forms

145

suggested to him the Doric. The Maheśamūrti was an object 'not only of sublimity but of terror', and a group of figures was all the more valuable because they expressed passion. It was with a romantic insight that Macneil was able to enjoy the portrayal of joyous, pensive, melancholic, and sorrowful expressions in the sculpture and was struck in particular with:

the representation of a tiger, a horse, and two men, executed in so masterly a manner, that we cannot help ascribing particular excellence to the rest. The tiger is couchant, and just ready to seize on his prey; but the terror and attitude of the horse is equal to any thing of the kind I ever saw; one of the men seems as if rushing in between the horse and danger, his countenance and attitude highly expressive of fortitude.[139]

It was the reputation that Elephanta and Salsette had for being some of the oldest monuments in the world which drew so many of the temporary residents in the Bombay area to these caves. But the final article in *Archaeologia* (1792) devoted to Indian art in this period was on the great temple of Mādurā, the very first serious essay on it. Written in the form of a letter to Sir Joseph Banks, its author Adam Blackader spent three years on making drawings of the temple, its main shrine, and the pillars of the choultry of Tirumal Nayak based on the exact scale of half an inch to a foot. The drawings and a model of the temple were sent to Banks who presented them before the Society. Blackader's curiosity was aroused by the fact that in and around Mādurā were to be seen some of the 'most magnificent buildings' in India with regard to size and richness of workmanship. They also represented a singular type of architecture totally unlike buildings in other countries. The main temple (*vimāna*) was four storeys high, the first storey or the base built of stone and the rest of bricks and covered with copper plates. Not only the *vimāna* but the *gopuras* and other architectural parts were carefully measured and it was suggested that the high walls and gate-towers served a defensive purpose. The stone slabs forming the roof of Tirumal Nayak's choultry, begun in 1623 as Blackader established, were rolled up to the top by means of an inclined earthen ramp surrounding the pillars. After the completion of the work the earth was simply removed leaving a covered hall. The iconography of the columns of the choultry was of such complexity that Blackader decided to include a description of the subjects depicted on them on the basis of temple records translated for his use.[140]

Already by the 1780s, the essential function of the Society of Antiquaries in disseminating the knowledge of Indian antiquities in Europe was made redundant, as it were, by the establishment of the Asiatic Society in Bengal, whose role in Oriental studies cannot be exaggerated. The brainchild of that visionary Sir William Jones, it was founded in

1784, the year after his arrival in India. A person of great imagination and complexity, Jones is not easy to fit into a neat category for not only does much subjective judgement colour the assessments of present-day scholars but even in his own time he had become something of a legend on account of his wonderful personal qualities and a precocious facility with a wide variety of languages. It is possible to argue that Anquetil-Duperron's contribution to Orientalism has been grossly underestimated and probably Wilkins's *Gītā* was as important a contribution as Jones's celebrated *Śakuntalā* to the rise of Sanskrit scholarship in Europe. Yet what the other two lacked was the charismatic quality, the ability to fire people with enthusiasm for undertaking research in diverse fields of Asian studies and to give cohesion and unity to all these different subjects. Someone was needed at this moment to rescue incipient Indology from the doldrums of ethnology and place it on a par with the study of other major civilizations and Jones eminently fulfilled this need.[141] Jones, who himself was romantic in temperament and sensibility, as is evident in his translations of Indian poetry, had a profound influence on the German Romantic movement. His *Śakuntalā* revealed to Goethe, Herder, and others a whole new world of experience and had even inspired Schubert to write an opera based on it.[142] His tragic death in 1794 robbed Indology of the prime moving spirit in its formative period. It also ended his own chance to accomplish much apart from his brilliant suggestion which laid the foundations of comparative philology.[143] Before his death Jones had drawn up a 'desiderata' of topics for research and it is significant that art was not left out of it.[144] He encouraged others to study Indian art by recognizing history, science, and art as the three major fields of study. He consequently became one of the decisive early influences in the development of Indian art history. He even sought to broaden the range of inquiry by encouraging the study of the practical arts: 'whilst you inquire with pleasure into their musick, architecture, painting, and poetry, will not neglect those inferiour arts, by which the comforts and even elegances of social life are supplied or improved.'[145] With his great imagination he was able to realize the need to study ancient Indian aesthetic texts in order to gain an insight into art, a suggestion that was taken up in earnest by the Indian, Rám Ráz:

The *Silpi Sástra*, or *collection of treatises on Arts and Manufactures*, which must have contained a treasure of useful information on *dyeing, painting*, and *metallurgy*, has been so long neglected, that few, if any, traces of it are to be found; but the labours of the *Indian* loom and needle have been universally celebrated.[146]

As for himself, Jones found greater pleasure in music and literature than in the visual arts. None the less, in *The Asiatic Miscellany* (1785), a very

147

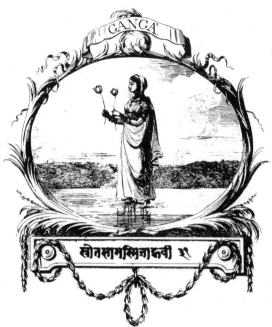

76. Indian divinity illustrated by Sir William Jones

perceptive tribute was paid to the *Rāgamālā* paintings which traditionally sought a synthesis of the three arts, poetry, music, and painting. In his words, they 'may be considered as the most pleasing invention of the ancient Hindus and the most beautiful union of Painting with poetical Mythology and the genuine theory of Musick.'[147] As regards mythology and religion Jones was a diffusionist and received the attention of scholars for his article 'On the Gods of Greece, Italy and India'. Written in 1784 the essay traced a supposed common origin of the gods belonging to these three countries [76].[148] In one other essay the visual arts only served to corroborate his diffusionistic theories:

The remains of *architecture* and *sculpture* in *India*, which I mention here as mere monuments of antiquity, not as specimens of ancient art, seem to prove an early connection between this country and *Africa*: the Pyramids of *Egypt*, the colossal statues described by PAUSANIAS and others, the Sphinx, and the Hermes *Canis*, which last bears a great resemblance to the *Varáhávatár*, or the incarnation of VISHNU in the form of a *Boar*, indicate the style and mythology of the same indefatiguable workmen, who formed the vast excavations of *Canárah*, the various temples and images of the BUDDHA, and the idols which are continually dug up at *Gayá*, or in its vicinity. The letters on many of those monuments appear .. partly of *Abyssinian* or *Ethiopick* origin; and all these indubitable facts may induce no ill-grounded opinion that *Ethiopia* and *Hindustan* were peopled or colonized by the same extraordinary race . . . the Hindu religion spread probably over the whole earth, there are signs of it in every northern country, and in almost every system of worship; in England it is obvious: Stonehenge is evidently one of the temples of Boodh.[149]

148

The Asiatic Society of Bengal became the model for other societies devoted to Oriental studies. Jones's influence was acknowledged at the first meeting of the Literary Society of Bombay held in 1804.[150] Finally, the Royal Asiatic Society, whose chief patron was George IV, was founded in 1823. As its first president the eminent Orientalist Colebrooke stated at the inauguration of the Society that its main aim was to present before the European audience the contribution of Asian societies to the common heritage of mankind as well as to seek the threads which linked Greek and Indian philosophies.[151] The first phase of British archaeological activities in India provided the essential foundations for interpretations of Indian art and architecture in the nineteenth century and our guidelines in this are the first fifteen volumes of the *Asiatic Researches*, the *Transactions of the Literary Society of Bombay*, and the first three issues of the *Transactions of the Royal Asiatic Society* of London. The first professional approach to archaeology in India involving careful explorations of Indian architectural antiquities came only after the establishment of British power, for it gave Europeans unrestricted access to monuments in a large part of the subcontinent without any fear of interference from local potentates. It is curious that most of the researches were undertaken by army officers and officials of the East India Company. For reasons of administration and defence these people had to make extensive tours around the country and whenever they happened to be in the vicinity of an important archaeological site they made sure to carry out extensive exploration of its monumental remains. Since a large number of the officials were trained and equipped for surveying, the particular task of measuring temples did not pose a problem to them. Therefore they were able to correct the errors of casual travellers and to place Indian archaeology on a more scientific footing. Their official duties involved the learning of different Indian languages, including Sanskrit. These came to their aid in their collection and interpretation of inscriptions, and ultimately in the dating of antiquities. Some of the most exciting discoveries in the nineteenth century, notably that of the Ajanta caves, were due to the army officers.

The earliest contribution on Indian art in the *Asiatic Researches* was by one of the founder members of the Asiatic Society, William Chambers, and dealt with the antiquities at Māmallapuram. The paper, written some years after his visit to the place and consequently suffering from a lack of precision, came out in the very first volume dated 1788. In the introduction he mentioned that the main temple was known to sailors as the seven pagodas and indulged in some speculations on its origins and date. He was taken with the skilful treatment of a group of monkeys [77] as well as 'a lion much larger than the natural size, but very well executed',[152] which contrasted with more recent Indian

149

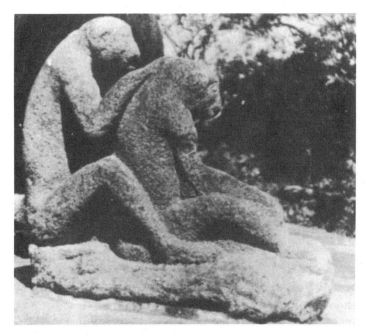

77. Group of monkeys in Māmallapuram

renderings of the animal. Chambers pointed out the difference in styles in the construction of Māmallapuram and contemporary temples and considered the reliefs in Māmallapuram to be in 'Gothic' style:

There is also great symmetry in their form, though that of the Pagodas is different from the stile of architecture, according to which idol temples are built now in that country. The latter resembles the *Egyptian*, for the towers are always pyramidical, and the gates and roofs flat and without arches, but these sculptures [ancient art] approach nearer to the *Gothic* taste, being surmounted by arched roofs or domes that are not semicircular but composed of two segments of circles meeting in a point at the top.[153]

The main temple, built of large stone slabs, was mistakenly assumed to be of brick. J. Goldingham, who stated in the fourth volume of the same journal that 'the sight was arrested by the pagoda' of Māmallapuram, was the first European to undertake its measurement. Contradicting Chambers's view he stated that the Indian lion was

by no means a likeness of that animal, wanting the peculiar characteristick, the mane. Something intended to represent this is, indeed, visible, which has more the effect of spots. It appears evident, the sculptor was by no means so well acquainted with the figure of the lion as with that of the elephant and monkey, both being well represented in this group.[154]

150

One is inclined to agree with Goldingham. Indian sculptors have traditionally represented the lion in a formalized, heraldic manner, while animals such as the elephant and the monkey have always been depicted with naturalism. The archaeologist repeated Chambers's distinction between Māmallapuram and recent south Indian architecture and further drew parallels between the first and Elephanta. Denying any historical connection between the late architecture in the south and Māmallapuram he stated:

The difference of style in the architecture of these structures, and those on the coast hereabouts (with exceptions to the pagodas of brick at the village) tends to prove that the artists were not of this country; and the resemblance of some of the figures and pillars to those in the *Elephanta* Cave, seems to indicate they were from the northward[155]

Recognizing the great difficulty of making categorical assertions about its origins Goldingham decided to reproduce the extant inscriptions which may help shed light on its date and style.

The definitive account of Māmallapuram appeared in 1830 when Dr. B. G. Babington presented the fruits of his research in the *Transactions of the Royal Asiatic Society*. During his expedition to the site he engaged in making drawings, in determining the dimensions of various monuments, and in reclaiming sculptures buried under the earth with the assistance of Andrew Hudleston. The result was a series of fine and accurate drawings, including an impressive one of the main temple [78, 79]. The account, showing an absence of fanciful speculations, began by offering a résumé of the state of knowledge about Māmallapuram to date. Chambers was criticized for lack of accuracy and Maria Graham and Bishop Heber for their casual approach, although the prelate's appreciation of the skill displayed in Māmallapuram sculpture was considered 'peculiarly valuable'.[156] Only Goldingham was approved of and bearing in mind his contribution Babington decided to concentrate on the sculptures. On the execution of various sculpture groups Babington gave a critical appraisal which included an appreciative account of the Mahiṣāsuramardinī figure:

here, under the same roof, there is much inequality in the execution of different subjects . . . The central compartment and that on the left on entrance are tame performances, compared with the very spirited representation of DURGÁ, seated on her lion, and attacking MAHÉSÁSUR, . . . I have no hesitation in pronouncing this to be the most animated piece of Hindu sculpture which I have ever seen; and I recommend that a caste of it should . . . be taken for this Society . . .[157]

The above figure [80, 81], drawn with accuracy and imagination, was one of several excellent illustrations which offered to the scholarly world the first correct view of this south Indian monument.

151

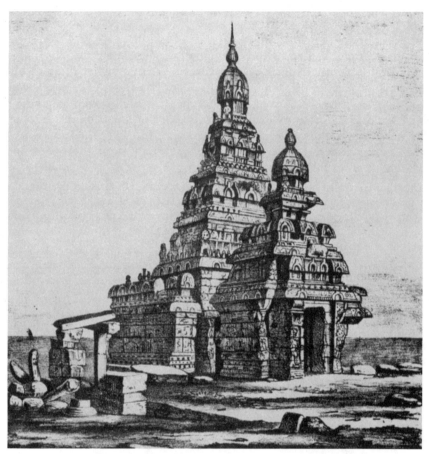

78. Babington's illustration of Māmallapuram temple

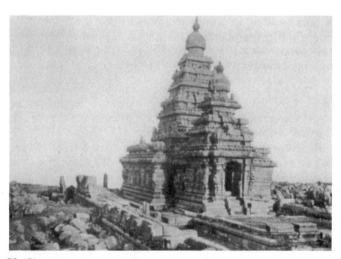

79. Shore temple at Māmallapuram

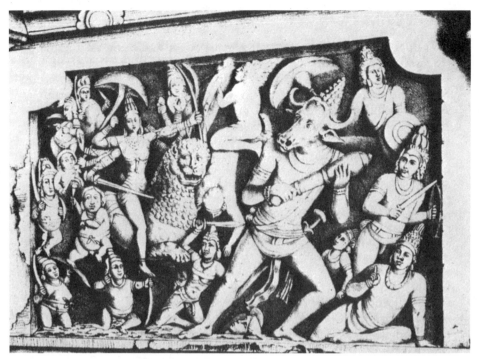

80. Mahiṣāsuramardinī figure from Māmallapuram in Babington's article

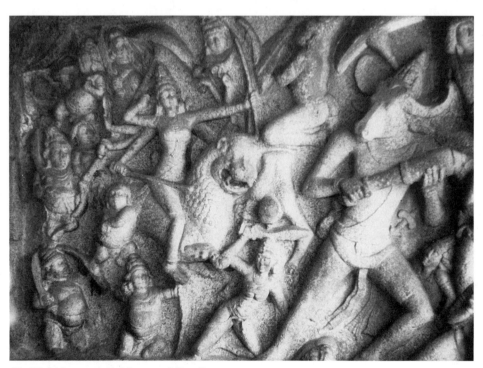

81. Mahiṣāsuramardinī figure at Māmallapuram

It does not surprise one that the best-known and admired temple in the west, the favourite of the antiquarians, Elephanta, continued to hold the interest of British officials. In volume IV of *Asiatic Researches* (1799), it was Goldingham again who contributed an article on it. Apart from providing an accurate ground-plan and a picture of Mahesa-mūrti [82] which was an improvement on that offered by Niebuhr, the English archaeologist measured some of the figures in order to discover the proportions and the distribution of form:

GIGANTIC as the figures are, the mind is not disagreeably moved on viewing them, a certain indication of the harmony of the proportions; having measured three or four, and examined the proportions by the scale we allow the most correct, I found many stood even this test, while the disagreements were not equal to what are met with every day in people whom we think by no means ill proportioned.[158]

On the question of its age and origin he refused to be drawn into fruitless speculations apart from rejecting myths about its Egyptian, Jewish, or Greek origin in favour of an indigenous one in the knowledge that the iconography was based on the Hindu pantheon. Although he continued to hold the Mahesamūrti as representing three different gods, the 'Amazon' figure (Ardhanārīśvara) was realistically though not quite accurately identified as the Ardhanārī Durgā, the consort of Śiva. The treatment of figures in the main temple, he found, ranged from the most gentle and soft expressions of modesty in the female to striking male images with their evocation of great fierceness and terror.[159]

For Elephanta the definitive work in this period was that of William Erskine in the *Transactions of the Literary Society of Bombay* (1819). Its quality was greatly enhanced by exquisite drawings of the Mahesamūrti [83, 84] and other figures and ornaments by Mrs. Ashburner. Like Babington on Māmallapuram, Erskine introduced the article with a background sketch of the state of European knowledge about Elephanta. According to him few 'remains of antiquity in the East had excited greater curiosity than the cave-temples of the Hindûs', because of the uncertainties about their age, purpose, and authorship, which were further increased by the absence of relevant historical tradition.[160] Ignorance of Hindu mythology led early travellers to put forward fantastic suggestions. Considering these limitations Niebuhr's account was the best one.[161] In view of the ignorance of Indian mythology on the part of early travellers Erskine's suggestion was to study the historical backgrounds of three major Indian faiths, Hinduism, Buddhism, and Jainism, all of which had certain affinities as well as differences. Erskine, who was able to make use of spectacular researches in the field of Indian religion and mythology by Orientalists, took a major step in

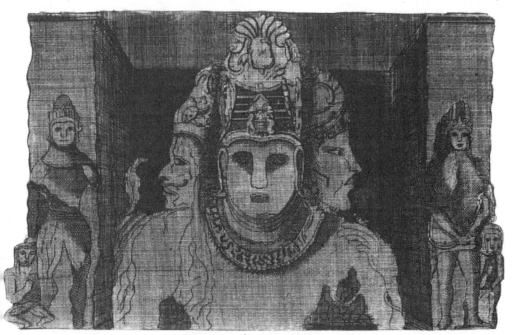

82. Goldingham's sketch of Maheśamūrti Śiva at Elephanta

formulating a methodology for Indian art history in the above sugges-
tion. On the question of the relative antiquity of Buddhist and Brahman-
ical sects he found the latter to have better claims. In analysing Hindu
and Buddhist architecture he arrived at the general conclusion that the
first type was commonly a square or oblong building with a flat roof,
while the second was pyramidal or shaped like the section of a globe.[162]
About Hindu images he stated: 'As in many of their incarnations, the
gods are supposed to have appeared with several heads, with the heads
of animals, with a number of hands, and other singularities; their
images in the temples correctly represent all these peculiarities.'[163] On
the other hand, as the 'Epicurean' Buddhists did not believe in super-
natural beings or in incarnations, 'no unnatural images, no figures
compounded of man and beast, no monster with many hands' were to
be seen in their temples.[164] Although somewhat over-simplified the idea
was correct in principle and with this rule of thumb Erskine drew some
important general conclusions about the three types of cave-temples in
western India:

Any monster, any figure partly human partly brutal, any multiplicity of heads
or hands in the object adored, indicate a Brahminical place of worship . . . The
presence of umbrella-covered pyramids or semi globes, and of simple human
figures sitting cross-legged or standing in a meditative posture, as certainly
shows the excavation to be Bouddhist. The twenty-four saintly figures without
the pyramid prove a temple to be Jaina.[165]

155

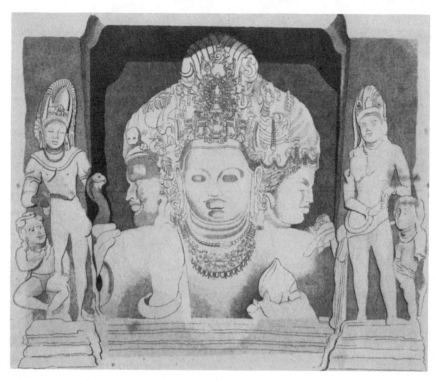

83. Mrs. Ashburner's drawing of Maheśamūrti

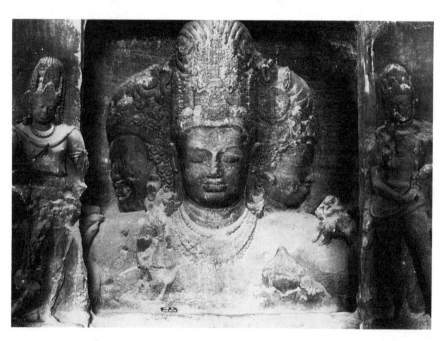

84. Maheśamūrti Śiva at Elephanta

He then proceeded to apply these principles to the particular case of Elephanta. The first question was its age. Like a number of his contemporaries Erskine preferred the early art of India to its later 'corruption'. But equally he made an essential distinction between the philosophical deistic faith of the Brahmans and the gross monstrous cults of the masses. In terms of history the simple, sublime Vedic religion gradually gave way to multiple symbolic gods of Hinduism. On the basis of Colebrooke's famous essays which argued that Śaiva and Vaiṣṇava cults arose long after Vedic worship Erskine successfully identified the iconography of Elephanta as deriving from *Purāṇic* mythology and concluded from this that the monument was not more than 800 years old— the period that witnessed the rise of these two religions. At one stroke the whole myth of its remote antiquity was demolished as it was brought within a conceivable historical era. Since then further researches have yielded results which have been responsible for some modification in its dating and now it is believed to date from the sixth century A.D. Yet the basic soundness of Erskine's position still holds.[166]

In specific identifications Erskine made similar valuable contributions. He correctly identified the great Maheśamūrti as the three faces of Śiva in accordance with the Indian tradition and roundly criticized previous authors for tracing parallels with the Christian Trinity. The other much misunderstood figure, called an Amazon in the sixteenth century by João do Castro and continued to be regarded as such by Valentia even in the nineteenth century, was first correctly identified by the mythographer Edward Moor in 1810 as the Ardhanārīśvara Śiva [50]. Of course, Goldingham had come close to identifying it. But basing himself on Moor's *Hindu Pantheon* Erskine was at last able to restore its true nature as the bisexual image of Śiva about which he stated: 'It is singular how much this distinction [man–woman] is preserved in all respects. The two sides of the cap are different ... ear-rings ... armlets are different ... The left breast is that of a female, and from being single has given rise to the idea that the figure represented an Amazon.'[167] The other celebrated figure, Śiva as the destroyer of the demon Andhaka, was rightly linked with Śaiva iconography, although its identification as Bhairava or Śiva in his terrific aspect shows ignorance of that particular myth.[168] In connection with these identifications he made a suggestion which was to prove very valuable for the study of Indian iconography, namely, that the chief marks of recognition of each Hindu deity were certain symbols or attributes by which it may be identified 'much as the family of an European may be discovered by its armorial bearings'.[169]

The prevailing interest in the sublime is reflected in Erskine's description of Elephanta:

the grand entrance of a magnificent temple, whose huge massy columns seem to give support to the whole mountain which rises above it . . . the gloomy appearance of the gigantic stone figures ranged along the wall . . . joined to the strange uncertainty that hangs over the history of the place—convey the mind back to distant periods, and impress it with that kind of uncertain religious awe with which the grander works of ages of darkness are generally contemplated.[170]

Unlike the typical devotees of the sublime, Erskine did not find Elephanta to be in sympathy with his taste. The term 'ages of darkness' not only takes us back to Baronius's description of the Middle Ages but also forward to Ruskin's prize poem about the idols of Elephanta, the clarion call for missionary efforts in India:

> Truth calls, and gladdened India hears the cry,
> Deserts the darkened path her father trod,
> And seeks redemption from the Incarnate God.[171]

Although Erskine had dutifully collected most impressive data on the detailed measurements of each part of the monument, he found the details tedious and uninteresting and presented them with a pronounced lack of enthusiasm. He found fault with much of its design and execution. After a meticulous examination, which befitted a surveying engineer, he found the columns lacking in regularity although they were very elegant and seemed to 'present to the eye the appearance of perfect regularity'.[172] His feeling is well brought out in the following extract:

Travellers have entertained very different ideas of the degree of genius and art displayed in this temple and the figures around it: some are disposed to rate them very high, and speak in rapturous terms of the execution and design of several of the compartments. To me it appears, that . . . while the outline and disposition of the separate figures indicate great talent . . . the execution and finishing of the figures in general (though some of them prove the sculptor to have had great merit) fall below the original idea, and are often very defective, in no instance being possessed of striking excellence. The figures have something of rudeness and want of finish, the proportions are sometimes lost, the attitudes forced, and everything indicates the infancy of the art. . .[173]

He went on to point out that the arrangement of the figures was even more defective and large compositions generally lacked an aesthetic and psychological unity.[174] From his study he came to the conclusion that the symbolic mythology of the Hindus discouraged the development of sculpture and painting which thrived on a successful representation of external objects and of various emotions on the human frame. If signs and attributes usurped the function of characterizing a particular god, there was then no room for the 'ingenuity of artist . . . to

158

indicate by the fine touches of his art, what is done by a rougher and grosser way'.[175] It was this conviction which led Erskine to criticize Sir Joshua Reynolds for seeking to restore certain 'hieroglyphic' elements in painting. The influences of the classical tradition and Romanticism came to the fore in Erskine's statement that the universal appeal of a style of art depended on its ability to represent external objects ideally and human emotions faithfully. The Indian approach to art was summed up:

The general use of such symbols, accordingly, appears . . . to have combined with other causes to blunt the sense of the Hindus for the fine arts: they are delighted to recognize a deity by his *Vahana*, his many heads and numerous arms, but they appear to set little value on the accurate delineation of a passion, or the fine forms that start from beneath the chisel or the pencil: the passion being represented by its artificial symbol, the natural sign loses its value.[176]

To Sir Charles Malet, a high-ranking administrator in the employ of the East India Company, Ellora had a very special attraction and he published in *Asiatic Researches* (1801) the results of his extensive measurements and explorations of the caves. Before the project was abandoned on account of his ill health he had been able to collect and document an enormous quantity of architectural evidence pertaining to these caves, with the help of James Manley who also prepared a ground-plan of Kailāsa. The most complete description of Ellora for the period, in terms of measurements of every major monument on the site, the article presented a table of dimensional figures to accompany each section devoted to a particular architectural site. Nine drawings [85] were made by an Indian, Gungaram. Apologizing for their quality, Malet declared that his intention here was only to arouse curiosity rather than gratify it. But for a fitting delineation of the beauties of Ellora the task was left to the taste and ability of the artist, James Wales [63]. As we have seen, Wales's drawings were posthumously published by Malet with the help of the Daniells. In Malet's paper the question of Ellora's authorship was brought up and settled in favour of an indigenous origin.[177] That the visit to Ellora was a thrilling experience for the Englishman was fully conveyed in his introductory statement:

Whether we consider the design, or contemplate the execution, of these extraordinary works, we are lost in wonder at the idea of forming a vast mountain into almost eternal mansions. The mythological symbols and figures throughout the whole, leave no room to doubt their owing their existence to religious zeal, the most powerful and most universal agitator of the human mind.[178]

All the different caves and excavated temples were subjected to scrutiny. Each part of a piece of architecture was thoroughly measured, the results being presented in the form of a table relating to a particular

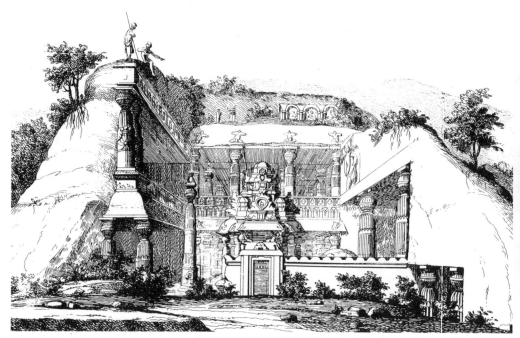

85. View of Ellora in Malet's article

building, so that a complete list of proportions, general design, and the distribution of each element was made available to scholars. The iconographic features were deciphered with the help of Brahman guides with the result that all the Hindu caves and excavations were correctly identified while even the Jain and Buddhist caves were attributed to the Hindu chisel. Malet admired the so-called Jagannātha Sabhā but failed to recognize it as Jain. Here he gave an important account of the ceiling paintings:

The ceiling . . . very handsomely painted . . . consisting of figures . . . both of men and women . . . the former . . . bare-headed with short drawers . . . women with only the lower parts covered. Some of the painted figures have highly ornamented head-dresses like *Tiaras* . . . it seems an argument against the antiquity of the painting, that much of the fine sculpture and fluting of the pillars are covered by it, which, it may be supposed, would not have been done by the original artist.[179]

Another Jain monument, the Indra Sabhā, was likewise identified as a Hindu fabric. Malet admired an obelisk here which had a light appearance and 'was fluted and ornamented with great taste'.[180] Because of the great abundance of figures he did not know whether to admire 'the minuteness of the parts or the beauty of the whole'.[181] The various proportions were, however, carefully presented in order to bring out the beauty of its form. The major Hindu cave Dhumar Lena was

160

recognized and the great Śiva Gajāsuravadha figure was rightly connected with this god, although it was held to tell the story of Vīra Bhadra and the sacrifice of Dakṣa.[182] In the Hindu Rameswara cave, the beauty and grace of relief sculptures and pillars were noted.[183] But understandably the great Kailāsa [20] took his breath away as he declared: 'This wonderful place . . . exhibits a very fine front . . . a vast area [is] cut down through the solid rock of the mountain to make room for an immense temple, of the complex pyramidal form, whose wonderful structure, variety, profusion, and minuteness of ornament, beggar all description.'[184] Malet praised the fine simplicity of Tin Thal, and considered the form of the Buddhist Viswakarma cave 'in beauty second to none, in form unique, in design elegant'.[185] Although he could not recognize the Buddhist character of the Viswakarma cave, he pointed out that its arched roof reminded him of that of Kānheri.[186]

In 1820 W. H. Sykes read a paper at a meeting of the Bombay Literary Society where he respectfully analysed Sir Charles Malet's errors. He suggested that they were due to the use of Brahman guides who confused the Brahman and Buddhist caves. While his criticism was perfectly justified, Sykes fell into a similar error because he did not allow for the existence of yet another sect, the Jains. When he identified the colossal 'naked' figure as the Buddha he simply failed to read the meaning of two revealing points: that the figure was still worshipped by the local Jains and that traditionally only Digambara Jain figures were depicted totally naked.[187] Like Malet the British officer paid a tribute to Kailāsa:

I cannot quit Kylas without expressing my opinion of the utter impossibility of doing justice to it by any description however diffuse. The design and magnitude of the work indicate a fertility of invention, and ability, energy and perseverance in the execution, incompatible with the apathy and indolence of the present Hindoos. Kylas must be seen to be justly appreciated.[188]

Sykes made a most interesting remark about the ceiling of the Viswakarma cave: 'I have already said it is the only grand arched temple at Ellora. The design of the cave corresponds with that at Karlee and the grand cave at Kenera; the arched roof being supported by the representation of wood-work not unlike the ribs of a ship.'[189] The peculiar feature of the ceiling which gives the impression of the inverted hull of a boat may have actually been derived from the construction of boats as the remains of wooden ribs in some of the *caityas* seem to suggest.

Methods for studying these different monuments in terms of style emerge from Sykes's discussion. To take up the question of chronology first. He disagreed with those who held that Brahmans and Buddhists were in a perpetual state of war because, he suggested, 'the temples of the both . . . indiscriminately had the same labour and expense

bestowed upon them.'[190] As the evidence seemed to make it clear that there was no basic difference between the two forms of art the conclusion was that one grew out of the other. Basing himself partly on Colebrooke's articles on Indian religions[191] and partly on the current evolutionary notion which correlated simplicity and antiquity, Sykes came to the conclusion that Buddhism and Buddhist art were the most ancient in India and that Brahmanism was the later development of Buddhism. On studying Buddhist and Hindu art Sykes found that as far as the general formation and design of temples, the ornament and figure sculptures, and the dress of the figures were concerned there was a certain unanimity of tastes. But how was one to distinguish between them? The answer was that Hindu excavations would yield fanciful mythological figures, whereas in Buddhist caves the figure of Buddha would be represented without ornaments.[192] One may note finally that he had provided nineteen illustrations and two inscriptions in the article.

In the early period the finest illustrations of Ellora caves appeared in the two articles by R. M. Grindlay in the *Transactions of the Royal Asiatic Society* dated 1830. These drawings [86, 87] were undertaken in order to illustrate the 'magnificence of design, the justness of proportion and the surpassing richness of ornament' of Ellora sculptures whose great antiquity and superior quality were widely acknowledged. These pictures helped to show that the 'art of sculpture formerly existed in India in a much higher state of perfection than is generally supposed'.[193] Ample evidence was already provided by the fragment from a colossal Elephanta figure in the collection of Sir Charles Forbes. Artists considered it as indicating a highly refined taste.[194] These sculptures did not, of course, match the classical purity of Greek art. Neither did the Indian sculptors succeed in rendering the muscular form. But they had no living models for it, as in India the Apollo Belvedere rather than the Farnesian Hercules was generally to be encountered. None the less the figures displayed 'considerable grandeur of design and intenseness of expression'.[195] To Grindlay the very fact that the sculptures at Ellora were some of the finest in India as well as the obscurity which surrounded the past history of Ellora made him attribute a 'remote antiquity' to the site. On the one hand it was a style of building refined by ages of practice and experience and on the other it could not but have been produced for a powerful and refined people living in a state of peace and prosperity.[196] Grindlay, who preferred Ellora to Elephanta, remarked:

The superior execution observable in the remains of sculpture and architecture throughout India appears to be in proportion to their antiquity: the more rude, though not less stupendous excavations at Karli . . . in the islands of Salsette

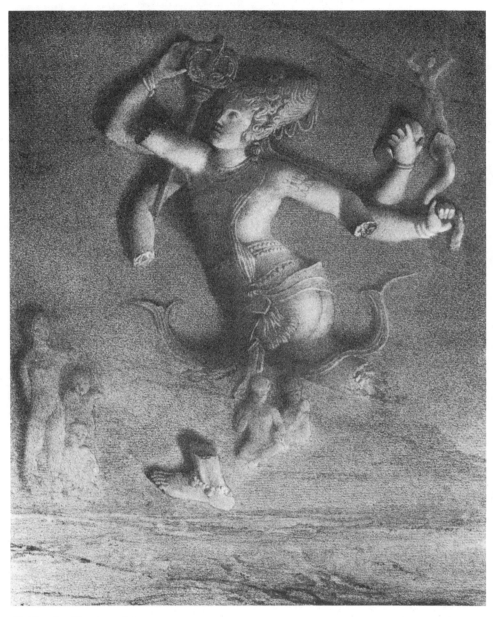

86. Dancing Śiva from Ellora in Grindlay's article

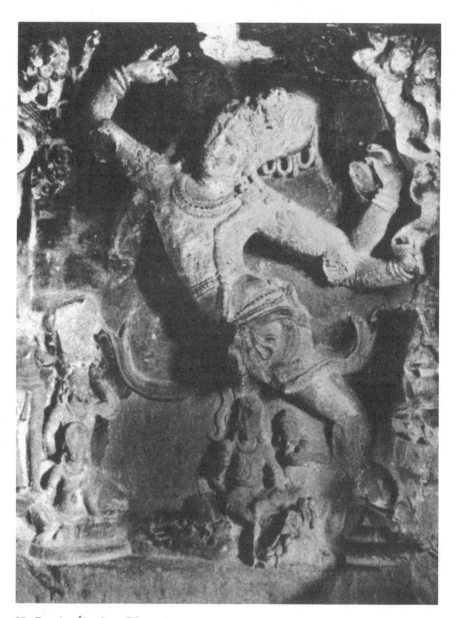

87. Dancing Śiva from Ellora

and Elephanta, and in other parts of the coast, bear similar relation to their respective distances from the seat of government, and, consequently from the source of art and refinement which was to be found alone in the interior.[197]

Although Grindlay admired Ellora, as a Protestant and a rationalist he found that religion encouraged an extravagant approach to art, to be seen no less in India than in Italy in the works of great painters like Raphael, Michelangelo, and Guido Reni.[198]

Henry Salt, who had accompanied Lord Valentia on his tour and was later to become the Consul-General in Egypt, made an extensive survey of the various monuments on the island of Salsette. An accurate ground-plan and sections were prepared by Major Atkins while Salt himself made very fine drawings of the different parts of each monument. These and a detailed and generally accurate iconographic and descriptive account of the caves of Salsette, such as Kānheri, Mandapeswar, and Jogeswari, were published in the *Transactions of the Literary Society of Bombay* in 1819. He correctly identified the Buddha figures as well as making drawings of them which were carefully studied by Sykes for his identification of the Buddhist caves at Ellora [88]. In the Yogeswari caves the windows were described as 'exactly the Venetian, or what are now termed Wyatt windows'.[199] He found the chapel in Mandapeswar elegantly finished and was struck by the manner in which Kānheri *caitya* suddenly 'bursts upon the view'.[200] He also remarked on the similarity of the external appearance of the same monument to Gothic buildings [89].[201] On the whole he did not care for the sculptures of these temples for they were 'by no means well proportioned',[202] and yet they were able to express a certain grandeur and simplicity.

The most important discovery of the nineteenth century was undoubtedly that of the Ajanta caves and their paintings. They were rediscovered by British army officers in 1819 and described in depth for the first time by James Alexander in the second issue of the *Transactions of the Royal Asiatic Society* (1830). Alexander, who was in Ajanta in 1824, declared that it was equally worthy of a minute investigation and much deserved recognition of its importance in scholarly circles, although he confessed his inability to rival Seely's bombastic phrases with regard to Ellora.[203] Alexander found that, while Ellora and Ajanta caves bore a certain external resemblance, there were many differences. First of all, Ajanta lacked minute ornamental sculptures in comparison with the exquisite pantheistic reliefs of Ellora. To compensate for the absence of ornamental sculptures there were paintings in fresco, 'much more interesting, as exhibiting the dresses, habits of life, pursuits, general appearance, and even features of the natives of India, perhaps, two thousand or two thousand and five hundred years ago, well

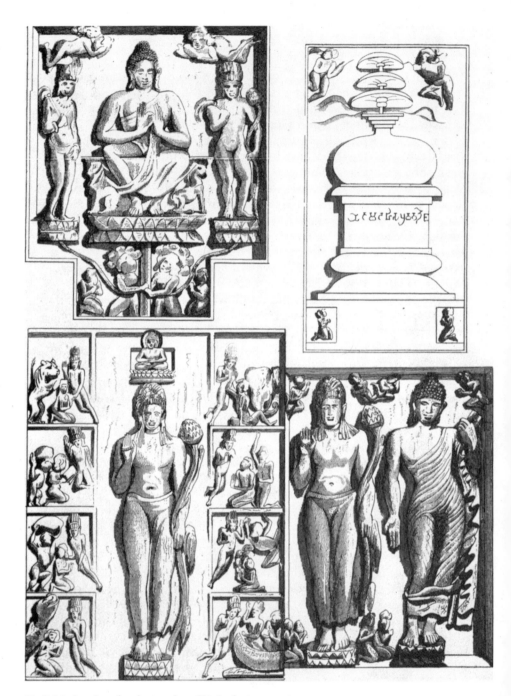

88. Salt's drawing of sculptures from Kānheri caves

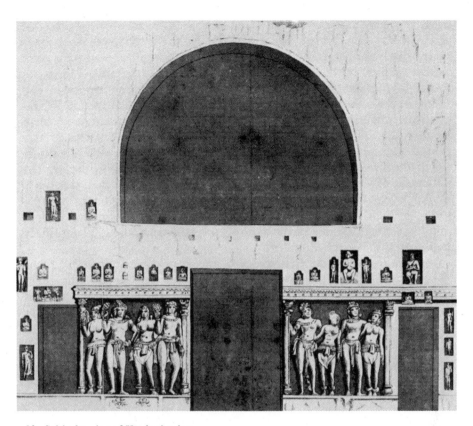

89. Salt's drawing of Kānheri caitya

preserved and highly coloured, and exhibiting in glowing tints, of which light red is the most common'.[204] A further assessment of paintings in the caves was made:

In the gallery, or passage behind the pillars, are fresco paintings of Buddha and his attendant supporters ... The colours are very vivid, consisting of brown, light red, blue and white: the red predominates. The colouring is softened down, the execution is bold, and the pencil handled freely; and some knowledge of perspective is shewn ... The paintings in many of the caves represent highly interesting and spirited delineations of hunting scenes, battles etc. The elephants and horses are particularly well drawn.[205]

The age of the caves was guessed mainly on the basis of their simplicity, although it must be stressed here that it was too early to realize that the different caves at Ajanta belonged to different ages. These caves were excavated when Jains and Buddhists were in full power and had not succumbed to Hindu persecutions, as Alexander pointed out, who

167

held the view that monotheism and simple forms of worship preceded elaborate rituals. The art based on early Indian religions at Ajanta was accordingly simple and less developed. Alexander disagreed with those who regarded the 'arched' temples of Ajanta, Karle, and Kānheri as being later than the flat-roofed Elephanta because the argument was that Hindus were unacquainted with the construction of an arch. Therefore the conclusion reached by Alexander was that these caves were two to three thousand years old and that 'these vast excavations must have been hewn out of the living rock, while the Jains were in the plenitude of their power, and long before the persecutions had begun by the followers of Brahma, I think we may safely assert that their antiquity is much greater than that of either the Ellora or Elephanta excavations.'[206] At the end of the article he confidently declared that he had made a strong case for Ajanta against 'the grotesque, though beautifully sculptured deities of Ellora'.[207]

A decade earlier the first notice of the Bāgh caves appeared in the *Transactions of the Literary Society of Bombay*. Written by F. Dangerfield who also provided several drawings [90], the paper contained some very interesting remarks on painting. He observed that the paintings on the roof, which was divided into square compartments, were in a 'superior style'. He not only made a general survey:

The whole of the walls, roof, and columns of this cave have been covered with a fine stucco, and ornamented with paintings in distemper of considerable taste and elegance. Few colours have been used, the greatest part being merely in *Chiaro scuro*; the figures alone, and the Etruscan border [for such it may be termed], being coloured with Indian red.[208]

but also gave a more detailed verdict on the paintings:

The roof . . . [had designs of] fruits, flowers, and the like . . . they appear . . . to have been executed with considerable effect and correctness of light and shade . . . many yet brilliant traces of the border . . . male and female figures . . . Such of the lower parts [the legs and feet] as remain, show them to have been executed in a style of painting far surpassing any thing in the art which the natives of India now possess.[209]

The first phase of archaeological writings is brought to a close with A. Stirling's extensive surveys of the antiquities of Orissa in volume fifteen of *Asiatic Researches* (1825). The great profusion of buildings in Bhubaneswar around the Liṅga Rāj temple gave Stirling the impression of a city. As he remarked, one found oneself in the midst of a ruined city as 'the great Pagoda of the Ling Raj . . . lifts its singular form, eminently conspicuous both for size, loftiness, and the superior style of its architecture.'[210] He concluded from the number of temples that in the past it was one of the greatest cities, whose reddish sandstone build-

90. Dangerfield's sketch of Bāgh caves

ings were remarkable for style, size, and decoration. The Liṅga Rāj temple impressed him enough not only to be illustrated by him in his article [91] but to make it the cornerstone of his analysis of Orissan temple style.

The forms and character of all the principal temples at Bhobunéser, and indeed throughout the province, being exactly similar, a more particular account of the plan and distribution of the great Pagoda will answer the purpose of a general description . . . About the centre, the . . . tower . . . or sanctuary . . . rises majestically to a height of one hundred and eighty feet . . . [the summit of which is] shaped somewhat like a turban, which forms so distinguishing a feature in the temple architecture of Orissa. . .[211]

The whole grandeur of the temple was enhanced by the richness of its decoration and figure sculpture. In contrast to 'the finest monument of antiquity which the province contains, and likewise indisputably the most ancient',[212] the temple of Jagannātha at Puri, 'the mirror of all wickedness and idolatry',[213] was described as an inferior work. On the other hand, Stirling found near the same temple a column 'remarkable for its light and elegant appearance and the beauty of its proportions, which supports a figure of Hanuman'.[214]

The sun temple at Konarak, illustrated with a plate, forms in some ways the most interesting part of his article. He mentioned that the great tower of the temple, known in English maritime charts as the

169

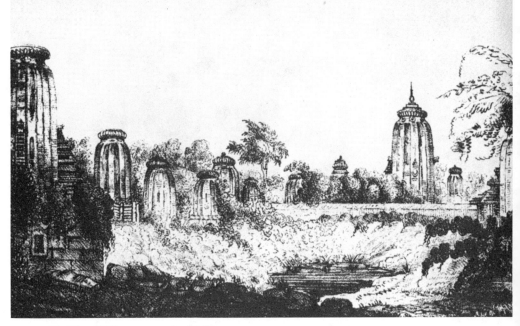

91. View of Bhuvaneswar by Stirling

Black Pagoda, was destroyed by some unknown but 'extraordinary force'. None the less, 'The Black Pagoda even in its present imperfect and dilapidated condition presents a highly curious and beautiful specimen of ancient Hindu temple architecture, and . . . we may here study at leisure and without interruption some of the most striking peculiarities of that style.'[215] In an age when mechanical inventions were not available the use of such large masses of stone and iron for the construction of the temple at Konarak particularly impressed Stirling. He also admired the alternation of massiveness and elegance in the temple design and remarked that the

the exterior of the side walls, as of the roof, is loaded with a profusion of the richest sculptured ornaments . . . The human figures are . . . frequently in the very act of sexual intercourse . . . Generally speaking, the style and execution of the larger figures, are rude and coarse, whilst the smaller ones display often much beauty and grace.[216]

On balance, he felt that 'the style of the black Pagoda betrays, in the rude and clumsy expedients apparent in its construction, a primitive state of some of the arts, and a deficiency of architectural skill', although the 'whole of the sculpture . . . is executed with a degree of taste, propriety and freedom which would stand comparison with some of our best specimens of Gothic architectural ornament'.[217]

170

92. Flaxman's drawing on Indian
subject

iv. FROM REYNOLDS TO RÁM RÁZ

The important group of rock-temples around Bombay, Elephanta,
Kānheri, Mandapeswar, and Yogeswari, the monuments of Karle and
Ellora, the southern temples of Māmallapuram, Tānjore and Mādurā,
and the temples of the east, notably Bhuvaneswar and Konarak, had
been presented in archaeological journals with increasing accuracy. At
the exhortation of archaeologists, most of whom were important East
India Company officials, the British government began to take an
active interest in the preservation of major antiquities. There is the
instance of government efforts to prevent a further deterioration of
Elephanta by putting up a fence around the main temple in the nine-
teenth century.[218] At the same time, Indian architecture, which had
caught the romantic imagination, was beautifully delineated in aquatint
and other kinds of prints. The sites of the cave temples on the western
coast had become the favourite picnic spots for European residents in
Bombay. Information about Indian architecture, sculpture, and paint-
ing continued to grow from the middle of the eighteenth century as
they began to be increasingly mentioned in books on widely differing
subjects. Major artists like Reynolds and Flaxman [92] took notice of
them. Reynolds, who possessed an album of Indian miniatures, even
advocated the introduction of Indian elements in European architec-
ture. For his interest in Indian architecture Hodges was largely re-
sponsible:

171

The Barbarick splendour of those Asiatick Buildings, which now are publishing by a member of this Academy, may possibly, in the same manner, furnish an Architect, not with models to copy, but with hints of composition and general effect, which would not otherwise have occurred.

It is, I know, a delicate and hazardous thing, . . . to carry principles of one art to another, or even to reconcile in one object the various modes of the same Art, when they proceed on different principles . . . A deviation from them, [Grecian architecture] . . . fit only for a great master, who is thoroughly conversant in the nature of man, as well as all combinations in his own Art.[219]

In a lecture on Egyptian sculpture John Flaxman had remarked that the

stupendous excavated temples of Ellora, Elephantis and other parts of India . . . are of high antiquity, and adorned throughout with mythological sculpture, the subjects of which are symbols, allegorical personages, and groups of figures expressing various attributes and energies of divine power, providence, and manifestation, according to the Brahman system . . . although [Indian sculpture] bears some resemblance to the Egyptian, it is inferior both in science and likeness to nature.[220]

Flaxman knew the works of Moor and Maria Graham.

John Martin's famous extravaganza, the painting called *Belshazzar's Feast*, partly inspired by the Seatonian prize poem by the Reverend T. S. Hughes, contained Elephanta columns. The painting [93] took its inspiration from the idea that the monarch's buildings were the products of the joint talents of Indian, Egyptian, and Babylonian architects, brought back to Babylon after Nebuchadnezzar's conquest of the first two nations.[221] Indian sculpture occurs also in John Gandy's phantasy-picture [94] representing the progress of the arts.[222]

In literature too Indian art was widely noticed. In Diderot's *Encyclopédie*, among a number of entries on India and its arts, there is an account of Elephanta under the heading of 'isle'. Elephanta, 'une des choses les plus célèbres dans voyageurs Portugais', had figures, as noted by the authors, which tore little children to pieces.[223] This was probably the strangest transformation of the subject of Śiva slaying the demon Andhaka [54]. For his compilation of the encyclopedia Diderot had used Indian miniatures that belonged to the Bibliothèque Royale.[224] In the nineteenth century for the first time Indian art found a place in works devoted exclusively to art and not only to ethnography. In Millin's well-known *Dictionnaire des beaux-arts* (1806) there are extensive discussions including the mention of known collectors of Indian art such as Ashton Lever, Townley, and Abbé de Tersan. Millin, who advocated the view that the cave-temples near Bombay were not only very ancient but that they preceded the Egyptian pyramids, also provided detailed measurements. Aesthetically Indian architecture was

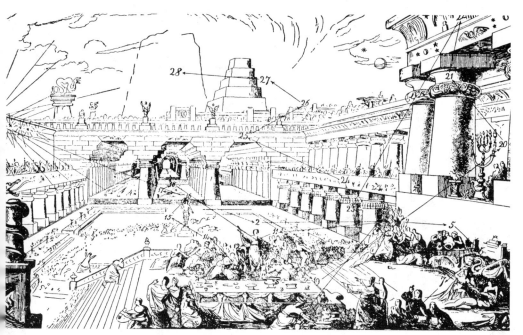

93. John Martin's 'Belshazzar's Feast'

regarded as being inferior to the Greek but more pleasing than the Egyptian.[225]

The strangest case was the inclusion of Indian art [95] in a work on the monuments of ancient Gaul. The author, Grivaud de la Vincelle, a sworn diffusionist who was able to recognize the universal nature of the sexual symbolism expressed in obscene objects found in different parts of France, wrote: 'It was by chance that we came upon in Paris about ten years ago several mythological sculptures from India of which the most remarkable were a large idol and a plaque with figures in relief.'[226] Included in the work were speculations about their nature and meaning.

In works dealing specifically with matters relating to India there was usually a section on Indian art. James Mill's famous *The History of British India* (1817) naturally contained a section on the arts. Associated with the school of political philosophy known as 'utilitarianism', Mill had a particularly low view of Indian society which he propounded in his colonial history. Like the philosopher Bentham he believed in the necessity of improving the human condition by means of enlightened laws and like Macaulay he was convinced of European superiority in all fields. The general argument was that Asian societies existed in the depths of degradation under unenlightened and irresponsible despots. In a society where the ruler imposed such misery the arts could not conceivably flourish. Earlier on, another 'progressivist', Sonnerat, had seen the achievement of Indian art in terms of its society and had come

173

94. John Gandy's picture of the progress of the arts

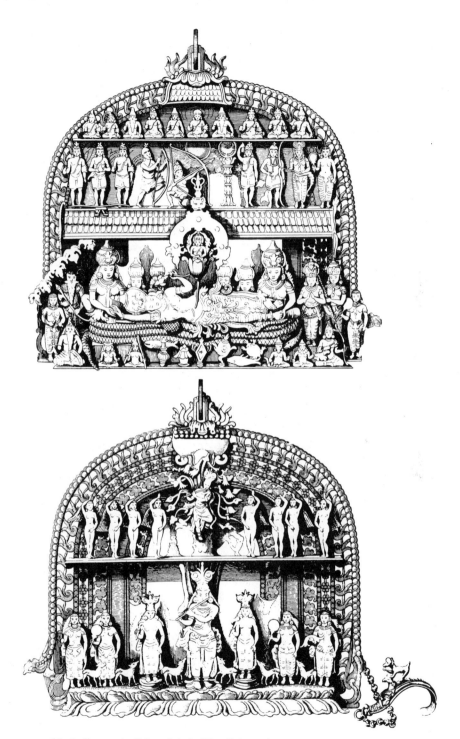

95. Indian art in Grivaud de la Vincelle's work

forward with a negative answer; a similar unflattering view was held by Abbé Raynal. Mill, who naturally endorsed this view, clearly stated: 'the improvement of the arts may be taken as one of the surest indications of the progress of society.'[227] Again as a 'progressivist' who believed in the superiority of European art, he argued that the arts in India were in a primitive state. He was willing only to concede that some progress had been made by the Hindus in the practical arts. In his words: 'Architecture, weaving, jewellery, are the only arts for which the Hindus have been celebrated; and even these, with the exception of weaving, remained at a low state of perfection.'[228] Mill realized of course that he was fighting against the prevailing tide of opinion about the 'celebrated' Indian architecture. He therefore decided to turn the full brunt of his incisive pen towards Orientalists and demolish the tradition which had grown up around the antiquity and excellence of Indian art. It is worth noting that Gothic architecture too was dismissed in the same manner by him. But for Mill the excellence of architecture rested on the ability of the architects to construct arches. This curious notion was no doubt influenced by the reports of English[229] archaeologists that the Hindus were never able to construct a 'true' arch. The attitude reflects the failure on the part of Mill and others to distinguish between what Lionello Venturi calls the artistic and the constructive elements in architecture.[230]

The general progress of architecture was discussed by Mill:

Antecedently to the dawn of taste, it is by magnitude alone, that, in building, nations can exhibit magnificence . . . in honour of gods . . . The Gothic cathedrals, reared in modern Europe, which remain among the most stupendous monuments of architecture . . . were constructed . . . at comparatively a very low stage of civilisation and science.[231]

While denying the general excellence in Indian art and architecture he felt that praise of the applied arts and especially of weaving would not weaken his basic argument:

of the exquisite degree of perfection to which the Hindus have carried the productions of the loom, it would be idle to offer any description . . . the only art which the original inhabitants . . . have carried to any considerable degree of perfection . . . to the skill of the Hindus in this art several causes contributed. It is one of the arts to which the necessities of man first conduct him.[232]

It is important to remember this distinction between the 'fine' and 'applied' arts for the first demanded intellect while the last only required a certain degree of skill. The argument which we see here only in a rudimentary form was to be presented with great refinement by Ruskin in his criticisms of Indian art.[233] According to Mill not only was Indian art primitive, unattractive, rude in taste and genius, but 'unnatural,

offensive and not infrequently disgusting'.[234] In painting what Indians had achieved was negligible:

The Hindus copy with great exactness, even from nature. By consequence they draw portraits, both of individuals and of groups, with a minute likeness; but peculiarly devoid of grace and expression . . . They are entirely without a knowledge of perspective, and by consequence of all those finer and nobler parts of the art of painting, which have perspective for their requisite basis.[235]

One cannot afford to underestimate Mill's opinions for even Hegel was to depend on the English Utilitarian for his remarks on Indian culture.[236]

Mill was in a minority among Indian specialists. Some twenty-five years before, the ancient historian, William Robertson, while discussing the progress of the arts and sciences, had regarded India as one of their earliest homes.[237] To him the cave temples, one of the earliest forms of architecture, indicated a developed state of society as equally the sculptures in them reflected considerable achievement for the period.[238] According to a certain Colonel Coll the elegance of the temples of Ellora and Elephanta was 'proof of the early and high civilization of the Indians'.[239] As society progressed in India, temple-building improved. The highly ornamented fabrics of great antiquity in India were 'monuments of the power and taste of the people by whom they were erected'.[240] Among a number of examples the ornamental parts of Chidambaram in particular were finished with an elegance 'intitled to the admiration of most ingenious artists'.[241] Robertson was impressed with the early development of science in India, for he had read in Le Gentil that the position of an Indian temple was determined with scientific precision.[242]

From the mid-eighteenth century onwards different aspects of Hindu civilization were given increasing attention. Holwell, Dow, Orme, and Halhed had given flattering accounts of Hinduism and Holwell had illustrated his work with popular mythological pictures from Bengal. Important accounts of India were also to be found in D'Anville's and Rennel's geographical works and in many other authors.[243] The Reverend Thomas Maurice, a fervent believer in the Indian *sagesse*, made a *bravura* display of his erudition in the last of the great diffusionistic works on India. In his *Indian Antiquities* he felt he had succeeded in proving an intimate connection between Greece, Rome, and ancient Britain on the one hand and India on the other. In justification of his work he wrote: 'I seemed to be under the necessity of writing, not so much the history of Hindostan, as THE HISTORY OF ASIA ITSELF, AND OF THE HUMAN RACE IN THEIR INFANT STATE.'[244] His work was profusely illustrated with either popular

177

Indian paintings or plates from famous travellers such as Baldaeus and Niebuhr.

For us by far the most important guide to Hindu mythology and particularly its role in Indian iconography was published in 1810 by Edward Moor. Admittedly, the *Śrī-sarva-deva-sabhā* (the audience-hall of all gods) or *The Hindu Pantheon* contained some inaccuracies. For instance, it described the Maheśamūrti Śiva as the triad of three gods, Brahmā, Viṣṇu, and Śiva.[245] But it was encyclopedic in scope and brought together most, if not all, that was known about Hinduism and Indian mythology. More important still, all the literary material was painstakingly compared with numerous examples drawn from art. Moor knew no Sanskrit but he was helped by friends such as Wilkins and other eminent Sanskritists. His illustrations were based on his own collection, the collections of Lord Valentia, Colonel Mackenzie, Lord Arthur Wellesley, the famous 'Hindoo' Stuart, and the Museum of the East India Company in London. Stuart's important collection of Pāla sculptures went to the British Museum.[246] Apart from a series of zinc casts of Indian gods [96] made under Wilkins's direction in order to educate the English public, there existed in the East India Company Museum two important sculptural fragments. Both were from the rock-temples near Bombay and one was most probably from Kānheri [97].[247] Among Moor's illustrations there were some fine Indian miniatures [98]. Moor had also made use of archaeological researches. He in his turn was able to provide the correct identification of Ardhanārīśvara Śiva which was duly noted by archaeologists.[248]

Moor's *Hindu Pantheon* followed the European tradition of publishing extensive pantheons of classical and ancient Near Eastern gods, a typical example of which was John Bell's *New Pantheon* (1790). In these pantheons the nature and genealogy of different gods were discussed and illustrations provided. Moor's pantheon had considerable influence outside the circle of scholars interested in India. His plate of the goddess Kālī, engraved by the artist Houghton, had inspired William Blake.[249] *The Hindu Pantheon* contains nearly 2,000 mythological figures, including the gods, Brahmā, Viṣṇu, Śiva, Viśvakarmā, Sarasvatī, Lakṣmī, Pārvatī-Durgā, Gaṇeśa, Kārttikeya, Indra, Sūrya, Agni, and Kṛṣṇa, all of which are copiously commented upon and accompanied by plates. The work betrays the residues of diffusionism and the influence of Sir William Jones. The ancient Western gods were generally traced back to India.[250] In a typical manner a distinction was made by Moor between Brahmanical philosophical religion and the superstitious cults of the common people. The feature that struck Moor with regard to the Hindu pantheon was the unbounded 'rage for personification'.[251] A section was finally devoted to the phallic cult, and to the *Yonī-liṅga* image in

178

96. Zinc casts of Indian divinities in *Hindu Pantheon*

97. Kānheri fragment in *Hindu Pantheon*

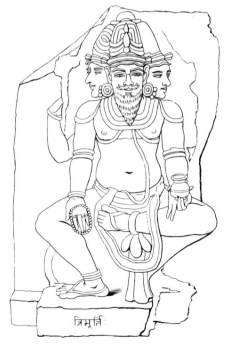

particular. Although Moor admitted that the *liṅga* image was not visually offensive, the erotic art displayed on temples was regarded by him as thoroughly indecent. The attitude was fairly representative but it was the very opposite of that which Payne Knight and other antiquarians held.[252]

The most important nineteenth-century compendium of Indian art and antiquities, *Monuments anciens et modernes de l'Indoustan*, appeared in two volumes in 1811 and 1821 respectively. Its author, Louis Langlès, a distinguished member of the French Asiatic Society and in charge of the Royal Library in Paris, had translated into French the travel journal of the Daniells. Langlès kept in close touch with the English Orientalists in India and there was not a single important account of Indian antiquities that did not find place in his work. In an inevitable discussion of the age of various monuments Langlès left open the more general question of India's antiquity since a new series of writings had already begun to appear which seriously questioned previous assumptions.[253] The analysis of major examples of Indian architecture included the mention of generally agreed dates concerning them and a description gathered from different authors, but it gave less attention to stylistic analysis. The temples of Mādurā [99], Śrirangam, Tānjore, Trichinapalli, Mysore, Elephanta, Ellora, Puri, and Māmallapuram were copiously documented, while some of them were embellished with beautiful prints [100] from the *Oriental Scenery* by the Daniells.[254] The French scholar also sought to present a most complete and classified account of Indian gods [101] and their iconography. For illustrating Hindu mythology and Indian society Langlès made extensive use of Indian miniatures [102] deposited in the Royal Library, some of which were of high quality. But he also made use of the collection of mythological paintings [48] executed by the so-called Brahmane Sami (Brahman *Svāmī*).[255] They were crude compared with other fine miniatures in the work.

Until 1834 the principles of Indian architecture known in Europe were almost exclusively based on observations of existing buildings made by European travellers and archaeologists. Those who sought to make formal studies of these monuments drew their conclusions from an application of European methods of studying works of architecture. But they had no way of knowing whether the same principles had any application at all in the case of Indian architects and their particular methods of building. Very little was known about the aesthetic manuals, the *Śilpa Śāstras*, although William Jones with his usual perspicacity had stressed the importance of these texts. To a young south Indian, Rám Ráz, fell the task of communicating to learned Europeans the substance of Indian aesthetics, the architectural problems faced by

180

98. Indian miniature in *Hindu Pantheon*

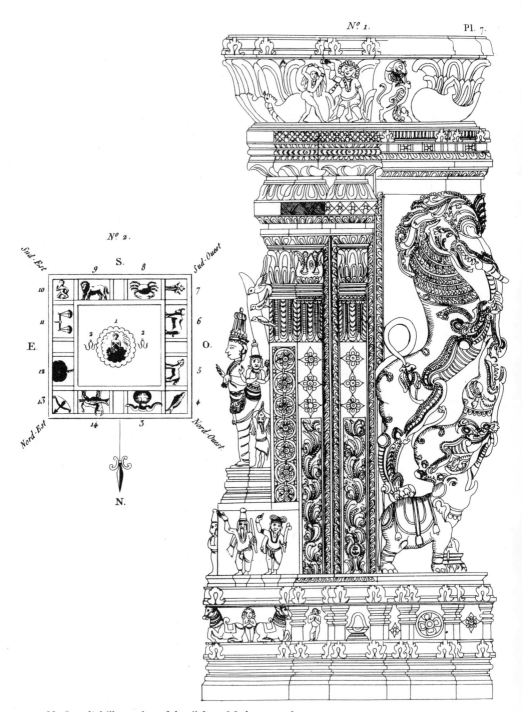

99. Langlès' illustration of detail from Madura temple

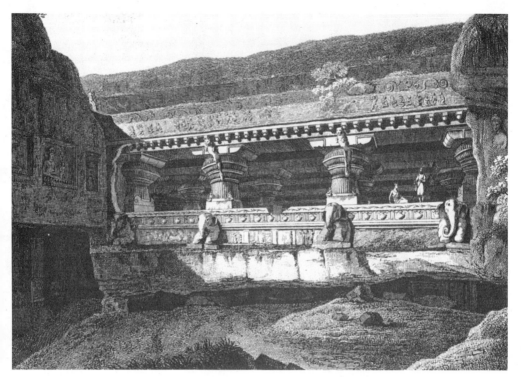

100. A page from *Oriental Scenery* in Langlès

Hindu craftsmen, and the solutions they came up with. Descended from an impoverished noble family, Rám Ráz began his career as a petty clerk, subsequently becoming the headmaster of an English-language school and ultimately rising to the position of a local judge. Richard Clarke, an English resident in India, recognized his linguistic abilities and encouraged him to translate into English Sanskrit texts on architecture. Rám Ráz at once set about this task with great enthusiasm. Although he enlisted the help of learned Brahmans, he realized at the same time that the technical terms used in the texts collected by him would be very difficult to interpret. On realizing further that most of these words had gone out of use he decided to seek the assistance of a certain sculptor from the Cammata tribe who was well acquainted with the applied side of Indian architecture. Although Rám Ráz was able to complete the work he did not live to see its publication. Thus in 1834 Europeans had their first glimpse of original Indian texts elucidating the principles of Indian architecture and the aims and achievements of Indian artists and architects.[256]

The importance of *The Essay on the Architecture of the Hindus* was fully recognized by Richard Clarke who stated in the introduction: 'If it shall appear that he has established the claim of his countrymen to the

183

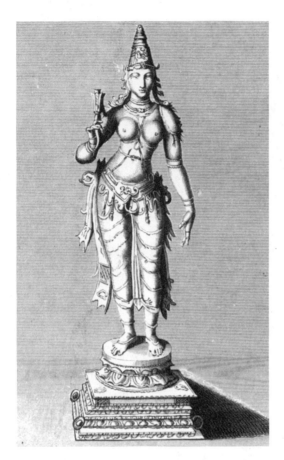

possession, in an eminent degree, of a knowledge in the art, and this at a period when its principles were but little understood among Europeans, he will have accomplished a task which he fondly looked forward to with every confidence of success . . .'[257] But recognition was slow to come. William Daniell and the Sanskritist Wilkins received the *Essay* with enthusiasm.[258] It was used by the German art historian Franz Kugler in 1842[259] and by the designer Owen Jones in 1856. An admirer of Indian design, Jones had quoted the following lines from Rám Ráz in support of his view that ancient Indians had a higher form of architecture than was generally supposed: 'Woe to them who dwell in a house not built according to the proportions of symmetry. In building an edifice, therefore, let all its parts, from the basement to the roof, be duly considered.'[260]

In his general discussion of Indian architecture Rám Ráz took note of the antiquarian debate on the antiquity of Indian civilization:

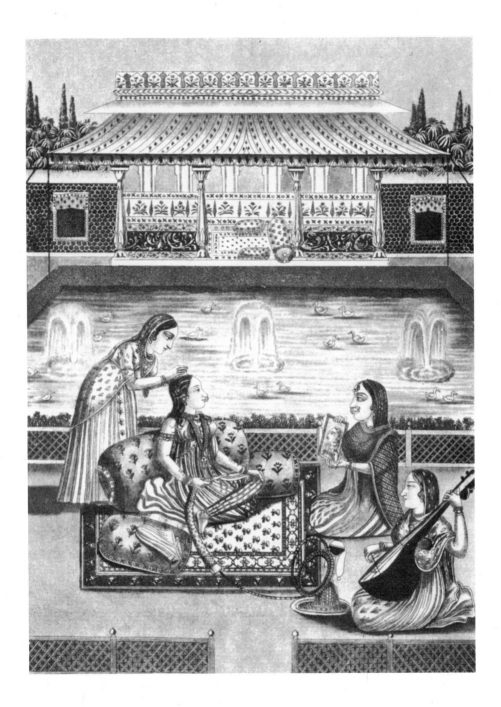

102. Indian miniature in Langlès

A correct account . . . of the art of building practised by the *Hindus*, must throw considerable light on the early progress of architecture in general. Some of the Western authors have traced a certain resemblance in the leading features of the buildings in Egypt and India, and have thence concluded that there has very early been a communication of architectural knowledge between the two countries.[261]

He was at the same time able to see that this superficial resemblance between Indian and Egyptian architecture could have been accidental. He also sensibly refused to speculate on the respective indebtedness of the two countries until he had more supporting evidence.[262]

Proceeding to deal with actual Sanskrit texts he, first of all, corrected William Jones's error that the traditional sixty-four treatises of the *Śilpa Śāstra* did not deal with sixty-four different arts and crafts but with either architecture or sculpture. The greater part of the *Essay* was based on the aesthetic manual called *Mānasāra*. This text, which had preserved detailed instructions regarding the building of sacred edifices, was consulted by practising architects down to Rám Ráz's day. *Mānasāra*, available for the first time in English translation, gave exact measurements of the different proportions used in different styles of architecture. It was indispensable for the construction of both sacred and secular buildings for it had something to say about each of the craftsmen involved in their construction, namely, the architect, the measurer, the joiner, and the carpenter. The various qualifications of an architect mentioned in *Mānasāra*—that he had to know different sciences, arithmetic, geometry, drawing, sculpture, mythology, and astrology— reminded the Indian scholar at once of Vitruvius.[263]

Other texts used by Rám Ráz were *Māyāmata*, *Kāśyapa*, *Vaikhānasa*, and *Āgastya* which were mainly concerned with sculpture. Different classes of temples (*vimāna*) and *gopuras* were studied as well as different orders of columns. Various sections of the column, namely, the pedestal, the base, the pillar, and the entablature, were given consideration.[264] The 'orders' of Indian architecture were compared with ancient Egyptian, Greek, and Roman examples: 'The difference in the Indian orders consists chiefly in the proportion between the thickness and height of pillars; while that of the Grecian and Roman orders depends, not only on the dimensions of columns, but also on the form of the other parts belonging to them.'[265] Rám Ráz mentioned the important principle in traditional architecture that the benevolent forms of divine images should look towards the village while terrifying forms looked away from it. The *Essay* which contained forty-six carefully drawn plates [103, 104] also discussed the types of building material used by Indian architects, such as stone, stone-brick, timber, and a combination of brick, stone, and metal.[266]

186

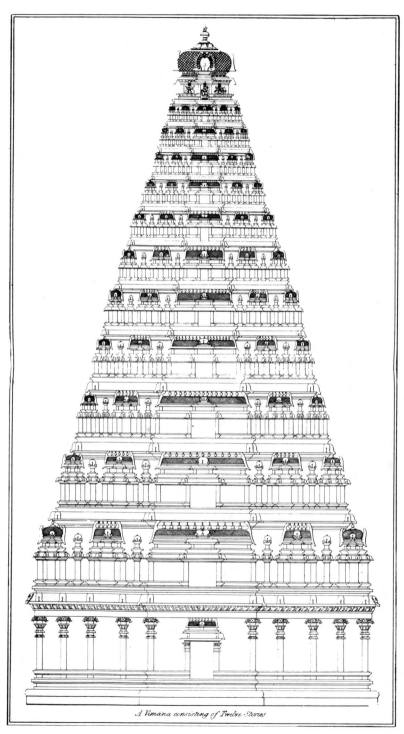

A Vimana consisting of Twelve Stories

103. Rám Ráz's drawing of a *vimāna*

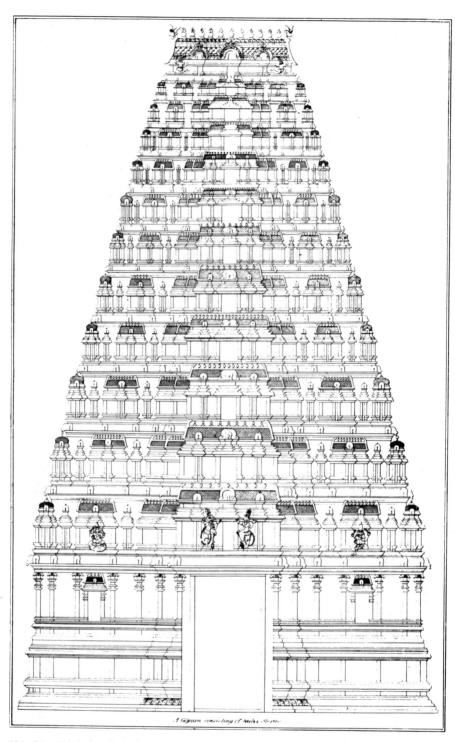

A Gopura consisting of twelve stories

104. Rám Ráz's drawing of a *gopura*

Historical and Philosophical Interpretations of Indian Art

COMPARED with the rapid and sure pace at which the systematic documentation of Indian art advanced from the middle of the eighteenth century onwards its European interpretations lagged somewhat behind. In the second part of the century considerable progress had of course been made by antiquarians in their appreciation of the sexual symbolism in Indian art. Equally, in the same period Indian art entered the confines of art-historical scholarship. Art history as a discipline was new and began to emerge in the second part of the eighteenth century. It claimed the status of an exact science (*Wissenschaft*) like the natural sciences. One of the main objectives of the pioneer art historians, and Winckelmann was the first and the most notable among them, was to trace the evolution of artistic styles. Moreover, they were to apply a clearly teleological notion of 'progress' to their studies of stylistic evolution. The problem of 'progress' in the arts came into focus in the eighteenth century although its germination was to be found in Vasari, who in his turn looked back to his classical predecessor Cicero.[1] The eighteenth-century concern with the evolution of the arts naturally brought Indian art within its area of interest simply because in this period this particular art-historical question was part of a larger question involving social history. The eighteenth-century histories of art, instead of concentrating on the development of the arts in a particular nation, tended to treat broad issues like the universal development of the arts in all nations. This concern with the whole of mankind stemmed from the eighteenth-century intellectual tradition which was still deeply involved with the Biblical interpretation of history. Whether it was the opponents of Christianity or its supporters, the basic assumptions remained the same. The starting-point was that all the existing nations in the world sprang from a single original nation. The idea encouraged in this period what one may call 'the debate on the origin of the arts'. At one stage India's position was crucial in the debate, to understand which it is first necessary to sketch the intellectual background.

189

The debate was influenced by ethnologists and social historians who had come to focus their attention on the monogenesis–polygenesis problem in cultural history, a problem originating in the historical relationship between different societies. Monogeneticists, the more influential of the two until the late eighteenth century, held that all societies owed their existence to one single original society, usually the Egyptian or the Hebrew.[2] The assignment of the Hebrews as the first people in point of time no doubt reflected the literal acceptance of the Old Testament as history. The secular liberals, however, gave Egypt the pride of place. The great Newton, for instance, generally maintained that Egypt was the centre of universal diffusion, but he was not always consistent.[3] Notwithstanding the preference either for the Egyptians or the Hebrews as the oldest nation, what the antiquarians of the period seriously believed was that the arts were actually 'invented' by the first nation to come into existence. The belief in the invention of the arts and sciences by the oldest nation went back to Classical Antiquity, although it became the centre of discussion in the Renaissance. The colourful Renaissance personality Polydore Vergil, who classified the arts and sciences in order of invention, did not, however, make any one particular nation responsible for their invention, but rather all of them. He was, in fact, content to cite different classical authorities on the subject in his *De Inventoribus Rerum* (1499).[4]

The problem did not receive any special attention until 1758 when Antoine Yves Goguet brought out his celebrated *The Origin of Laws, Arts and Sciences, and their Progress among the most Ancient Nations*. The idea of 'progress' had by this time penetrated intellectual discussions and, as the title clearly indicates, the concept of progress was now applied to the initial Renaissance interest in the origin of the arts and sciences.

Several important features of Goguet's contribution to the debate on the origin of the arts may be noted. Basing his arguments on the influential eighteenth-century evolutionary doctrine that any form of development proceeded from the simple to the complex, he pointed out that simple forms of architecture were first built which were then increasingly ornamented as men's tastes became more and more refined.[5] He also suggested that architecture was the very first of the arts to be invented because it was closely connected with basic human needs. The idea was that the simple unadorned forms of architecture were the earliest examples of human effort, the decoration of which was not only a sign of later refinement but also of the superfluous. This idea was very much in the air, but it was Winckelmann who, characteristically, turned it into a moral question by wedding the notion of

simplicity to that of necessity in his discussion of Greek art. Ornament was both superfluous and superficial.[6]

A new element had crept into the debate as early as the end of the seventeenth century. The traditional monogenetic assumption was that civilization had its inception in the ancient Near East. It was entirely a matter of personal preference whether one chose the Egyptians, the Chaldeans, or the Hebrews. Gradually, however, other nations found favour and for a time China was the favourite of the French intellectuals. It was then replaced by India. From the seventeenth century onwards India's prestige and more particularly that of her Brahman priests was on the increase. In 1665 Sir Edward Bysshe had collected in one volume the classical sayings on the 'Brachmans', including the text of Palladius, in *De Gentibus Indiae*.[7] The famous tradition that Pythagoras and Plato had come to the Brahmans of India for instruction in philosophy was of classical origin, but it was given wide currency in the seventeenth century.

The first monogeneticist to adopt the view that India instead of Egypt was the source of all knowledge concerning the arts and sciences was Sir William Temple, an early contributor to the theory of the picturesque but best known as the patron of Swift. His *Essay upon the Ancient and Modern Learning* (1690) was prompted by the famous *querelle* between the adherents of ancient and modern learning. It was intended to challenge the claims of empiricists such as Perrault and Fontenelle that modern science was superior to ancient learning. Although he was branded by contemporaries as an obscurantist who stood against progress, in fairness to him it must be added that all he questioned was the belief in the 'inevitability' of progress.[8] In the course of his arguments supporting the excellence of ancient learning he set up India as the fountain-head of all ancient knowledge:

From these famous Indians, it seems most probable that Pythagoras learned, and transported into Greece and Italy, the greatest part of his natural and moral philosophy, rather than from the Aegyptians . . . Nor does it seem unlikely that the Aegyptians themselves might have drawn much of their learning from the Indians; . . . long before . . . Lycurgus, who likewise travelled to India, brought from thence also the chief principles of his laws.[9]

Temple's ideas remained in isolation in his period until they were revived in the middle of the eighteenth century when a battle was raging between the 'believers' and the 'infidels' on the question of the value of Mosaic interpretation of history. The deists and the aetheists marshalled all their arguments in order to prove that Judaic monotheism was utterly derivative and much more recent than it was traditionally held to be. Far more ancient nations had already anticipated

Christian ideas in their sublime moral philosophy. In his search for an ancient religion which would undermine the unique position of Christianity Voltaire came to discover Hinduism. He was possibly the greatest admirer of India during the Enlightenment and unequivocally set up India as the original nation, the cradle of humanity, and the centre of diffusion for all knowledge of the arts and sciences. The ground had already been prepared by travellers, who had told astonished Europeans how very ancient the cave-temples of India were, but a more immediate influence on Voltaire were the Englishmen, Holwell and Dow, and the French savants, Le Gentil and Bailly.[10]

The monogenesis–polygenesis controversy naturally affected Winckelmann when he came to write his *History of Ancient Art* (1764). Although he was not directly concerned with Indian art, there are several good reasons for considering him here. His claim that he was the first author to write a history of art in terms of styles as distinct from a history of artists was in large measure justified.[11] He was the first author to write a universal history of art. For this there already existed a model in German historical scholarship. The Göttingen school of historians, led by Johann Christophe Gatterer, had concerned themselves with the problem of universal history, especially in the period between 1759 and 1789 when Gatterer was active.[12] As a universal historian Winckelmann was expected to concern himself with the question of cultural diffusion. Here he took an independent stand. While he accepted that Egyptian and Chaldean art had preceded the Greek, he also took the view that the arts had developed independently in each nation owing to an inner necessity. There was an urgent reason why he refused to see any connection between Egyptian and Greek art. It was bound up with his unique view of the progress of Greek art. He employed the prevailing evolutionary doctrine to show that all art, including the Greek, had been simple and rude in the first stage of development. There was, therefore, no essential difference in quality between them. And yet, while Greek art went triumphantly along its path of progress, Oriental art, namely Egyptian and Persian, remained stagnant and moribund.[13] The reason for this offered by Winckelmann is, of course, well known. Climatic determinism had been influential in the eighteenth century, especially in the writings of Montesquieu. But it was Winckelmann who sought to demonstrate that the progress of Greek art towards perfection owed much to the climate of Greece.[14] Therefore, the reason why Winckelmann was prepared to concede that the Egyptians had invented the arts before the Greeks was in order to use the former as a foil to set it off against the inevitable progress of Greek art. Winckelmann had not discussed India, but his view of what Oriental art was like was applied by later historians to Indian art, including his climatic deter-

192

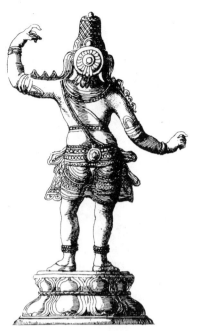
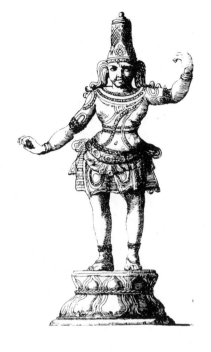

105. South Indian bronze in Caylus' work

minism. There is another special reason for including Winckelmann here. As we shall see, he was taken to task by two German antiquarians for not regarding Indian art as the oldest in the world.

In contrast to Winckelmann, the great French antiquarian le Comte de Caylus, to whom the German scholar had been hostile, gave serious consideration to Indian art and assigned it an essential place in his discourse on the origin and progress of architecture. Caylus travelled extensively on archaeological expeditions and helped set the standards of classicism in France.[15] He was one of the first antiquarians to appreciate the importance of Herculaneum.[16] His awareness of Indian art may have followed from his close connection with the Académie des Inscriptions et Belles-Lettres. The famous Orientalist Anquetil-Duperron was an intimate friend of his, who brought back a piece of sculpture from the Yogeswari caves for the Count.[17] Caylus's knowledge of Indian art could not always keep pace with his interest and there were occasional lapses as when in his *Recueil d'antiquités égyptiennes, étrusques, grecques, romaines et gauloises* he identified a south Indian bronze figure [105] as Japanese.[18]

Apart from Anquetil, the Academy contained a number of Orientalists in the latter half of the eighteenth century, most of whom were ranged on opposite sides on the question of superiority between two civilizations, the Chinese and the Indian. The members were also

193

engaged in a discussion on certain similarities between Egypt and China, giving rise to the view that China began as a colony of Egypt. It may be recalled that Kircher held a similar belief. This as well as the antiquity of Egypt was challenged by Abbé Mignot, who sought to prove through five articles that not only was Indian civilization more ancient than the Egyptian but it was the actual original nation.[19]

Unlike Winckelmann, le Comte de Caylus was a monogeneticist and a believer in Egypt as being the inventor of the arts. He is generally considered to be one of the earliest to appreciate Egyptian art and was connected with the Egyptian Revival. He decided to join the battle raging in the Academy by taking up the cause of Egypt. By a comparison of styles as evident in different ancient monuments he came to the conclusion that the Assyrians, Medes, and Persians had derived the knowledge of architecture from the Egyptians. He also argued as a champion of Egypt that the similarity between Egyptian and Chinese monuments mentioned by European travellers showed clearly that the Chinese too drew their knowledge of architecture from the same source. Caylus did not wish to insist that China was therefore an Egyptian colony. He rather imagined that not only China but also India might have received their knowledge of architecture from Egypt through certain intermediate countries.[20]

In a lecture on the subject given in 1763 Caylus chose to show the similarities between different ancient monuments by citing two examples from Herodotus. It was pointed out by the French antiquarian that these monuments in Herodotus were distinguished by their curious seven-storied square forms which were painted in many colours.[21] He was convinced that they were of Egyptian origin because 'this particular usage belonged to Egypt; the Egyptians have not left us any public monument whose elevation [form] was round.'[22] The first example in Herodotus mentioned the ancient temple of Ecbatana built by the Medes which consisted of square towers painted in different colours. Each successive storey diminished in scale until finally the seventh one was reached, which contained a palace.[23] Similarly, the temple of Jupiter-Belus [106] in Babylon, whose towers rose like the Egyptian pyramids, consisted of seven successively diminishing levels of solid square enclosures, which terminated at the top in a great temple.[24]

This was the stage at which the late south Indian *gopuras* or temple gate-towers came into the discussion. Like the rest of his contemporaries Caylus did not question the great antiquity of these structures. The *gopuras* are relatively new in the history of Indian architecture and most of them do not go beyond A.D. 1000. Yet it was their pyramidal form, giving them a superficial resemblance to the Egyptian pyramids, which

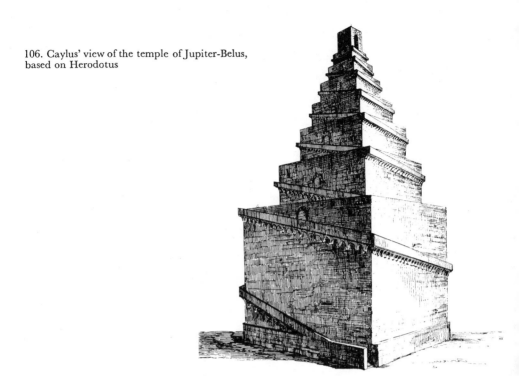

106. Caylus' view of the temple of Jupiter-Belus, based on Herodotus

gave rise to speculations connecting them historically with Egyptian architecture. The influential traveller Le Gentil called them pyramids. He too believed that India was more ancient than Egypt.[25] Therefore, in Caylus's mind the question was not whether these Indian pyramids were ancient but of their antiquity in relation to the Egyptian pyramids. In view of this it was not too much to expect from Caylus examples of parallel architectural practices in Medea, Babylon, India, and Egypt. What he did contest was India's claim to have originated the arts. This was rejected on the grounds that Indian architecture betrayed a lack of originality.

Du Rocher de la Périgne, an engineer in the service of the French East India Company, had sent Caylus a faithful sketch of a *gopura* [107, 108, 109] belonging to the great Chidambaram temple in south India.[26] This drawing became the crucial evidence for a stylistic comparison between the *gopura* of Chidambaram and the two examples from Herodotus, the temples of Ecbatana and Babylon:

The bands indicated on the drawing are of copper and cover the whole surface of the pyramid. There are three other similar pyramids, which, along with this one, serve as the entrance doors to the enclosure of the pagoda . . . These bands are washed and the copper is given a coat of gold paint once a year . . . This construction recalls the manner of building by the Egyptians . . . One of the great singularities of these buildings, which is difficult to attribute to chance,

195

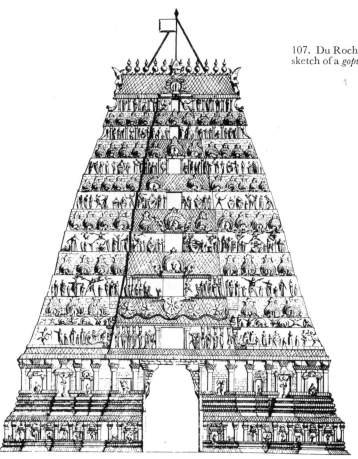

107. Du Rocher de la Périgne's sketch of a *gopura*

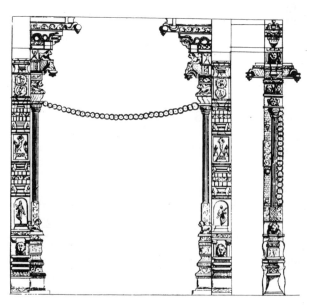

108. Another detail by Du Rocher de la Périgne

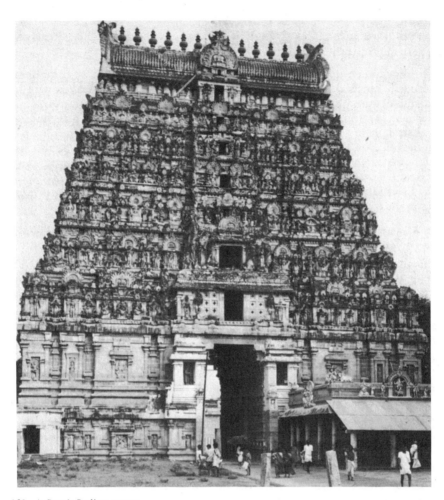

109. A South Indian *gopura*

is the relationship between their interior division and the number of enclosures in Ecbatana and the storeys of the tower of Belus: these pyramids (*gopuras*) are divided into seven floors . . .[27]

He insisted that 'this division of seven and eight floors, constantly repeated in Persia, India and China, merit some reflexion; it indicates a shared idea which can only be produced by commerce and intimate connexions.'[28] The inevitable conclusion was that 'one rediscovers pyramids in India: these buildings are characteristically Egyptian and one cannot dispute their invention by Egyptians.'[29]

In his summing up Caylus firmly attributed the invention of architecture to the Egyptians. Simplicity and originality were the two principal requirements for the invention of architecture, the two features

197

which were present to a high degree in Egyptian architecture and which the imitative Indian lacked:

The Egyptian works bear in their simplicity combined with an astonishing grandeur an original character. The pyramids of India are loaded with an infinite detail of little ornaments; this pursuit betrays an imitative spirit; on the contrary all is simple and grand in Egypt; it was in Egypt that the marble was straightway brought out of the quarry, hewn simply, placed one on top of of the other and in the direction of the four cardinal points of the earth; they had formed the pyramids. The other nations had arrived afterwards, chisel in hand, in order to make up for, by means of detailed embellishments, what they lacked in respect of far-reaching ideas and the grandeur of efforts. Men have always commenced by the simple in all their operations . . .[30]

The assumptions on which Caylus's hypothesis rested were challenged in 1803 by the German antiquarians, B. Rode and A. Riem, in an article on ancient painting attached to Winckelmann's *History of Ancient Art*. The authors first of all denied that Egypt was the first inventor of the arts, to be subsequently imitated by the Indians. They also questioned the doctrine that simplicity was necessarily an indication of antiquity. On the contrary, they asserted, simplicity was a clear sign of maturity and good taste, whereas ornateness was a reflection of the infancy of art,[31] thus reversing Caylus's argument. The two Germans looked up to another member of the Academy whose works lent support to their particular view of India. Abbé Mignot, an Indophile like Voltaire, had sought to prove the origin of philosophy in India on the basis of classical authors.[32] Accepting the authority of Mignot, the joint authors proceeded to rectify certain errors not only of Caylus but of Winckelmann as well. The last author had totally ignored the Indian contribution to the invention of art. The way Caylus and Winckelmann are brought together here is somewhat ironical, as they would certainly have disliked being forced into the same camp.

According to Rode and Riem neither Winckelmann nor Caylus had considered it necessary to trace the history of art beyond the Egyptian period. Although Winckelmann did not categorically attribute the invention of art solely to the Egyptians, for he had implied that it may have originated independently in all nations, he none the less accepted Egypt as his 'nec plus ultra'.[33] Caylus, on the other hand, had made positive claims on behalf of Egypt. By marshalling examples from Bishop Pococke's travels in Egypt and by citing the case of the temple of Karnak [110, 111], the two antiquarians argued that, contrary to Caylus's assertion, not everything was all that simple and sublime in early Egyptian art. To his other argument, that simple works necessarily preceded those which were overloaded with ornament, they provided their own answer: that architecture began its career by impos-

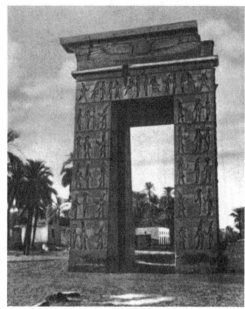

110. Pococke's sketch of the temple of Amun 111. Temple of Amun at Karnak, Egypt

ing a vast quantity of tasteless ornaments. But as it advanced these ornaments were increasingly discarded or reduced so that ultimately a superior style of architecture expressing simplicity and good taste was achieved.[34]

First of all, the historical validity of Caylus's claim, that ancient Egyptian architecture was all simple and grand, was questioned. The antiquarians did not, of course, disagree with the Count that 'simplicity combined with a grandeur worthy of admiration constituted the highest peak of art and could only be the fruit of a refined taste and deliberate study.'[35] But, as they pointed out, these qualities were certainly lacking in ancient Egyptian art.[36] On the other hand:

It is inconstestable that in the infancy of all the arts, the style, which should have consisted in an assemblage of a large number of related parts, was shabby, without proportions, without symmetry and loaded with all that was regarded as beautiful in this period, a period destitute of principles and experience. The more one tended to aspire towards perfection the more one lavished ornaments in order to lend an air of grandeur to the *ensemble* and to excite admiration on account of the difficulty overcome.[37]

Applying this principle to both Indian and Egyptian architecture they reached the conclusion that 'This puerile style, we find in the first and the most ancient works of art, equally among the Egyptians as among

199

the Indians; and the overloaded style itself is a proof of their high antiquity.'[38]

When Caylus was writing, the dates of different Egyptian monuments had not yet been correctly fixed, and dating them simply on superficial stylistic grounds inevitably proved treacherous. Caylus had asserted in intrepid vein that the very simplicity of the pyramids indicated their antiquity. Rode and Riem simply chose an example from a different style of Egyptian architecture, namely the temple of Karnak, and put forward the contrary argument with equal conviction. They regarded the Theban temple at Karnak as more ancient than the pyramids precisely because of its ornate decorations, which agreed well with their doctrine that lavishly decorated architecture represented an early stage of art history. The authors argued further that Pococke's description of the interior and the doors of the temple at Karnak was in perfect accord with the pyramidal doors of the Indian temples with their lavish decoration.[39] The German antiquarians brought forward further evidence from history that the Thebans had a flourishing, settled population long before the Nile delta, and Memphis in particular, were inhabited. And it was on the delta that the first pyramids were built.[40] In addition, they claimed to have discovered by a close reading of the classical texts that philosophy had made remarkable progress in India long before lower Egypt was even formed by the accumulation of the silt of the Nile. The implication was that if philosophy had already made such progress in India then surely architecture, the very first art-form to arise, must have advanced considerably. The authors felt satisfied that they had been able to counter the French antiquarian's erroneous argument that the simplicity of the pyramids was a sign of their great antiquity, since both the ornate monuments of antiquity, the Theban temple and the Indian pyramids, had clearly preceded the Egyptian pyramids.[41]

The question of the transmission of the knowledge of architectural practice by the Egyptians to the Indians was taken up next. According to Rode and Riem, the assertion of Caylus that the infinite number of minute ornaments on Indian pyramids reflected an imitative spirit was totally unfounded. First of all, Caylus had not recognized the enormous difference between the Egyptian and Indian pyramids. In fact the only possible stylistic comparison could be made between the doors of the Theban temples and the Indian pyramids. But the former in their primitive style had very little advantage over Indian temples, and their symbolic decorations were no less monstrous. Moreover, it was impossible to decide on the antiquity of a form of architecture simply on the presence or absence of decorative ornaments, as it was perfectly possible for a nation to evolve a petty style and puerile ornaments without

200

necessarily imitating anyone. Caylus's argument, in fact, did violence to the actual character of the ancient Indians who abhorred any kind of imitation and whose sages were reputed to have never left the land of their forefathers.[42]

On the other hand, wrote Rode and Riem, there were good reasons why the Egyptian pyramids were simple: the hard marble did not encourage ornamentation, nor was it easy to blend monstrous decoration with the simplicity of the general structure. At this moment they recalled that not only were the south Indian pyramids generally regarded as very ancient but there was a particularly strong tradition which attributed great antiquity to the western cave-temples. Therefore, the conclusion drawn was that even the Egyptian pyramids were only late and feeble monuments compared with the great enduring pagodas of Salsette and Ellora, which must have taken at least a millennium to build.[43]

Having proved Caylus wrong to their satisfaction the joint authors proceeded to delineate the kind of art produced by the Egyptian Thebes and India at the dawn of human history. After reinstating India as an ancient seminal civilization they provided this picture of Indian architecture:

It is certain that whoever has some knowledge of art will not regard as beautiful these productions of the Hindus and the Egyptians, and that it was only their excessive grandeur which could cause some admiration; on the other hand they are the certain proofs of the barbarism of the arts, incapable either of beauty or of proportion. They had, in order to satisfy the vain attachment to great magnitude, piled masses upon masses. It is not the beauty of these masses of stone which astonishes us but the amount of labour it should have required, considering the ignorance of machines which would have made the task easier. We admire a lot more the enormous expenditure, the patience and the base servitude which these works demanded than the works themselves. Their structure has still not aroused in anyone the desire to imitate.[44]

India was thus a perfect instance of the primitive stage of art preceding the rise of taste. Rode and Riem further stated that Indian buildings could not be properly termed architecture after the Palladian principles of architecture but could be considered only as essays in the infancy of art, the products of unregulated fancy and arbitrary rules. Their undoubted antiquity was clearly indicated by the puerile taste in decoration and by the constant use of gigantic figures, a favourite mode of expression in the early stage of art. A people who had better models before them could not have produced such essays in bad taste, but being the inventors they had no good models to emulate. An imitative nation could improve its taste and style of art more easily than the nation which had made the first discovery. The natural vanity of the original

201

society would prevent it from destroying the works which had cost it centuries of toil simply because the times demanded innovation.[45]

In their summing up the German scholars attributed the bad taste and uniformity of Indian art to the influence of climate, a notion which had been applied by Winckelmann in his evaluation of Egyptian art. A further reason for the bad taste was the rich and varied nature of Hindustan. Seeing lush tropical nature all around them, its inhabitants loved to overload works of art with ornament. The uniformity of Indian art was caused by the enervating hot climate, which led to fatigue of the spirit so as to make people remain content with the existing state of things and to lose all desire to improve the arts. This then was the real reason for the uniformity in the art of the Indians, Chinese, Japanese, and Egyptians, whose present productions have remained the same since antiquity. The Asiatic regarded with disdain the European master-pieces and preserved his own ancient methods. It brought back to the authors' minds the case of the ancient Egyptians on whom the marvels of Greece had not made the slightest impression. These additional factors reinforced the argument regarding the antiquity of Indian art, gross, devoid of either taste or rules. In ancient India, unlike in Greece, the progress of art had been arrested in its infancy.[46]

ii. CREUZER AND HEGEL

The conclusion reached by Rode and Riem, that Indian art represented the archaic, the primitive, and the unformed, was commonly held by the nineteenth-century savants. But it was the very primitive quality of Indian art which appealed to the German Romantics. Not only did they equate the primitive with intuitive and sublime wisdom, but their reaction against the scientific rationalism of the eighteenth century led them to seek the unity of emotion and knowledge, inconceivable in rational terms. The Classical Revival had invested early Greek archi-tecture with a certain primitive aura and later Gothic art had been similarly treated. But too much was already known about either tradi-tion. Therefore, when under Hamann the Germans turned against the rationalism of the Enlightenment and all that it stood for, they naturally searched for an ideal land beyond Europe. Under the influence of what Leslie Willson calls 'the mythical image' of India the Romantics set it up as the archaic homeland of mankind, the archetype of the primitive stage of history, and the ultimate source of all religion, poetry, and moral laws. Among the luminaries of the period Goethe expressed an ambivalent attitude to India. While he admired the dramas of Kālidāsa and was fascinated by Indian thought in general, he found the 'ir-rationalism' of Indian religion and Hindu art disturbing. But one suspects that Goethe's criticism of Indian art was a parable which

202

reflected on his own reservations against the anti-classical emotionalism of Romanticism.[47]

But Friedrich Creuzer, who found that he was in close sympathy with Indian civilization, emphasized 'the importance of India as a source for poetry, social culture, morality and religion'.[48] He had also made Indian art, religion, and mythology the cornerstone of his famous *Symbolik und Mythologie der alten Völker* (1810). Creuzer's interpretation of Indian myths and symbols as represented in art carried forward the essential task of coming to terms with the meaning of Hindu art. A start was made by Payne Knight, Dupuis, and others in their interpretations of Indian erotic art and further developed in Creuzer's works, while the final definitive shape for the nineteenth century was given by Hegel, also deeply concerned with the role of symbols in art and religion. Not the least of Creuzer's importance rests on the fact that his approach to symbolism was adopted by Hegel. In his lectures on aesthetics Hegel characterized Indian art as being the ultimate expression of unconscious symbolism.[49]

Creuzer's *Symbolik*, as Professor Momigliano writes, has remained famous and has enjoyed a revival of popularity following the fashionable interest in symbols and symbolism. The work was written with the intention of giving a scientific basis to the Neoplatonic interpretation of Greek mythology.[50] The Belgian scholar Franz Cumont states that 'Creuzer thought he had discovered in the Greek mysteries an occult tradition of ancient wisdom and he rediscovered the traces of their esoteric doctrines on Greek vases and on Roman reliefs.'[51]

In the Romantic period the distinction between allegory and symbol appeared in the work of Schelling, who took the first step towards the modern Romantic interpretation of symbols as both *being* and *signifying* a particular idea. However, Creuzer's *Symbolik* contains the most valuable ideas in this field. He was the first modern scholar to start off his study of the nature of ancient symbols with traditional Neoplatonic assumptions but gradually developing ideas full of Romantic insight.[52] As we have seen in previous chapters the attitude to symbols in European art reflected two opposed schools of thought. In the traditional Christian art of the West, symbols in general were a sign language containing a religious message to be translated by the viewer for his edification. Against this 'consonance of meanings' in Christian art may be set the whole influential school of Neoplatonic mysticism epitomized by Dionysius the Areopagita. Dionysius considered symbols as more than a mere sign—the very dissonance of their meanings made them the carriers of profound ideas.[53]

The question of the difference between the two types of symbols was brought up again by the Romantics with the revival of interest in the

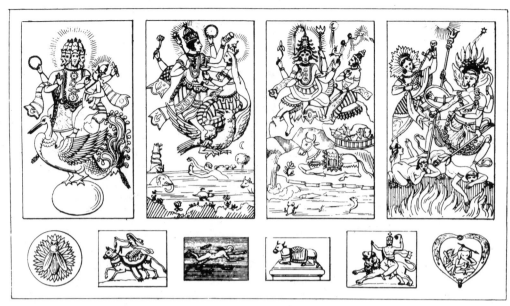

112. Hindu symbolic deities in the French edition of Creuzer

Neoplatonic interpretation of symbols. In the context of art two distinctions were made by the Romantics. Following Winckelmann both Creuzer and Hegel had accepted the superiority of classical art with its 'consonance of meanings', which had achieved a perfect harmony of form and meaning. This aspect of Creuzer's and Hegel's view was less original, however, than the important distinction they made between the 'translatable' language of Greek art, which had created visible shapes for gods, and the enigmatic, mystical and untranslatable symbols of all ancient Oriental art. Professor Gombrich argues that the special importance of Creuzer for us consists in the way in which, with rare insight, he touched upon the problem of symbolism in art and also upon the multiplicity of our responses to the visual image. According to Creuzer the whole range of ancient art from Egypt to India expressed this kind of symbolism with its dissonance of meanings which attempted to hint at something beyond what appeared to the eye.[54]

To Creuzer symbols were the simpler and more archaic forms of human expression, created generally by priests in order to teach ordinary people the fundamental moral truths and were in essence the visual guides to the divinity. These early symbols were responsible for the gradual rise of art. All early art was considered by him as essentially symbolic in nature, and it was described as characterizing the transition from the mystic to the plastic symbol.[55] India and Indian art formed the central core of his argument relating to ancient symbols [112]. He considered Indian cosmogony as one of the earliest mani-

204

festations of mystical symbols, for he saw no reason not to accept the prevailing view of India's great antiquity.[56]

It was in this spirit that he wrote that 'India was the home of the fable as a vehicle of moral didactics',[57] a method of teaching that was essentially symbolic. An admirer of India in the German Romantic tradition, Creuzer had come in contact with its culture quite early on. He was closely associated with the creative writers of German Romanticism and had a brief and tragic love-affair with a minor poetess, Karoline von Günderode who had modelled herself on Indian heroines in literature. However, unlike the Schlegels', Herder's, or Majer's attitude to India, Creuzer's admiration for India was in large measure academic, reserved, and detached.[58] From his early career Creuzer was involved in investigating the relationship between the classical world and India. One reads in Guigniaut, his biographer, that already in his youthful work *Dionysus* Creuzer had seen the origin of classical religions in India. But he did more, for not only did he trace the cult of Bacchus in the religion of Osiris and Serapis in Egypt but 'he pointed a finger at India as the distant and primary source.'[59] This view which had its inception in *Dionysus* was greatly expanded in the ambitious *Symbolik und Mythologie*, in which work he sought to penetrate the mysteries of ancient religion. As his biographer recorded, Creuzer explained how he was directed to this attractive theory relating to myths and symbols, the twin forms of religious conscience, and how he followed their development throughout the ancient world from Egypt and India to Greece and Italy.[60] The symbologist was forcefully struck by the discovery of a superior state of moral and religious culture in the primitive world. He had discovered the evidence of this in the sacred works of the Hindus, Persians, and in Egyptian hieroglyphic monuments.[61]

The first edition of the *Symbolik* contained only the rudiments of his system apart from the long and in many ways crucial introduction setting out his basic doctrine. This introduction was omitted in later German editions but retained in the French one. In the same edition Creuzer's text was developed by Guigniaut in accordance with the author's instructions, incorporating more detailed treatment of themes only touched upon in 1810.[62]

At the very outset Creuzer set out in a highly romantic vein India's key position in the history of civilization. He felt that if there was one country on earth which could justifiably claim the position of honour for having been the cradle of humanity, or at least the scene of a very old civilization whose successive advances had been faithfully transmitted to the rest of the ancient world, it was undoubtedly India. Hinduism, which expressed itself through powerful impressions of nature and free inspirations of the spirit and whose forms were at once naïve and

sublime, conceptions simple and profound, doctrines vast and bold, was able to explain with success the religious dogmas and symbols of other nations.[63] Hinduism was eternally old and eternally new, a fact which had always fascinated the rest of the world.[64] The difference between India and other countries extended even to its people who were unlike the rest of the world in features, *mores*, and in general character.[65] In particular, he pointed to Kashmir as the birth-place of all the gods, spirits, and other creatures of ancient mythology.[66]

This was a particularly flattering picture of India. Creuzer felt that the delightful Indian climate had a lot to do with its early development. He was convinced that such beautiful and magnificent climate in all periods led to the early flowering of Indian mythology to a degree that one did not encounter in other societies. Nature also directly intervened in forming the unique character of this mythology, grand, vivacious, rich, occasionally gigantic, bizarre, exaggerated, and which appeared to reunite in itself the diversities of all others.[67]

Elaborating his doctrine that all pre- and non-classical civilizations were the repository of ancient wisdom, as expressed in their symbols, Creuzer further defined Hinduism as a religious philosophy in which profound moral truths were revealed through the veil of symbols.[68] The profound and enigmatic symbols in Hinduism were seen in the two images most frequently, and with some justification, given a symbolic interpretation by Europeans: the image of the *liṅga* and that of the Trimūrti (Maheśamūrti). The first image was symbolically accepted as standing for life and death, a view in which a not so distant echo of Hancarville could be heard.[69] The same image was considered to represent the grand principle of nature which again recalled Dupuis. Next, the German scholar suggested that the Trimūrti which combined the essence of the three supreme Hindu gods, Brahmā, Viṣṇu, and Śiva, and was similar in concept to the Christian doctrine of the Trinity, represented in reality the three natural elements, earth, fire, and water.[70] Erskine's article setting out the actual character of the so-called Trimūrti, that it represented the three faces of Śiva, was yet to come.[71] At all events, this grand triadic symbol like the phallic one, wrote Creuzer, toured the whole world.[72] In conclusion to his assessment of Hindu mythology he reaffirmed that it forcefully expressed the operation and the mysteries of nature and of the divine power.[73]

Indian myths, of course, were realized in plastic form in Indian art. Accordingly Creuzer went on from myths to symbolic art. The general sentiments expressed showed the unmistakable shadow of Winckelmann in their implicit acceptance of the superiority of Greek art compared with the rest of the world. He mentioned that the Greeks too had initially employed symbolic forms in their art, thus agreeing with

206

Winckelmann that they had begun modestly and on a par with the ancient Oriental nations. Yet, at a crucial moment in history the Greeks diverged from the rest when they discarded symbolic representation in art in favour of the naked human form in order to express the most sublime ideas. Their high mission in art was accomplished by adopting an important artistic device, the representation of action in painting and sculpture. On the other hand, the Hindu divinities and those of other Asian nations continued for the most part to be depicted in a sitting or lying posture. According to these peoples it expressed sanctity. The practice gave clear evidence of the static nature of all Asian art. Creuzer was no doubt thinking of the Buddhas and the lying Viṣṇu figures. Furthermore, the figures of Asiatic gods were heavily draped and ornamented which also hindered artistic progress. The Greeks had achieved their precious superiority over others by simply shedding all clothing and ornament. In the final analysis it was the nude in classical art which distinguished it from the barbarians.[74] No less important a reason for the lack of development in Oriental art was the absence of all rules.[75]

Finally, an important definition of symbolic art was offered. Among these peoples the image of divinity [84] had to express all the different ideas and the diverse relationships existing in their rich and profound theology. That was the reason for the several heads and arms of the Indian gods, the numerous breasts of the Diana of Ephesus, and Janus with four or, more commonly, two faces. One of the striking features of ancient thought was to explain all by multiplying the attributes up to infinity.[76] The subject of symbolic gods brought to his mind the famous symbolic Hindu god mentioned in Porphyry.[77] Some fifteen years before, Dupuis was the first philosopher to refer to it.[78] With considerable insight Creuzer observed that these statues of gods in primitive societies were a call for the meditation on the infinite, the only subject worthy of religious thought. Piling signs upon signs and symbols upon symbols these images aspired to attain the sublime plenitude of the divine. These images, which reflected the desire and at the same time the impossibility of representing the totality, warned the believer that the right to penetrate unattainable profundities belonged only to the pure intelligence. These collections of images which desired to reach out to infinity were to be found among the Hindus as well as the Greeks.[79]

Although Creuzer's *Symbolik* carried much prestige just after its appearance it soon fell into disfavour. Cumont thought that the school of Creuzer could not escape the criticism of using an arbitrary method, but the same author admitted that despite the 'pitiless criticism of Lobeck this fantastic system fascinated archaeologists up to the middle of last century'.[80]

The colossus in all spheres of intellectual history in the nineteenth and twentieth centuries is of course Georg Wilhelm Friedrich Hegel, who held the Chair of Philosophy at the University of Berlin from 1818 until the year of his death. He ruled the intellectual world with such a firm hand that, whether one followed or opposed him, he certainly could not be ignored, especially in cultural fields. It was therefore appropriate that the evolution of interpretations of Indian art led up to him, where they reached the peak of complexity. There was no subject he did not deal with. Therefore it is not surprising that he had much to say about Indian art and religion. In the evolution of the European image of Indian art Hegel's position was unique because, while he raised the same kind of questions which had generally concerned and sometimes perplexed his predecessors, his answer bore the peculiar stamp of his world-system. He created a new myth about Indian art. The myth owed its existence to two essential elements: to certain aprioristic assumptions derived from his grand design of history and to the influence of the literary tradition about India on Hegel. In some ways he may be considered as reinterpreting old monster myths, but in a transformed mould. The rise of Idealist philosophy coincided in Germany with the Romantic movement. Problems connected with art criticism deeply concerned them. Reacting against empiricism Hegel and others not only stressed the subjective character of art but they also assigned essential value to the spiritual and religious elements in it. Since the argument was that art represented the Ideal Platonic world beyond the visual, objective one, it became possible to argue that different traditions had different ideals. In other words, the classical, Renaissance objective of perfecting the representation of the visual world no longer remained the only measure of excellence, as it gave way to a form of relativism. Romanticism augured well for an appreciation of Indian art. Hegel himself often gave evidence of perceptive judgements on works of art he knew and liked. And yet hopes raised by these developments were not entirely fulfilled. To understand why this happened, we must look at his approach to art history and the way he used the available evidence regarding Indian art. It is worth noting that in his extensive discussion of Indian art in his *Ästhetik* there are only two references to actual works of art and they are most probably on the basis of literary descriptions. There is reference to the architecture of Ellora and Salsette and to the Trimūrti, an image which became famous on account of its supposed likeness to the Christian Trinity.[81]

First of all, his method. It is well known that Hegel wrote the most famous and influential universal history of art. In this he of course carried forward the work of Winckelmann. Hegel's history of art formed only a part, although a very essential part, of his history of world civil-

208

ization which covered virtually all aspects of human activity. The bond which cemented these diverse aspects was the belief in the 'eternal creativity' of history, which subject was raised by him to the level of rational logic.[82] Hegel advanced the argument that his historical method rested on the one hand on critiques of Kantian metaphysics and on the other hand on certain *a priori* laws which had a logical validity parallel to that of mathematics.[83] But history is simply not mathematics. It can well be argued that his historical method was an enormous metaphysical system deriving inspiration from two traditions, the classical and the Christian. In short, the history of the universe was the history of God creating himself, and the history of mankind was the continuous incarnation of the spirit (*Geist*).[84]

First, the classical tradition: two important doctrines determined the Western conception of the universe, the Great Chain of Being. Plato had supplied the metaphysical notion of a Perfect Being who ruled the timeless, perfect world of the Idea. If the Perfect Being was thus self-sufficient, how could we, transient, insufficient beings, relate to Him? The Perfect timeless Being transcended into *becoming* in order to create the transient universe, which process has been called 'plenitude' by A. O. Lovejoy. Aristotle in his turn put the whole world of beings into strictly defined classes. He however conceded that it was possible to move up in this hierarchy. The hierarchy consisted of the Perfect Being at the apex and rocks and plants at the very bottom with human beings somewhere in the middle.[85] Until the eighteenth century the Great Chain of Being was essentially static. With the expansion of science in the eighteenth century the problem arose of accommodating plenitude in the scientific conception of the universe. Accordingly the Chain of Being was temporalized in order that it may take note of progress. It was Schelling who advanced the doctrine of a continuous progression from the lower orders to the ever higher, reaching ultimately the realm of the Perfect Being.[86]

When we remember this background, we at once realize why Hegel viewed historical development as the gradual unfolding of the spirit in time as well as in self-knowledge, for the view was none other than a temporalized conception of the Chain of Being. Not only was Plato's metaphysical Creator turned into a logical category, but also history came to take the place of the Creator in Hegel's system as the self-thinking spirit, impelled by the need to resolve contradictions in order to move to progressively higher planes of articulation.[87]

The second element was Christian, whose historical determinism was strongly millenarian and not based on empirical evidence. History moved not only with logic but according to a predetermined 'divine' plan. The 'triadic' arrangement of historical periods in Hegel strongly

suggests the influence of Christianity. In short, for Hegel every nation had a preordained place in his 'ladder' of historical progress and reflected a unique 'national spirit'.[88] Hegel also argued that each particular facet of a nation or culture was interlinked with the rest, for the national 'spirit' premeated all spheres of life. The conclusion was that if we were to judge a particular style or tradition of art we must first of all see what particular national spirit it represented and to what particular point in history that nation in its turn belonged. Hegel admittedly often came up with remarks full of insight, but in order to fit a real aesthetic or art-historical situation to his rigid structure he was frequently led to make generalizations which distorted the actual character of that particular tradition.

Indian art naturally sprang from the unique national character of the Indians, a reflection of the peculiar Indian spirit. The evidence primarily derived from literature was ingeniously employed by Hegel to sustain his own argument about the Indian character in which often facts were sacrificed for the sake of a certain symmetry. He admired Persia because he felt that that was where history first germinated, for the Persians had shown the first signs of political consciousness in their empires. By contrast, the two great civilizations from the East, China and India, stood, as it were, outside the pale of history. They were presented as the two contrasting principles and, in Hegelian terminology of dialectics, China represented being, totally objective, prosaic, and lacking imagination and the spirit; while India was non-being, all imagination and fantastic irrationality, completely lacking objectivity. Neither had the ability to progress because neither was perfect.[89] In Hegel's words: 'over against the thoroughly prosaic mind of the Chinese, we find set the dreaming unregulated fancy of the Hindus; the unimaginative realism of the former is confronted by the fantastic idealism of the latter.'[90] In several places this view of India was elaborated with impressive arguments. In *The History of Philosophy* he stated that it was inconceivable that a nation with such advances in astronomy and mathematics had no sense of history.[91] The lack of a sense of history to Hegel meant a lack of objectivity:

The Hindoo race has consequently proved itself unable to comprehend either persons or events as parts of continuous history, because to any historical treatment a certain objectivity is essential . . . The natural impulse to refer all and everything back to the Divine is hostile to this prosaic rationality and so is the tendency to imagine for itself in the most ordinary or most sensuous of objects a presence and reality of godhead.[92]

The Hindu therefore lived as if in a dream in that he could not distinguish between himself and the objects of his knowledge. Since he was

210

unconscious of his own individuality he identified himself with every-thing, including even the divine.[93]

Hegel found that the absence of objectivity was reflected in religion as far back as the Vedic religion about which he had read in Cole-brooke's famous articles. From them he had the impression that Indian philosophy was still at a stage where it was identical with religion.[94] The dreaming consciousness of the Hindu was a form of pantheism, not of thought but of the imagination.[95] To the Hindu:

everything is a God—sun, moon, stars, the Ganges, the Indus, beasts, flowers. Finite objects, thus divinized, lose, of course, their fixed and constant character, and all understanding of them vanishes; while the divine, rendered thus change-able and inconstant, is reduced to a form at once corrupt and absurd. . . . one part of the Hindu cult consists in the benumbing of consciousness in a wild frenzy of sensuous excesses.[96]

The nature of Indian pantheism with its worship of animals was ex-plained in *The Phenomenology of Mind* as the state in which the spirit broke up into many mutually hostile folk-spirits who accepted certain specific forms of animals as their essential reality.[97]

Enumerating the essential features of Hinduism Hegel mentioned its constant blurring of the differences between the most abstract concepts and grossly concrete objects. He readily agreed that despite the plurality of divinities the Indian imagination remained constant to an abstract, spiritual concept of a supreme god. Also most serious speculations on the universals were limited in Indian texts to the most abstract.[98] And yet this extreme abstraction itself was an obstacle to the development of art:

One extreme of the consciousness of the Hindoo is the consciousness of the Absolute, here regarded as the essentially and absolutely Universal, undif-ferentiated and consequently wholly indefinite. This supreme of abstractions, inasmuch as it is neither in possession of a particular content, nor is conceived under the mode of concrete personality, is from whatever side you may look at it, no object at all that the imagination acting through the senses can reclothe for art.[99]

Having established to his own satisfaction the relative position of India in the continuum of historical progress, Hegel went on to delineate the essence of Indian art. Like all other components of culture the dev-elopment of art also reflected the logical process of the unfolding of the spirit as it increasingly became aware of itself. Several important features of Hegelian history of art may be noted here. First, the German philo-sopher divided the history of world art into three essential phases, the symbolic, the classic, and the romantic. The first or *symbolic* phase re-presented a situation where a contradiction existed between form and

211

meaning. Here matter still refused to yield to spirit. The outcome was an inadequate expression of the idea which strove for self-expression and also the imperfect form which evolved from it. In the second or *classic* phase the idea was fully clothed in matter which became the perfect expression of the spirit; this phase, which represented the Greek spirit in its particularity, posed no impossible tasks for the artist. However, according to the inner dialectical logic of history, even this perfect moment could not last and the spirit was found to be wanting. Therefore, it moved on to the mystery of the Incarnation and Christian idea of infinity. Henceforth the spirit was to dominate over matter in the third or *romantic* phase.[100] If we set aside Hegelian terminology for a moment, it becomes clear that the three essential phases of the visual arts owed their origins to the Biblical 'Trinitarian' notion of historical periodization. The division of historical developments, not only in art but also in political and social histories in Hegel, into clusters of three periods, exemplifies this influence.[101] On this historical notion Hegel, of course, imposed his logical structure, thesis, antithesis, and synthesis. Secondly, Winckelmann's glorification of Greek art was never far from Hegel's mind. Hegel could not admit that Greek art was superior to the Christian, but he certainly agreed with Winckelmann that Greek art expressed the perfect balance of form and meaning.

In Hegel's system India, which was an archaic society like Egypt, evinced the first inadequate development of a conception of history as equally it expressed an imbalance of form and content. This notion of the 'inadequacy' of expression must be placed against the 'adequate' blending of form and content in classical art. In the symbolic phase the classical balance of form and meaning was yet to come. The first period was symbolic because it was all spirit and very little matter. All old civilizations of the Orient from Egypt to India were brought into it, for Hegel accepted the prevailing image of India's great antiquity. He did subsequently modify this view to some extent in the light of researches by English Indologists.[102]

In *Vorlesungen über die Ästhetik*, however, where most of his important pronouncements on Indian art are to be found, India was accepted as an archaic society. About it and other early civilizations which represented the *symbolic* period of art he stated that 'we may consequently regard it as only the forecourt of art, which is principally the possession of the East, and through which after a variety of transitional steps and mediating passages, we are at last introduced to the genuine realization of the Ideal in the classical type of art.'[103] The fact that Hegel accepted India's great antiquity agreed well with his own hypothesis that the first or archaic phase of art was symbolic. It was also in accord with Creuzer's portrayal of India as the first homeland of symbolic art, and

212

there is no doubt as to Creuzer's influence on Hegel's analysis of symbolic art. After establishing the relative position of India in his world-system, Hegel went on to describe its essence which was reflected in its art. This was the stage when ideas were inadequately realized because the spirit had not yet come to terms with matter:

These earliest and still most uncontrolled attempts of imagination and art we meet most signally among the ancient races of India, the main defect of whose productions . . . consists in this, that they are never able to seize the profounder aspects of significance in independent clarity, nor grasp the reality of sense-perception in its characteristic form and meaning . . . These people consequently, through their confused intermingling of the Finite and the Absolute, in which the logical order and permanence of the prosaic facts of ordinary consciousness are disregarded altogether, despite all the profusion and extraordinary boldness of their conceptions, fall into a levity of fantastic mirage which is quite as remarkable, a flightiness which dances from the most spiritual and profoundest matters to the meanest trifle of present experience, in order that it may interchange and confuse immediately the one extreme with the other.[104]

Hegel did not, however, deny spirituality to Indian art. Indian art belonged to the sphere of proper symbolism, the second symbolic stage in his history:

In the *second* stage we pass to the symbol in its real sense; . . . while, on the one hand, the significances assert themselves in their independent universality above the particular phenomena of Nature, on the other they are necessarily forced with a like insistency to present themselves to consciousness together with this preconceived universality in the concrete form of natural objects. In this . . . struggle to spiritualize Nature, and to present that which is born of Spirit to sense, . . . we meet with all the ferment and the motley of wild and unstable elements, the entire fantastic and confused world . . . of symbolic art, which half surmises, it is true, the incongruity of its manner of shaping, yet is unable to remedy the same save through the distortion of its figures, while straining after a purely quantitative sublimity that seeks to devour all limits. In this phase consequently we think ourselves in a world steeped with poetic fantasies, incredibilities and miracle, yet fail to encounter one work of genuine beauty.[105]

But at the same time this form of symbolic art presented certain problems. External nature was represented by means of universal characteristics and abstractions instead of in concrete terms. In Hegel's view this was because there occurred a breach between the Notion (*Begriff*) and its external manifestation. Therefore, all that was left for the Idea to do was to assert a kind of accord with external objects because it could not achieve a complete identification with them in this period. Not only did the rise of art coincide with the desire of the Notion to bridge the

213

gap between external nature and itself, but this anomalous situation produced a strange mode of representation. It produced a form of art which, being neither complete in its artistic fusion nor indeed capable of being completed, suffered the object to emerge as 'reciprocally external, strange and inadequate to itself'. Moreover, in its desire to narrow the gulf between nature and itself the Notion made a rich use of the images of fantasy.[106] It is not difficult to see the age-old Western spectre of the 'irrationality' of Indian art behind Hegel's compelling portrayal. Here, once more we are reminded by Hegel that the arts had originated in India. Symbolic art as exemplified by Indian art was, however, only a transitional phase for it did not represent genuine symbolism but 'the forms of a fermenting phantasy, which in the restlessness of its fantastic dreams merely indicates the path which conducts us to the real centre of symbolical art'.[107] Genuine symbolism only belonged to the realm of Christian art.

The 'exaggerations' in Indian sculptures were then explained in terms of the contrast between extreme abstractions in Indian thought and its gross manifestation in art. These two contradictory qualities indicated a spiritual inadequacy. As Hegel stated:

The imagination here is only capable of rendering assistance by means of distortions which carry the particular shapes over and beyond their secure boundaries, adding to their extension, making them even more indefinite, by an imaginative leap which mounts to the immeasurable, breaks up every bond of union, and in its very strain after reconciliation reveals each opposing factor in its most unmitigated hostility.[108]

What Hegel attempted to show here was that the symbolic images in Indian art crossed with impunity the threshold of rationality. For Hegel therefore the contradiction between the most abstract and the grossly concrete explained the fantastic and irrational character of Indian iconography. In a classic statement he put a new gloss over the traditional criticism regarding the multiple limbs of the Indian gods:

The most obvious way in which Hindoo art endeavours to mitigate this disunion is . . . by the *measureless* extension of its images. Particular shapes are drawn out into colossal and grotesque proportions in order that they may, as forms of sense, attain to universality . . . This is the cause of all that extravagant exaggeration of size, not merely in the case of spatial dimension, but also of measurelessness of time-durations, or the reduplication of particular determinations, as in figures with many heads, arms, and so on, by means of which this art strains to compass the breadth and universality of the significance it assumes.[109]

It was not at all fortuitous that he chose to criticize the Indian approach to the *human* form rather than any other aspect of art. To a

214

Europe deeply attached to the Renaissance treatment of the human figure in art the superhuman symbolism of the Indian gods had always proved difficult to assimilate. This difficulty was shaped in Hegel's own logic:

the purest form of representation . . . at this stage . . . is that of . . . the human figure . . . not as yet grasped . . . as the true subjectivity of Spirit, but rather . . . under a determination of abstract universality . . . it builds up Nature in the most various forms as the content of its human divinities . . . Hindoo art . . . is unable to advance beyond a grotesque intermingling of these two sides of Nature and humanity, so that neither is treated according to its rightful claim, but both are merely given the forms which are appropriate to the other.[110]

In a further passage in his lectures on the philosophy of religion Hegel brought up the subject again. He made a qualified condemnation because he felt even in its imperfect symbolic form Indian art was not entirely devoid of certain imaginative elements which indicated the presence of the spirit. On the basis of his idea that beauty was none other than the spirit manifesting itself through sensuous form, he commented on Indian art:

Thus the art . . . here is symbolical art, which does indeed express essential characteristics but not characteristics of the Spiritual. Hence the unbeautiful, the mad, the fantastic character of the art which makes its appearance here. The symbolism is not the purely Beautiful, just because a content other than spiritual individuality is the basis . . . here is a complete dissolution of form. The endless breaking-up of the One into the Many, and an unstable reeling to and fro of all content . . . mythological forms . . . which are on the one hand *baroque* and wild, and are horrible, repulsive, loathsome distortions, but at the same time prove themselves to have the Notion [*Begriff*] for their inner source.[111]

Hegel felt that he could not employ logic in the case of Indian art where everything was either turned into its very opposite, thus reflecting the existence of a state of *coincidentia oppositorum*, or where everything was expressed in terms of 'inflated enormities.'[112] The unhappy intermingling of the spiritual and the material in the Hindu phallic cult especially bothered him. He wrote that procreation was divinized in a wholly material way and the sexual organs were regarded as sacred in the highest degree. The creative act was not presented in a spiritual manner but as 'a purely *natural* process of *generation*'. What disturbed Hegel was the sensuous excesses in Hinduism, but he none the less pointed out that the only way to understand the meaning of these phallic images was to gain an insight into 'this mode of imaginative vision'.[113]

Arguably, the most valuable contribution of Hegel to the interpretations of Indian art was his analysis of its symbolism in terms of 'inadequate' symbols, possibly the last major exegesis of Neoplatonic

215

symbolism from a philosophical viewpoint. First of all, he defined the nature of an 'inadequate' symbol as expressed in Oriental art, which he then contrasted with the 'consonant' symbols of classical art. He felt that it was in the former that a real symbolism was to be encountered:

Although symbol may not, as is the case with the purely external and formal sign, be wholly inadequate to the significance derived from it, yet, in order that it may retain its character as symbol, it must on the other hand present an aspect which is strange to it. In other words, though the content which is significant, and the form which is used to typify it in respect to a *single* quality, unite in agreement, none the less the symbolical form must possess at the same time still *other* qualities entirely independent of that *one* which is shared by it, and is once for all marked as significant, just as the content need not necessarily be a bare abstract quality . . . but rather a concrete substance, which on its side, too, possesses a variety of characteristics which distinguish it from the primary quality in which its symbolic character consists, and in the same way, but to a still greater degree, from anything else that characterises the symbolical form.[114]

The term symbol was necessarily open to ambiguities with reference to the particular nature of the content which a given form may be held to symbolize under all its different aspects. These different aspects, moreover, could be employed symbolically through associating links that did not appear on the surface.[115] On the other hand, as Hegel showed, the inherent ambiguity of a symbol disappeared when the exact relation between the symbolical import and its external form, as well as the sense carried by them, were clearly stated. In literature this was to be seen in the case of 'simile' where both the general conception and its concrete image were presented to view.[116] In art the most perfect example of the marriage between the external form and its import was of course classical sculpture and painting. Although occasionally ambiguous symbolism was to be met with in Greek art, in general its message was clear, intelligible, and on the surface. Greek art was clear because 'it comprehends the true content of art . . . both the ideal aspect and the plastic shape being entirely adequate to each other'.[117] It was mainly in the field of Greco-Roman mythology that one confronted ambiguities of meaning, for often a mythical story contained under its surface certain profound ideas.[118] In Germany two opposing schools on the interpretation of ancient mythology existed. The first refused to see myths as something more than stories of purely external significance. Creuzer and his adherents with their Neoplatonic interpretation of mythology opposed this view. Hegel, who powerfully reaffirmed Creuzer and his *Symbolik*, moulded his precursor's arguments in his dialectical logic and with his notion of the spirit. His defence of 'inadequate' symbols is worth quoting in full:

216

In this view mythology must necessarily be apprehended as bound up with *symbolism*. And by symbolism all that is meant here is just this, that however bizarre, ridiculous, grotesque such myths appear to be, however much the adventitious caprice of a plastic imagination may contribute to their form, they are essentially a birth of Spirit; . . . myths and fabulous tales have their origin in the human spirit . . . Religion discovers its fountain-head in Spirit, which seeks after its truth, dimly discovers it, bringing the same to consciousness by means of any form, which discovers an affinity with this form of truth, be it a form of narrower or wider borders. But once grant that it is reason which seeks after such forms and the necessity is obvious to recognize the work of reason. Such a recognition is alone truly worthy of human inquiry.[119]

Hegel was of course aware that the notion of ambiguous symbols could be even better applied to the visual arts. A visual image which generally carried a particular significance was considered a *symbol* only when that significance ceased to be 'expressly marked by itself'.[120] With a great deal of perception he described the realm of Oriental art, including the Indian, as the perfect expression of the notion of inadequate symbols:

Moreover this ambiguity does not merely apply to isolated cases, but extends to vast areas of the entire domain of art, to the content of an almost unlimited material open to our inspection, to the content in full of all that Oriental art has ever produced. For this reason, as we enter for the first time the world of ancient Persian, Indian, or Egyptian figures and imaginative conceptions we experience a certain feeling of uncanniness, we wander at any rate in a world of *problems*. These fantastic images do not at once respond to our own world; we are neither pleased nor satisfied with the immediate impression they produce on us; rather we are instinctively carried forward by it to probe yet further into their significance, and to enquire what wider and profounder truths may lie concealed behind such representations . . . Nations . . . even in their childhood, require as the food of their imaginative life a more essential content; and this is just what in fact we find in the figures of Indian and Egyptian art, although the interpretation of such problematical pictures is only dimly suggested, and we experience great difficulty in deciphering it.[121]

It is fascinating to follow Hegel as he builds up, with a formidable exercise of learning and imagination and with the compelling use of words and concepts, a whole superstructure on which rests his own particular image of Indian art. And yet, for all the fascination which this amazing *tour de force* holds for us even today, did he mark a significant advance in European appreciation of Indian art? The answer must be in the negative, although a qualified one. In the first place, he created a new myth about the essence of Indian art and like all myths it was a mixture of truths and untruths. Paradoxically, his dynamic principle of history, the dialectics of change, only helped to establish a fundamentally static image of Indian art, its immemorial immutability,

217

its unchanging irrationality, and its poetic fantasy, all predetermined by the peculiar Indian national spirit. It needs to be repeated here that Hegel's characterization of the Indian 'spirit' was not based on empirical evidence but determined essentially by India's temporal position in Hegelian metaphysics. According to the German Idealist both India and China arrived on the scene before the spirit had embarked on its march of progress through history. Much energy was spent on asserting that China was all matter as India was all spirit. The resulting picture of China was insipid and puerile, a second-hand version of the Jesuit accounts. Likewise, Indian art had to furnish the essential contrast to the progress of classical art. It was thus condemned to remain always outside history, static, immobile, and fixed for all eternity. However attractive and even persuasive this view may be, it has the character of a myth and as such it fails to take into account the immense richness and variety of Indian art. The attempt by Hegel to treat all aspects of Indian art from all periods by posing a hypostatic image of the Indian spirit forced any developmental and morphological approach to be still-born.

It must be admitted that unlike Ruskin, Hegel did not reject Indian art out of hand simply because it contained bizarre forms. This acceptance was, of course, in line with his sympathy with Creuzer and the Neoplatonic approach to symbols. In fact, Hegel focused attention on the problem of assimilating Indian art in the light of the classical canon of beauty, the problem which had given rise to the monster myths. He himself took care to go through the important material published in the field of Indian religion and mythology. In fact, the problem with Hegel was that his image was almost entirely formed by literary evidence and not by works of art. From Colebrooke he had received extensive information about Indian religion, metaphysics, and logic, about the Vedas, the *nyāya*, and the *sāmkhya* systems.[122] He showed some knowledge of Buddhism in the *Philosophy of Religion*.[123] In his *Ästhetik* he cited passages from the *Rāmāyaṇa*, the *Mahābhārata*, and the Purāṇas. It may even be argued that his knowledge of Indian religion and philosophy was anything but superficial. In contrast, there exists only one specific reference in his whole output to Indian architecture. In his *Ästhetik* he stated that 'whatever instance of grandeur and magnificence we encounter overground [in India, Egypt and Nubia] cannot equal that which is to be found underground in Salsette, opposite Bombay, in Ellora, in Upper Egypt and in Nubia'.[124] Likewise there is the isolated example of a Hindu image in the same text. 'If we turn now to the more important examples of the imaginative sense on the plane we are now considering, we have first to draw attention to Trimûrtis, the triformed God-head.'[125] Apart from his world-system, this predilection, the lack of concern for actual works of art and a total dependence on literature

218

for making aesthetic judgements, constitutes a major weakness in Hegel's view of Indian art. The generalizations lack the substance which can only be provided by applying universal principles to concrete examples. The weakness was of course shared by Hegel with other contemporary Idealists. As Venturi shows, the curious fact is that the late eighteenth-century students of art looked by preference to the works of the past rather than to those of their contemporaries.[126] It is true that Hegel's obsession with history prompted his interest in Indian art. His indifference, however, to contemporary art robbed him of a sound empirical basis to judge different forms of art. In short, the image of irrational fancy which he laboriously fashioned for Indian art had less to do with facts than with certain aprioristic assumptions. He did not care to search for the differing norms of Indian art in relation to the classical. Rather, in drawing the picture of dreaming consciousness as expressed in Indian art, he helped to grant a new lease of life to the monster myth by reinforcing old attitudes with his deterministic philosophy.

Hegel's concern with the universal history of art and his establishment of art history within the history of ideas left its mark on the succeeding generations, and even on his opponents in Germany, let alone his supporters. C. O. Müller, who coined the term 'architectonic' and who influenced nineteenth-century archaeological method with his development of a scientific archaeology of art in 1830, regarded artistic activity as externalizing in sensible form the internal spiritual impulse. Displaying a formidable knowledge of current publications on Indian art, he arrived at the view that, while Indians had great intellectual accomplishments to their credit, in art they lacked the essential plastic sense and a directing intelligence. Consequently, Indian art was full of riotous fancy. In his words, 'we here see art roaming about with inconsistency amid an abundance of forms.'[127] Although the individual decorative members of architecture had a classic elegance, the whole generally reflected barbaric taste. Significantly, on the basis of Townley's famous erotic piece from Elephanta, he drew the conclusion that it was produced in a period of internal decay.[128]

A major art-historical work, Franz Kugler's now virtually forgotten *Handbook of the History of Art* (1842) dealt with universal history. The Indian section in it was based on an enormous amount of published material on India including the work of Rám Ráz.[129] His *Handbook* contains a remarkably appreciative account of Indian painting. According to him the Indian miniatures on mythological subjects in European collections betrayed a certain hieratic rigidity. And yet scenes from real life in particular displayed a gracefulness entirely their own. The intention of the artist was not to translate in prosaic terms the external

219

features of life but to create a poetic mood, an emotional *rapport*. In this the innate poetic sensibility of the Indians was evident, especially in the attractive treatment of the daily lives of women. Although fantastic tendencies in Indians often came to the fore in art, these lyrical paintings often exhibited a peculiarly delicate *naïveté* which overcame their conventional treatment of figures.[130]

Finally, Carl Schnaase, who followed him, wrote the most ambitious universal art history for the nineteenth century in 1843, on the basis of Hegelian principles of cultural history. Hegel had offered very little concrete evidence in his generalizations about different periods of art and about the art of different nations. Schnaase sought to fill in Hegel's conceptual framework with actual examples derived from all over the world, a task which became increasingly difficult to accomplish. Art for Schnaase was the essential expression of the spirit of a nation. The discussion on India was thus introduced with a description of the land and its religions. Following Hegel he described Hinduism as a mixture of the intensely spiritual and the grossly material, a pantheism full of sensual restlessness, reflecting the instability of the spirit.[131] Applying this notion to art he held that, although Ellora sculptures in some cases were not unworthy of the Greek chisel, they showed an absence of rules and of the harmony of proportions and 'the presentiment of the struggle of the wild forces of nature against the mighty power of the spirit [where] art and nature were still in brooding chaos'.[132] The use in these temples of diverse forms indicated the arbitrariness of wild natural forms 'struggling, jostling, and bringing confused and strange shapes before us'.[133] In ornament the disorderly imagination of the Hindus did not attach itself to the regularity of natural vegetation. The architecture was the outcome of Hindu philosophy, the wild mythological tradition, the sensuous excesses, and the orgiastic precepts of its cults. Schnaase concluded in a Hegelian tone that Indian art was symbolic in an imperfect sense for it pointed to a higher notion although it did not itself as yet reflect a free spirit. There were thus hints of tenderness, of human feelings, and of beauty in Indian art, but the spirit still struggled with forces of nature which led to frenzied excesses and unstable movements. Therefore, although deeper elements existed in Indian art, in this transitional phase in the history of art it was mainly incomprehensible, threatening, and mysterious.[134]

CHAPTER V

The Victorian Interlude

i. OWEN JONES AND THE NEW SCHOOL OF INDUSTRIAL DESIGN

THIS particular chapter deals with an episode in the history of the reception of Indian art in the West, namely, the growing awareness of and the concern with the decorative arts of India, noticeable in writings on design from about the middle of the nineteenth century. The preoccupation with Indian design coincided with the rise of a new aesthetic movement which demanded the reformation of industrial design. The leading figures in the movement were the designers Owen Jones, Matthew Digby Wyatt, Gottfried Semper, Richard Redgrave, and Henry Cole. These designers looked to Indian ornamental design to provide inspiration and to infuse a new life into the moribund industrial arts in Britain. Significantly, they did not show much interest in Indian sculpture or painting, but then they were not generally concerned with the visual arts. The popularity of Indian craftsmanship, of course, preceded by nearly two centuries this intellectual concern with Indian design. The importance of Indian cotton painting for European textile industries has been reconstructed with great imagination by John Irwin and Katharine Brett.[1] India, undoubtedly the greatest exporter of textiles from 1600 to 1800, not only revolutionized European taste and fashion with its chintz but struck at the very roots of economic stability. Chintz, which captured the fabric market with ease in the eighteenth century, caused hardship among weavers, provoked riots, and finally inspired satirical poems about noble ladies who preferred exotic finery to honest, English home-spun products.[2] There was also a demand in Europe for small art-objects, especially Mughal ones, from an early period as their existence in various Royal and noble collections testifies. Therefore, one essential point is useful to bear in mind here: it is not primarily the taste for or the collecting of Indian applied arts which concerns the present chapter. It is rather the manner in which Indian ornamental design emerged in the nineteenth century as the focal point in theoretical discussions on design and the way in which its principles were held up to be superior to those of advanced industrial countries of Europe.

The following are the historical antecedents to the sudden heightening

221

of awareness of Indian design. The profound technological achievements made possible by the Industrial Revolution brought with them an unfortunate attendant feature. The traditional methods of training artisans were obliterated during the Revolution, which led to a serious decline in craftsmanship. In the process the quality of manufactured products suffered. As mass-produced articles were churned out very little attention was paid to originality either in the conception of design or in its execution. The aesthetic movement which voiced its discontent with the prevailing industrial design took two forms: there was a desire to formulate new principles of design to replace the vulgar, illusionist design; there was a concern for educating the industrial manufacturers and artisans as well. Although there were some notable exceptions, the same critics who agitated for educational reforms invariably happened to hold radical views about design.

It was widely felt that traditional design had lost its vitality because manufacturers, under the influence of the prevailing demand, applied illusionist ornament indiscriminately to furniture, jewellery, carpets, and even household utensils. In doing this they frequently disregarded the essential nature of the material, thus robbing naturalistic design of its value and beauty. Although critics like Lord Clark have argued in favour of a reassessment of Victorian design,[3] the evidence that industrialization led to the decline of traditional craftsmanship and to stylistic confusion is overwhelming.[4] Alf Bøe, for instance, shows convincingly that a genuine dissatisfaction existed among a number of designers and critics. They were Henry Cole, William Dyce, Richard Redgrave, Digby Wyatt, Owen Jones, and Gottfried Semper, men who sought to reformulate the essential principles of good design.[5] Most of their criticisms centred on one aspect of design, namely ornamental design. This obsession with ornament may appear to us as somewhat strange. That is because the role of ornament in art and architecture or even in furniture has ceased to be of any consequence in our period. Simple, austere, and strictly functional design is so much taken for granted that ornamentation appears even to be positively distasteful. Think of the ultimate opulence in the internal combustion machine, the 1950s' Cadillac 'Eldorado' with its enormous fins. Without fear of contradiction, this model may be said to have earned virtually universal opprobrium for its designer because of its superfluous decorations. Arguably, our own severely functional approach to form would have been meaningless in the Victorian context; in that period it was, for instance, inconceivable that architecture should be unornamented and functional. Hence it was the general Victorian desire to re-examine the nature and function of decoration that contributed to a fresh interest in Indian design. In fact, when designers like Owen Jones turned against Western illusionist

design, they came to appreciate the principles of non-illusionist design prevailing all over the East and spanning an area from Arabia to China. The special appeal of Eastern design to the Victorians lay in the fact that they were not attempting to create an illusion of the external world. Of all Eastern traditions it was the work of Indian craftsmen which left a lasting impression on the Victorian mind. Even that great art critic, Ruskin, despite his unremitting hostility to Indian art in general, readily admitted not only the excellence of Indian design and craftsmanship but its great originality.[6]

The first important influence on the movement which demanded the reform of architectural industrial design was August Welby Pugin. He was one of the initial critics to disapprove of the extravagant use of Gothic minutiae and 'unmeaning detail' in contemporary decoration. Pugin's principle that the decorative ornamentation of flat surfaces 'must consist of pattern *without shadow*, with the forms relieved by the introduction of harmonious colours' profoundly affected his followers.[7] That surfaces should be ornamented without shading, in other words, their treatment should be flat, was to become the cardinal doctrine of the new movement. The view that decoration should be flat instead of illusionist is the one element which directly links this movement to our own period.

In 1835, the year in which Pugin acquired his reputation as a critic and reformer of industrial design, a Parliamentary Committee was set up to consider the aesthetic quality of English industrial products; these products were subsequently found to be inferior to those produced on the Continent.[8] The report of the Committee gave rise to much soul-searching. It was clearly realized that the quality of craftsmanship had declined in the wake of large-scale industrialization in Britain. This had allowed the aesthetic consciousness of the industrial workers to lapse. The growing concern with the crisis in taste is reflected in the pages of the leading organ in the field of industrial arts, the *Art Union Journal* or *Art Journal*. The journal recognized that there was a crisis and laid down aesthetic obligations for the manufacturer to meet it.[9] Throughout the second part of the century this feeling of crisis persisted. Even as late as 1853 the *Catalogue of the Museum of Ornamental Art* complained about the inferiority of European design in relation to the Indian: 'These works show a people faithful to their art and religion and values, whereas European workmanship shows a disordered state of art at which it has arrived ... we have no guiding principles in design, and still less of unity in its application.'[10]

One of the ways suggested by the 1835 Committee for improving industrial design was to provide education for the artisans, which problem became involved with a broader question on the setting up of art

schools in Britain. Two shades of opinion existed on the question of the type of art education to be imparted in Britain—whether there were to be 'academies' which provided a broad-based cultural education or whether there were to be workshops to train artisans for the industry. It was largely because one of the first leading figures in the controversy, Benjamin Haydon, supported the case for schools of design for industrial workers that he had been able to persuade the government to set up the 1835 Committee. His purpose was served, since a central school for industrial workers was founded at Somerset House in 1837.[11] From the very beginning people who supported the new movement for the reform of design were involved with the government art-education project with the only exception of Haydon. Dyce was the first superintendent of the schools of design, but Redgrave was to become even more important. As we shall see, he assisted Cole in his sweeping reforms of the schools of design after 1851. The point to bear in mind here is simply this: because designers like Cole struggled to achieve and eventually succeeded in establishing their ideas on how to run art schools in Britain they were also able to spread their new theory of design on a wide scale. Eastern design, and Indian design in particular, received wide diffusion through their efforts, for it became the model to be emulated by students in schools of design all over the country during the second part of the nineteenth century.

The years after 1835 were marked by feverish activity. Not only was the founding of new state-financed art schools envisaged but means were sought to improve the general standards of industrial design. The policy of direct application of art to manufactures recommended by the Committee reached its peak in 1851, the year of the Great Exhibition. According to the *Art Journal* the Exhibition was organized with the object of improving design by bringing together for comparison artefacts from nations all over the world.[12] The Great Exhibition of 1851 was the very first international exhibition of its kind. Its main authors were the Prince Consort and Henry Cole. Cole was to be one of the decisive influences in the founding of schools of practical art and the exhibition considerably enhanced his reputation. Not only Cole but other radical designers, such as Semper, Jones, Dyce, and Wyatt, had important parts to play in the Exhibition.[13] Although the general public, and especially Queen Victoria, was enchanted with the display of British industrial advances, informed opinion, including Cole's own group, was disappointed by the general performance of British industries. On the other hand, it was really this exhibition which opened their eyes to the wealth of Indian design and craftsmanship. Of special significance are the remarks of Owen Jones which will be discussed below. The Indian sections were of great importance for Jones's formu-

224

lation of 'correct' principles of design in *The Grammar of Ornament*.

A contrary opinion about Indian decorative arts was held by Ralph Wornum, a personal friend of Ruskin. Wornum, who joined the *Art Journal* in 1846, represented the orthodox view on the industrial arts.[14] While Cole and his associates held that industrial design was different from pictorial art and should be concerned with natural forms in outline and with their flat treatment, the traditionalists maintained that it was essential to imitate nature in design.[15] As early as 1843 a hostile view of Indian architectural ornament was put forward by Sarsfield Taylor: '[they] display a profusion of barbaric ornaments and gaudy colouring, gilding etc., expensive but not refined, as our recent publications on India clearly demonstrate.'[16] In 1851 Wornum emerged as a major opponent of non-European design as the Exhibition was drawing to a close. Remarking that the 'best shapes remain Greek' he offered a critical report of the displays in his prize essay 'The Exhibition as a Lesson in Taste', published in the *Art Journal Catalogue* of 1851. He criticized European designers for their slavish imitation of Indian shawls. Instead of copying 'the crude patterns of the hereditary weavers of the East', the educated and skilled weavers of the West could produce far better patterns if they did not spend much of their time making 'spurious Cashmeres'. Wornum's view was thus summed up by the following lines:

... Often in the best of Indian specimens the details which would not bear looking at; much of the design is put in to fill a space, the whole thing generally only an infinite combination of minute portions of different colours, aiming at a purely general effect. The merits of the best are negative, rather than positive; there is an absence of glaring faults, but no one feature of beauty; if we except the general harmonious colouring and uniform unobtrusiveness of detail, which last, however, is in itself a great quality ... In carpets, there is a decided superiority on the side of home productions.[17]

Agreeing with this sentiment the *Art Journal* decided to include only a page of Indian objects [113] from the Exhibition in its sumptuously produced catalogue. The objects brought over from India by one Captain James were summarily dismissed as 'curiously characteristic of Eastern taste'.[18]

On the other hand, foreign visitors to the Exhibition, who were not involved in the conflict, spoke highly of the Indian section. The most distinguished visitor to the Great Exhibition was Flaubert. Forced to interrupt his writing by a nagging mother, he found solace in visiting not only the Indian section in the Exhibition but the East India Company Museum in Leadenhall Street as well. In his youth he had caught the romantic fever of longing for the East, above all for India, a feeling which remained with him thoughout his life. In the notes from London

113. A page from *Art Journal* catalogue of 1851

left by him there are some rare but revealing aesthetic remarks about the Indian section at the Exhibition, apart from extensive objective reporting. But in general the Indian objects served only to lend substance to his Indian dream, composed until now entirely of literary evidence.[19] Greater attention was paid to the aesthetic side by the economist Blanqui who offered an unstinted tribute to the Indian collection:

The products of British India merit the attention of the technologists as well as philosophers and economists. There is truly an Indian art which has the same distinction as French art and moreover an originality often elegant and of good taste . . . This brilliant section of the Exhibition has been a veritable revelation. It was so rich and so complete in that it had represented the Orient from ancient times to our days. Indians are the French of the East for their industrial genius, only lacking our positive knowledge, but they are also artists in their own field like our craftsmen of Paris, Lyon, and Mulhaus . . . for us it [India] is all a new industrial world partly due to its great antiquity which

226

goes back to the heroic times and due to its original nature which does not resemble anyone else. From the opening of the Exhibition we have seen new products appearing, one more admirable than the other and which draw the greatest attention of the visitors . . . Indian art deserves such preference; it does not resemble any other form of art. It does not have the bizarre taste of the Chinese, neither the regularity of the Greek and the Roman, nor the vulgarity of the modern . . . It is an art apart, meaningful in its own context.[20]

The great success of the Exhibition brought its main architect Henry Cole before the public gaze. From now on he would seek a total control of art education in Britain. Cole already had a foretaste of success when he clashed in 1848 with the Secretary of the Board of Trade, Stafford Northcote, over the reform of schools of design. The events in the aftermath of the Great Exhibition only helped to sharpen the strife between the old and new critics of design.[21] At this stage, the *Art Journal* decided to intervene, with Wornum being its chief spokesman. But already the battle was lost for the traditionalists. Such was the success of the Exhibition that Cole, the younger Pugin, Jones, and Redgrave were appointed by the government to purchase objects to be permanently displayed at the new museum of Marlborough House. The collection, which formed the nucleus of the later South Kensington and Victoria and Albert Museums, was to serve the important function of providing superior examples of industrial design for students.[22] The idea for a museum had first come to the reformers. With a touch of envy Wornum complained that the selection of Cole and his associates was 'inauspicious' and the consequences would be 'unfortunate'.[23] In spite of criticisms a total victory for Cole came when he was made the head of the new Department of Practical Art and Redgrave his deputy. Once and for all it was decided that the Schools of Practical Art would only provide vocational training for industrial workers and not general liberal-art education. A significant outcome of Cole's success was the encouragement of flat non-illusionist design, deriving mainly from Eastern traditions. This triumph of the new designers provoked bitter criticisms on Wornum's part. He stated that the consequence would be fatal for schools of design because Redgrave's taste, knowledge, and experience were of a 'singularly low order', which no manufacturer would ever dream of consulting. In support of his view he quoted a jeweller who disapproved of Cole's peculiar mode of trying to 'wed Art and Manufacture'.[24] It was felt by Wornum that the government should not give up the substantial achievements of the schools of design in favour of wild speculations and theorizings. A reconciliation between Wornum and Cole was ultimately achieved when the latter decided to win over Wornum by offering him a post in his department. Wornum, too, sensing the wind of change, agreed to join Cole's ranks.[25] The

227

personal conflict thus resolved, Wornum kept up his criticism of Oriental design for some time. On the occasion of the manufacturers' exhibition at the Department of Practical Art he stated:

There is no reason why the taste of our own manufacturers should be formed solely by that of the Asiatic. There may be fashion among our aristocratic female society which inclines them to the produce of Benares and Aurangabad, because an artificial value is attached to the silks and woollens of the East which does not really belong to them for elegance of design. In arrangement of colour and in combination of rich tints, many valuable lessons may doubtless be learned from them; but the forms of their designs are open to vast improvement, being for the most part conventional, and too often without any apparent meaning . . . If the object of these gentlemen who selected the fabrics impelled them to go to a foreign market, we think that a few shawls from France . . . might have been well substituted—[thus procuring] a greater variety.[26]

This lone opposition was, however, no match for the crusading zeal of the reformers who continued to arrange exhibitions of applied arts in which Indian objects figured prominently. In order to instruct the students of practical art in good design as well as to instil in them a sense of what was beautiful the Museum of Ornamental Art was set up in Marlborough House. The objects displayed there as a sequel to the Great Exhibition came from the personal collection of the Queen and from private collectors but mostly from the Department of Science and Art. The last was connected with Cole's own department.[27] In 1853 the royal collection consisting of old Indian 'porcelain' and a series of Sèvres were exhibited.[28] The next year a collection of arms was displayed in which Indian arms were especially prominent.[29] Even the *Art Journal* offered its readers a selection of Indian objects from the above museum. The most notable were two alabaster pieces, a paper-weight inlaid with semi-precious stones and made in Agra,[30] and a vase whose ornamentation 'consists of delicate scroll-work and leaves in pure gold inlaid, the flowers and buds . . . of rubies and emeralds'.[31]

The Museum itself put out a catalogue in 1853 containing descriptions of Indian objects which included lacquered boxes from Lahore in the Queen's collection. The boxes were 'remarkable for sobriety and fullness in the ornament, for elegant distribution of the masses . . . with due regard to the constructive arrangement of the ornament, and serve as excellent models for teaching correct principles to the manufacturers'.[32] In the metal collection the sheath and dagger from Sind illustrated 'how orientals always decorated their construction but never constructed decoration', thus creating a brilliant total effect.[33] Noticeable too was the good design and excellent arrangement of form and colour harmony in a sword from Rajputana.[34] The prize exhibit donated

by the East India Company was an ivory carving of a Hindu mythological scene whose 'flat sculpturesque decoration of the background [formed] an admirable contrast to the figures in front'.[35] The catalogue contained several important remarks by the new school of designers on the correct principles of ornament. These principles were illustrated by examples taken from Indian designs. Dyce, one of the first heads of schools of design, stated:

If you ask me why Oriental ornamentation is so agreeable and natural, though it consists of little that resembles natural objects, I reply at once, it is because Oriental fabrics are ornamented in the same way as natural objects are. The forms employed are natural and beautiful forms . . . the object of the ornamentalist is *not to make mere copies of natural objects*.[36]

But it was the theorist among the group, Owen Jones, who undertook an extensive analysis of the basic strength of Indian design. He regarded these particular Indian objects in the Museum as being exceptionally valuable for teaching the fundamental principles of design:

Among the articles purchased by the Department of Practical Art—attention is directed more particularly to the 'Indian portion'—as the most important, both from the variety and beauty of the articles themselves, and as furnishing most valuable hints for arriving at a true knowledge of those principles which should regulate the employment both of Ornament and Colour in the Decorative arts.[37]

Contrasting Indian craftsmen, a people faithful to their own cultural values, with their European counterparts who were reduced to a desperate search for ever new styles, he lamented that the latter had 'no guiding principles in design, and still less of unity in its application'.[38] On the other hand, the Indian collection showed 'no struggle after an effect'. Every ornament was inspired by a true feeling for form. Neither were there artificial shadows or highly wrought imitations of natural flowers.[39] Indian design confirmed the dictum 'that construction should be decorated. Decoration should never be purposely constructed.'[40] His conclusion was that 'in the management of colour, again, the Indians, in common with most Eastern nations, are very perfect.'[41] Jones was acutely conscious that without a warning the British artisans might blindly copy Indian patterns as yet another style they could incorporate in their work. The manufacturers were therefore advised that: 'The principles belong to us, not so the results; . . . if this collection should lead only to the reproduction of an Indian style in this country, it would be a most flagrant evil.'[42]

Finally, the well-known art critic and director of the Berlin Museum, G. F. Waagen, spoke about Indian design. Waagen, who had a great reputation in Britain in this period, represented a genre of German

connoisseurs whose chief reputation was built not on research but on reviews of public and private collections in European countries.[43] Waagen recalled the impact of Indian applied arts at the 1851 Exhibition:

Indian emphasis on flatness and [design] remarkable for the rich invention shown in the patterns, in which the beauty, distinctness, and variety of forms, and the harmonious blending of severe colours, called forth the admiration of all true judges of art, what a lesson such designs afford to manufacturers, even in those nations of Europe which have made the greatest progress in Industry.[44]

As I have attempted to show, it was mainly through the efforts of the new school of designers that a climate of opinion was created in Victorian Britain which welcomed sweeping changes in industrial design. Not only was the eclectic use of different styles of design in industrial products generally rejected but, more important still, illusionist design in particular was condemned. In rejecting traditional design the reformers had to look for alternative conventions and in the process they came to recognize the importance of Indian decorative arts. One of the reasons why Indian ornamental design was appreciated was its flat treatment of forms. These designers were, of course, not radical enough, for, unlike Morris, they were only able to scratch the surface of the problem of Victorian design and the industrial arts. And yet their contribution to modern design should not be dismissed. They were without doubt some of the earliest designers to appreciate flat, non-illusionist design. If Cole may be regarded as the leading force in the aesthetic movement, *The Grammar of Ornament* (1856) by Owen Jones was its manifesto. Much of the theoretical discussion in the work centred on a close examination of Indian and other Eastern designs and their guiding principles.

The importance of the Indian collection at the Great Exhibition provided the introductory discourse in *The Grammar of Ornament*. First of all, a contrasting picture was painted of the respective states of European and Indian applied arts. In the contribution of the industrially advanced European countries the most noticeable features were the absence of a common principle in design and a 'fruitless struggle after novelty'. Without taking into consideration whether a particular style was appropriate to the subject, manufacturers engaged in an uncritical application of styles derived from all periods in the past. They did not ever reflect if these styles were able to meet present needs. It thus resulted in 'the carver in stone, the worker in metal, the weaver and the painter, borrowing from each other, and alternately misapplying the forms peculiarly appropriate to each'.[45] In contrast to this anarchical situation:

The Exhibition of the Works of Industry of all Nations in 1851 was barely opened to the public ere attention was directed to the gorgeous contributions of India. Amid the general disorder everywhere apparent in the application of Art to manufactures, the presence of so much unity of design, so much skill and judgement in its application, with so much of elegance and refinement in the execution as was observable in all the works, not only of India, but of all the other Mohammadan contributing countries,—Tunis, Egypt and Turkey —excited a degree of attention from artists, manufacturers, and the public, which has not been without its fruits.[46]

In praise of Eastern applied arts Jones wrote that 'there were to be found in the isolated collections at the four corners of the transepts all the principles, all the unity, all the truth, for which we had looked elsewhere in vain.' He attributed the strength of design in Eastern decorative art to the living tradition which deeply influenced the works of Eastern craftsmen. Unlike the break in tradition which had come with the Industrial Revolution in the West, these traditional workers were still deeply rooted in their own culture. The beneficial effect of tradition was illustrated in the works of the Turks, the Tunisians, and the Indians. The guiding principles of decorative ornament seen in Arabian and other Islamic countries were also to be noticed in Indian works. They were seen in the finest works of embroidery and textile as equally in ordinary earthen vessels or children's toys. The most striking feature of these works

is always the same care for the general form, the same absence of excrescences or superfluous ornament; we find nothing that has been added without purpose, nor that could be removed without disadvantage. The same division and sub-division of their general lines, which form the charm of Moresque ornament, is equally to be found here; the difference which creates the style is not one of principle, but of individual expression. In Indian style ornaments are somewhat more flowing and less conventionalised, and have, doubtless, been more subjected to direct Persian influence.[47]

Apart from these general remarks Jones made a detailed study of the Indian section in the 1851 Exhibition. The decorative ornament on objects was divided into two basic types: strictly architectural and conventional; naturalistic. This classification was elucidated with magnificent illustrations [114].[48] The second type of ornament, where a direct imitation of nature was attempted, Jones felt, provided a valuable lesson to European designers 'how unnecessary it is for any work of decoration to more than indicate the general idea of a flower'. As he argued,

The intention of the artist is fully expressed by means as simple as elegant. The unity of the surface of the object decorated is not destroyed, as it would be by the European method of making the flower as near like a natural flower as possible, with its own light and shade and shadow, tempting you to pluck it from the surface.[49]

114. Indian ornament from *Grammar of Ornament*

Further merits of Indian ornamental design were enumerated by Jones:

In the equal distribution of the surface ornament over the grounds, the Indians exhibit an instinct and perfection of drawing perfectly marvellous. The ornament No. 1, on Plate L, from an embroidered saddle-cloth, excited universal admiration in 1851. The exact balance, obtained by the gold embroidery on the green and red grounds, was so perfect that it was beyond the power of a European hand to copy it with the same complete balance of form and colour. The way in which the colours are fused in all their woven fabrics, so as to obtain what they always appear to seek, viz., that coloured objects when viewed at a distance should present a neutralised bloom, is very remarkable . . . each step nearer should exhibit fresh beauties . . . an Indian shawl [is] constructed precisely on the same principles.[50]

From a general criticism of ornament in the decorative arts Jones proceeded to make a more fundamental critique of ornamentation in architecture. The essential difference between classical and Indian approaches to architectural ornament was brought out. His knowledge of Hindu ornament was derived from Rám Ráz's outstanding work on ancient Indian architecture published in 1834. Jones was one of the first writers outside the Indological tradition to give serious consideration to this important work. It is all the more remarkable considering that he was not primarily interested in either architecture, sculpture, or painting. About Greek ornament Jones felt that while it reflected a refined taste it lacked one quality, namely symbolism, which often added a certain charm to ornamental design. Consequently, ornament in Greek architecture was 'meaningless, purely decorative, never representative, and can hardly be said to be constructive'. The surfaces in classical Greek architecture were ideally receptive to ornament and they were accordingly ornamented. But decoration was not an integral part of the structure in that it could be omitted without affecting the general arrangement of the building. As an illustration Jones cited the Corinthian capital on which 'the ornament is applied, not constructed: it is not so on the Egyptian capital; there we feel the whole capital is the ornament—to remove any portion of it would destroy it.' Jones found further fault with the Greek use of sculpture as architectural decoration: 'However much we may admire the extreme and almost divine perfection of the Greek monumental sculpture, in its application the Greeks frequently went beyond the legitimate bounds of ornament. The frieze of the Parthenon was placed so far from the eye that it became a diagram.'[51]

Examples of Hindu architectural ornament [115] were not easy of access. Jones however found some specimens displayed at the Royal Asiatic Society. The famous copies of Ajanta paintings made by Griffiths were seen by him at the United Services Museum and the East India

115. Hindu ornament from *Grammar of Ornament*

Company Museum. He appreciated that from such meagre evidence he could not form a balanced opinion of ancient Indian ornament. Neither was the published material adequate in this respect, excepting the work of Rám Ráz; the books on Indian art to date did not make a special study of ornament in buildings. As a result it was difficult to make out the essential and individual character of Hindu ornament. As Jones recalled, for a long time Egyptian sculpture and ornament were rendered in such a distorted manner that it was impossible to know that works of great excellence and refinement existed in Egyptian art. Until there were works which gave a correct picture of Indian architecture it would not be possible to form an opinion about the quality not only of Indian architectural decoration but of architecture itself. In this connection Jones also remarked that while ornament should not take over the function and the importance of the structural parts of a piece of architecture it none the less was 'the very soul of an architectural monument; and by the ornament alone can we judge truly of the amount of care and mind which has been devoted to the work.'[52] A truly exalted view of architectural decoration, it can only make sense to us in the light of Victorian attachment to ornament. The interesting point here is that, although Jones was not in a position to know, decorative ornament in Hindu architecture was also extremely important.

While admitting the paucity of information on the subject, Jones pointed out that it was impossible to read Rám Ráz's *Essay* on Hindu architecture 'without feeling that a higher state of architectural perfection [had] been reached than the works published up to the present time would lead us to believe'. The work by Rám Ráz not only mentioned precise rules which governed the arrangement of buildings but also 'minute directions ... for the divisions and subdivisions of each ornament'. Jones was particularly impressed with the ancient precept cited by the Indian scholar that in 'building an edifice therefore, let all its parts from the basement to the roof be duly considered'. According to Jones this gave a clear indication of how much general perfection was cared for. The English designer reproduced from Rám Ráz an account of the design for columns, including their various proportions. The best example of Hindu ornament illustrated by Jones in his *Grammar* was from a sculpture of the sun god, Sūrya, in the collection of the Royal Asiatic Society. Describing the beautiful treatment of ornament in the figure, he suggested a possible Greek influence.[53] Finally, he remarked on the illustration depicting decorative ornament in Ajanta paintings:

In Plate LVII we have gathered together all the examples of decorative ornament that we could find in the copies of the paintings from the Caves of Ajunta, exhibited by the East India Company at the Crystal Palace. As these copies,

notwithstanding that they are said to be faithful, are yet by a European hand, it is difficult to say how far they may be relied upon. In the subordinate portions, such as the ornaments, at all events, there is so little marked character, that they might belong to any style. It is very singular, that in these paintings there should be so little ornament; a peculiarity that we have observed in several ancient paintings in the possession of the Asiatic Society. There is a remarkable absence of ornament even on the dresses of the figures.[54]

There is evidence of a continuing interest in Indian decorative arts throughout the nineteenth century, partly because, despite the sweeping changes in art education carried out by the reformers, industrial design continued to reflect inferior and uninspiring standards. The effective reform of design had to wait for the arrival of Morris on the scene.

There remains now one other nineteenth-century figure who cannot be left out of this study. Sir George Birdwood did not belong to the new group of designers but he was certainly to become one of the greatest champions of Indian decorative arts. It is therefore appropriate that we end this section with a short account of his *The Industrial Arts of India* (1880), one of a series of handbooks published in connection with the Indian collection at the South Kensington Museum. In the work Birdwood presented in an expanded form the catalogue of Indian industries he had initially prepared for the Paris International Exhibition of 1878. An upholder of romantic primitivism, he emerged in this period as a major critic of the evils of Western industrialism which he contrasted in his work with the ideal village communities in India. In many ways he was more radical than the Cole group, for he went beyond a mere formal analysis of Western and Indian handicrafts by making Indian social structure responsible for the excellence of the decorative arts of India, both in conception and in execution. A warm tribute was paid to his service to the industry by William Morris and a number of eminent people in a letter dated 1 May 1879, the year after the Paris Exhibition. They especially praised his courageous stand in condemning the Indian government for letting the Indian applied arts perish while large-scale industries were set up in India. This was all the more poignant in view of the educative importance of Indian traditional industries to Western craftsmen.[55]

Birdwood thus emerged as one of the major critics of the industrial policy of the Indian government and of Victorian materialism. His view was that it was in architecture that the worst effects of 'mongrel' forms of Westernization were to be encountered in India. And art 'never long survives among a people who neglect architecture, the chief of all arts'.[56] As an antidote to the evils of industrialism Birdwood advocated the return to the simple life of the Indian villages. He felt

that the strength and excellence of industrial art in India sprang from a cohesive and self-sufficient communal life, something which was entirely absent in industrial Britain.[57]

An idealized image of Indian village life formed the basis of his appreciation of the decorative arts. He did not care for Indian sculpture or painting as many passages in his works testify. It was not unusual that he would have little patience with Indian iconography. He, in fact, roundly blamed Hindu mythology for the monstrous nature of Indian art. In a chapter on the evil influence of the Purāṇas on art he claimed that these texts were not essential to Indian art. On the contrary, they had hindered art from developing. Denying a congenital defect on the part of the Indian artist, Birdwood asserted that his instinctive creative ability was evident the moment he was not inhibited by Hindu mythology. On the contrary, Buddhist art appealed to Birdwood for dealing with human stories. Birdwood's notorious statement on Hindu art is worth quoting here: 'The monstrous shapes of the Puranic deities are unsuitable for the higher forms of artistic representation; and this is possibly why sculptures and painting are unknown, as fine arts, in India.'[58] Birdwood held that the monstrous gods had also affected decoration. He introduced in this context the notion of 'racial romanticism' which, as Frankl shows, was influential in the nineteenth-century art histories. Not only did a romantic picture of Indian village communities determine his view of the decorative arts, but he also found inspiration in the prevailing 'Aryan' myth. In his words, 'Admirably though the unnatural figures of the Puranic gods, derived from the Dravidian and Indo-Chinese races of India, sometimes shew indetailed ornamentation, yet their employment for this purpose is in direct defection from the use of the lovelier, nobler forms of trees and flowers . . . introduced . . . by the Aryan race wherever they went.'[59]

An early 'ecologist', Birdwood had nothing but praise for Indian artisans 'who, for all the marvellous tissues and embroidery they have wrought, have polluted no rivers, deformed no pleasing prospects, nor poisoned any air'.[60] Similarly, every house in India was 'a nursery of the beautiful . . . which must have its effect in promoting the unrivalled excellence of the historical arts handicrafts of India'.[61] *The Industrial Arts* is full of appreciative insights into the traditional crafts such as metal and damascened works, enamels, arms, trappings and caparisons, jewellery, household furnishings, and decorations. A particularly glowing tribute was paid by Birdwood to the simple arrangement of the living-room of a cultivated Indian. Not only was Birdwood 'simply entranced by the perfect proportions of the room', but he was convinced that this was how ancient Greeks had lived in their days of splendour. It was this experience in India which led him to conclude

237

that it was foolish to clutter up the living space in tropical countries with useless furniture.[62]

ii. JOHN RUSKIN AND WILLIAM MORRIS

It is a difficult task to try to discover a pattern of development in Ruskin's attitude to Indian art. He first came into contact with it early in his youth when he wrote the prize poem, *Salsette and Elephanta*. Through the whole span of his active career Indian art continued to haunt him. His impressions of Indian art were deeply marked by his own mental attitudes to art, to society, and to life itself, as all the things he was to touch in his life were to be transformed by the strangeness of his tragic genius. As has been remarked time and again, there is no point in trying to see his works in terms of a logical or chronological development or to divide them according to problems or chapters. They were the essential product of a 'unified vision over an often divided and ravaged mind'.[63] It was this intensely personal approach which set Ruskin apart from the general European art-historical tradition. But if a comparison may be offered between Hegel and Ruskin, two of the greatest figures in nineteenth-century art criticism, Hegel was 'all system', as equally Ruskin represented a total lack of system. Hegel presented an impersonal view of the history of world art as it stemmed from his world-view and from his dialectical system. Totally lacking any 'historicist' tendencies, Ruskin brought to bear upon art criticism a whole series of personal comments, at times bizarre but most often compelling. However, over and above all the contradictions and inconsistencies in Ruskin, there is evidence of a singularly powerful point of view, which runs through the whole of his extensive output. Ruskin, who was undoubtedly one of the greatest Victorians, pursued with relentless fury certain key ideas which had their inception in his youth. His remarks about Indian art were no more true than those of Hegel, but they were a remarkable testimony to his own faith in the moral role of art.

Ruskin's obsessive character and his extreme religiosity were formed by his unhappy childhood and oppressive Victorian upbringing. His conviction that human nature was essentially depraved derived from his mother's Evangelism.[64] A lifelong opponent of Victorian impiety and materialism, he set up his own faith as an effective barrier against it. Although at a later stage Ruskin had formally renounced Evangelism, some of its characteristics were to leave a permanent imprint on his personality. Evangelism was on the ascendant in the nineteenth century as the dominant ideology of the British empire builders in India. Evangelists equated the material superiority of the West with the moral superiority of Christianity. A supremely confident religion, the middle-

class Protestantism of the nineteenth century combined a genuine desire to improve the lot of the less fortunate classes and less fortunate nations with a superior attitude to other denominations as well as to other religions.[65] Ruskin of course did not share the average Victorian's unbounded optimism in the industrial might of the West. And yet certain features of Evangelism are distinctly noticeable in him, such as a unique moral earnestness in dealing with any subject however trivial, and a singular lack of sense of humour. It was the evangelical strain in Ruskin and a unique sense of mission that coloured his approach to art. As Bell writes, while 'other critics have on the whole written about work that they liked, Ruskin wrote extensively about that which he did not like.'[66] He saw himself essentially as a reformer in art. Therefore, different artistic traditions came under his fire in different periods of his life. No doubt, the greatness of Ruskin rests in no small measure on the manner in which he turned art from an aesthetic problem into a moral question.

As one of the major critics of Victorian industrialism along with Morris, his view of the moral power of art was rooted in his conception of an ideal society. Influenced by the prevailing Gothic Revival movement, he was convinced by Pugin's argument that the nineteenth century could not produce vital art so long as the artisans were held prisoners of the machine.[67] The conclusion drawn by him was that there was a need to revive medieval social values because only a morally viable society was capable of producing a superior form of art. It should have followed from this that India, an industrially backward nation, was an ideal society from the viewpoint of producing great art. This was the view not only of Cole and his group but of Birdwood and finally of Morris. Significantly, Ruskin did not share this view. It is true that, although Ruskin attacked Victorian materialism, he was neither as radical as Marx and other social philosophers nor did he clearly anchor his faith in the future. A 'revivalist' at heart and a sympathizer with the aristocracy against the middle classes, his ideal society lay in the past. Moreover, for all his condemnation of industrial progress his own view of art had a residue of 'progressivism' in it. A supporter of the British Empire, he never seriously questioned European superiority in relation to other nations. This comes through in all his statements on Indian art. In fact, nineteenth-century Evangelism had pinned its faith on scientific progress and had considered it a duty to convert non-Christians to the true religion.[68] The view among the English that the benighted Indians needed to be helped to see the light is evident in Ruskin's poem on Salsette and Elephanta. Based on Linschoten and possibly on Erskine's description of Elephanta, the poem ends on the note that India was to be saved by Christianity from the prevailing religion of fear.[69] The

239

evangelical influence on Ruskin and his confidence in the Empire made him see India as primitive, cruel, and despotic. But, as we shall see, Ruskin's worst suspicions were confirmed at the time of the 1857 Uprising. Today there is no general agreement among scholars about the relative responsibility of either side. But to contemporaries the news of Sepoy atrocities came as a great shock. Inevitably, the 1857 Uprising convinced Ruskin of the utter immorality of the Indians as well as the inferior quality of their arts.

In spite of his general condemnation of the visual arts of India, it is not difficult to see why he appreciated the decorative arts. Of course, with his eye for colour and design he was able to appreciate the remarkable qualities of Indian applied arts. He was, after all, the first major critic to recognize Turner. But Ruskin was also influenced by the prevailing Victorian interest in Indian decorative ornament. On the other hand, he maintained that inferior nations were able to produce excellent decorative art which involved neither the intellect nor a developed moral sense. The question of moral involvement only arose in the case of sculpture and painting, in other words, 'high art'.[70] An art which was morally worthy must, according to Ruskin, be based on a close study of nature. The study of nature for Ruskin did not mean the traditional concern with representation but an empirical study of nature in all its details in a thoroughly scientific manner. None the less, the implication was that it was the study of nature which separated Indian art from European, especially from classical art.[71]

The unique quality of Ruskin's prose loses much in paraphrasing. Therefore in my presentation of Ruskin's view of Indian art I have sought to retain as much of his actual language as possible, in other words, I have let him speak. No one can make Ruskin clearer than the man himself. In *Modern Painters* (vol. V, 1860) the climates of the various parts of the world were divided by Ruskin into five groups according to their fitness for art. He felt that the tropical forest lands characterized by moist and enervating heat and represented by India were not conducive to the growth of mind or of art, for the inhabitants 'may reach great subtlety of intellect, as the Indian, but not become learned, nor produce any noble art, only a savage or grotesque form of it'.[72]

Yet he could not very well deny the wonderful achievements of Indian decorative arts as displayed in 1851, and he admitted the strong and instinctive colour sense of Indian craftsmen. He, however, maintained that this quality did not in itself indicate a higher moral and intellectual conception of art. In *Modern Painters* (vol. III, 1856) he had declared that 'the Chinese and Indians, and other semi-civilized nations, can colour better than we do, and that an Indian shawl and China vase are still, in invention of colour, inimitable by us. It is their glorious

ignorance of all rules that does it; the pure and true instincts have play, and do their work.' As he felt, the least interference with these instincts by educating them destroys their power. Therefore,

it has been an actual necessity, in order to obtain power of colouring, that a nation should be half savage: everybody could colour in the twelfth and thirteenth centuries; but we were ruled and legalised into grey in the fifteenth; —only a little salt simplicity of the sea natures at Venice still keeping their precious, shell-fishy purpleness and power; and now that is gone; and nobody can colour anywhere, except the Hindoos and Chinese.[73]

He paid another glowing tribute to the colour sense of the Indians in his lecture entitled 'The Two Paths' (1859). He stated that the 'skill with which the thirteenth-century illuminators in books, and the Indians in shawls and carpets, used the minutest atoms of colour to gradate other colours, and confuse the eye, is the first secret in their gift of splendour: associated, however, with the many other artifices which are quite instinctive and unteachable'.[74] With the same insight Ruskin realized the limitations in the Greek use of colour, although he did argue that the limitation itself was proof of their superiority over other nations. The design on the shield of Atrides was of dark colour and yet described as being of the colour of the rainbow. From this Ruskin felt that the Greeks tended to take colour in a figurative sense and they often sought 'to look through the hue to its cause'. They seldom found pleasure in colour for its own sake and did not find 'abstract pleasure in blue, or green, or gold; but only in their shade or flame'. The reason, as Ruskin argued, lay in 'the brooding shadow of death . . . without any clear hope of immortality' in the Greeks, and in general reflected a preoccupation with tragic thought. He further remarked that in the Greeks,

the failure of colour-perception is partly noble, partly base: noble, in its earnestness, which raises the design of Greek vases as far above the designing of mere colourist nations like the Chinese, as men's thoughts are above children's; and yet it is partly base and earthly; and inherently defective in one human faculty: and I believe it was one cause of the perishing of their art so swiftly.[75]

Yet again in 1870 he stressed the importance of light as opposed to pure colour in Greek art.[76] In contrast to the Greeks he presented an alternative convention, called here the Gothic but included a wide range of non-classical styles:

When I briefly speak to you of the Gothic school, with reference to delineation, I mean the entire and much more extensive range of schools extending from the earliest art in Central Asia and Egypt down to our own day in India and China:—schools which have been content to obtain beautiful harmonies of colour without any representation of light; and which have, many of them, rested in such imperfect expressions of form as could be so obtained; schools

usually in some measure childish or restricted in intellect or similarly childish or restricted in their philosophies or faiths: but contented in the restriction; and in the more powerful races, capable of advance to nobler development than the Greek schools, though the consummate art of Europe has only been accomplished by the union of both.[77]

Recalling the greatness of European art, he had pointed out in *The Queen of the Air* (1869) that colour sense alone could never make up for the lack of moral ideas. Therefore, 'the pure colour-gift, when employed for pleasure only, degrades in another direction; so that among the Indians, Chinese, and Japanese, all intellectual progress in art has been for ages rendered impossible by the prevalence of that faculty.'[78] As an admirer of Turner's paintings he paid Indian design a handsome compliment by comparing it with the master's work in that 'Turner's colour has . . . conditions of mosaic effect, like that of the colours in an Indian design, unaccomplished by any previous master in painting.'[79] But the beautiful arrangement of colours certainly did not by itself constitute high art. As he pointed out:

Abstract colour is of far less importance than abstract form; that is to say, if it could rest in our choice whether we would carve like Phidias (supposing Phidias had never used colour), or arrange the colours of a shawl like Indians, there is no question as to which power we ought to choose. The difference of rank is vast: there is no way of estimating or measuring it.[80]

But as was the case with all other European critics including Hegel, it was Indian iconography and the symbolic images which presented the most serious problem of assimilation for Ruskin. In this English critic there is the clear evidence of his willingness to accommodate only one kind of symbolic image—the consonant or the allegorical kind. In this respect Ruskin was in accord with his Victorian contemporaries who were able to recognize only one kind of symbolic or allegorical image, the one whose meaning could be clearly translated into rational terms. This bias, in part encouraged by scientific rationalism, naturally ignored the whole world of Neoplatonic symbolism.[81] The outcome was that Indian images were generally dismissed as irrational. The question of 'irrational' sculptures was first raised in connection with the discussion of fantastic Venetian bases in *The Stones of Venice* (1851). Here Ruskin made a distinction between the occasional but legitimate use of grotesque motifs in a high form of art and the presence of grotesque in a superstitious artistic tradition. Although he felt that the grotesque in Venetian architecture went against all bounds of reason and natural order, their existence was justified on the grounds of their 'extravagant' conception. Since this appeal purely to the imagination was made by the physically and intellectually robust Lombards, there was no fear of being misled, for 'the visions of a distempered fancy are not indeed permitted to

replace the truth, or set aside the laws of science: but the imagination which is thoroughly under the command of the intelligent will, has a dominion indiscernible by science, and illimitable by law.' As against this deliberate use of monstrous forms as an artistic convention he set the irrationality of Indian art:

... We may acknowledge the authority of the Lombardic gryphons in a mere splendour of their presence, without thinking idolatry an excuse for mechanical misconstruction, or dreading to be called upon in other cases, to admire a systemless architecture, because it may happen to have sprung from an irrational religion.[82]

It has been pointed out by his editors, Cook and Wedderburn, that by referring to 'a systemless architecture' he was hitting hard at the admirers of Indian architecture. In a further discussion of grotesques in the third volume of the same work he developed the same theme by relating the ability of certain races to combine intellect with imagination in art. In his view 'the human soul' reached the highest level of achievement in two great human families. One included the Egyptians, Jews, Arabs, Assyrians, and Persians. The other comprised the north Europeans who filled Europe with their 'Norman and Gothic energy'. In both these families the grotesque represented the highest possible development in art. Therefore:

The reader who has not before turned his attention to this subject may, however, at first have some difficulty in distinguishing between the noble grotesque of these great nations, and the barbarous grotesque of mere savageness, as seen in the work of the Hindoo and other Indian nations; or, more grossly still, in that . . . of the Pacific islands.[83]

Unlike Hegel, Ruskin's essentially rational approach to symbolic images was clearly expressed in a lecture given at Oxford in 1870 where he warned his audience against accepting an image as indicating a real presence of a supernatural being instead of symbolizing that presence.[84] This view was even more clearly stated in a lecture on Idolatry (November 1870) where he approved of a consciously fashioned symbolic image. On the other hand,

... the essence of evil idolatry begins only in the idea or belief of a real presence of any kind, in a thing in which there is no such presence ... But, as a matter of historical fact, the idea of such presence has generally been both ignoble and false, and confined to nations of inferior race, who are often condemned to remain for ages in conditions of vile terror, destitute of thought. Nearly all Indian architecture and Chinese design arise out of such a state; so also, though in a less gross degree, Ninevite and Phoenician art, early Irish and Scandinavian; the latter, however, with vital elements of high intellect mingled in it from the first.[85]

In his inimitable manner he even prescribed with a somewhat superior

air what form of idolatry was permissible. He said that 'you must have not only the idolizing instinct but an ἦθος which chooses the right thing to idolize! Else, you will get states of art like those in China or India, non-progressive, and in great part diseased and frightful, being wrought under the influence of foolish terror or foolish admiration.'[86]

In *The Queen of the Air* (1869) Indian sculpture was subjected to an aesthetic criticism on account of extreme 'undercutting' in relief sculpture. Often the sculptor, in wishing to demonstrate his skill at undercutting, made the recess exaggeratedly deep which tended to over-emphasize the shadow. Ruskin argued that unlike in Venice the 'extreme of vulgarity is reached when the entire bas-relief is cut hollow underneath, as in much Indian and Chinese work, so as to relieve its forms against an absolute darkness'. Thus '... the Lombardi of Venice undercut delicately, in order to obtain beautiful lines and edges of faultless precision; but the base Indian craftsmen undercut only that people may wonder how the chiselling was done through the holes or that they may see every monster white against black.'[87]

Ruskin's juxtaposition of Greek and Indian art has now become classic, although at various times in his life he had refused to be moved by classical art, especially when Gothic art came to hold his undivided attention. In his famous lecture on the *School of Athens* (1870) he sought to clarify the essential character of Greek art by drawing a contrast between Greek and Indian sculpture. According to him, Greek art was the source of all simplicity as well as of all complexity. The Greeks were held to have rescued the forms of man and beast and to have sculptured them 'in the nakedness of their true flesh, and with the fire of their living soul'. Ruskin interpreted the myth of Daedalus in this context, that Daedalus gave 'motion to statues' from 'the binding together of the feet to their separation'. On the other hand, the 'figures of monstrous gods on Indian temples have their legs separate enough; but they are infinitely more dead than the rude figures at Branchidae sitting with their hands on their knees.' Then came the famous contrast between Greek and Indian examples of art [116]. The example of Indian art was the colossal bull from Delhi:

I can put the relation of Greek to all other art, in this function, before you, in easily compared and remembered examples ... Here, on the right, ... is an Indian bull, colossal, and elaborately carved, which you may take as a sufficient type of the bad art of all the earth. Fault in form, dead in heart, and loaded with wealth externally. We will not ask the date of this; it may rest in the eternal obscurity of evil art, everywhere and for ever. Now, beside this colossal bull, here is a bit of Daedalus-work, enlarged from a coin not bigger than a shilling: look at the two together, and you ought to know, henceforward, what Greek art means, to the end of your days.[88]

244

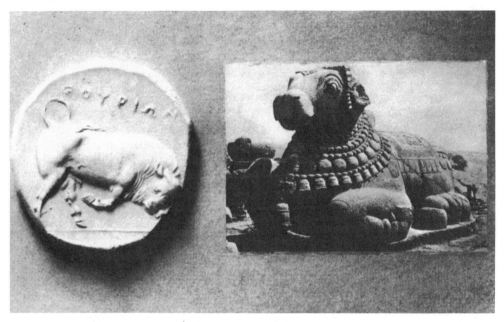

116. Ruskin's contrast of Greek and Barbarian sculpture

A personal conception of nature was central to Ruskin's art theory. The study of nature was to an artist a moral duty, in fact, the highest moral duty. Although in numerous passages on the splendours of nature the meaning constantly shifts, Ruskin's truth to nature can be said to stand for a photographic fidelity, a close observation of the infinite details and beauties of nature.[89] The influence on Ruskin here is not of the academic, classical tradition in art but that of science. Therefore, while Ruskin did appreciate the beauties of Indian design, it still did not come up to his ideal in art, for it was not concerned with the study of nature but only with abstraction. In *The Two Paths* (1859) he had characterized the essential quality of Indian art:

It is quite true that the art of India is delicate and refined. But it has one curious character distinguishing it from all other art of equal merit in design —*it never represents a natural fact*. It either forms its compositions out of meaningless fragments of colour and flowings of line; or if it represents any living creature, it represents that creature under some distorted and monstrous form. To all facts and forms of nature it wilfully and resolutely opposes itself: it will not draw a man, but an eight-armed monster; it will not draw a flower, but only a spiral or a zig-zag. It thus indicates that the people who practise it are cut off from all possible sources of healthy knowledge or natural delight; that they have wilfully sealed up and put aside the entire volume of the world, and have got nothing to read, nothing to dwell upon, but that imagination of the

245

thoughts of their hearts, of which we are told that 'it is only evil continually' . . . for them neither their heaven shines nor their mountains rise—for them the flowers do not blossom—for them the creatures of field and forest do not live. They lie bound in the dungeon of their own corruption, encompassed only by doleful phantoms, or by spectral vacancy.[90]

Therefore, the dire warning given to the manufacturers was that, instead of basing themselves on a study of nature, if they designed decorative ornament 'either in the ignorant play of [their] own heartless fancy, as the Indian does, or according to received application of heartless laws, as the modern European does, . . . there is but one word for [them]—Death.'[91]

Ruskin's idea of nature was many-faceted. In *The Two Paths* (1859) the role of nature in art was further elaborated. Answering the charge that he was often accused of making art too moral, he stressed that it was not necessary for a 'good' painter to be an exceptionally virtuous man. But the artist's essential morality lay in the way he approached nature because the study of nature in itself was the great moral force. Therefore, there were two clear paths to be taken in art:

. . . here are your two paths for you: It is required of you to produce conventional ornament, and you may approach the task as the Hindoo does, and as the Arab did, without nature at all, with the chance of approximating your disposition somewhat to that of the Hindoos and Arabs; or as Sir Joshua and Velasquez did, with, not the chance, but the certainty, of approximating your disposition, according to the sincerity of your effort—to the disposition of those great and good men. And do you suppose you will lose anything by approaching conventional art from this higher side? Not so.[92]

Continuing this argument, Ruskin asserted that while the Alhambra in Spain had certain captivating features it lacked the intense and profound qualities of true ornamental art; such qualities belonged to only three traditions, the Greek, the early Gothic, and the great Italian schools. This was simply because true decoration presupposed an intimate knowledge of the human form.[93] The conception of nature in Ruskin was also related to his notion of truth. Thus there were two kinds of artists, those who placed pleasure, derived from the arrangement of colours and lines, above the search for truth from nature and those who put truth before pleasure. Applying the pleasure and truth principle to world art he found that Indians and Arabs put pleasure before the search for truth in nature. The contrary was true of Fra Angelico and other great European painters. In the following passage Ruskin proceeded to equate the notion of Humanism with the essential humanity in a nation's character. Therefore, a nation whose artists were not concerned with the study of nature were necessarily cruel and inhuman. Recalling Indian art he wrote:

You will find that the art whose end is pleasure only is pre-eminently the gift of cruel and savage nations, cruel in temper, savage in habits and conception; but that the art which is especially dedicated to natural fact always indicates a peculiar gentleness and tenderness of mind . . . the production of thoughtful, sensitive, earnest, kind men, large in their views of life and full of various intellectual power.[94]

It is important to remember this distinction for, while he had praised Indian worker in gold for producing 'beautiful design out of nothing but crudesome knots and spirals' in his essay 'A Joy For Ever' (1873),[95] elsewhere he had criticized the abstract patterns in Indian products for not showing an interest in nature:

There are a large mass of the nations of the earth which appear to have a peculiar skill in this conventional ornament. They get at it from below by refusing all natural art whatsoever. The Arabians of old, for instance, refused all natural form, and sought out all possible grotesque ornament of mere line and colour—they get at it from below. And so the Indians at this moment got at it from below; they refuse all true portraiture of nature, produce nothing but grotesques and monsters, and seek mere relations of colour and lines. This is what I call getting at it from below.[96]

Again he had repeated that:

All ornamentation of that lower kind is pre-eminently the gift of cruel persons, of Indians, Saracens, Byzantians, and is the delight of the worst and cruellest nations, Moorish, Indian, Chinese, South Sea Islanders, and so on . . . The fancy and delicacy of eye in interweaving lines and arranging colours—mere line and colour, without natural form—seems to be somehow an inheritance of ignorance and cruelty . . . Get yourselves to be gentle and civilized, having respect for human life and a desire for good, and . . . you will not be able to make such pretty shawls as before. You know that you cannot make them so pretty as those Sepoys do at this moment . . . If you want a piece of beautiful painted glass . . . you have to go back to the thirteenth or fourteenth century, to the days . . . when the Black Prince killed two thousand men, women and children.[97]

The study of nature evinced a concern for human life as, conversely, the pursuit of pure pleasure in art rendered men cruel, ignorant, and despotic. The question whether it was at all possible to reconcile a love of art with the deep moral commitment of human existence had assumed an unusual intensity at the time of the so-called Indian Mutiny of 1857. In a lecture at the Museum of Ornamental Art in 1859 he brought up the subject of the Mutiny. About Indian design he said that among

the models set before you in this institution, and in the others established throughout the kingdom for the teaching of design, there are, I suppose, none in their kind more admirable than the decorated works of India. They are,

247

indeed, in all materials capable of colour—wool, marble, or metal,—almost inimitable in their delicate application of divided hue, and the fine arrangement of fantastic line . . . the love of subtle design seems universal in the race, and is developed in every implement that they shape, and every building they raise; it attaches itself with the same intensity, and with the same success, to the service of superstition, of pleasure, or of cruelty.[98]

Against the Indians he set the Scots as representing an indifference to art or even an inability in it. Therefore, on 'the one side you have a race rejoicing in art, and eminently and universally endowed with the gift of it; on the other you have a people careless of art, and apparently incapable of it, their utmost efforts hitherto reaching no further than to the variation of the positions of the bars of colour in square chequers.' Then the inevitable moral question was posed, what effect did art have on the character of the people and was it better to have noble human beings lacking artistic sense or base ones who were artistically advanced? The answer had been provided by the events of the Mutiny:

We have had our answer. Since the race of man began its course of sin on this earth, nothing has ever been done by it so significative of all bestial, and lower than bestial, degradation, as the acts of the Indian race in the year that has just passed by. Cruelty as fierce may indeed have been wreaked, and brutality as abominable been practised before, but never under like circumstances; rage of prolonged war, and resentment of prolonged oppression, have made men as cruel before now; and gradual decline into barbarism, where no examples of decency or civilization existed around them, has sunk, before now, isolated populations to the lowest level of possible humanity. But cruelty stretched to its fiercest against the gentle and unoffending, and corruption festered to its loathsomest in the midst of the witnessing presence of a disciplined civilization, —these we could not have known to be within the practicable compass of human guilt, but for the acts of the Indian mutineer.[99]

Ruskin dismissed Indian art on moral grounds; Morris on the contrary had a great deal of admiration for it. Morris was naturally influenced by Ruskin's writings like most other Victorians. And yet no two people could have been further apart in temperament. The gentle socialist lacked the authoritarian trait, the deep religious faith, and the messianic violence of Ruskin. At heart an agnostic and a radical in his political views, Morris looked forward to the establishment of the socialist order in contrast to his older contemporary who preferred aristocratic control of the state. On the other hand, Morris was far more in sympathy with mysticism than Ruskin, who stood for cold rationalism and clear logic. Morris's daughter related an incident which throws light on the character of both. Asked by the *Pall Mall Gazette* in 1885 to choose their favourite books, Ruskin significantly rejected all Eastern literature, whereas Morris not only stressed the importance of romantic

248

literature in his life but that of a great deal of Eastern literature.[100]

Again, they shared an intense dislike of the industrial society in Victorian Britain. Of course the new designers, including Cole and Jones, had been in their own ways critics of Victorian industrialism. But the criticisms of the two art critics were far more profound and influential than those of the designers belonging to the Cole group. Both Ruskin and Morris and Birdwood as well had realized that it was not enough to criticize the state of the arts, for the source of the malaise lay in the infected condition of the society. Morris's influence on modern design as well as on the reform of Victorian design was particularly profound: in order to remedy the social alienation brought about by the Industrial Revolution he was the first designer to encourage 'art for the people' including the building of ordinary dwellings.[101] As critics of Victorian industrial and materialistic society both Ruskin and Morris looked for an alternative one. Birdwood had adopted rural India as an attractive alternative to Western industrialism. To Ruskin and Morris the Middle Ages represented the lost ideal, in architecture, in society, and in life. The evangelical and imperialistic traits in Ruskin inhibited him from seeing India as an equally important alternative. Morris, however, was able to recognize that India, like medieval Europe, was the very antithesis of Victorian materialist society; he did, therefore, accept India as a viable alternative to the evils of industrialism. There exists evidence of Morris's genuine interest in Indian art. The first important piece of Indian sculpture in the Victoria and Albert Museum was presented to that institution by Morris.[102]

Although Morris was known to have been interested in Indian art, very little is to be found on the subject in his published writings. In this aspect too the contrast with Ruskin is striking. Morris's attitude, however, comes out clearly in a lecture on the lesser or decorative arts delivered to the Trades' Guild of Learning on 4 December 1877. He said:

Now if the objection be made that these arts have been the handmaids of luxury, of tyranny, and of superstition, I must needs to say that it is true in a sense; they have been so used, as many other excellent things have been. But it is also true that, among other nations, their most vigorous and freest times have been the very blossoming-times of art.[103]

The question is—did he have Ruskin in mind here? He appears to answer Ruskin's charge that the finest flowering of the decorative arts had been invariably attended with an oppressive, cruel, and tyrannical social system, as exemplified by contemporary Indian society and by England in the days of the Black Prince.[104] Disagreeing with Ruskin he argued that a great period in art, instead of representing a decline,

249

often coincided with social progress. Morris even argued that sometimes the only redeeming feature of a society was its art, for only art reflected the sole aspiration towards freedom:

I must allow that these decorative arts have flourished among oppressed peoples, who have seemed to have no hope of freedom: yet I do not think that we shall be wrong in thinking that at such times, among such peoples, art, at least was free; when it has not been, when it has really been gripped by super-stition, or by luxury, it has straightway begun to sicken under that grip.[105]

Morris's confidence sprang from his faith that the arts in general, and the industrial arts in particular, were the achievements of the ordinary and anonymous craftsmen, the real hopes of a society.[106]

In a rare instance, we get a glimpse of his admiration for the industrial arts of India. The occasion was a lecture on 'The Art of the People', given at the town hall in Birmingham on 19 February 1879. In the lecture he praised Cole and others for presenting to the public the decorative arts of India:

I dare say many of you will remember how emphatically those, who first had to do with the movement of which the foundation of our art-schools was a part, called the attention of our pattern-designers to the beautiful works of the East. This was surely the most well judged of them, for they bade us look at an art at once beautiful, orderly, living in our own day, and above all, popular.[107]

As one acutely conscious of the political implications of the Industrial Revolution he had taken notice of Birdwood's warning that the British government in India was responsible for destroying local industries by encouraging technological revolution. The year before, Birdwood had come into public eminence with his handbook on the Indian collection at the Paris Exhibition.[108] Following Birdwood, Morris mentioned the ironical situation that, while European designers looked up to Indian craftsmen for inspiration in design, the very same people were being deprived of their means of existence by the Indian government. A critic of economic imperialism Morris showed great concern for the Indian situation:

Now, it is a grievous result of the sickness of civilization that this art is fast disappearing before the advance of western conquest and commerce—fast and every day faster. While we are met here in Birmingham to further the spread of education in art, Englishmen in India are, in their short-sightedness, actively destroying the very sources of that education—jewellery, metal-work, pottery, calico-printing, brocade-weaving, carpet-making—all the famous and historical arts of the great peninsula has been for so long treated as matters of no impor-tance, to be thrust aside for the advantage of any paltry so-called commerce.[109]

As he pointed out in the same lecture, the presents given by the Indian

princes to the Prince of Wales on his visit to India in 1875 hardly justified the fame of the 'cradle of the industrial arts'. It was pitiful to notice how the conquered people had copied 'the blank vulgarity of their lords'.[110] Morris held the English directly responsible for this deterioration by actively encouraging the production of inferior goods. The government was determined 'that it will make its wares cheap, whether it make them nasty or not'.[111] Losing their proper function, the Indian objects were reduced to the level of museum pieces:

Their famous wares, so praised by those who thirty years ago began to attempt the restoration of popular art amongst ourselves, are no longer to be bought at reasonable prices in the common market, but must be sought for and treasured as precious relics for the museums we have founded for our art education.[112]

Morris's profound sympathy for the plight of the Indian village industries influenced the first major work of Coomaraswamy, *Medieval Sinhalese Art*.[113]

CHAPTER VI

Towards the
Twentieth Century:
A Reassessment of
Present Attitudes

WILLIAM MORRIS presented to the South Kensington Museum in 1869 a fine bronze figure of Hanumān, thereby laying the foundations of the present Indian collection in the Victoria and Albert Museum, which along with the British Museum contains the greatest collections of Indian sculpture and painting in Western Europe.[1] The original East India Company Museum, founded in 1801 with the contributions of the Company officials, was taken over by the Secretary of State in 1858, when its contents were distributed between the British Museum and the South Kensington Museum. The last, renamed after Victoria and Albert in 1899, embarked on the collection of Indian art from an aesthetic standpoint from 1909 onwards.[2] But even in the nineteenth century important collections of Indian sculpture were not entirely lacking. The British Museum had acquired the major collection of Pāla sculptures originally belonging to Charles 'Hindoo' Stuart.[3] After the discovery of Amarāvatī, relief fragments were sent over to the same museum which still form some of its major acquisitions.[4] For the rest of Europe Denmark was exceptional in possessing a magnificent collection because of its colonial links with India. This collection, however, still languishes in the Copenhagen Nationalmusaeet as an ethnographic curiosity. Fourteen south Indian bronze figures including a Naṭarāja were acquired by the museum in 1799 to which were added a number of fine Pāla figures in the nineteenth century. In many ways the most important collection in Copenhagen consists of Hoyśala sculptures presented by the missionary Edward Løventhal between 1894 and 1900.[5]

Parallel to the collecting activity of these museums there were great advances in archaeological researches leading to a systematic reconstruction of ancient history and to discoveries of Gandhāra art and of major sites like Sāñci and Amarāvatī. Extensive reproductions of Ajanta

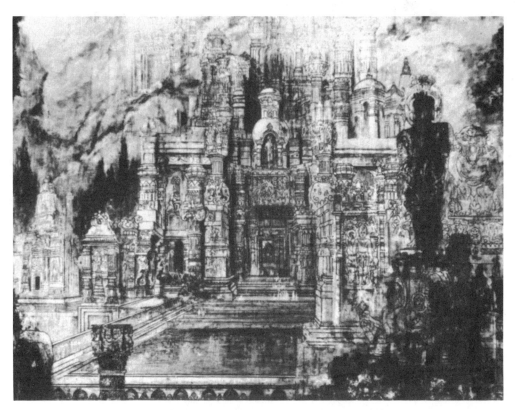

117. Detail from Moreau's 'Triumph of Alexander'

paintings were undertaken by Major Gill and later by John Griffiths.[6]

Even a selection of random samples serves to illustrate the extent to which Indian art impinged on the contemporary mind. The great Rodin was possibly the most sensitive and perceptive of the admirers of Indian art, but Degas too had shown a great deal of interest in it.[7] Among minor painters Gustave Moreau used a proliferation of Indian temples as a backdrop to his symbolic painting, *Triomphe d'Alexandre* [117].[8] The veritable *apotheosis* of Elephanta came in 1875, when a grand banquet was held in the main cave [118] in honour of the Prince of Wales who was visiting India, 'the brightest jewel in the Imperial crown'.[9] It was especially apposite that *L'Exposition Universelle* of 1900 which announced the grand opening of our century displayed [119] in its architectural *Panorama du Tour du Monde* a composite Indian building incorporating features derived from different periods.[10]

In short, as far as the Western knowledge of Indian art went, very little was left to be desired by the end of the nineteenth century. Collections had been formed in European museums. Archaeology had taken rapid strides. We have thus come a long way since Marco Polo's nuns

253

118. Banquet in Elephanta caves

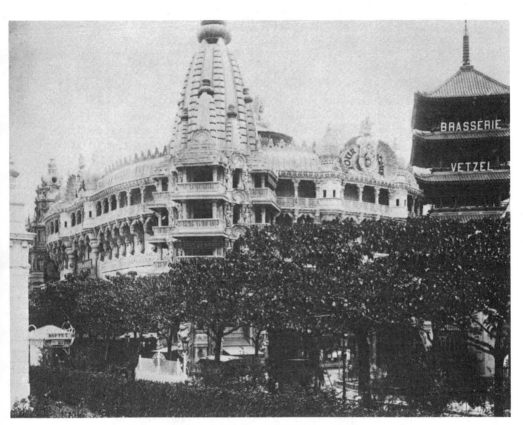

119. Indian architecture at the Paris Universal Exhibition of 1900

and Varthema's Deumo. In the long period covered in previous chapters a clear pattern emerges: in all the different facets of European interpretations there was hardly any aesthetic appreciation except occasional, tantalizing glimpses of it in the case of architecture. Now, in the twentieth century, Europeans came at last to possess a knowledge of Indian art to a degree that was inconceivable in previous periods. Hence it could no longer be maintained that European appreciation was severely limited by a general ignorance of works of high quality. Therefore, the most fundamental question underlying my study takes on a new urgency. Does at long last the availability of all this information lead to an aesthetic appreciation of Indian art in our period? The answer could perhaps be given in a sentence but that would only be oversimplifying the problem before us.

First of all, it needs to be recognized that the prevailing views about Indian art held by us even as late as 1973 were essentially formed by several influential authors who happened to write the first histories of Indian art and architecture. It is therefore necessary to examine what views and attitudes they reflected in their reconstructions of the history

255

of Indian art, accomplished between the years 1874 and 1927. The first date marks the publication of Cole's catalogue for the Indian collection at the South Kensington Museum, while the last coincides with Coomaraswamy's classic *History of Indian and Indonesian Art*. During this period the burning issues relating to Indian art were fiercely debated and important categories of style and taste put forward with unflinching conviction. The time was ripe for comprehensive histories because it became possible for the first time to view Indian art in its entirety, from its inception to the most recent period. The problems faced by the pioneer art historians may be reduced to two essential ones: first, to devise a theoretical and chronological framework in order to determine how one style was related to another in time, unless it was assumed that they coexisted; second, to make aesthetic evaluations. As will become clear, aesthetic judgements were to have an immediate influence on questions relating to the morphology and evolution of styles. Again, according to their approach these art historians may be divided into two broad groups, the 'archaeological' and the 'transcendental'. The major figures in the first group were Henry Cole and James Fergusson, while the second group was led by Ernest Binfield Havell and Ananda Kentish Coomaraswamy. At the risk of showing my hand, let me state briefly in what particular aspect these two schools differed one from the other. To the first, classical art was the exemplar of perfect taste against which all periods of Indian art were judged. Therefore, by definition even the highest form of Indian art was inferior to the classical. The second group denied for the first time the unquestioned supremacy of classical art which it did not consider to be superior to the best of Indian art. Apart from these four major figures there were others like Vincent Smith but they were not of the same importance.

Henry Cole's *Catalogue of the Objects of Indian Art exhibited in the South Kensington Museum* contained the very first history of Indian art, although he had his precursors in the German art historians. It is true, though, that the Germans treated Indian art as part of universal history.[11] The outline history of Indian art in Cole's *Catalogue* served a most useful purpose in providing an introduction to the Indian collection in the museum. We have already encountered Cole when he was busy promoting the applied arts of India in the circles of Victorian designers.[12] There is further evidence of Cole's growing interest not only in the practical arts but in the visual arts as well in his 1869 publication on the art of ancient Kashmir. Similar to Winckelmann's preface to his history of ancient art, Cole refused to indulge in false modesty about his contribution to Indian art history: 'Up to the present time no work has, I believe, appeared which avowedly deals with the general subject of Indian art.'[13] It was indeed a new departure, particularly his inclusion

256

of the Islamic period in the *Catalogue*. The history of Indian art was traced in a continuous line beyond the ancient period down to the end of the Mughal empire.[14] The *Catalogue* contains chapters on the visual arts as well as on the applied arts such as metal and ivory work, jewellery, pottery, textiles, etc. Since he had played a major role in acquiring specimens of decorative arts from India for the museum, he naturally gave them an important place in his work.[15]

Several interesting features in Cole's history of Indian art may be enumerated here. First of all, his judgements of taste. As an admirer of the Indian facility for ornamental design he spoke highly of Hindu craftsmen:

The quality of imagination, which pervades the existence of the Hindu and causes the history of this religion to melt into tradition, precludes direct imitation in the matter of ornament. Hence ornaments are strictly conventional, and even the representation of human figures and gods is frequently of a conventional character. The system of Hindu ornaments is full of fancy, free and yet curved, for the ruling spirit of structural fitness rigidly controls the areas of freedom and brings them into subjection and propriety.[16]

On the other hand he failed to see any merit in Indian painting. He felt that Buddhist painting never came up to Buddhist sculpture in quality because the Buddhist instinct for form was 'far in advance of those for colour'. Similarly, Hindus never achieved 'any important result in painting except as a decorative art'.[17]

Next in importance is Cole's discussion of problems relating to style in Indian art. With regard to the general problem of periodization he accepted the reconstruction of ancient history as put forward by the great archaeologist, Cunningham. His chronology offered Cole a useful initial framework:

General Cunningham's geographical division of India fairly distinguishes the different periods of Indian art and serves as a broad classification of the numerous styles which have left their marks on the country. He deals with three periods: —the *Brahmanical* which includes the spread of the Aryans over the northern portions of India from their first arrival in the Panjab to the rise of Buddhism, and which would comprise the earliest section of the history of the Aryan race, during which time the religion of the Vedas was the prevailing belief of the country: —the *Buddhist* period which includes the history of the rise and decline of the Buddhist religion and art, from the era of Buddha to the conquest of Mahmud of Ghazni, during which time Buddhism was the principal religion: —the *Muhammadan* period which embraces the rise of Muhammadan power, from Mahmud of Ghazni to the battle of Plassy or about 750 years, during which time the Mussalmans were the paramount sovereigns.[18]

The above division of Indian history into three essential periods

257

reinforced the nineteenth-century doctrine that Indian art had proceeded from the simple to the complex, a notion which was tacitly accepted by Cole. He could appreciate early Buddhist art, something which he could not bring himself to do in the case of Hindu art. It was the simplicity of Buddhist art which appealed to nineteenth-century archaeologists and it also appealed to Cole. He could therefore regard later Hindu art only in terms of a decline in standards. As we shall see, these aesthetic judgements were to have serious implications for the appreciation of Indian art. His partiality towards Buddhist art is revealed in several important passages. Accepting the great importance of Buddhism in the development of Indian art, he paid a warm tribute to Sāñci: 'The sculptures which cover the four stone gateways surrounding the great Buddhist Tope at Sanchi are wonderful records of the state of art in India at the period of the commencement of the Christian era.'[19] The conclusion he drew was that 'as works of art, they testify to the superior skill then possessed by native sculptors as compared with the native productions of modern times.' He then stated: 'That the power of delineating human and other forms was *formerly* greater than is now evinced by the modern Hindu sculptures, is proved by the excellence of the carvings which still exist in the capitals of the edict pillars and in the Sanchi bas-reliefs.'[20]

The view was not startlingly original for it had often been expressed by late eighteenth-century archaeologists. But Cole was the first art historian to make a general statement that the early Buddhist style was superior to the later Hindu. In this he significantly anticipated Fergusson's notion of 'inverted' evolution of Indian art. But Cole also felt that the 'simplicity' of Buddhist art, which reminded one of classical art, could not simply be attributed to fortuitous circumstances. He was not alone in this, though probably the first to make the necessary connection between classical and Indian art. In 1833 Gandhāra art came to the notice of European scholars who were understandably excited by its discovery. To art historians the knowledge that there existed in India a style of art which owed its origin to the classical tradition proved immensely valuable. Since it was never in doubt that classical art was the epitome of perfection, the art of Gandhāra produced under that influence had of necessity to be superior to the rest of Indian art. Therefore, a descending scale of values could be formulated with Gandhāra at the apex, which would make the task of judging different Indian styles easier.[21] Cole felt that the greatness of Sāñci clearly revealed the hand of the Greeks:

There is reason to believe that Buddhist art was a good deal influenced by that of the Graeco-Bactrians. The Greek colonies in the Panjab have left a number of carvings and coins so far south-west as Mattra, and the exceptional

258

excellence of the Sanchi bas-reliefs suggests that Greek masons, or possibly designers, may have been called in to assist the great work.[22]

He came to the conclusion that foreign styles influenced Buddhist art in its formative period. It, therefore, had affinities with other traditions during its period of progress. On the other hand, Hindu art was 'perfectly indigenous, and its styles reproduce the thoughts and aspirations of the country, as revealed in its religious beliefs and history, of the different periods in the last 10 or 12 centuries'.[23]

Finally, in one other respect Cole anticipated the theories of Fergusson, although it is possible that his ideas were derived from the last writer. They had met in 1866 when Cole attended a lecture on Indian architecture given by Fergusson at a meeting of the Society of Arts. In order to explain the rise of art Cole wrote:

Between two such religious theories as these the success of the more rational Buddhistical faith was secured, and the uprising of the numerous Turanian populations (whose instincts were against hereditary priesthood and caste) against the caste-loving Aryans, resulted in a revolution both in religion and artistic taste.[24]

The statement contains several interesting features. The argument was that the rise of art represented a social revolution which marked the transition from Vedic religion to Buddhism. But more important still, the Buddhist revolution also represented the success of a particular ethnic group against the Aryans. This is the first important instance where 'race' is introduced to explain a particular style of Indian art. The notion of the 'Turanian' population as a catalyst in the rise of art had little to do with history, but the misleading though persuasive 'agent' was conveniently employed to sustain a hypothesis based on racial determinism. The use of ethnic peculiarities to account for the uniqueness of a particular style occurred first in the field of medieval European art. When in the late eighteenth century there was a revival of interest in medieval art its admirers faced certain problems. To put it briefly, what was remarkable about the prevailing image of medieval art in the eighteenth century was that it was deeply influenced by Vasari's criticism of Gothic art. As an admirer of Renaissance art Vasari denied any merit whatever to medieval Gothic art which he dismissed as 'barbaric'. Vasari's condemnation was naturally rejected by the admirers of medieval art in the eighteenth century. And yet these critics were not able to reject the particular norm of taste against which medieval art had been judged by Vasari and his followers. These standards were naturally related to classical art and were especially applicable to the art of the Renaissance. Since Renaissance artists had before them a clear objective—the representation of the visual world—

they were able to set before them a tangible ideal of perfection. Stress was placed on certain notions of balance and rationality. Now, even the admirers of Gothic art were brought up to believe in the primacy of the rule of taste as exemplified by classical art. On applying the classical canon to medieval art it was found to be wanting. The natural solution would have been to search for alternative standards of criticism operating in the Middle Ages. And yet this was not done. To put it briefly, there was no clear recognition until the twentieth century that the classical canon was not universally applicable and that it was at all necessary to search for critical standards within and not outside a tradition. But this required, I think, a certain amount of relativism, something we are accustomed to now.[25]

While the supporters of Gothic art accepted the assumptions of classical art, the manner in which they met their critics was this: Gothic art did not come up to the standards of Renaissance art because it embodied a different philosophy, a separate ethos. Their ideas received powerful support at this stage from Hegel who announced that art expressed the innermost spirit of a people or nation.[26] Therefore, a certain type of art could only spring from a particular people. The supporters of Gothic art were also greatly encouraged by the discovery of the family of Indo-European languages by comparative philologists. The knowledge had given rise to a form of 'racial romanticism' and in particular the 'Aryan' myth. The racialist historians asserted that different ethnic groups had essentially different talents. They also stressed the immutable characteristics of each race and declared that each nation was capable of producing only a certain kind of art which could not be produced by anyone else, without doing violence to their innate nature. These collective notions, which deeply influenced Gothic art historians, were felt to answer Vasari's criticism.[27] Therefore, the task before the historians was to seek out the 'essence' of Gothic art because it was the same philosophy which pervaded all aspects of medieval culture from its scholastic philosophy to its flying buttresses.

In 1866 Cole had attended a meeting of the Society of Arts where James Fergusson had presented in a paper a number of basic principles which were germane to his classic history of Indian architecture published in 1876.[28] In many ways Fergusson was a remarkable person. He was the first architectural historian to recognize the importance of the camera for documenting buildings and for making available to the public illustrations of architecture at a reasonable price, thereby ensuring their wide diffusion. Indian architectural remains, particularly of Ajanta [120] and Ellora, were thus presented in photographs to European audiences in 1864 through Fergusson's efforts.[29] An influential critic in the late nineteenth and early twentieth century, he became famous for

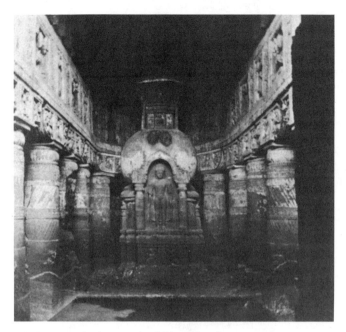

120. Fergusson's photograph of Ajantā interior

his pronouncements on architecture, ancient and modern. He can be held to have popularized Ruskin's ideas.[30] He had Ruskin's habit of expressing vigorous opinions and forthright disapprovals but lacked his mentor's style and imagination. Fergusson was as fearless in attacking modern architectural styles, most of which he could not tolerate, as in criticizing the 'sacred cow', Greek architecture.[31] Fergusson was influenced by archaeologists working in India. Unlike the archaeologists, however, he, with his sweeping vision, was able to conceive the whole history of the development of Indian architecture. Not only did he write the first comprehensive history of the different styles of Indian architecture but he also contributed the first important universal history of architecture in the English language. It was the only one before that of Sir Banister Fletcher.[32] As a writer who covered such a wide span of history it was inevitable that he would be concerned with a broad conceptual framework. In this too Fergusson differed from the pragmatism of his English colleagues in archaeology.

Fergusson stated that his works were influenced by certain aesthetic principles which were derived from Indian and other forms of architecture in the East. There is no doubt that his love for Indian architecture of the Islamic period was deep. His early career as an indigo merchant in Calcutta gave him his first taste in Indian architecture. In

261

the 1840s he was to produce two books on Indian architecture containing a number of fine drawings. In an ambitious book on aesthetics Fergusson sought to apply to Western architecture some of the principles derived from Eastern architecture. As he confessed in *An Analytical Enquiry into the true principles of Beauty in Art* (1849): 'The theory of art which runs through every page of it was elaborated from a study of Indian, Mahomedan, and Gothic architecture, with which I am personally far more intimately acquainted than with the styles enumerated in the present volume [classical].'[33] Only the first volume dealing with Western architecture came out, leaving us to speculate endlessly on what the volume on Oriental aesthetics might have contained.

The prevailing concern with the 'decline' in industrial design was reflected in Fergusson's interest in Indian architecture. For his part he felt that architecture in the Victorian period had gone into decline because architects had become committed to reproducing in their works a whole succession of styles derived from different countries and different ages. He felt that Indian architects, who were still deeply rooted in their own tradition, could set an example to modern European architects, who had lost all sense of direction in their eclecticism. Fergusson's view parallelled the favourable contrast often made by Victorian designers between the tasteless mass-produced industrial goods and the 'true' principles of design evinced in traditional Indian craftsmanship.[34] In his 1866 lecture he strongly emphasized the importance of studying Indian architecture. In particular he urged practising architects to study the underlying principles and not to copy different Indian styles. He held that the main 'crime' of contemporary architects consisted in their indiscriminate copying of widely different styles. In his work on Indian architecture he regretfully noted: 'What perfect buildings the ignorant, uneducated natives of India are now producing . . . because [their] principles are right.'[35] He was painfully aware that architecture in his time was produced only in the culturally inferior East, whereas it was merely a brilliant failure in the West.[36] The statement summed up the curious ambivalence in Fergusson who often showed a genuine feeling for Indian architecture and for Islamic buildings in particular. And yet as a disciple of Ruskin he could not help upholding the moral and cultural superiority of the West. For all his declarations of the importance of Indian architecture he could repeat with impunity that: 'They may contain nothing so sublime as the Hall at Karnac, nothing so intellectual as the Parthenon, nor so constructively grand as a Medieval Cathedral; but for certain other qualities—not perhaps of the highest kind, yet very important in architectural art—the Indian buildings stand alone.'[37] This in spite of his often outspoken criticisms of Greek architecture.

In *History of Indian and Eastern Architecture* Fergusson stated that one of his main intentions was to familiarize Europe with Indian architecture. He considered that it was chiefly the strange names and customs which had stood in the way of a proper appreciation of Indian architecture. And:

were it not for this, there is probably no country—out of Europe at least—that would so well repay attention as India. None, where all the problems of natural science or of art are presented to us in so distinct and so pleasing a form . . . It cannot of course be for one moment contended that India ever reached the intellectual supremacy of Greece, or the moral greatness of Rome; but though on a lower step of the ladder, her arts are more original and more varied, and her forms of civilization present an ever changing variety, such as are nowhere else to be found. What, however, really renders India so interesting as an object of study is that it is now a living entity.[38]

Since Fergusson expressed his intention to bring the study of Indian architecture within the domain of science, it is interesting to examine what approach he developed over the years. He was rightly critical of the limitations of a purely positivistic approach followed by archaeologists. He none the less inherited from them the eighteenth-century evolutionary doctrine of progress from the simple to the complex. It is true that Buddhist art appealed to him more than the Hindu, a feeling he shared with other Indian specialists of the age. It is not difficult to see that Buddhist art expressed a certain 'classical' simplicity which was easier for Europeans to appreciate than the complex and rich imagery of Hindu art and architecture. It was also generally accepted by the nineteenth-century archaeologists that in India, as in other countries, art had progressed from the simple to the complex. This view was certainly consonant with Fergusson's own ideas. What is striking is that Fergusson's imagination turned these separate but related notions into a consistent art-historical principle. The idea of India as a continually decaying society was already in the air. But it was he who presented a vivid picture of how the history of Indian architecture expressed itself only through a continuous decline as opposed to constant progress. When Winckelmann had discussed the question of how Greek art proceeded from simplicity to ever increasing ornamentation and complexity he had, of course, seen this development as being essentially one with progress. In the fifty years which followed him a 'unilinear' concept of inevitable progress in European art had come to be firmly established as was the case in other areas of social study. It was this teleological idea of progress which was at the back of Fergusson's mind. He saw that early Buddhist architecture represented a certain simple treatment of form, which was very different from later architecture, especially of the Hindu period. Now, it was possible to hold that

Buddhist and Hindu buildings represented two basically different types of architecture, as it was equally possible to see the history of Indian architecture as the evolution from the first type to the second. Significantly, Fergusson did not do that. He asserted that the development from the Buddhist to Hindu art showed a clear case of decline in architecture. Fergusson's notion of 'decadence' was simply an elaborate scaffolding to justify his dislike of Hindu architecture. The sentiment expressed was not new, for the tendency to criticize rich decoration as expressing decadence can also be seen in European art. This was the common attitude of the classical critics to the Baroque style.[39] In a powerful, yet misleading, passage Fergusson contrasted the history of progressive decline in Indian art with the steady but sure progress of medieval European art:

Sculpture in India may fairly claim to rank, in power of expression, with mediaeval sculpture in Europe, and to tell its tale of rise and decay with equal distinctness; but it is also interesting as having that curious Indian peculiarity of being written in decay. The story that Cicognara tells is one of steady forward progress towards higher aims and better execution. The Indian story is that of backward decline, from the sculptures of Bharhut and Amravati topes, to the illustrations of Coleman's 'Hindu mythology'.[40]

Decline naturally presupposes a prior 'golden age'. Fergusson never actually made clear what he thought the golden period of Indian art was, although his arguments seemed to suggest that Buddhist art was as close to perfection as was possible in a corrupt period. The English historian, however, claimed to discover that point in time when corruption had begun its course in India. And this was the moment when his own brand of 'racial romanticism' was brought into his history of Indian architecture. Whereas Cole had only suggested that religious and artistic revolutions in India took place when non-Aryans were able to reassert themselves against the Aryans, Fergusson asserted that it was this very predominance which led to the decline not only of art but of culture in general.

The history of Indian art was divided by Fergusson into two broad periods. In the first, a very high level was reached in artistic achievement. This great epoch, however, did not last because of the mixture of races between the Aryans and the culturally inferior Dravidians and Turanians. The decline in art and civilization in general did not, however, take place until the superior Aryan religion was completely overwhelmed by the superstitious fetishism of the mixed races. Fergusson refused to be bound by the traditional chronology of political history. Cole had accepted Buddha as non-Aryan, but this Fergusson refused to do. Because Buddhist art was superior to the Hindu it only seemed reasonable to him that Buddha was a pure-blooded Aryan. Therefore

264

it followed that later 'decadent' Brahmanism was a non-Aryan faith.[41] Social decline began when the Aryan Buddha was turned down by Indians in favour of the degraded Hinduism of the Brahman priests. He even claimed that Vaiṣṇavism in contemporary India was a corruption of Buddhism.[42] It was inevitable that this degraded form of religion only produced a decadent form of art, the art of the Hindu period.

Somehow Fergusson did not feel entirely convinced by his own argument for he saw the necessity of introducing yet another racial group, a further agent of corruption. The *Dasyus* were, according to him, a third ethnic group in India who were neither Aryan nor Dravidian, but were inferior to both and the first to be converted to Buddhism. The *Dasyu* racial style of architecture was discovered in the late Orissan temples with their *āmalaka* shaped towers.[43] I think it was in the identification of styles on ethnic grounds that the most sinister influence of 'racial romanticism' was felt. Fergusson believed architecture to be a far more reliable guide to the development of Indian history than the surviving chronicles which were notoriously unreliable. In fact he asserted that 'the architecture of the country may be considered as a great stone book, in which each tribe and race has written its annals and recorded its faith, and that in a manner so clear that those who run may read.'[44] Not only was architecture a complete illustration of Indian ethnography but also the indication of the degradation of religion. As an example that each style of art represented an ethnic group in India he cited the case of the Dravidians who were 'one of the greatest building races in the world'.[45]

Fergusson's inability to appreciate anything beyond early Buddhist art posed serious problems for his history of architecture covering the period down to the present day. Not only did he present an essentially distorted picture of the development of Indian art and architecture, but he seriously underestimated the art of the Gupta period, the whole development of later Buddhist and Hindu art. And he was especially severe to south Indian architecture.[46] No doubt the early Buddhist monuments of Sāñci, Bhārhut, and Amarāvati contain much that is fine and beautiful. But they essentially belong to the formative period of Indian art history. To regard them as the only great achievements of Indian art and to dismiss all subsequent development as being decadent is to ignore the great flowering of Indian art throughout history. It may well be argued that early Buddhist art was simple not in a 'classical' sense but in a purely technological one. The complex imagery and rich ornamentation were only possible in a later period when it came to be within the means of the sculptors and architects. Even within early Buddhist art Fergusson's approach was beset with inconsistencies. About Bhārhut [121] he made the following definitive statement:

265

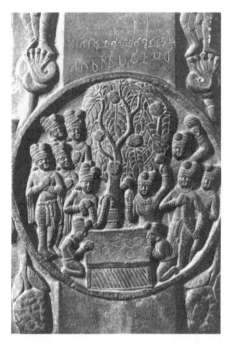

121. Bhārhut relief

122. Sāñci relief

123. Amarāvatī relief

It is thoroughly original, absolutely without a trace of foreign influence, but quite capable of expressing its ideas, and of telling its story with a distinctness, that never was surpassed, at least in India. Some animals . . . are better represented there than in any sculptures known in any part of the world . . . architectural details are cut with an elegance and precision which are very admirable. The human figures, too, though very different from our standard of beauty and grace, are truthful to nature, and where grouped together, combine to express the action intended with singular felicity. For an honest purpose-like pre-Raphaelite kind of art, there is probably nothing much better to be found elsewhere.[47]

But clearly he found Sāñci no less impressive. However, since it post-dated Bhārhut, Fergusson was forced to admit that Sāñci [122] showed only breadth but neither delicacy nor precision.[48] On the other hand he solved the problem of Amarāvatī in a very different way. The fact that this particular monument followed both Bhārhut and Sāñci was known to him. How then was one to account for the excellence of Amarāvatī [123] which was produced in a period of decline? This was a moment convenient for the intervention of a foreign agent. As Fergusson pointed out, the steady and inevitable decline of Indian art was temporarily arrested by the infusion of new blood in the form of Greek art. In his words: 'Though it may, in some respects, be inferior to either of the parent styles [Bhārhut and Greek], the degree of perfection reached by the art of sculpture at Amaravati may probably be considered as the culminating point attained by that art in India.'[49] The logical conclusion was drawn that Amarāvatī was the highest achievement in Indian art: 'Although the rail at Bharhut is the most interesting and important in India in a historical sense, it is far from being equal to that at Amaravati, either in elaboration or in artistic merit . . . the most remarkable monument in India.'[50]

Less original than Fergusson, Vincent Smith, a historian of some competence, entered the arena in 1889 with an article on the classical influence in Indian art. His paper was one of the earlier and more important ones to assess all Indian styles against the Gandhāra which was taken as the ideal. The view was representative of the archaeologists and their assessment of Indian art, especially after the discovery of Gandhāra in around 1833. Gandhāra provided them with a yardstick for measuring aesthetic perfection according to the classical canon. Smith showed his hand at the very outset of his essay when he declared: 'Nothing could arrest the sure and world-wide progress of the ideas and culture, which constituted the real strength of Hellas.'[51] He was convinced that it was in art that the Greeks had left their indelible imprint, although he had no evidence to support his claim. 'At Bharhut, Sanchi, Buddha Gaya, Ajanta, and Amaravati proof may be given that

the local style of art was modified by contact with that of the western world, but the evidence does not lie upon the surface.'[52] He had a rather low opinion of Ajanta paintings. They did not deserve a high rank 'when compared with the world's masterpieces—no Indian art work does—but they are entitled to a respectable place among the second or third class.'[53] Smith was of course aware of those scholars who were fervent admirers of Ajanta and remarked: 'Whether these panegyrics are overstrained or not I shall not attempt to decide, but I am fully persuaded that no art at all deserving of such praise was ever born on Indian soil.'[54] He was also fully persuaded that 'they are to be numbered among the fruits of foreign teaching, either by Greeks, or Roman pupils of Greek masters.'[55] In other words, Indians were incapable of producing great art and, if they did at all, this must have been the outcome of commerce with classical culture. Although Smith had argued that Gandhāra was the highest possible achievement in Indian art, he realized that it could by no means be regarded as a superior style since in the first place it was obviously derivative:

The Gandhara . . . sculptures . . . would be admitted by most persons competent to form an opinion, to be the best specimens of the plastic art ever known to exist in India. Yet even these are only echoes of the second rate Roman art of the third and fourth centuries. In the elaboration of minute, intricate, and often extremely pretty, ornamentation on stone, it is true, the Indian artists are second to none . . . But in the expression of human passions and emotions Indian art had completely failed, except during the time when it was held in Graeco-Roman leading strings, and it has scarcely at any time essayed an attempt to give visible form to any divine idea.[56]

To the 'racial romantics' Smith's assertion was totally unacceptable. They had no such optimistic faith in the transforming power of Hellas. To them a style of art was determined from the start by the unique spirit of a race, whose special talents could not be imitated by people belonging to a different race without exposing themselves to grave dangers. An extreme spokesman of this view was Gustave Le Bon whose theories were to influence Hitler. Le Bon brought out a profusely illustrated work in 1893 entitled *Les Monuments de l'Inde.* On the basis of his assumption that the peculiar racial features of each individual ethnic group moulded its artistic style, he denied any classical influence on Indian art because, he argued, the mental state of the Indians was incompatible with classical forms. Le Bon treated Indian architecture on the basis of the 'psychology of the people' in order to illustrate the truth of this argument. In short, any classical influence on Indian art was ruled out on the grounds that 'the two races were too different, their thoughts too dissimilar, their artistic genius too incompatible to have exerted any influence on each other.'[57] Since the psychological

make-up of the Indians made them prone to rich ornamentation, the origins of Indian inspiration were to be sought in Persia. According to him it was evident that 'the arts of Persia were very much in rapport with their [Indian] cast of mind, while the spirit of the Greeks was not at all.'[58] Although Le Bon admitted that the ultimate common source of both Greece and India was the Near East (Egypt, Assyria), the two civilizations diverged profoundly later.[59] In fact, he felt so strongly about the part played by race in national culture that he even considered it disastrous for one nation to copy the art of another:

Art is in effect the faithful expression of the mental constitution of a nation, so that whatever this nation might borrow, it is obliged to transform it according to the necessity of its own mental constitution, which necessity varies from race to race. Whether art, religion or any particular element of civilisation, this foreign element will transform itself fatally as soon as it is adopted by a different race. India furnishes precisely the proof of this.[60]

Everywhere in India Le Bon found strong evidence that race rather than the identity of experience had shaped the art and architecture of each particular area and again it was race which had been responsible for such fundamentally different styles in the north and the south. For him 'L'influence de la race apparaît partout.'[61] It was seen not only in architecture but also in statuary and not only in the different types represented in sculpture but in the manner of treatment as well.[62]

Whatever else, the authorities discussed above could not be accused of over-enthusiasm with regard to Indian art. The first whole-heartedly partisan support of Indian art came early in the twentieth century, in 1910. It had been provoked by Sir George Birdwood's celebrated statement with regard to the Javanese Buddha displayed at the Royal Society of Art. Birdwood, who agreed with the views of the 'racial romantic' historians with regard to India that it was the Aryan *Urland*, none the less asserted in his characteristic manner that the 'unfettered and impassioned realisation of the ideals kindled within us by the things without us was not to be found in Indian art.'[63] In all fairness it should be pointed out, however, that he was one of the greatest admirers of Indian applied arts. But at the same time he asserted patronizingly that sculpture and painting are unknown as fine arts in India.[64] His famous remark about the Javanese Buddha is as follows: 'The senseless similitude, by its immemorial fixed pose, is nothing more than an uninspired brazen image, vacuously squinting down its nose to its thumbs, knees and toes. A boiled suet pudding would serve equally well as a symbol of passionate purity and serenity of soul.'[65]

A number of English intellectuals and artists immediately leapt to the defence of Indian art as they correctly recognized that Birdwood had really addressed his remarks to India. The signatories to the letter

269

to *The Times,* dated 28 February 1910, are worth noting. They were Frederick Brown, Walter Crane, George Frampton, Laurence Housman, E. Lanteri, W. R. Lethaby, Halsey Ricardo, T. W. Rolleston, W. Rothenstein, G. W. Russell, W. R. Stephens, Charles Waldstein, and Emery Walker. The letter itself is an important document in the history of the reception of Indian art in the West. It said:

We the undersigned artists, critics, and students of art . . . find in the best art of India a lofty and adequate expression of the religious emotion of the people and of their deepest thoughts on the subject of the divine. We recognise in the Buddha type of sacred figure one of the great artistic inspirations of the world. We hold that the existence of a distinct, a potent, and a living tradition of art is a possession of priceless value to the Indian people, and one which they, and all who admire and respect their achievements in this field, ought to regard with the utmost reverence and love. While opposed to the mechanical stereotyping of the particular traditional forms, we consider that it is only in organic development from the national art of the past that the path of true progress is to be found. Confident that we here speak for a very large body of qualified European opinion, we wish to assure our brother craftsmen and students in India that the school of national art in that country, which is still showing its vitality and its capacity for the interpretation of Indian life and thought, will never fail to command our admiration and sympathy so long as it remains true to itself . . .[66]

The year 1910 may thus be taken as the great watershed. In common parlance, Indian art could at last be said to have arrived. Its rehabilitation in the West was complete with the powerful affirmation of its aesthetic and not merely archaeological significance. If one were to search for a name to give the credit for this extraordinary transformation it would no doubt be that of Havell. It was his dedicated work which was in a large measure responsible for generating wide interest in Indian art in learned circles. It is therefore very important to see how he portrayed Indian art in his writings.

Havell's major ideas about Indian art and his basic art theory are to be found in two works, *Indian Sculpture and Painting* (1908) and, more important, *The Ideals of Indian Art* (1911). *The Ideals of Indian Art* was written with the express purpose of changing the prevailing European indifference to Indian art and of bringing about a proper appreciation of its aesthetic qualities. He felt that even more than in Europe. where there were signs of a growing interest, the indifference in England to Indian art was particularly marked. It was the positivistic tendencies in English archaeologists and their use of classical standards for judging Indian art that came under Havell's fire. He argued for an intrinsically 'perceptual' approach to replace the 'conceptual' approach of the archaeologists. A supporter of an intuitive appreciation of art, he felt that European misunderstanding of Indian art arose because attempts

had not been made to gain a direct insight into it. Europeans had not been able to do this because, until now, they had been led astray by archaeologists who had in general been aesthetically misleading. For all its impressive accumulation of information archaeological scholarship had been inadequate for appreciating Indian art precisely because the latter was 'a living thing . . . of such unique value to India and the world . . . The half-hearted admirers . . . do it most injury.'[67] The basic cause of misunderstanding was diagnosed by Havell with a rare insight:

Indian artistic expression begins from a starting-point far removed from that of the European. Only an infinitesimal number of Europeans, even of those who pass the best part of their lives in India, make any attempt to understand the philosophic, religious, mythological and historical ideas of which Indian art is the embodiment.[68]

In other words, he was perceptive enough to see that it was vital to judge works of Indian art on the basis of standards of art criticism evolved within the Indian tradition instead of employing European standards which were extraneous to that tradition. As he emphasized, the Indian sculptors and painters responsible for these works of art must have been influenced by the aesthetic conventions prevailing in their period and society.

The all too apparent weakness of the archaeologists in judging the quality of Indian art from a classical standpoint was mercilessly exposed by Havell with his typical acuteness. He gave two blatant instances. Smith had asserted that Gandhāra sculptures were superior to all other styles of art produced in India. This, according to Havell, was based on a curious misunderstanding. The Buddhist divine ideal did not find the best expression in the debased Greco-Roman art of Gandhāra. In fact, Gandhāra was far too much overvalued by archaeologists. The ideal human figure used with reference to Buddha was not an imperfect approximation of the Greek ideal as filtered through Gandhāra. The Buddha image was not deficient in anatomy, for the Indian approach was essentially different. It was pure Indian in spirit and idiom and was, moreover, inspired by yoga. Therefore it had a logic of its own.[69] Fergusson's famous generalization that Indian art represented a continuous regression from the Vedic and early Buddhist periods was then taken up. Havell was able to point out its essential weakness by reminding us that the view misrepresented artistic intention.[70] With admirable clarity he suggested that the critic must 'place himself at the Indian point of view'.[71]

Aristic 'intention' may be taken to be the keynote of Havell's art-historical arguments and the essential propelling mechanism of his view of the evolution of art. In his view, for Indian art it was the 'idea'

271

rather than the imitation of nature which played the crucial part in its development. Two important passages reveal Havell's basic attitude to art, its nature and function. He was convinced that the 'true aim of the artist is not to extract beauty from nature, but to reveal . . . the Noumenon within the phenomenon . . . so all nature is beautiful for us, if only we can realise the Divine Idea within it.'[72] In *Indian Sculpture* he stated that the 'common philosophic basis of art in all countries assumes that art is not merely an imitation . . . of . . . phenomena in Nature, but an interpretation [of] the inner beauty, and meaning of the external facts of Nature'.[73]

The implications of these two excerpts may be fully understood only by taking note of the prevailing intellectual atmosphere. The main aim set before the artists of the Renaissance and their great achievement was the mastery in the representation of the visual world. It has been mentioned that when students of art came to discover medieval European art in the late eighteenth century they rejected Vasari's condemnation of it. At the same time they implicitly continued to judge the achievements of Gothic art on the basis of Vasari's stylistic categories. But it was obvious that medieval art fared very badly if it was judged according to the classical canon. The classical measure of perfection, a successful representation of the external world, could be easily applied to Renaissance art and be further used to show how it progressed from one point to the other. And yet by these standards medieval painting would appear to be very imperfect indeed, for, clearly, medieval painters were not attempting to perfect their skills at objective representation. The solution would have been to seek out the norms applicable to medieval art, but this was not done. The students of medieval art reacted in two ways. They came to despise the academic tradition with its concern for the mastery of representation. They also held that medieval art embodied a different philosophy. The nineteenth-century critics of classical art interpreted this philosophy of art to be concerned with representing an ideal world beyond our world of appearances. In other words, a 'transcendental' quality was the most significant feature not only of medieval art but, generally speaking, of all non-classical traditions.[74]

Although 'transcendental' became the favourite mode for describing medieval art in the nineteenth century, this particular view of art was rooted in a long-standing intellectual tradition, originating in no less a person than Plato. The Platonic notion of the Idea has played a very crucial part in Western aesthetics and especially in the visual arts. As it may be recalled, the Idea was in Plato a cognitive notion. In simple terms, it meant that corresponding to every single object in the material world there existed a perfect and eternally valid prototype in an ideal, metaphysical world. By this token artists were assigned an inferior place

272

in the Platonic hierarchy because at best they were only able to present an imitation of the material world which in its turn was but a pale shadow of the ideal one. The Neoplatonists, however, argued that it was precisely the ideal world which concerned the artist. Identifying the Platonic Idea with the 'inner vision' of the artist, they placed greater importance on this inner, ideal world than on the treatment of the material world. Cicero further developed Plato's theory. Taking his cue from the Greek philosopher, he not only argued that beauty was a metaphysical concept but held that artistic creation aimed at something more than the representation of purely material beauty. In short, the anti-naturalist tendency in art criticism developed at an early period in Classical Antiquity, although the dominant ideal was the skill with representation.[75] Clear echoes of the anti-naturalist doctrine can be heard in the above two passages in Havell where he speaks of the inner beauty to be extracted by the artist from nature and the divine Idea to be realized in art. One further feature needs comment here.

In the above extracts the Idea is derived from nature and does not exist either as a pure metaphysical entity or entirely in the mind of the artist. The great difference which marked the art of the Renaissance from that of the Middle Ages was its stress on objective correctness or, as it was commonly expressed, a faithful imitation of nature. But it was in part due to the Renaissance Neoplatonists that the Platonic Idea entered humanist art. As gradually a direct imitation of reality or nature was discarded it came to be held that the artist interpreted nature according to an 'antecedent' ideal, mental image, which, though derived from nature, transcended it. When the nineteenth-century critics of academic art reacted against its materialism and concern with representation, they turned to the Platonic doctrine that art was concerned with an inner world beyond the material one. But it was somewhat ironical that this was the very same doctrine which had been the inspiration of classicists who sought a balance between nature and idea.[76] The influence of the Platonic doctrine is seen in Havell's argument that the lack of concern in Indian art with objective representation reflected its interest in interpreting the ideal world. He claimed to find a confirmation of this view of art in Indian philosophy. According to him Indian artists were engaged in representing the spirit and the spiritual world which were the only realities in Indian philosophy while the rest was illusion. If the visual and material world was an illusion then there was no point in trying to capture it in art. Therefore, there was no need to imitate nature as in classical art. This view of the world does not really apply to the whole of Indian philosophy. Significantly, Havell had chosen the *Vedānta* school which considered the world of perception as illusion or *māyā*.[77]

273

The stress on the spiritual as against the material world was also a reflection of the widespread anti-materialistic tendencies in the nineteenth century. Their origins are to be found in the discontent with Victorian industrialism whose leading spokesmen, Ruskin and Morris, advocated the revival of medieval social and cultural values. As dissatisfaction spread, some aspects of the movement took on a religious hue. The theosophists came to represent the conscience of the antimaterialist movement. The form of Christianity which prevailed in the Victorian period had become tainted by association with industrialism. It was therefore felt by the theosophists that the spiritual values of the human race were preserved only in the pre-industrial East. The English theosophists in particular turned to India for inspiration, a land reputed since the days of Alexander to be the home of the spiritual. The German theosophists, and Rudolf Steiner in particular, had been influential in the *avant-garde* movement in art, notably in Kandinsky's and Mondriaan's work.[78] In India too the theosophists had a part to play in art. Annie Besant, a lifelong admirer of Indian civilization and a participant in the national movement was associated with the intellectual circle of Havell, Coomaraswamy, and others. While she herself was influenced by them, it is not difficult to see that she too provided them with inspiration. In Havell the Platonic Idea became deeply suffused with spiritualism as Plato's metaphysical world became one with the spiritual world of theosophy. Thus, as Havell was convinced, Indian art was concerned with the presentation of an inner spiritual world, whereas Renaissance art, which was in consonance with Western materialist society, aimed at the representation of the material world. This was expressed in the following lines: 'The West, surfeited with the materialism of the Renaissance, is turning again to the East for spiritual instruction. The East, reawakening, is becoming conscious of the truth of her inspiration.'[79] It was this common reaction against representational or illusionistic art which led people to seek a universal unity between archaic Greek, Egyptian, medieval European, and Indian art, although they were all different from one another. It was this confidence in their affinity which provoked Havell's remark that Indian art could provide the key to the understanding of medieval art.[80]

Havell's criticism of the archaeologists was that they ignored the spiritual element in art. In order to gain an insight into Indian art it was essential to correlate archaeological evidence with the spiritual impulse. First Smith and then Alfred Foucher in a famous article had attributed the invention of the human figure of Buddha to the Greco-Romans through the intermediary of the Gandhāra workshop. Foucher's thesis was that an innovation of such import was only possible through the intervention of the classical world, for Indians were by nature

274

conservative. Havell's answer to both of them was simply this: the obvious lack of spirituality in Gandhāra art furnished clear evidence that it was not capable of such an invention even though, technically speaking, it might have been possible for Gandhāra to do so.[81]

The spiritual as a category provided the main impetus in Havell's theory relating to the evolution of Indian art. Like Cole and Fergusson, Havell saw race as a dominant factor in art. Where he departed from his precursors was in his view of the particular contribution of an ethnic group to a style of art. He argued that the contribution of a race was to the creative idea in art, something, he felt, which had not been sufficiently recognized by Cole, Fergusson, or Smith. As the following quotation makes clear, Havell made ideas rather than technical innovation the main determinant in the morphology of styles:

the fundamental principle upon which all art-history must be based, that as art is primarily subjective and not objective, we must always seek for the origin of the great art-schools of the world, not in existing monuments and master-pieces or in fragmentary collections of painting and sculpture in museums, but in the thoughts which created them all.[82]

It was this sentiment which prompted the statement that Indian art was the visual embodiment of Indian philosophy. Accordingly, the rise of Indian art was traced back to a 'Vedic philosophy of art'. The Vedic idea became sculpture between the fourth and tenth centuries, as all sectarianism was overcome and all India became one spirit.[83] The problem was that there was little evidence to support a belief in the existence of any form of art in the Vedic period. Havell, therefore, was forced to admit that the visual arts did not exist in this period, since Vedic religion was followed exclusively by the chosen people, the Aryans, whose task was to preserve the purity of religion from the non-Aryans. None the less, he felt justified in arguing that the philosophy of Indian art was conceived in this era. The conviction that the origins of Indian art must be sought in the pre-artistic Vedic period sprang from the notion that artistic ideas preceded technical achievement, a view made popular by the Idealists in the nineteenth century.[84]

In Havell the Aryans were invested with a mythical quality. They were an ideal people, the very antithesis of the puritanical Victorians. Now, if it was accepted that Vedism permeated all spheres of Indian art, how then was one to explain the existence of Buddhist art in India? The obvious solution lay in making Buddha a Hindu. Havell thus wrote that Buddha was the Hindu of Hindus as equally the *Upaniṣads* had inspired Buddhism.[85]

Since Hinduism comprised so many diverse states of civilization and stages of intellectual development, it inevitably embraced many artistic monstrosities, 'the wild imaginings of primitive races'. None the less, as

Havell reminded us, the keynote to the evolution of styles was to be sought in the 'spiritual contemplation' deriving from Vedic culture.[86] When compared with other traditions in Asia the unique quality of Indian art, which was prominently displayed in works of sculpture and painting, was its ideal, spiritual conception of artistic creation. In this connection the English art historian divided the history of Indian art into two periods. In the first period, the age of early Buddhist art, art went through a phase of naïve naturalism, as exemplified in the anthropomorphic realism of the Aśokan period and in the undeveloped but vigorous art of Sāñci. This was also the period when Buddhist art engaged in gathering experience all over Asia. The genius of the East Asiatic races, including China, found true expression in naturalism, but it was only India which was able to provide the requisite idealism. There is a hint here that Havell was getting at Fergusson for regarding the early naturalism of Buddhist art as being the highest achievement in India. According to Havell, the great transformation in Indian art came only when Vedic idealism took over. In the early Christian era 'north Indian universities' had provided Asian art 'once and for ever with a philosophical basis and created the Indian divine ideal in art'.[87] This divine ideal was composed of a mixture of philosophy and art and of local and foreign traditions.

On applying his 'spiritual' category to various aspects of Indian art, especially to aesthetic questions, Havell came up with the following answers. He argued that the ideal of feminine beauty was determined by the status women had in Indian society. They claimed equality in spiritual and not temporal life. Therefore, in significant contrast to the stress on physical beauty in the female nude in European art, the spiritual beauty of the mother type was preferred in Indian art to the voluptuous *Apsarā* who epitomized physical desire.[88] While even a casual glance at Indian sculpture and Sanskrit literature would reveal that the assertion was not borne out by the facts, it is important to recognize the problem facing Havell. Simply, he was rejecting the classical canon of beauty here but he possessed no alternative convention to replace it with. The assertion of the spiritual quality of the female figures in Indian art was a clear reflection of his failure to consider them as physically and aesthetically pleasing types. Similarly, without trying to establish what principles were in use in India, he argued that Indian artistic anatomy was a consistent and ideal anatomy. The implication here was that Indians had consciously rejected classical anatomy based on empirical study. Similarly, the Indian approach to perspective was held to be consistently idealistic. Although Havell dealt with ancient art in general in these works, his last remark seems to suggest that he had Renaissance art in mind here. In answer to those critics who had asserted that Indian

276

history reflected a continuous decline, Havell suggested that this was a misunderstanding of its spiritual character. Turning to modern India he warned about art that it could be preserved only by a revival of spiritual power to combat the encroaching empiricism of the West, a sentiment well in accord with theosophical writings.[89] In pursuing the spiritual element in Indian art Havell discovered that Indian artists translated their inner, mental vision of the deity into art by means of yogic exercises in which the identity of the Yogin merged into that of the divinity.[90] This Platonic Idea was to be elaborated into an important theory by Coomaraswamy.

The erotic in Indian art was also glossed over by the English artist with a metaphysical interpretation:

Though phallic associations are undoubtedly connected with it [*Liṅga*] popularly, to the cultured Hindu it is only suggestive of the philosophic concept that God is a point formless ... The ideas connected with sex symbolism in Hindu art and ritual are generally misinterpreted by those who take them out of the environment of Indian social life. In the Upaniṣads sexual relationship is described as one of the means of apprehending the divine nature [and] the true relationship between the human soul and God.[91]

Regarding other kinds of symbols he exhorted his readers to understand the intention of the artist in employing them. Havell sought to 'attach to Indian artistic symbols the meanings which the great Indian artists who used them intended them to convey, not that which, now or formerly, has been given to them by superstitious priests and ignorant peasants'.[92] Finally, in an answer to Birdwood's pronouncement that India had remained even in modern times 'a reservation of antiquity' he remarked that while India had borrowed certain forms from other ancient nations it was striking how this country had been able to transform them in accordance with its own philosophy of art.[93]

The last author to be considered in my study of Western interpretations of Indian art is Ananda Kentish Coomaraswamy, a remarkable critic, scholar, and mystic, who dazzled the Western world with his message concerning the spiritual greatness of Indian art. Of mixed Ceylonese and German parentage, he played a leading role in the cultural regeneration which accompanied the rise of the Indian nationalist movement. His cosmopolitan background gave him a unique breadth of vision and imagination. He is included in a study of European attitudes because the reactions of a Westernized Indian, as opposed to those of an orthodox one, belong more appropriately to European intellectual history than to an Indian tradition. And Coomaraswamy made no mean contribution to European art criticism in the twentieth century. A younger contemporary of Havell's, he carried forward the Englishman's pioneer work of convincing Europeans of the true spiritual

277

character of Indian art, a task for which no one was probably better suited than he. In many ways Coomaraswamy was the last of the Neoplatonists and the image of Indian art he fashioned was essentially Idealistic. He made his literary début with an important account of *Medieval Sinhalese Art* (1908), in which he discussed the plight of the traditional industries in Ceylon.[94] The national revival in South Asia coincided with the English intellectual reaction against industrialism, led by thinkers like Morris. It was therefore appropriate that Coomaraswamy's indictment of industrialization in Ceylon in favour of the traditional crafts found a supporter in Morris. *Medieval Sinhalese Art* was brought out by Morris's Kelmscott Press.

Agreeing with radicals like Morris, Coomaraswamy condemned the British government for its attempts to turn Ceylonese society into an industrial one, for, he felt, this had led to the destruction of traditional crafts and especially to the neglect of indigenous art and architecture. His conclusion was that these activities were destroying the very fabric of Ceylonese society.[95] Unlike the theosophists, however, who regretted the passing away of traditional values on account of pressures put by Western materialism, Coomaraswamy produced economic arguments to support his view, thereby marking a departure from the prevailing sentiments. The increasing disintegration of society, he stated, was the result of an overproduction of commodities in a growing industrial world of Ceylon. Overproduction contributed to a form of social alienation which brought about a false relation between art and life.[96] As is obvious, this particular social theory derived from the radical critiques of capitalism, particularly from the works of Marx and other social philosophers. Coomaraswamy agreed with Socialists that art needed to be reintegrated with life. And yet he did not accept their particular solution which lay in changing the mode of production. Unlike them he made religion the cohesive force in Ceylonese society, for it was his conviction that only religion could restore the harmony between art and life.[97] It is worth noting that the mystic element which pervades his writings already makes its appearance in this early work. The marriage of art and religion was to form the pivot of his art theory.

Medieval Sinhalese Art made a valuable methodological contribution to the study of Indian art history. As was pointed out by Coomaraswamy with considerable imagination, any study of Indian arts and crafts needed to take into account their contemporary forms which have survived from the past, because, in India, most of these skills represented a continuous living tradition.[98] Therefore, by studying their survivals, we may be able to project into the past their rise and early development. In the dearth of written evidence in India the particular anthropological approach admirably served to reconstruct past history. This anthro-

278

pological approach was unfortunately neither developed nor applied in other fields of art, as it was abandoned by Coomaraswamy in favour of a more mystical one.

Coomaraswamy's total output was considerable and bore witness to the vast range of his learning and the knowledge of many languages ranging from Icelandic to medieval Latin. Out of his extensive *oeuvre* I have chosen two volumes which set out his basic tenets as well as indicate the development of his art theory. They are also typical in that they present in a clear manner his style and approach. The two works in question, *The Dance of Śiva* (1920) and *The Transformation of Nature in Art* (1934), studied various aspects of Indian art in order to define its nature with ever greater clarity, to show the community of ideas which inspired both Indian and medieval European art, and finally to show the essential difference between them and the classical art of the Renaissance.

There is evidence that Coomaraswamy's reading of medieval literature was wide and his knowledge of the Middle Ages of Europe in many ways profound. The method he adopted for explaining the nature of Indian art was to place it next to medieval European art in order to bring out the similarities of their 'artistic intentions'. This affinity between the two traditions was then contrasted with the different artistic ideals of classical art. To Coomaraswamy and Havell we undoubtedly owe the insight that Indian art could not be properly appreciated by means of categories of taste belonging to Renaissance art. To Havell's mind the spiritual art of India could not simply be explained in terms of the materialistic ideals of the Renaissance. Coomaraswamy argued somewhat differently. He presented something more concrete in that both Indian and medieval European societies were traditional and religious. Therefore it followed that their values were very different from those of the Renaissance. This line of argument was developed in a number of essays where he made persistent attempts to trace affinities between Indian and medieval art. It is therefore easy to see why he found Meister Eckhart's mystical writings appealing. Eckhart's sermons were described by him as the *Upaniṣads* of the West. The traditional nature of Indian and medieval societies was stressed in *The Dance of Śiva*. Coomaraswamy felt that they were societies in which artists did not engage in self-expression or in an objective discussion of aesthetic problems: 'the purpose of the imager was neither self expression nor the realisation of beauty. He did not choose his own problems, but like the Gothic sculptor obeyed a hieratic Canon . . . not [a] . . . philosopher or aesthete, but . . . a pious artisan.'[99] In these societies the whole 'conception of human life in operation and attainment is aesthetic . . . Art is religion, religion art, not related but the same.'[100]

279

The ideal society presented in the two passages reflects the general discontent with Victorian industrial society. It was felt that the growing deterioration of cultural life and especially of the arts was one of the unfortunate outcomes of industrialism. The crisis in art was brought about by the loss of its assigned function in society as it increasingly became divorced from life. The ideal of the unity between art and life was, however, in existence in the Middle Ages in the West. Coomaraswamy reflected the prevailing sentiment when he argued that art should not be isolated from religion and other facets of life. He also argued in this context that the rise of the concept of taste represented the alienation of art from the rest of life. Since in the Middle Ages art had a proper function and role in society, it was not only unnecessary but irrelevant to bring in the question of taste when speaking about medieval European or Indian art. Taste as a cognitive category emerged in the West only when there occurred a dichotomy between art and religion and between art and society. Life became fragmented and a total unified conception of society perished in the process. In the same article on Eckhart Coomaraswamy wrote: 'To speak of art exclusively in terms of sensation is doing violence to the inner man, the knowing subject; to extract from Eckhart's thought a theory of taste (*ruci*) would be doing violence to its unity.'[101]

The argument that Eckhart's art theory reflected a unified conception of life as it prevailed in pre-Renaissance Europe, as equally in traditional India, was central to Coomaraswamy's writings on Indian art. He reinforced the notion of the unity of life not only by drawing upon the works of the nineteenth-century Idealists but upon the psychologist Jung's work as well. For instance, it was mainly on the basis of Jung's theory that myth, dream, and art were the 'dramatisation of man's innermost hopes and fears' that Coomaraswamy characterized medieval society as expressing a 'unity of consciousness'.[102] The synthesizing tendency in the Middle Ages extended to medieval intellectual systems. Their approach to knowledge was very similar to that of the Indians as well as the nineteenth-century Idealists in the West. In other words, to an empiricist, who followed an essentially analytic approach, knowledge was based on the detachment of the subject from the object. Idealists, who refused to create a distance between the subject and the object, criticized their standpoint. Coomaraswamy was in sympathy with the Idealists and wrote:

It should be realized that from the Indian (metaphysical) and Scholastic points of view, subjective and objective are not irreconcilable categories, one of which must be regarded as real to the exclusion of the other. Reality (*Satya*) subsists there where the intelligible and sensible meet in the common unity of being.[103]

Behind his rejection of the primacy of taste lay his strong disapproval of the Renaissance tradition which sought to set up art as an autonomous and isolated social activity, thereby losing sight of the 'unity of consciousness'. As early as 1908 Coomaraswamy had thrown in his lot with the Idealists when he described as materialistic the classical mastery of representation. To him naturalistic art was the product and the essential image of materialism and contrary to everything that idealism stood for.[104] This line of argument was pursued further in *The Transformation of Nature in Art*, where he declared that all the forms of Indian art and its Far Eastern derivatives were ideally determined.[105] Here, a distinction between the 'ideal' and the 'sentimental' was made and a new interpretation of 'nature' offered: 'Asiatic art is ideal in the mathematical sense: like Nature (*natura naturans*), not in appearance (viz. that of *ens naturata*), but in operation.'[106]

Coomaraswamy added a fresh nuance to the Neoplatonic doctrine of art by suggesting here that Eastern art was as concerned with 'nature' as the Western. It was his interpretation of what nature meant that proved to be novel in this context. In the classical tradition, nature as the subject-matter of art, simply meant the visual, external world. Instead of using nature in this traditional sense he significantly equated it with the Ideal world of Plato. In other words, nature, the point of departure in art, rested on a plane beyond the world of appearances. There is no doubt that the only world worthy of treatment in art for Coomaraswamy was the metaphysical world which existed in the artist's mind. In *The Transformation of Nature* he had written that the 'formal element in art represents a purely mental activity' and that India had developed 'a highly specialized technique of vision'.[107]

Now, the problem Coomaraswamy faced was this: if nature was transcendental and it existed on a metaphysical plane or in the mind of the artist it was very necessary to reduce it to material terms in order that it may be intelligible to us. For, after all, we need to use our sense organs, especially our sight, in order to perceive a work of art, let alone enjoy it. That the problem was recognized by Coomaraswamy is evident from his suggestion of the method by which the inner, mental vision may be externalized and represented in art. In the above quotation he stated that a special technique of vision was known to Indian artists. Yoga was this specialized technique of vision which aided artists in translating the inner image into an art form. Indian aesthetics was held to treat the practice of art as a form of yoga. It identified aesthetic emotion as that which was felt when 'the self perceives the Self'.[108] The role of yoga was further defined: 'The purpose of Yoga is mental concentration, carried so far as the overlooking of all distinction between the subject and the object of contemplation; a means of achieving

harmony or unity of consciousness.'[109] As equally the importance of the mental image was emphasized:

The maker of an icon, having by various means proper to the practice of Yoga eliminated the distracting influences of fugitive emotions and creature images, self-willing and self-thinking, proceeds to visualise the form of the *devata* . . . aspect of God. The mind 'produces' or 'draws' . . . this form to itself, as though from a great distance . . . The true-knowledge-purity-aspect . . . thus conceived and inwardly known . . . reveals itself against the ideal space . . . [110]

This particular interpretation of artistic creation, that it was the product of an inner, ideal image in the mind of the artist, posed certain problems for art criticism. In the Renaissance the intention of the artist was clear: to perfect the method of representing the external world. Therefore, when judging a particular work it was possible to see whether the artist had succeeded in capturing a likeness of his subject. On the other hand, when it was argued by Neoplatonists that art dealt only with an abstract, mental image, they faced two essential problems. The difficulty of translating an inner vision into stone or paint has already been mentioned. The question also whether an artist had been successful in representing his inner world is very difficult to answer, for that world was best known to that artist alone. In other words, what objective criteria could be applied so that it may act as a check against arbitrary claims? The problem of devising the criteria of taste in consonance with the Platonic doctrine has often perplexed its advocates. It has been argued by Neoplatonists that the Idea existed independently of any objective criteria. And Coomaraswamy too felt that he had to meet the criticism of his opponents. The perfection of a transcendental form of art consisted not so much in any external standards as in the degree to which the artist could achieve self-identification with his inner vision through a mystical experience. In the case of Indian art the identification with the divinity in question was to be attained through yoga. In his words:

The imager must realize a complete self-identification with it . . . whatever its peculiarities . . . , even in the case of opposite sex or when the divinity is provided with terrible supernatural characteristics; the form thus known in an act of non-differentiation, being held in view as long as may be necessary . . . is the model from which he proceeds to execution in stone, pigment, or other material.[111]

The argument that the religious art of India and of medieval Europe had been the outcome of mystical activities received further reinforcement from his doctrine of the unity of consciousness, based on Jung's theory about myth, dream, and art. In order to circumvent the whole question of taste in art Coomaraswamy sought to set up aesthetic

experience as an autonomous and uncaused activity by deriving certain notions from the romantic aestheticians:

Notwithstanding that aesthetic experience is thus declared [in Hindu aesthetics] to be an inscrutable and uncaused spiritual activity, that is virtually ever-present and potentially realizable, but not possible to be realized unless and until all affective and mental barriers have been resolved, all knots of the heart undone, it is necessarily admitted that the experience arises in relation to some specific representation.[112]

By reducing artistic process to 'an uncaused spiritual activity' he closed all roads to an effective analysis of Indian art and to attempts to define its nature in concrete terms.

There now remains a final assessment of the two major critics of Indian art, Havell and Coomaraswamy. A separate assessment of Havell was postponed because essentially these two authors belong together and their works must be judged together. As critics of the archaeological approach they advocated an idealistic view of art which they felt served to explain the qualities of Indian art much better than the first one. To Indian art Havell brought a certain intuitive approach as an antidote to dry and unfeeling scholarship. His strength consisted in the fact that he came to Indian art as an art teacher and practising artist. He was also immensely enthusiastic and was capable of arousing enthusiasm in others. It was largely on account of him that William Rothenstein and Roger Fry came to appreciate Indian art.[113] His intuitive reaction to individual works of Indian art often gave him a wonderful insight into them. Two instances may be cited. The first is a description of the figure of Pārvatī from a south Indian temple:

In this wonderfully animated and festive group, as fine in human sentiment as it is decorative in beauty, the sculptor has entered heart and soul into the spirit of Kalidasa's verse. Very charming is the modest, half-shy expression of the beautifully poised oval head; the robust, rich modelling of the goddess's body gives the true Indian ideal of ripe womanhood, the full bosom, the slender waist, the swelling hips, and the tapering limbs. The joyous rhythm of the dance vibrates through the whole group like the breath of spring.[114]

The second is an account of painting in Ajanta:

... In one case the painter uses a sweeping brush-drawn line so intense and full of vitality that it needs only the slightest complement of colour and tone to perfect the aesthetic creation. Similarly, the sculptor, in concentrating himself upon the spiritual feeling of the subject, uses the boldest chiaroscuro, and reduces all lines and modulations of surface to their simplest forms, so that no superfluous details distract the eye from the essential points of movement and expression.[115]

Coomaraswamy is of course regarded as one of the greatest exponents of Eastern aesthetics and of Asian art criticism. He profoundly

influenced the course of art-historical studies with reference to India. Among his many admirers was the artist Eric Gill. Recently there has been a revival of interest in him. In specific cases of art criticism he often showed clarity and imagination. Again, an instance may be cited:

The sculpture of the seventh and eighth centuries . . . excels not only in static conceptions, but in the representation of movement: its forms are more slender and more elegant than those of Gupta art, though lacking its magnificent solidity. By contrast with the earliest Indian art it is typically learned and conscious, even when it seems most spontaneous. The study of gesture and stance in connection with dramatic dancing and the plastic arts had now been pushed to an extreme limit. The modes followed by all subsequent schools are already established and the art is classic in this sense. The still later schools, exceptions apart, never again attain to the same dramatic vitality or the same directness of statement.[116]

There are passages like this in Havell and Coomaraswamy which give refreshing evidence of their ability to treat their subject with admirable sympathy and imagination. But, since the importance of these authors extends well beyond the question whether they were able to appreciate specific works, it is all the more necessary to judge their contributions to method and approach. After all, they were primarily responsible for laying the foundations on which the present art-historical scholarship concerning Indian art rests. Even at the risk of coming up with harsh answers, it is essential to ask the final searching question, were they were able to bring us any closer to a real appreciation of Indian art? To put it briefly, Havell was optimistic that Indian art would provide us with the key to the understanding of medieval art. But the only common feature between the two traditions was their concern with the portrayal of an ideal, spiritual world beyond our material one. What is clear is that he characterized both medieval European and Indian art by an undifferentiated anti-classical category. Behind this characterization lay his attempts to answer the charge levelled by classical critics that these traditions were incapable of representing the objective world, which only classical art was really able to do. But the charge remained, for he continued to judge Indian and medieval art against classical categories of taste. His second suggestion was that it was necessary to understand the 'artistic intention' which inspired a particular work of Indian art. This ought to have provided him with an exciting starting-point. However, instead of searching for the Indian ideal of beauty or the standards of taste in concrete terms, he was reduced to employing collective notions like the 'Indian spirit' or the 'Indian ideal'. His works, therefore, are full of vague metaphysical generalizations such as that Indian art was predetermined by the Vedic philosophy of art. After rescuing Indian art from the patronizing atti-

tude of the archaeologists, Havell was able to elevate it to an exalted and spiritual plane, but at the same time he could not help draining it of the vital substance. For, after all, the great strength of Indian art consists in its wonderful, life-affirming vitality. By encouraging a reverent attitude he prevented discussions of its more interesting and positive side.

Arguably, the chief importance and reputation of Coomaraswamy rest on the philosophy of art he propounded. The success of that philosophy, moreover, owed to the clarity and conviction with which he voiced the general European discontent with the naturalistic art of the Renaissance. As I have stressed, although Coomaraswamy was part-Ceylonese by birth, he was closer to European intellectual tradition and was inevitably affected by the widespread reaction against naturalistic art. It may be recalled that late nineteenth-century artists, art critics, and students of art in general had turned away from the academic tradition for its concern with representation. Those in revolt had identified the classical tradition as standing for Victorian industrialism and the capitalistic society and all three were despised by them. Their search for lost spiritual values extended to the realm of art. They felt, therefore, that only those forms of art which attempted to capture the real and essential world behind the veil of appearances were worthy of consideration. In their eyes only Eastern and medieval traditions qualified.

It was at this opportune moment in history that Coomaraswamy appeared on the scene, holding up before the eyes of expectant Europe the idealistic and spiritual image of Indian art. His task was made somewhat easier by the fact that the skill in imitation did not happen to be one of the main aims of Indian art. Thus he fulfilled an urgent need in the West in this direction, but the success with which he impressed his particular image of Indian art was not the least due to his compelling literary style and wide-ranging erudition.

However persuasive Coomaraswamy's interpretation may have been it did not really bring us any closer to the understanding of Indian art. In short, the limitations in Coomaraswamy arose from the fact that even he ultimately fell back upon European standards for evaluating Indian art, a problem which had beset his predecessors. This is particularly in evidence in his comparisons between Indian and medieval European art. Reduced to essentials, the real affinity between the traditions, as shown by Coomaraswamy, was their non-representational character. Although there was undeniably some truth in this comparison, it too rested on a negative thesis and did not make clear what distinct qualities they had. The comparison was in effect unspecific, vague, and undifferentiated. As has been argued before, the transcendental feature of Indian art depended for its existence on the classical

norm of pictorial representation. In other words, both Coomaraswamy and Havell succeeded in asserting what art was not rather than what it actually was.

When it came to describing the actual nature of Indian art the real weakness of Coomaraswamy's school became apparent. No one can deny that Coomaraswamy was correct to stress the role of religion in Indian art. But when called upon to explain the precise relation between art and religion he took refuge in metaphysical generalizations derived not only from Plato but from Romantic aestheticians of the nineteenth century. One of the crucial tenets held by Coomaraswamy that art was an 'uncaused spiritual activity' reduced art criticism to the level of irrational mysticism. Today the need to look afresh at Indian art has taken on a great urgency because of the lacuna left by the man who was most suited to answer questions on style and taste. I would suggest here that a more effective and fruitful way of studying the nature and quality of Indian art and the entire relations between art and religion would be in concrete and human terms and not by presenting collective notions or metaphysical generalizations. This may be done by seeking to restore the religious, cultural, and social contexts of Indian art. In the process we shall have to make a conscious effort to learn what actual standards of art criticism were in operation among those Indians who had created these works and among those for whom they were created, and not continue to depend on the classical tradition whether to affirm its principles or to deny them. But that exciting task belongs to the future. Meanwhile my own task has only been to draw aside the veil of misinterpretations so that the Indian gods may reveal their true beauty to us.

Notes

CHAPTER I

1. Schwab, R., *La Renaissance orientale*, Paris, 1950, p. 499; see Appendix I for note on early collections.
2. Yule, Sir H., *The Book of Ser Marco Polo*, I, London, 1903, pp. 52 ff. For Marco's travels in Asia between 1271 and 1295 see ibid., pp. 19 ff. Yule discusses his nickname, 'il milione' (pp. 54, 67), and his reputation and importance among contemporaries (pp. 104 ff.). L. Olschki, the outstanding Polo scholar argues that, 'Although he [Marco Polo] had in mind composing a description of Asia on an empirical basis, it is incorrect to interpret this attempt as a result of Marco's scientific intentions' (*Marco Polo's Precursors*, Baltimore, Md., 1943, p. 13), and concludes that he was medieval in character, a mixture of the objective and the fantastic (L. Olschki, *Marco Polo's Asia*, Cambridge, 1960). On the other hand, M. Hodgen argues that he did represent a modern scientific attitude to Asia but was not appreciated by contemporaries who held on to the fabulous tradition (*Early Anthropology in the Sixteenth and Seventeenth Centuries*, London, 1964, pp. 78 ff.).
3. Yule, op. cit. II, p. 345. Yule's English translation is still the most authoritative one. But it is not literal. I have therefore gone to the most reliable early version in Franco-Italian (Bibl. Nat. MS. Fr. 1116), given in Benedetto's monumental critical edition (L. F. Benedetto, *Il milione*, Florence, 1928), for certain changes made in Yule's text. Instead of 'monks' of a convent I have put in 'nuns', which is much more in accord with Boucicaut's painting discussed in the following pages. In Benedetto, op. cit., p. 184, we find the same passage as 'Et puis que il les ont ofert, toutes les foies que li *nonnain do mostier* [italics mine] de l'idres requirent celes damoiseles, que sunt estes ofert a l'idres, qu'elle reignent au moistier por fer seulas a l'idres, tantost hi vient; et chantent et calorent e font grant feste.' 'Nonnain de mostier' literally translated is 'nuns of a monastery'.
4. *Le Livre des merveilles*, MS. Fr. 2810, Bibl. Nat. (Paris), fol. 80. For the history of the MS. see facsimile edition by H. Omont. M. Meiss, *The Boucicaut Master*, London, 1968, pp. 116–17, shows that the MS. was finished before 1413 and that the painting (fol. 80) came from the Boucicaut workshop. On p. 42 he writes: 'Among the secular manuscripts illuminated by the Associates the *Merveilles du Monde* is known best. Indeed with the *Très Riches Heures* it enjoys a greater fame than any other manuscript of the late Middle Ages.'
5. Meiss, *French Painting in the time of Jean de Berry*, 1967, p. 9, writes that the Boucicaut Master was 'The greatest illuminator in Paris in the first years of the fifteenth century ...' Although this and other paintings in this MS. were executed by the workshop of Boucicaut, for the sake of simplicity I have decided to call the author of the painting Boucicaut or the Boucicaut Master. This is justified in view of the fact that he was the main inspiration behind the workshop and its style.
6. Gombrich, E. H., *Art and Illusion*, London, 1962, p. 60. My analysis closely follows Professor Gombrich's method for the understanding of how an artist proceeds from the known to the unknown by means of schema and correction and the mental process that lie behind it. My work leans particularly heavily on the chapter called 'Truth and the Stereotype' (Pt. I, ch. II, pp. 55 ff.). I have therefore attempted to summarize here the parts most relevant for my arguments. For further information I would direct my readers to the chapter itself.
7. Gombrich, loc. cit. It is interesting that when Wolgemut was assigned the task of representing Nuremberg he did it quite well. Although there are some fanciful elements, Strauss shows that a number of architectural landmarks are still recognizable (G. Strauss, *Nuremberg in the Sixteenth Century*, New York, 1966, pp. 10–11). Clearly Wolgemut was able to modify his initial formula in the light of his own knowledge of the city. In fact most of his cities do look a little bit like Nuremberg!
8. Meiss, *The Boucicaut Master*, p. 46, discusses the role of conventional motifs in the MS.:

287

'The illuminators of the *Merveilles* were not of course given the sights and sounds of Asia but only the more or less conventionalized record of them, and if they proceeded—as indeed they did—to alter and embellish this record with what the earlier pictorial tradition told them, they acted similarly to the travellers themselves. The difference between travellers and illuminators is not in kind but in degree . . . The illuminators endeavoured to make the subjects . . . vivid for their clients by introducing well-known emblems . . . Like all Medieval illuminators they felt no compulsion to translate the texts fully.'

9. Wittkower, R., 'Marvels of the East', *Journal of Warburg and Courtauld Institutes*, V, 1942, pp. 159 ff. This is the definitive article on the image of India in the medieval period, an image based entirely (directly or indirectly) on classical authors. Wittkower traces on the one hand the antique sources for the marvels and monsters of India and on the other the influence of these fables on post-Renaissance European thought. He has shown that people in the Middle Ages knew or cared to know authors like Pliny and his imitator Solinus with their uncritical collection of geographical and anthropological knowledge in preference to more objective reporters like Strabo, Aulus Gellius, or Ptolemy. In his *The Dawn of Modern Geography*, London, 1897, I, pp. 294 ff., C. R. Beazley was one of the first to discuss the geographical myths in the Middle Ages and their importance, but the book is out of date now. A much more penetrating study of the geographical knowledge in the Middle Ages is to be found in J. K. Wright, *The Geographical Lore of the Time of the Crusades*, New York, 1965 (new ed.); especially relevant for us are pt. I, ch. II, pp. 71 ff., ch. IV, pp. 113 ff. and pt. II, ch. XII, pp. 272 ff.

10. Cary, G., *The Medieval Alexander*, Cambridge, 1956, pt. A, sects. I and II. This third-century text is a collection of Eastern, particularly Indian, marvels, purporting to be the work of Callisthenes, a companion of Alexander in his conquests (Wright, op. cit., p. 49).

11. Wittkower, op. cit., p. 180, comments on the Romance being taken as a real history of the supernatural adventures of Alexander, which was quoted by historians and chroniclers; and on p. 166 he discusses the influence of Pliny's *Historia Naturalis* on medieval authors. Even more influential was Solinus' handbook which was taken over *in toto* by Isidore, for his description of the East.

12. Ibid., p. 159.

13. Ibid., p. 195.

14. James, M. R., *Marvels of the East*, Oxford, 1929, p. 25. He edited three versions of this popular medieval text. Cited by Wittkower, op. cit., p. 159. *Marvels* presents the common stock of monsters going ultimately back to such authors as Homer, Herodotus, Ctesias, Megasthenes, Strabo, Aelian, Photius, Pliny, Solinus, and Callisthenes. On linguistic and other evidence Sisam shows the interrelationship of the *Marvels* and other contemporary material, and argues for an early date for them. The so-called *Beowulf* codex, containing (i) *The Passion of St. Christopher*, (ii) *The Wonders [Marvels] of the East*, (iii) *The Letter of Alexander to Aristotle*, (iv) *Beowulf*, and (v) *Judith*, is in fact a collection of marvellous stories. The first three deal with Eastern monsters including St. Christopher who is related to the classical cynocephali here for his dog-head. The Old English poem *Beowulf* too deals with monsters and is thus part of the codex. What is most interesting is that the work was not intended for rich patrons but was a compilation of several hands, in essence a 'Liber de diversis monstris, anglice', produced for the whole community. Sisam also shows that the *Marvels* was compiled in England in the eighth century as was also at about the same time the *Liber Monstrorum*, another very popular text (K. Sisam, *Studies in the History of Old English Literature*, Oxford, 1953, ch. 5, pp. 65 ff.). An early iconographic tradition of monsters is to be found in the Ghent MS. of *Liber Floridus* of Lambert de St. Omer completed *c.* 1120. Lions, crocodiles, and other living creatures are shown with griffins and dragons as also the Biblical Behemoth, Leviathan, and Antichrist. Behemoth is in fact called an Oriental beast (Lambert of St. Omer, *Liber Floridus*, facsimile ed. P. Dérolez, Ghent, 1969). Recently Professor R. A. Wisbey has traced these marvels in *Wiener Genesis* and Wolfram's *Parzival* (in *Essays in German and Dutch Literature*, London, 1973).

15. Wittkower, op. cit., p. 159. In fairness it must be added that these monsters were never entirely arbitrary inventions but had their origins in the garbled transmission of stories from Indian mythology. McCrindle showed that Ctesias' monsters had their counterparts in the *Mahābhārata* (J. W. McCrindle, *Indika of Ktesias*, London, 1882, p. 5). See also Wittkower, pp. 163 ff.

16. Baltrušaitis, J., *Le Moyen Âge fantastique*, Paris, 1955, p. 11.

17. Wittkower, op. cit., pp. 167 ff.

18. Isidore of Seville, *Etymologiarum sive originum*, lib. XI (ch. III), translated by W. D.

Sharpe, 'Isidore of Seville: The Medical Writings', in *Transactions of the American Philosophical Society*, New Series, LIV, pt. 2, 1964, pp. 51 ff. Here Isidore is using the word 'portent' as monster in its original sense. The meaning of the Latin word *monstrum* given in Lewis and Short's *Latin Dictionary* is a divine omen or portent.

19. Sharpe, op. cit., p. 31.

20. Baltrušaitis, op. cit., pp. 197 ff. While it is quite true that in general these antique handbooks like that of Solinus were not only popular but were taken seriously, there are of course some remarkable exceptions. Peter Dronke shows the sophisticated parodistic use of such handbook material in an eleventh-century poem (*Medieval Latin and the Rise of European Love-Lyric*, II, Oxford, 1968, pp. 513 ff.).

21. Baltrušaitis, op. cit., p. 198.

22. Manuel, F. E., *The Eighteenth Century confronts the Gods*, Cambridge, Mass., 1959, pp. 49 ff.

23. Huizinga discusses the role of the pagan gods in medieval Christian thought, especially with reference to its conceptions of sin, in his essay on Alain de Lille. Unlike in the Renaissance, when 'personification' became a literary 'device', for the medieval thinker the heavenly and hellish spirits had a very real existence and a precise function. Problems relating to the boundaries between faith and imagination were more serious when one dealt with a twelfth- or thirteenth-century author than an ancient classical or Renaissance one. When in the early Middle Ages the poetic and mythological remains of pagan antiquity remained suspended in the sphere of half-belief the scholastics were more interested in what could be done with them in Christian terms than whether they made sense as literary allegories. The figures of vices taken from the classical tradition were interpreted as devils of hell, a tradition which went back to Gregory's notion that sins were actual evil spirits. In this highly charged atmosphere the allegories of vices and virtues were not detached classical figures but active participants who plunged right into the struggle (Huizinga, J., 'Über die Verknüpfung des Poetischen mit dem Theologischen bei Alanus de Insulis', *Verzamelde Werken*, IV (Culturgeschiedenis II), Haarlem, 1948–53, pp. 3 ff.).

24. St. Augustine, Bishop of Hippo, *De Civitate Dei*, book II, chs. x, xxiii, xxiv, xxix; book VIII, chs. xix, xxiii, and *passim*. English translation, *The City of God*, J. Healey, London, 1931. H. C. Lea, who undertook the systematic compilation of Christian texts on demonology, showed that central to Christian demonology was the devil and also that the idea that false gods were demons went back to Hebrew demonology. The belief that pagan deities were demons went back to Paul (I Cor. 10: 20) and even earlier in Psalm 96: 5. Justin Martyr, Cyprian, Augustine, all of them argued that these gods were not harmless idols but dangerous evil demons who misled people (H. C. Lea, *Material toward a History of Witchcraft*, I, London, 1957, pp. 13 ff.).

25. Hughes, R., *Heaven and Hell in Western Art*, London, 1968, pp. 243 ff.

26. Villeneuve, R., *Le Diable dans L'art*, Paris, 1957, pp. 14, 46. Hughes, R., op. cit., pp. 248, 252.

27. Bousset, W., *The Antichrist Legend*, London, 1896, discusses the origins and development of the Antichrist legend from its connection with the Babylonian myth of Tiamat to its identification with the devil in the Middle Ages (pp. xi, 142, 144, *passim*).

28. Villeneuve, R., op. cit., pp. 12, 55 ff., 84. Several other Biblical creatures were drawn into the ever-widening category of medieval demons. Leviathan and Behemoth were all made to serve the devil as we see from pictures (Hughes, p. 176). *Liber Floridus* is a good place to study these demons (see *supra*, note 14).

29. Sharpe, op. cit. p. 53. Also cf. Wittkower, op. cit., pp. 190 ff., for a discussion of the confusion between the satyr, a mythological creature, and the ape, in the minds of people as late as the seventeenth century.

30. Hrabanus Maurus, German, 1425, Rome, Bibl. Vat. Pal. lat. 291. f. 75v, illustrated in Wittkower, op. cit., pl. 42c. The zoological collection in *Liber Floridus* includes the lion, dragon, crocodile, Behemoth, Leviathan, and Antichrist (see *supra*, note 14). In *The Story of the Devil*, London, 1931. p. 37, A. Graf mentioned that he had come across in an ancient bestiary the devil listed along with other animals.

31. Yule, Sir H., *Cathey and the Way Thither*, II, London, 1913, p. 138.

32. Ibid., pp. 262 ff.

33. Ibid., pp. 262 ff., note 5. H. Omont, *Le Livre des merveilles* (Paris, 1907, Bibl. Nat. facsimile ed.), placed the valley in Khorasan area in Central Asia. Strange noises in the deserts of Central Asia were reported by Marco Polo (Yule, *Marco Polo*, I, p. 197).

34. James, M. R., *The Romance of Alexander* (a collotype facsimile of MS. Bodley 264), Oxford, 1933, p. 21. Although the work on this particular text of the romance was finished in 1338, the traditions of Alexander's adventures went back to earlier times. For instance, the oldest and the most voluminous version of the romance by Lambert

li Tors contains the episode of the Valley Perilous which must antedate Odoric by many generations. There are so many versions of the romance that it is not possible to say which one was known to Odoric. The idea of the Valley Perilous is of Christian origin and is derived most probably from the 'valley of the shadow of death' in Psalm 23. In the visions of medieval mystics such as Alberic or Tundale 'the dark valley' was a prominent feature of life after death. When Alexander was identified as a hero in the Judeo-Christian tradition a number of Biblical episodes came to be attached to the earlier pagan tradition of his adventures in the East. Such an example is that of Alexander and the enclosing of the Biblical nations of Gog and Magog. In the same way the Valley Perilous was one of the hazards that Alexander as a Christian hero had to overcome. The best study of the nations Gog and Magog and Alexander is by Anderson, A., *Alexander's Gate, Gog and Magog, and the Inclosed Nations*, Cambridge, Mass., 1932. For a discussion of the Valley of the Shadow of Death, see Patch, H. R., *The Other World*, Cambridge, Mass., 1950, pp. 110 ff.

35. *Livre des merveilles*, fol. 115. This work is attributed to the Boucicaut workshop by Meiss, *Boucicaut Master*, p. 117.

36. The description of the region as set forth in the colourful German edition by Michelfeld (*Sie hebt sich . . . Montevilla*, Augsburg, 1482, unpaginated) is as follows: 'I want to tell you of the entrance to hell. Not far from the waters of Physon going from the island of Millestozothe to the left you come towards the waters of Physon. There is a valley . . . of perdition . . . in the Middle . . . a large rock and on the rock there is a devil's face. The most abhorrent one that one could see anywhere in the world and it is only visible as far as the chest, and I am sure that there is no man in the world so courageous that seeing this figure his heart would not tremble or take fright . . . It wants to devour him at once for it turns its eyes and sends a stinking smoke from its mouth and a filthy stench, and it also hisses and bares its teeth, and shakes itself so that the monsters in the valley tremble' (Diemeringen, see *infra*, note 38). Letts, M., *Sir John Mandeville*, London, 1949, p. 88, places the Valley in Malasgird in Armenia. The mention by Mandeville of the river Physon however suggests the earthly paradise context and its own mythology of the terrors surrounding it. Mandeville's valley was identified as an ante-inferno in the region of the river Physon by Arturo Graf in his discussion of the situation of the earthly paradise in *Miti, leggende e superstizioni del medio evo*, I, Turin, 1893, p. 21 ('Il mito del paradiso terrestre'): 'No less common is the contrary view: at the bottom of the paradise extends a wild, gloomy, and horrific region enclosed by inaccessible mountains, full of frightening serpents and other creatures. Jacques de Vitry writes that in the period of chaos when the First Parents lived a large part of the earth was infested with serpents. Jordan de Severac places the earthly paradise in the third India . . . Mandeville and others have spoken of the inhospitable and rugged area situated between our world and paradise, which sombre region is described in Alexander legends. In the visions of the earthly paradise the region is often placed very close to the inferno and the purgatory in a manner that the soul passes very suddenly from the world of suffering to that of beatitude . . . Mandeville describes a kind of ante-inferno in the neighbourhood of the river Fison, and Ariosto unfolds the orifice of hell in the centre of the mountain on which paradise is situated. Dante holds that paradise crowns the mount of purgatory . . . elsewhere the purgatory is a pit enclosed all around by paradise.'

Mandeville's Valley Perilous was identified with ante-inferno by Graf as we see from the above passage. This is even more clearly stated in Patch who holds that Mandeville had gathered together all the different medieval traditions about the earthly paradise in his passage on Valley Perilous and writes further: 'Near the river Phison is the Vale Perilous, about four miles long, supposed to be full of devils because of its storms and mysterious noises, with a devil's head under a rock at its midst' (Patch, H. R., op. cit., p. 164). Neither of these authors however discusses the actual geographical location of the valley which Mandeville derived from Odoric's description of Bamian. The river Phison was for a long time identified both in classical and Christian traditions with Ganges. Pseudo-Callisthenes, bk. III. 7, had identified Phison with Ganges. Scriptural tradition which placed the earthly paradise in the East also held that the fountain of Eden was the source of the four major rivers of the world, Phison (Ganges), Gehon (Nile), Tigris, and Euphrates. These rivers go underground in their early stages and reappear again in Armenia. See Ringbom, Lars-Ivar, *Paradisus Terrestris*, Helsingforsiae, 1958, p. 436.

37. Hodgen, op. cit., p. 103.

38. Diemeringen, O. von, *Johannes von Montevilla Ritter*, Strassburg, 1484, unpaginated. Another illustration is in Michelfeld (*supra*, note 36). See also Letts, op. cit., p. 91,

for discussion of Diemeringen and pp. 34 ff. for Mandeville's influence on European literature.

39. *Livre des merveilles*, fol. 215. Attributed to Boucicaut by Meiss, *Boucicaut*, p. 117.

40. *Livre de merveilles*, fol. 185. Meiss, *Boucicaut*, p. 117, attributes to the Bedford Master. Although the figure has some resemblance to the Sphinx, I would argue in favour of Martikhora because not only is it iconographically closer to this mythical beast but its reputed Indian provenance would encourage the artist to present it as an Indian idol. Martikhora, the mythical Eastern monster first described in Ctesias and which may well have derived from the Persian words, *Mard* and *Khora* meaning man-eater, became popular in the Middle Ages through Pliny and Solinus. For a discussion of this beast see Wittkower, op. cit., pp. 160 ff., and Wright, op. cit., p. 468, note 112. Wittkower provides a number of illustrations too (pl. 47d, e, f). The Mandeville illustration slightly modifies the paws but the beard clearly evokes the Martikhora of the thirteenth-century Hereford map.

41. Ibid., fol. 184. Attributed by Meiss, *Boucicaut*, p. 117, to the Bedford Master. This is the earliest use of a devil figure for an Indian god that I have been able to find, but the iconography is not yet sharply defined as it would be in Varthema (see *infra*, note 48).

42. Jones, J. W., *The Travels of Ludovico di Varthema*, London, 1843, pp. 136 ff. *Itinerario de Ludovico de Varthema Bolognese . . .* Rome, 1510.

43. Ibid., pp. 137 ff.

44. Jarl Charpentier in *Livro da seita dos indios orientais* dismisses Varthema as follows: 'Nor is the description (devils) at Calicut and the mode of worshipping them of any special value as the author did apparently know very little about the topic' (see *infra*, note 277). Charpentier's remark is somewhat harsh but I think it supports my conviction that the Deumo owed a great deal more to the Western tradition than to the Indian. None the less Varthema did pick up bits of information during his visit which were presented in a confused manner in the account of the king's chapel and Calicut idolatry in general. From the later account of Ziegenbalg (see *infra*, note 284), p. 141, we learn that in the temple of Ankalammen, a folk or village deity (*grāmadevatā*), one usually finds the image of Periya *tamburan* (the great god), a śaivaite deity. While the image of this god is like that of Śiva or Īśvara, Ankalammen, whose function is to ward off evil, is surrounded by several horrific images. One possibility is that Varthema might have seen one of these temples by the roadside and deduced therefore that a similar image must exist in the Samorin of Calicut's own chapel.

45. Hughes, R., op. cit., p. 189, illustrates the fresco which forms part of the universal judgement cycle executed by Traini at the Campo Santo in Pisa *c*. 1350. A print by Baccio Baldini inspired by Traini's fresco exists at the Warburg Institute, London (Coll. Rysbrack, H. 20, Pass V, 43, 102). Francesco Traini, active 1321–69, was a pupil of Orcagna. To him is attributed a cycle of frescoes of the Campo Santo, Pisa (E. Bénézit, *Dictionnaire critique et documentaire des peintres, sculpteurs*, new ed. XIII, Librairie Gründ, 1955, p. 366).

46. Jones, J. W., op. cit., p. 155.

47. Ibid., pp. 115 ff. and note 1.

48. *Die Ritterlich und Lobwirdig Raisz . . .* etc., Augsburg, 1515, pp. i, iii.

49. The most recent discussion of printing presses, travel reports, and artists in sixteenth-century Germany is in Lach, D. F., *Asia in the Making of Europe*, II, bk. I, ch. II, sect. 3, 'Woodcuts and Engravings', Chicago, 1970, pp. 78 ff. Particularly interesting is the discussion of Burgkmeir and his engravings of the 'People of Calicut' (p. 80). For information on Jorg Breu, see Hallstein, F. W. H., *German Engravings, Etchings and Woodcuts*, IV, Amsterdam, 1954, pp. 157 and 177. Breu was born *c*. 1480 and died in 1537; see also Lach, p. 81.

50. Peter Dronke kindly gave me the information that the best-known example in Dante is in *Inferno* XIX.

51. The Revelation of St. John 12–16. The dragon as the agent of Satan has as its attributes seven heads, seven diadems, and ten horns. Different interpretations have been given by different exegetical commentators while they all agree on the mystical significance of these numbers. The number seven is known specially to have magical import in most civilizations. Parallel number symbolism of course exists in Indian religious texts as well. Short, E. H., *The Revelation of St. John the Divine*, London, 1926, p. 71, suggests that the ten horns had symbolized ten Caesars, but this is disputed.

52. The connection between the dragon and old Babylonian mythology has been discussed above (see *supra*, p. 10). But I think Short is right to believe that the dragon also symbolizes pagan despotism, particularly in Babylon. This pagan empire is for instance

represented as a harlot seated on the seven-headed beast of Satan. Clearly all pagan empires are attacked here, the Roman in the West and Babylonian in the East (Short, op. cit., pp. 69 ff.).

53. *Die Ritterlich*, p. m.
54. Mckenna, J. B., *A Spaniard in the Portuguese Indies*, Cambridge, Mass., 1967, p. 125. Mckenna describes the man, his travels, and the book, in the introduction.
55. Eden, R., *The History of Travayle in the West and East Indies . . .* etc., London, 1577, 'The Navigation and Voyages of Lewes Vertomannus', pp. 388 ff.
56. Foster, W., *Early Travels in India*, London, 1921, p. 15. Bijapur was a powerful Muslim kingdom in the Deccan and was the nearest Muslim neighbour of Portuguese Goa in the sixteenth century. The word for idol used by Fitch is *pagode*, which meant three different things in this period: idol, temple, and a type of coin (see *Hobson-Jobson*). The earliest explanation occurs in D'Herbelot, *Bibliographie Orientale*, Paris, 1697, p. 534b.
57. Foster, op. cit., pp. 20 ff.
58. Ibid., p. 163.
59. Ibid., p. 155.
60. Ibid., p. 307.
61. Ibid., p. 321.
62. Burnell, A. C., *The Voyage of J. H. van Linschoten*, London, 1885, I, introduction, p. xxv, discusses his voyage between 1583 and 1592, and p. xxxi the drawings he did in India. Burnell edited the 1598 English translation by William Phillip (?) of Linschoten's *Itinerario*, Amsterdam, 1596. Lach, op. cit., p. 94, discusses the illustrations in the *Itinerario* and their engravers.
63. See *infra*, ch. III, p. 123.
64. Burnell, op. cit. I, pp. 289 ff.
65. Ibid., p. 300.
66. Burnell's edition does not contain this illustration which may be found in the 1596 Dutch edition of Linschoten, p. 66–7.
67. Baltrušaitis, op. cit., p. 30.
68. Du Jarric, P., *Histoire des choses plus memorables advenues tant ez Indes Orientales*, I, Bordeaux, 1608, p. 44.
69. Herbert, Sir T., *A Relation of Some Yeares Travaile*, London, 1634, p. 37.
70. Ibid., p. 188.
71. Ibid., pp. 38 ff.
72. Davies, J., *The Voyages and Travels of the Ambassadors (1633–39)*, London, 1669, p. 52. The English translator based his work on Olearius, A., *Ein Schreiben . . . in welchem er Seine der newen orientalischen Reise*, 2 parts, Schlesswig (1645–), 1647, which included A. von Mandelslo's voyage. For Mandelslo's description of Indian temples see *infra*, p. 43.
73. Thiébaux, M., 'The Mouth of the Boar as a Symbol in Medieval Literature', *Romance Philology*, XXII, no. 3, 1968, pp. 281 ff.
74. Davies, loc. cit.
75. For the biography of Tavernier see *La Grande Encyclopédie*, XXX, Paris, 1886–1902, p. 985.
76. Tavernier, J. B., *Collection of Travels through Turkey into Persia and the East Indies . . . being the Travels of Monsieur Tavernier, Bernier and other great men*, I, London, 1884, p. 174. The translation was based on *Les Six Voyages de Jean-Baptiste Tavernier*, Paris, 1676.
77. Ibid., p. 178.
78. Ibid.
79. Ibid.
80. For his life and travels see *La Grande Encyclopédie*, XXXI, p. 8. On Ellora see *infra*, p. 41.
81. Lovell, A., *The Travels of M. Thévenot into the Indies (III)*, London, 1687, p. 105. It is based on Thévenot, J., *Voyages de Mr de Thévenot contenant la relation de l'Indostan . . .*, Paris, 1684.
82. Bernier, F., *Voyages de François Bernier*, II, Amsterdam, 1699, p. 97.
83. Tavernier, *Collection*, I, p. 97.
84. Churchill, A. and J., *A Collection of Voyages and Travels*, II, London, 1704, p. 249. 'Mr John Nieuhoff's Remarkable Voyages and Travels to the East Indies' in this collection is the translation of J. Nieuhof's *Zee en Lantreise, door verscheide Gewesten von Oostindien*, Amsterdam, 1682.
85. Ovington, J., *A Voyage to Suratt in the year 1689*, London, 1696, p. 160. Taste for the sublime and picturesque is discussed *infra*, ch. III, pp. 120 ff.
86. Ibid.

87. Fryer, J., *A New Account of East India and Persia*, London, 1698, p. 39. On Elephanta, see ibid., p. 75.
88. Ibid., p. 44.
89. Ramusio, G. B., *Delle navigationi et viaggi*, I, Venice, 1550, fol. 159–88[v]. The great influence of Varthema can most interestingly be studied by going through the British Museum catalogue. The reasons for the great importance of Varthema's description are several: not only was he the earliest major traveller of the modern age, but Calicut was regarded as the most important Indian port in sixteenth-century Europe.
90. Münster, S., *Cosmographae Universalis*, Basle, 1550, p. 1087.
91. Thévet, A., *La Cosmographie universelle*, I, Paris, 1575, pp. 404 f.
92. See *supra*, p. 19.
93. See *infra*, p. 57.
94. Seznec, J., *The Survival of the Pagan Gods*, New York, 1961, gives the definitive and comprehensive account of the influence of Oriental cults on European iconographic tradition. See pp. 149–252.
95. Iversen, E., *The Myth of Egypt and Its Hieroglyphs*, Copenhagen, 1961, pp. 39 ff.
96. Seznec, op. cit., pp. 232–9.
97. Cartari, V., *Le vere e nove imagini degli dei degli antichi*, part II ('Imagini degli dei indiani'), Padua, 1615.
98. Seznec, J., 'Un Essai de mythologie comparée au debut du xviie siècle,' *Mélanges d'archéologie et d'histoire*, xlviii, 1931, pp. 268 ff.
99. Cartari, op. cit., Pl. xxviii. The original passage in Italian is as follows: 'Scrive un Padre del fin del 1553, di Goa, d'hever offeruato [asservato tr.] un Pagode de quei paesi, nel quale si vedeva una statua con tre capi, tre gamba, tre mani, & che si chiamava il Pagode dell' Elefante; & del 1560 il Padre Ludovico Fores racconta, che un Idolo nel paese di Goa, detto per nome Ganissone, ha pure il capo d'Elephante: & ne racconta il perche in questo modo.'
100. Seznec, 'Un Essai de mythologie', p. 277.
101. Grey, E., *The Travels of Pietro della Valle in India* (from the 1664 English translation of G. Havers), II, London, 1892, pp. 339 ff. The fifty-four letters of della Valle were published as *Viaggi di Pietro della Valle* in 1657–63. The letters on India came out *c.* 1663.
102. Grey, op. cit. I, p. 72.
103. Ibid., pp. 73 ff. The passage seems to be a paraphrase of Macrobius' commentary on the *Dream of Scipio*, Book I, ch. ii (W. H. Stahl, Macrobius, *Commentary on the Dream of Scipio*, New York, 1952, pp. 86 ff.).
104. This important problem, which may be expressed as the relationship between image and symbol in Western art, was first discussed by Professor Gombrich in 'Icones Symbolicae', *JWCI*, XI, 1948, pp. 166 ff. Recently in *Symbolic Images*, London, 1972, he considerably expanded his original theme. I have tried to summarize his main ideas on symbolism here. See particularly his chapter 'Icones Symbolicae, Philosophies of Symbolism and their Bearing on Art', pp. 123 ff., especially sects. II, 'The Didactic Tradition' and III 'Neoplatonism' (pp. 130 ff.).
105. Ibid., pp. 150 ff. Ezekiel 1: 5–10 (the same idea is seen in Revelation 4: 6–8).
106. Ibid., p. 151.
107. A most scholarly discussion of the rise of the allegorical interpretation of myths in antiquity and its influence on the Christian Fathers is to be found in Pépin, J., *Mythe et allégorie*, Paris, 1958. His chapter on early reactions to Homer and Hesiod is particularly valuable (pp. 93 ff.). A popular account of the problem is given in Beardsley, M. C., *Aesthetics from Classical Greece to the Present*, London, 1966, p. 25. See also Seznec, *Pagan Gods*, pp. 248 ff.
108. Gombrich, op. cit., p. 149. See also Iversen, op. cit., pp. 64 ff.
109. Grey, op. cit. I, pp. vii ff.
110. Ibid. I, pp. 74 and II, p. 217. On eighteenth-century syncretists see *infra*, ch ii, p. 73.
111. The importance of the nude in Western art is far too well known for me to discuss in detail here. Not only was man the centre of the Greek world, but the greatest attention was paid to the human figure in art as equally it served as the unit of measurement for architecture. Also various parts of architecture were likened to various limbs of the human body. There is no study of the psychological implications of the aesthetic reactions to the representations of the human figure. As human beings we are too involved to take a detached and objective view of the nude. One of the interesting points to remember is that very often in most cultures animals have been represented with a fair degree of fidelity, whereas there has always been the tendency to stylize the male or female nude. In the introduction to *The Nude* (London, 1956), Kenneth Clark raises some very interesting questions on these problems.

112. See *infra*, p. 42.
113. See *infra*, p. 37.
114. Yule, *Cathey and Way Thither*, II, p. 142.
115. *Livre des merveilles*, fol. 103.
116. Major, R. H., *India in the Fifteenth Century*, London, 1857, p. 27. Conti's account was put out by Poggio Bracciolini in his *Historia de Varietate Fortunae*, Lib IV.
117. Ramusio, G. B., *Navigationi e viaggi*, I, 1550, Lettera di Andrea Corsali Fiorentino, scritta in Cochin (6 Jan. 1515), fol. 192v. The island of Divar is near Goa and was a well-known place of pilgrimage in the sixteenth century. The destruction of its temples and general persecution of the Hindus are recorded by the Jesuit historian, Du Jarric (op. cit. I, pp. 341, 349). See also Lach, *Asia*, I, bk. I, Chicago, 1965, pp. 440 ff., for a contemporary account of Divar.
118. Thévet, A., *La Cosmographie universelle*, I, Paris, 1575, p. 381 f.
119. Maffei, J. P., *Historiarum Indicarum Libri XVI*, Florence, 1588, p. 259a.
120. Ibid.
121. Lach, op. cit. I, bk. I, p. 449.
122. Du Jarric, op. cit. I, p. 44.
123. Markham, Sir C., *Colloquies on the Simples and Drugs of India*, London, 1913, pp. 444 ff. Translation of Garcia da Orta's *Coloquios dos simples e drogas . . . da India*, Goa, 1563.
124. Fletcher, W. K., 'Couto's Decade VII—Book III—Chapter X' in *The Journal of the Bombay Branch of the Royal Asiatic Society*, I, July 1841—July 1844, pp. 44 ff. Translation of the parts of Couto's *Da Asia* which describe Western Indian cave temples.
125. Markham, loc. cit.
126. Ibid., p. 443. Markham thinks Orta may have been to Mandapeswar as well, which may be identified with Maljaz; see ibid., p. 144.
127. Joao de Castro arrived in India in 1538, four years after Orta's visit to the caves in 1534. Castro was in Goa as viceroy between 1545–48. His biography is to be found in Sanceau, E., *Knight of the Renaissance*, London, 1949.
128. See Appendix 2, p. 326, for the remark on Apelles and other details, where a full translation of Castro's description of Elephanta and Salsette is given.
129. Ibid., p. 327.
130. Ibid., p. 327.
131. See *supra*, pp. 27 ff.
132. Thévet, op. cit. I, p. 383 f.
133. Pinto, O., *Viaggi di C. Federici e G. Balbi alle Indie Orientali*, Rome, 1962, p. 136. Gasparo Balbi, *Viaggio dell' Indie—Orientali*, Venice, 1590. The legendary association of Alexander with Indian monuments might be based on Philostratus, II. 42.
134. Burnell, *Linschoten*, I, p. 291.
135. Couto was a pioneer Orientalist and to him goes the credit of identifying the story of Barlaam and Josaphat with the life of Buddha. This is discussed by Boxer with an excellent account of his life and work (see Boxer, C. R., *Three Historians of Portuguese Asia*, Macao, 1948, pp. 13 ff.).
136. Fletcher, op. cit., pp. 35 ff. Couto's *Asia*, Decada VII, was published in 1616; see Boxer, pp. 14 ff.
137. Fletcher, op. cit., pp. 34 ff.
138. Ibid., p. 35 ff.
139. Ibid., p. 40.
140. Ibid., p. 41.
141. Ibid.
142. Ibid., p. 42.
143. Ibid.
144. Ibid., p. 44.
145. Ibid., p. 43.
146. Ibid.
147. Ibid., p. 41.
148. *Le Voyageur curieux* (by Sr le B.), Paris, 1664, p. 106. The posthumous work put out by the noted publisher François Clovsier was supposedly written by someone who had made an around-the-world voyage.
149. Ovington, op. cit., p. 158.
150. Ibid., pp. 159 ff.
151. Ibid., p. 160.
152. Ibid.
153. Ibid., pp. 158 ff.
154. Fryer, op. cit., p. 72.

155. Ibid., p. 75.
156. Ibid., p. 73.
157. Sen, S. N., *Indian Travels of Thévenot and Careri*, New Delhi, 1949, p. 171 (sect. 2 containing Careri's work). Dr. G. F. Gemelli-Careri, *Giro del Mondo*, III, Naples, 1700.
158. Ibid., pp. 173 ff.
159. Ibid., p. 171.
160. Thévenot, op. cit., p. 74.
161. Ibid.
162. Ibid.
163. Ibid., p. 76.
164. Sewell, R. A., *A Forgotten Empire*, London, 1900, pp. 240 ff. The manuscript of Domingo Paes's description of Vijayanagar, written about 1520-2 (Port. no. 65, Bibl. Nat., Paris), was translated by Sewell.
165. Ibid., p. 254.
166. Ibid., p. 256.
167. Brown, P., *Indian Architecture*, I, Bombay, 1971, p. 94. Brown cites Paes as a witness to the splendour of Vijayanagar.
168. Ibid., p. 92.
169. Sewell, op. cit., pp. 286 ff.
170. Ibid., p. 286.
171. Foster, op. cit., p. 20.
172. Ibid., p. 205.
173. Ibid., p. 171.
174. Ibid., p. 151.
175. Ibid., p. 294. Nagarkot is the present Kangra region in Punjab.
176. Foster, Sir W., *The Embassy of Sir Thomas Roe to India*, London, 1926, p. 82.
177. Ibid., p. 323.
178. Ibid.
179. Wessels, C., *Early Jesuit Travellers in Central Asia (1603–1721)*, The Hague, 1924, p. 95.
180. Davies, op. cit., p. 23.
181. Lovell, op. cit., p. 14. The temple of Cintāman built in 1638 must have been a magnificent sight as it was noticed by both Mandelslo and Thévenot. It was destroyed in 1644–6 by the orders of Aurengzeb when he was the viceroy in the Deccan but was rebuilt by the merchant Santidas (see Sen, op. cit., p. 285).
182. Ibid., p. 41.
183. Brown, op. cit. I, pp. 129 ff.
184. Lovell, op. cit., p. 68.
185. Ibid., p. 71.
186. Ibid., p. 79.
187. Ibid.
188. Ibid., p. 112.
189. Tavernier, op. cit. I, p. 173.
190. Ibid., p. 178.
191. Ibid.
192. See Brown, op. cit. I, pp. 129 ff.
193. Churchill, op. cit. II, p. 249.
194. Temple, Sir R. C., *The Travels of Peter Mundy in Europe and Asia (1608–1667)*, II, Cambridge, 1914, p. 251.
195. Ibid., p. 262.
196. Bowrey, T., *A Geographical Account of Countries round the Bay of Bengal, 1669 to 1679*, ed. Sir R. C. Temple, Cambridge, 1905, p. 7.
197. Fryer, op. cit., p. 39.
198. Ibid., p. 54.
199. Ibid., p. 101.
200. Ibid., p. 135.
201. Ibid., p. 159.
202. Ibid., p. 161.
203. Lach, op. cit. II, bk. I, pp. 65 ff. Listed as *Album di disegni indiani*, they were first published by Schurhammer, G., 'Desenhos Orientais do Tempo de S. Fransisco Xavier', in *Gesammelte Studien*, II, Orientalia (Bibliotheca Instituti Historici S.I., vol. xxi), Rome, 1963, p. 111–18. The pictures are not accompanied by any information and remain tantalizingly anonymous. Schurhammer believes the author to be Portuguese but this is not obvious from the style which contains European elements but is not necessarily European. The album (Plate 25 of Lach) depicts a pagode that reminds one

of European churches, possibly Northern European. The album also contains an early picture of the gods, Śiva, Viṣṇu and Brahmā.

204. Rudolf Wittkower's work on Renaissance architecture answers, I think, some of the questions much better than I am able to do here (see Wittkower, R., *Architectural Principles in the Age of Humanism*, London, 1971, pp. 1 ff. and Appendix II, pp. 158 ff.).

205. The rise of anthropological interest in the Renaissance and its antecedents as far back as Herodotus are studied by Hodgen (see op. cit., pp. 20 ff.).

206. Watreman, W., *The Fardle of Facions*, London, 1555, ch. 6, iii. English translation of Boemus, J., *Omnium Gentium Mores, Leges, Ritus . . .*, Augustae Vindelicorum, 1520.

207. Hodgen, op. cit., p. 283.

208. It would be tedious to mention all the notices of these practices, but it may be noted here that virtually all the travellers in question describe these practices. Bernier even attempted to prevent a *satī*, from taking place.

209. In this period, the great reputation among the learned of the wisdom of the Brahmans and the tradition that they were the ancient teachers of Plato and Pythagoras had their origins in antiquity. Megasthenes was the first author to speak of the wisdom and exemplary morality of the Brahmans (McCrindle, J. W., *Ancient India as described by Megasthenes and Arrian*, Calcutta, 1960, pp. 120 ff.). He was followed by Philostratus among others. In his life of the Pythagorean teacher Apollonius of Tyana, Philostratus made an unfavourable comparison between the materialism of the contemporary Athenians and the ideals of Plato and Pythagoras. According to him, both Plato and Pythagoras believed in the transcendental nature of the soul. Moreover, the latter also advocated vegetarianism and he was anticipated in these ideas by the Brahmans of India, noted for their originality and wisdom (Philostratus, *Life of Apollonius of Tyana*, III, 16 and VI, 10, 11). See also *infra*, ch. II, note 76.

210. Ross, D. J. A., *Alexander Historiatus* (Warburg Institute Surveys, I), London, 1963, p. 30.

211. The discussion of the part the Brahman legends played in the rise of ideas relating to to primitivism in the Middle Ages is to be found in Boas, G., *Essays on Primitivism and Related Ideas in the Middle Ages*, Baltimore, Md., 1948, pp. 1–147.

212. Ross, A., *Pansebia*, London, 1653, p. 56.

213. Yule, H., *The Wonders of the East*, London, 1863, p. 22. Translation of Friar Jordanus's *Mirabilia Descripta* (*c.* 1330) which was first published in Latin in Paris in 1839.

214. Dames, M. L., *The Book of Duarte Barbosa*, I, London, 1918, p. 111. First published in Ramusio's *Navigationi e viaggi*, Venice, 1563.

215. Foster, *Embassy of Roe*, p. 271.

216. Grey, *Della Valle*, I, p. 76.

217. Herbert, op. cit., p. 36.

218. Moreland, W. H., *Relations of Golconda in the Early Seventeenth Century*, London, 1931, p. 15 (Methwold), p. 57 (Schorer).

219. Churchill, *Nieuhoff*, p. 270.

220. Bowrey, op. cit., pp. 32, 205.

221. Yule, *Marco Polo*, II, p. 341.

222. Yule, *The Wonders of the East*, p. 25.

223. Yule, *Cathey*, II, p. 137.

224. Foster, *Early Travels*, p. 14.

225. Foster, *Embassy of Roe*, p. 275.

226. Grey, op. cit. II, p. 237.

227. Moreland, op. cit., pp. 13 ff.

228. Philpotts, Dame B., *The Life of the Icelander Jón Ólafsson*, London, 1932, pp. 114 and 120 ff. Ólafsson finished his work in 1661.

229. See *infra*, pp. 57 ff. and note 277.

230. Lord, H., *A Display of Two Forraigne Sects in the East Indies*, London, 1630, p. A3.

231. Ibid., pp. 45 ff. and *passim*. On Pignoria see *supra*, p. 28.

232. See ibid., ch. 1.

233. Manuel, op. cit., p. 6.

234. Hodgen, op. cit., p. 167. *Geographia Generalis* by Varenius appeared in 1650.

235. Willson, A. L., *A Mythical Image: The Ideal of India in German Romanticism*, Durham, N. C., 1964, pp. 8–13.

236. Lach, op. cit. I, bk. I, pp. 439 ff., discusses the limitations from which early Jesuit reports suffer.

237. La Grue, T., *La Porte ouverte, pour parvenir à la conoissance du paganisme caché*, Amsterdam, 1670, unpaginated introduction. This is the French edition of Rogerius.

238. Gombrich, *Icones*, p. 149; Iversen, p. 61.

239. La Grue, loc. cit.
240. Caland, W., quoted in Willson, op. cit., p. 9.
241. La Grue, op. cit., pp. 291 ff.
242. Ibid., introduction. Not only Rogerius but all the missionaries down to Ziegenbalg offered their readers south Indian practices and religious traditions. The only exception was Boullaye-le-Gouz (see *infra*, p. 55). It was probably because, unlike the north which was under firm control of the Mughals, the missionaries had much more free-dom to proselytize or study local manners and beliefs. To say a few words about the Purāṇas: much more than earlier Vedic literature, most of these texts written from the viewpoint of the two influential sects, Śaiva and Vaiṣṇava, reflect the day-to-day religious beliefs and observances by the Hindus. More important still, the vast mytho-logical storehouse contained in these Purāṇas has provided the basic iconographic material to the artist since the Gupta period.
243. See ibid. Part I (pp. 1 ff.) of the work is devoted to the actual practice and customs, social habits, etc., and the second (pp. 139 ff.) to philosophical principles. There are certain parallels between the legend of the flood in the Bible and the idea of the incarnation in Christianity and the Vaiṣṇava doctrine of the incarnations of Viṣṇu, the personal god of the Vaiṣṇava sect who reincarnates himself many times in order to save mankind. The story of the fish incarnation of Viṣṇu has similarities with the episode of the deluge in the Old Testament. See Daniélou, A., *Hindu Polytheism*, London, 1964, p. 166, for an account of Viṣṇu's incarnations or *avatāras*. Daniélou cites Louis Renou that both Biblical and Hindu legends of the flood are possibly based on an old Babylonian legend. An account of the three gods, Brahmā, Viṣṇu, and Śiva in early European literature is to be found in Schierlitz, E. *Die Bildlichen Darstellungen der Indischen Göttertrinität*, Hanover, 1927.
244. Ibid., p. 216.
245. Ibid., p. 198.
246. Ibid., p. 204.
247. Ibid., p. 198.
248. Ibid., p. 221.
249. Ibid., p. 243.
250. Ibid., pp. 204 ff.
251. See *supra*, p. 38.
252. La Grue, op. cit., pp. 205 ff.
253. Ibid., p. 160.
254. Ibid., pp. 185 ff.
255. Ibid., p. 196.
256. Ibid., pp. 245 ff.
257. Ibid., pp. 204 ff.
258. Ibid., p. 247.
259. Boullaye-le-Gouz, F., Sieur de la, *Les Voyages et observations de Sieur de la Boullaye-le-Gouz*, Paris, 1653, p. 123.
260. Ibid., pp. 142 ff.
261. Ibid., p. 181.
262. Ibid., p. 163.
263. Ibid., p. 169.
264. Tavernier, op. cit., I, pp. 96 ff.
265. Iversen, op. cit., pp. 89 ff.
266. Kircher, A., *China Monumentis qua Sacris qua Profanis . . . Illustrata*, Amsterdam, 1667, unpaginated preface.
167. Ibid., p. 129.
268. See *supra*, p. 28.
269. See *infra*, ch. II, p. 82.
270. Kircher, op. cit., pp. 132 ff., 151 ff., and *passim*. Siequia or Xaca is none other than Śākyamuni Buddha.
271. Ibid., p. 78.
272. Ibid., p. 148.
273. Ibid. On Kircher's universal system see Iversen, op. cit., pp. 89 ff.
274. Kircher, op. cit., pp. 156 ff.
275. Ibid., pp. 154 ff.
276. Ibid., p. 162.
277. In 1967 Professor P. H. Pott (Rijksmuseum Voor Volkenkunde, Leiden) kindly pro-vided me with the following information which is supplemented here with information from his *Naar Wijder Horizon* (S'-Gravenhage, 1962, pp. 56 ff.): In 1658 Philip Angel,

297

a Dutch artist, translated a Portuguese MS. on Hindu mythology into Dutch as *Devex Avataars*. He illustrated it with Indian miniatures and presented it to Batavia's Director-General. The work arrived in Europe in 1660s. It was used extensively without acknowledgement by Baldaeus, sometime tutor to the Director-General's son, and subsequently by Dapper (*infra*, note 296) and Kircher (*supra*, note 266). Angel's Portuguese text was used by Faria y Sousa (*infra*, note 278). Although Professor Pott is right in substance about Baldaeus' use of *Devex Avataars* the story is more complicated. Jarl Charpentier showed that for Viṣṇu's incarnation Baldaeus used Fenicio's Portuguese text, also used by Faria y Sousa (*The Livro da seita dos Indios orientais*, Upsala, 1933; 'Preliminary Report on the Livro . . .', *BSOS*, II, 1921–3, pp. 731 ff.). He discovered another Dutch MS. *Deex Avataers*, which differed from Baldaeus only in some respects ('The British Museum MS. Sloane 3290, The Common Source of Baldaeus and Dapper', *BSOS*, III, 1923, pp. 413 ff.). After comparing the two authors and consulting the three texts (made possible through kindness of Père Pillot, Librarian, Abbey Postel-Retie, Belgium and generous research grant from the University of Sussex) my conclusion is: Baldaeus used Angel's miniatures but turned to the Portuguese Fenicio for his description of Viṣṇu's incarnations. The differences between Angel's and Baldaeus' texts include spellings of names of Indian deities. For instance, Kṛṣṇa is spelt Kissna in Angel whereas both the author of *Deex Avataers* and Baldaeus retain the Portuguese Krexno. Presumably different versions of Hindu mythology were circulating in translation for missionary use in India in this period whose ultimate source may have been Fenicio. Baldaeus had access to several of them. Finally, while Dapper used Angel's illustrations, Kircher's illustrations were based on Heinrich Roth.

278. Faria y Sousa, M., *The Portuguese Asia*, II, London, 1695, p. 375 (tr. J. Stevens).
279. Churchill, A. and J., *A Collection of Voyages and Travels*, III, London, 1703, pp. 563 ff. Translation of Baldaeus, P., *Beschreibung der ostindischen Kusten Malabar und Coromandel . . .*, Amsterdam, 1672.
280. Ibid., p. 563.
281. Ibid., pp. 663 ff. on Malabar language; p. 893 on metempsychosis; pp. 830 ff. on mythology; part I, ch. I, on God and the creation; chs. II–VII on Śiva and his family; part II, chs. I–XI, pp. 843 ff. on the ten incarnations of Viṣṇu.
282. Ibid., p. 844.
283. Ibid., p. 893.
284. See Dr. Germann's preface to the German version and Ziebenbalg's preface in Metzger, G. J., *Genealogy of the South Indian Gods*, Madras, 1869. This is a translation of W. Germann's 1867 edition of *Genealogie der malabarischen Gotter*, written by B. Ziegenbalg at Tranquebar in south India in 1713.
285. Lach, op. cit. II, bk. I, p. 65 and pl. 24, and *supra*, note 203.
286. Lord, op. cit., title-page.
287. Hind, A. M., *Engraving in England in the Sixteenth and Seventeenth Centuries*, III, Cambridge, 1952–64, p. 170, No. 200. See *infra*, p. 72 and note 302.
288. Rogerius, *Open Deure*, title-page. In La Grue's French edition the details on the title-page were enlarged and printed separately in the book.
289. Boullaye-le-Gouz, op. cit., p. 123 ff.
290. Kircher, op. cit., p. 155 and plate facing p. 154.
291. Ibid., pp. 145 and 131. On p. 72 there are two further pictures of Menipe, one recognizably a Buddha.
292. Ibid., pp. 157–62.
293. Churchill, op. cit. III, p. 564.
294. Ibid., p. 833 (Īśvara) and p. 836 (Gaṇeśa).
295. Ibid., pp. 844, 847, 851, 853, 856, 861, 868, 888, and 890.
296. Dapper, O., *Asia*, Amsterdam, 1672. Hindu gods: p. 84, Brahmā (Kircher), p. 149, Viṣṇu (Rogerius), pp. 86, 88, 90, 96, 134, and 136, Ten Incarnations of Viṣṇu (Baldaeus). Ogilby, J., *Asia*, London, 1673, See pp. 136, 138, 140, 142, 145, and 146 for Baldaeus prints and p. 147 for Rogerius Viṣṇu.
297. Picart, B., *Cérémonies et coutumes religieuses des tous les peuples du monde . . .*, Amsterdam, 1723.
298. Lightbown, R. W., 'Oriental Art and the Orient in Late Renaissance and Baroque Italy, *JWCI*, XXXII, 1969, pp. 265 ff.
299. Hind, op. cit. II, 1955, p. 179, no. 35, and pl. 98(b).
300. Ibid., pp. 387 ff., no. 58, pl. 244(a). One of the Mughal paintings used here was the one given to Sir Thomas Roe by the emperor Jahangir himself which Terry reproduced in his book to show his readers what the great Mughal looked like. This was published by Purchas along with Terry's diary in 1625 (see Foster, *The Embassy of Sir Thomas Roe to India*, London, 1926, p. lxviii); see also *supra*, p. 21.

301. Laet, J. de, *De Imperio Magni Mogolis sive India Vera*, Batavia, 1631, title-page.
302. Hind, op. cit. III, p. 161, no. 183, pl. 84(b).
303. Kircher, op. cit., plate facing p. 104.
304. For the full story of this album, which now belongs to the Rijksmuseum, Amsterdam, see Goetz, H., *The Indian and Persian Miniature Paintings in the Rijksprentenkabinet*, Amsterdam, 1958, p. 31.
305. Valentyn, F., *Oud en Nieuw Oost-Indien . . .*, Amsterdam, 1724; for the illustrations see vol. IV, part II. Valentyn reproduced Rogerius's and Baldaeus's accounts of the Malabar gods in volume V.

CHAPTER II

1. While it is true that pagan practices and pagan gods received widespread and consistent criticisms from the early Church Fathers, one cannot accuse them of ignoring the subject of improper practices among the ancient pagans. These practices provided the Fathers with valuable polemical armoury to fight the evils of paganism. Therefore not only were the sensuous practices, which the Fathers disapproved of, described in graphic detail but very often the testimonies of early Christian writers are the only surviving literary evidence for mystery cults like the Eleusinian. The Fathers had also used allegorical methods for interpreting pagan gods. In this they were only following the footsteps of pagan classical philosophers. Already in the period of pre-Socratic philosophers allegorical interpretations of the grosser aspects of Homeric gods had become well established. For the best study of classical and Christian allegorical traditions see Pépin, J., op. cit. (ch. I, note 106), pp. 93 ff. (Greek reactions), and pp. 265 ff. (Church Fathers).
2. Major, op. cit. (ch. I, note 115), pp. 16 ff. (part devoted to Nikitin).
3. Mandelslo, op. cit., p. 23.
4. Grey, op. cit. II, pp. 235 ff.
5. Picart, B., *The Religious Ceremonies and Customs of the Several Nations of the Known World*, III, London, 1731, pp. 426 ff. English translation of Picart's *Cérémonies et coutumes* (1723), see note 295 of ch. I.
6. Moreland, op. cit. (ch. I, note 217), p. 71.
7. Bowrey, op. cit. (ch. I, note 195), p. 17.
8. Lovell, op. cit. III (ch. I, note 81), p. 105.
9. Hamilton, A., *A New Account of Voyages*, London, 1727, p. 379.
10. Fletcher, op. cit. (ch. I, note 120), p. 42.
11. Picart, op. cit. III, p. 427. This is implied in Picart.
12. Burnell, J., *Bombay in the Days of Queen Anne*, London, 1933, p. 44; introduction by Sheppard, S. T.
13. Temple, op. cit. (ch. I, note 193), II, p. 123. The remark is especially important in view of Mundy's statement that he was allowed inside the great Śiva temple in Benaras.
14. What is natural is never disgraceful: Latin form of Euripides, Frag. 863 (Stevenson's Book of Proverbs, Maxims and Familiar Phrases, B. Stevenson, London, 1949, p. 1661).
15. Barb, A. A., 'Diva Matrix', *JWCI*, XVI, 1953, pp. 195 ff.
16. Bonner, C., *Studies in Magical Amulets* (University of Michigan Studies, Humanistic Ser. vol. XLIX), Ann Arbor, Mich., 1950, pp. 80 ff.
17. Barb, op. cit., pp. 194–6.
18. For an excellent discussion of the Barberini circle and their interests, see Dempsey, C., 'The Classical Perception of Nature in Poussin's Earlier Works', *JWCI*, XXIX, 1966, pp. 220 ff., and *supra* ch. I, p. 28.
19. Casalius, J. B., *Sacrae Prophanaeque Religionis Vetustiora Monumenta, hoc est symbolicus et hieroglyphicus Aegyptiorum cultus*, Rome, 1644–6.
20. Agostini, L., *Le gemme antiche figurate*, Rome, 1657. My illustration is taken from part II of the 1686 edition.
21. Manuel, op. cit., p. 259. The process of de-allegorization of ancient myths is described in detail in this important work, but see especially the introduction.
22. Ibid., pp. 17 ff.
23. See *supra*, ch. I, p. 57. On syncretism see *infra*, p. 82.
24. See *infra*, p. 82.
25. La Grue, op. cit. (ch. I, note 236), p. 157 and note. Here Augustine's *Civitate Dei*, VII. 21, is quoted.
26. Churchill, op. cit. (ch. I, note 83), III, p. 831.
27. Ibid.

28. Picart, op. cit. III, p. 426.

29. Picart, IV (pt. 2), p. 138, top illustration. On Gaṇeśa see Getty, A., *Gaṇeśa*, Oxford, 1936, pp. 18, 21 ff.

30. Toland, J., *The Agreement of the Customs of East Indians, with those of the Jews and other Ancient People*, London, 1705, pp. 36 ff. English translation of *Conformité des coutumes des indiens orientaux avec celles des juifs*, Brussels, 1704. On the notion of India as a Jewish colony see Slotkin, J. S., *Readings in Early Anthropology*, London, 1965, p. 228.

31. La Croze, M. V. de, *Histoire du christianisme des Indes*, The Hague, 1724, pp. 430 ff. Herodotus, II, 42, identifies Osiris as Dionysus.

32. For a modern study of Plutarch's treatise, *De Iside et Osiride* (*Moralia*, 351C–384C), see Parmentier, L., *Recherches sur la Traité d'Isis et d'Osiris de Plutarque* (Académie Royale de Belgique Mémoires, 2e ser., tom. XI), Brussels, 1913, esp. pp. 11–14.

33. La Croze, op. cit., pp. 430 ff. Pignoria's treatise *Mensa Isaica* was published in 1605 (see Iversen, op. cit. (ch. I, note 95), p. 85, and also *supra*, p. 28, on Pignoria). Multiple eyes of Osiris are mentioned by Plutarch (*Moralia*, 355).

34. La Croze, loc. cit. See Herodotus, II. 49; he had also suggested that all the Greek names of the gods were derived from Egypt (II. 50).

35. Jablonski, P. E., *Pantheon Aegyptiorum*, Frankfurt, 1750, pp. 285 ff.; see also Manuel, op. cit., p. 259.

36. Herculaneum first came to public notice in 1709 but regular excavations began only in 1738 and continued up to 1765 (*Encyclopaedia Britannica*, XI, 1970, p. 414). In an article Seznec points out that the world of learning, especially in France, was left in the dark about Herculaneum until 1757 by the deliberate policy of the Neapolitan government. Seznec, J., 'Herculaneum and Pompeii in French Literature of the Eighteenth Century', *Archaeology*, II, Sept. 1949, p. 151.

37. Manuel, op. cit., p. 262. Sylvain Maréchal's work on Herculaneum gave wide publicity to the erotic objects found on that site (see *infra*, p. 84). The phallic gods are exceptional; even as late as 1719 Bernard de Montfaucon's *L'Antiquité expliquée*, II, part II, Paris, 1719, has only a few phallic Abraxas figures, pp. 353–79.

38. See *supra*, ch I, p. 55.

39. Examples of erotic vase paintings are to be found in Pfuhl, E., *Malerei und Zeichnung der Griechen*, Munich, 1923, and in Licht, H. (Brandt, P.), *Sittengeschichte Griechenlands*, Dresden, Zurich, 1925–8. Small erotic objects were found in great quantities in Herculaneum, which are illustrated in Roux Ainé, H., *Herculanium et Pompéi*, Paris, 1840. References to large ithyphallic sculptures, relating mostly to phallic gods, such as Hermes and Priapus, are diffused throughout classical literature; many of them are represented in ancient paintings.

40. Freese, J. H., *Sexual Life in Ancient Greece*, London, 1932 (1931), pp. 3 and 180 ff. English translation of Licht's *Sittengeschichte* (see *supra*, note 38).

41. Ibid., p. 89.

42. Gombrich, E. H., 'The Use of Art for the Study of Symbols', *American Psychologist*, XX, No. 1, Jan. 1965, pp. 38, 44, 45, and *passim*.

43. Hildburgh, W. L., 'Images of the Human Hand as Amulets in Spain', *JWCI*, XVIII, 1955, p. 80.

44. See *supra*, note 1 (ch. II), and Pépin, op. cit., part 1, chs. II and III (pp. 93 ff.).

45. 'Syncretism', a key word for this chapter, is defined in *OED* as 'attempted union or reconciliation of diverse or opposite tenets or practices, esp. in philosophy of religion'. Here I have summarized the syncretistic tendencies in late antique religion from its authoritative account in Guthrie, W. K. C., *Orpheus and Greek Religion*, London, 1935, pp. 100–251. For a further study of Christian metamorphosis of Orpheus, see Dronke, P., 'The Return of Eurydice', *Classica et Mediaevalia*, XXIII, 1962, pp. 206 ff. The earliest evidence of the connection between Orpheus and Christianity is, according to Dronke, late second century A.D.

46. Nilsson, M. P., *The Dionysiac Mysteries of the Hellenistic and Roman Age*, London, 1957, pp. 133–9, and Guthrie, op. cit., pp. 83, 107, and 119 ff.; see also *infra*, p. 90.

47. Guthrie, op. cit., pp. 255–6.

48. See *infra*, ch. III, p. 148.

49. See Guthrie and Nilsson, loc. cit.

50. Schwanbeck, E. A., *De Megasthene Rerum Indicarum Scriptore*, Bonn, 1845, pp. 43 ff.

51. McCrindle, J. W., *Ancient India as described by Megasthenes and Arrian*, Calcutta, 1960 (new ed.), pp. 35 ff. and 162 ff.

52. Toland, op. cit., pp. iii ff.

53. Maréchal, S., *Antiquités d'Herculanum*, Paris, 1780–1803. On Maréchal's pronounced anticlericalism, see *La Grande Encyclopédie*, XXIII, Paris, 1886–1902, p. 50. He colla-

borated with Lalande on *Dictionnaire des athées anciens et modernes* (1800). He had also parodied the lives of saints in *Almanack des honnêtes gens* (1788).

54. See Maréchal's *Voyages de Pythagore en Egypte, dans la Chaldée*, Paris, 1799, III, pp. 145 ff.
55. Cust, L., *History of the Society of Dilettanti*, London, 1898, pp. 1 and 117 ff.
56. See *infra*, p. 91 and ch. III, p. 126. Townley's Indian pieces came to light very recently. See *infra*, note 59.
57. Cust, op. cit., pp. 121 ff.
58. Pevsner, N., 'Richard Payne Knight', *Art Bulletin*, XXXI, No. 4, Dec. 1949, pp. 293 and 296.
59. Cust, op. cit., p. 118; Pevsner, op. cit., p. 293. The German translation is called *Tagebuch einer Reise nach Sicilien*. It survives only in Goethe's translation. On picturesque see *infra*, ch. III, pp. 122 ff.
60. Pevsner, op. cit., pp. 296-7. Like Townley, Knight was an important collector of Indian sculptures but these have only recently come to light with the reorganization of the British Museum. I am indebted to Dr. Wladimir Zwalf of the Dept. of Oriental Antiquities for drawing my attention to the pieces. Space does not permit further discussion of Knight's Indian collection.
61. Ibid., p. 297, and Cust, p. 124; Mathias, T. J., *The Pursuits of Literature*, London, 1794, pp. 67 ff. Professor Pevsner is not quite correct that the British Museum does not possess a copy of Knight's *Priapus*. The 1786 copy is in the restricted category and is not generally available to the public.
62. Knight, R. P., *Two Essays on the Worship of Priapus*, London, 1865, p. vi.
63. Pevsner, op. cit., p. 297.
64. Manuel, op. cit., p. 263.
65. Pevsner, op. cit., p. 298.
66. *La Grande Encyclopédie*, XV, p. 97.
67. Manuel, op. cit., pp. 264 ff.
68. Dupuis, C., *Origine de tous les cultes ou la religion universelle*, III, Paris, 1795, p. 868.
69. Maréchal, *Antiquités*, III, pp. 108 ff.; see *infra*, ch. III, p. 108.
70. Maréchal, op. cit. VII, pp. 88 ff.
71. Hancarville, P. F. de, *Recherches sur l'origine, l'esprit, et les progrès des arts de la Grèce*, I, London, 1785, pp. 37 ff., 76, and *passim*. On the miniature Hindu temple in Townley collection, see *infra*, p. 101.
72. Knight, R. P., *A Discourse on the Worship of Priapus*, 1786, p. 49.
73. Dupuis, op. cit. IV, pp. 568 ff. The Cabirian rites connected with the great Mother goddess at Samothrace were probably the most archaic of the Greek mysteries; see Kerenye, C., 'The Mysteries of the Kabeiroi', in *Mysteries*, London, Bollingen Ser. XXXII, 1955, pp. 44 ff.
74. Dupuis, op. cit. I, pp. 381 ff.
75. Manuel, op. cit., pp. 266 ff. See index in Dupuis, vol. VII, for references to solar and planetary symbolism. Gébelin, A. Court de, *Monde primitif*, Paris, 1776.
76. A recent study of Macrobius' *Saturnalia* is to be found in the annotated edition introduced by Percival Vaughan Davies (London, 1969), pp. 14 ff. But from a much earlier period, as Nilsson, op. cit., p. 44, shows, Dionysus has been intimately connected with the sun.
77. Maréchal, op. cit. I, p. 131. The citation is from Philostratus' *Life of Apollonius*, III. 48, but there is another reference in II. 22. Philostratus attributes to the Pythagorean philosopher several very remarkable and detailed descriptions of Indian gods. Apollonius may well have actually seen these gods, for a modern authority strongly defends the historicity of his Indian voyage as described in Philostratus (Charpentier, J., 'The Indian Travels of Apollonius of Tyana', *Skrifter utgivna av K. Humanistiska Vetenskaps —Samfundet i Uppsala*, Upsala, 1934, pp. 15 ff.); see also *supra*, ch. I, note 209.
78. Dupuis, op. cit. I, p. 87.
79. Knight, op. cit., p. 68.
80. Hancarville, op. cit. I, p. 86.
81. Dupuis, op. cit. I, p. 88. The moon god figures in pl. 19 in MS. Od. 38, *Dieux des Indiens peints a Gouache par les missionaires* (Dept. des Estampes, Bibl. Nat. Paris). The undated volume is said to have been acquired before the 18th century, which is also suggested by the archaic spellings in the text. The second well-known set belonged to Charles Adrien Picard. Entitled *Recueil des dessins et enlumineurs des dieux de l'Inde* (Od. 40–40a), they were acquired by him from the collection of a Brahman in Madras in 1765 and deposited in the Library in 1767. Even better known was the volume called *Dieux des Indiens par Sami (Svāmī)*, which the Library acquired in 1784 (Od. 46). Sami's work was used by Sonnerat (*infra*, ch. III, note 41) and was reproduced by Langlès (*infra*,

ch. III, note 255). For the fourth set, see *infra*, ch. III, note 9. It is striking that all the information about Hinduism in Paris was derived from the south, a reflection, no doubt, of French political influence there.

82. Dupuis, op. cit. I, p. 158.
83. Ibid., p. 397. On Le Gentil's symbolic deity, see *infra*, ch. III, p. 113.
84. Peter Dronke kindly drew my attention to the definitive article on Zagreus in Pauly-Wissowa, *Real-Encyclopädia* (2. Reihe, Neunter Band, 1967, cols. 2221–83, by Wolfgang Fauth). Zagreus, the great hunter, originally a pre-Hellenic god, with chthonic features and relations to the realm of the dead, was assimilated into the mysteries of Thracian Dionysus, Dionysus Bacchus, and of Zeus Idaius in Crete in the early historic period. The original omophagy of the great hunter was replaced by a bull sacrifice, in the Cretan mysteries as known to Euripides. The most striking features of this chthonic god are his epithet 'lord of the animals', his association with orgies, and his position as the leader of the host of the dead, characteristics that belong to Śiva as well, but there is no evidence to connect them.
85. Hancarville, op. cit. I, p. 71.
86. Ibid., p. 47.
87. Ibid., p. 97. The information about Dharmadeva was derived from Sonnerat, op. cit. II, p. 110 (ch. III, note 42).
88. Ibid., pp. 72 ff.
89. Dupuis, op. cit. III, pp. 1–2, 342; V, p. 198.
90. Knight, op. cit., p. 34.
91. Ibid., pp. 33 ff.
92. Ibid., pp. 47 ff. The particular erotic group, said to have been brought over from Elephanta, arrived in England on the Cumberland along with several other pieces from the same temple. There is no definite evidence, however, that these pieces actually belonged to Elephanta. The Society of Antiquaries acquired a piece from the Cumberland collection (see *infra*, ch. III, p. 143). Another piece belonged to Sir Charles Forbes (*infra*, ch. III, p. 162). The erotic group, acquired by Townley and discussed here by Knight, later came to the British Museum as part of Townley collection. I was able to trace it with the kind assistance of Dr. Zwalf. Knight mentioned (p. 80) that the fragment belonged to a relief, 130 ft. long and 110 ft. wide and decorated with columns and sculptures.
93. Dupuis, op. cit. III, pp. 430 ff. Reference to Dupuis' sources for the three paintings mentioned by him, see *supra*, note 80. The goat held by Śiva and supposedly by Viṣṇu as well is none other than '*kalāvita* 'or the deer emblem associated with Śiva. Although there is one mistaken reference to Viṣṇu, Dupuis is really talking about Śiva here, confirmed by Śiva's names, Yogiśvara and Īśvara used by Dupuis. Among the paintings seen by Dupuis (Ods. 38, 40–40a and 46), there are a number of examples of Śiva holding the deer in his hand. Of the paintings mentioned by Dupuis the easiest to identify is 'Iogui Hisper' for the same title is given to pl. 20 of the missionary album (*supra*, note 80), which depicts Śiva with the crescent moon. The killing of the demon Tiperant by Śiva possibly refers to pl. 82 of the Sami album (Od. 46). The reference to the goat-deity at Ellora is derived from Anquetil (see *infra*, ch. III, p. 108).
94. Guthrie, op. cit., pp. 80 ff. and 153; Nilsson, op. cit., pp. 44 and 130; see also Pauli-Wissowa (*supra*, note 83), col. 2281. Myths relating to the cosmogonic egg are numerous and occur in most cultures. The egg stands for such diverse ideas as creation, renovation or periodic creation, and the four elements. In Dionysiac mysteries eggs were offered to the dead for their property of regeneration, as equally they were a prohibited food among the Orphics who wished to end the cycle of reincarnation. The literature is vast. Most useful is the account in Eliade, M., *Patterns in Comparative Religion*, London, 1971, pp. 413 ff. See also Turcan, R., 'L' Oeuf orphique et les quatre éléments', *Revue de l'histoire des religions*, CLX, 1961, pp. 11–23.
95. Nilsson, op. cit., p. 136.
96. Ibid., pp. 21 ff.
97. Ibid., pp. 66 ff. The reference is to the famous Villa of the Mysteries, outside Pompeii, near Porta Ercolanese.
98. Ibid., pp. 42 ff. Proclus quoted by Nilsson, p. 43.
99. Mylonas, G. E., *Eleusis*, Princeton, N. J., 1961, p. 259.
100. Ibid., p. 282.
101. Guthrie, op. cit., pp. 18 and 211 ff.; Nilsson, op. cit., p. 56.
102. To give some brief indications of the common mythological background: myths connected with Dionysus were common to both Dionysiac and Orphic cults. Guthrie (op. cit., p. 41) points out that Dionysus was the central god of Orphic religion, since

the religion reputedly founded by Orpheus was a species of the Bacchic, though a reformed version. The relation between Dionysus and the Eleusinian mysteries is a more complex problem. Admittedly, the main story at Eleusis concerned Demeter, the great mother, and her daughter, Persephone. Yet, one must not forget that Dionysus was the specific classical name for the widely worshipped 'dying god', known throughout the ancient West and Near East. While explaining the 'dying god' concept, Frankfort showed that antique gods such as Adonis, Osiris, and Dionysus, all of whom had similar functions, were originally concerned with the seasons' cycle. They later embodied philosophical ideas about men's concern for the afterlife. Eleusis too was connected with the cult of 'the dying god', although not specifically with Dionysus (Frankfort, H., 'The Dying God', *JWCI*, XXI, 1958, pp. 141 ff.). But apart from this there are indeed more specific links between Dionysus and Eleusis, although it is difficult to say how important he was in the cult. In one tradition, he is the son of the chthonian Zeus and Persephone, Demeter's daughter (Kerenyi, C., *The Gods of the Greeks*, London, 1951, p. 250). Moreover, Eubouleus, also mentioned in connection with Eleusis (Mylonas, op. cit., pp. 238 and 309), is generally identified as Dionysus Chthonius (Kerenyi, *The Gods of the Greeks*, p. 231). The pig, an animal sacred to Dionysus (Nilsson, op. cit., pp. 88 ff.), was sacrificed at Eleusis (Mylonas, op. cit., pp. 242 and 250). Finally, Orpheus, generally regarded as the founder of all mystery religions, is present at the Eleusinian mysteries (Guthrie, op. cit., pp. 17 ff.).

103. Guthrie, op. cit., pp. 148 ff.
104. Mylonas, op. cit., p. 282. A different interpretation is offered by Otto, who suggests that something more than an ear of corn was shown, perhaps a mysterious act which convinced the initiates of the presence of the deity (Otto, W. F., 'The Meaning of the Eleusinian Mysteries', in *Mysteries* (*supra*, note 72), pp. 24 ff.).
105. Hancarville, op. cit. I, pp. 79 ff.
106. Ibid., pp. 81 ff.
107. For an account of the Śiva figure at Elephanta, see Sastri, H. N., *A Guide to Elephanta*, Delhi, 1934, p. 27. See also *supra*, ch. I, p. 36.
108. See *infra*, ch. III, p. 110.
109. Hancarville, op. cit. I, pp. 106 ff., 118 ff., and note 205 (p. 119). On the question of Brahmā's age Hancarville followed the authority of Bailly, who had put forward a new interpretation of ancient chronology based on Newton's computation. In his *Histoire de l'astronomie ancienne* (Paris, 1775), Bailly had put forward a section on Indian chronology, later elaborated in his *Traité de l'astronomie indienne et orientale* (Paris, 1787), based on the available astronomical and Purāṇic evidence. The history of Indian astronomy, undertaken as a further contribution to ancient knowledge, was responsible for a new appreciation of the ancient history of Asia. See Smith, E. B., 'Jean-Sylvain Bailly, Astronomer, Mystic, Revolutionary', *Transactions of the American Philosophical Society*, XLIV, part IV, 1954, pp. 498 ff., and Marshall, P. J., *The British Discovery of Hinduism in the Eighteenth Century*, Cambridge, 1970, p. 32.
110. Knight, op. cit., pp. 74 ff.
111. Peter Dronke has brought together some of the earliest Greek testimonies on the 'cosmological' conception of love and also early Orphic conceptions of Phanes-Eros. (See Dronke, P., 'L'amor che move il sole e l'altre stelle', *Studi Medievali*, Ser. 3, VI. 1, 1965, pp. 391–6.
112. Guthrie, op. cit., pp. 114 and 128.
113. Mylonas, op. cit., pp. 283 ff.
114. Farnell, L. R., *The Cults of the Greek States*, III, Oxford, 1896, p. 197, cited by Mylonas, loc. cit.
115. Guthrie, op. cit., pp. 72, 156 ff., and 242.
116. Plato, *Phaedrus*, tr. R. Hackforth, London, 1952, introduction, pp. 10–98.
117. Ibid., pp. 92 ff.
118. See Dronke, 'Amor', p. 396. For a detailed study of Orphic theogony see Wili, W., 'The Orphic Mysteries and the Greek Spirit', *Mysteries*, pp. 64 ff.
119. Plato, *Symposium*, 204d; on the nature of Hermaphroditos, 212a.
120. Eliade, op. cit., pp. 418–21.
120. La Croze, op. cit., pp. 462 ff.
122. See *supra*, ch. I, pp. 30 ff.
123. Maréchal, op. cit. I, p. 56.
124. Ibid. VII, pp. 88 ff.
125. Hancarville, op. cit. I, pp. 75 ff.
126. Ibid., pp. 91 ff. and note 151. See Niebuhr, *infra*, ch. III, pp. 112 ff. The information about Rudra's bisexual character was derived from the MS. of one Broughton Rouse,

but the information does not seem to be correct as the earliest bisexual deity occurs in Ṛg Veda and not Yajur, and the deity is not Rudra (Ṛg V. x. 90).

127. Dupuis, op. cit. I, p. 412, and III, p. 868.
128. Dupuis, op. cit. IV, p. 568 ff. What presents a great problem with regard to these cults is that not only Dupuis but even modern scholars are dependent on the testimonies of the Fathers for information about them, especially Eleusis. Mylonas (op. cit., p. 224, and appendix, pp. 287 ff.) argues that none of the inner mysteries was ever revealed, that the invocation and *hieros gamos* of the sky and the earth was only part of the outer ceremonies, that Eleusis was not concerned with sexual rites, and that the Fathers had misrepresented Eleusis.
129. Dupuis, op. cit. I, p. 381, and IV. p. 602. Bardesanes's account of the Indian god is in both Porphyry and Stobaeus fragments. Dupuis probably derived his information from Mignot (*infra*, ch. IV, note 19). The Porphyry fragment is in Langlois, V., *Collection des historiens anciens et modernes de l'Arménie*, Paris, 1867, I, pp. 68–9. In J. W. McCrindle's *Ancient India as described in Classical Literature*, London, 1901, pp. 172 ff., there is a translation of the same passage taken from Stobaeus, *Physica*, I. 56 (Gaisford ed.). Bardesanes reports:

> They [the Indian ambassadors] told me further that there was a large natural cave in a very high mountain almost in the middle of the country, wherein there is to be seen a statue of ten, say, or twelve cubits high, standing up right with its hands folded crosswise—and the right half of its face was that of a man, and the left that of a woman; and in like manner the right hand and right foot, and in short the whole right side was male and the left female, so that the spectator was struck with wonder at the combination, as he saw how the two dissimilar sides coalesced in an indissoluble union in a single body. In this statue was engraved, it is said, on the right breast the sun, and on the left the moon, while on the two arms was artistically engraved a host of angels and whatever the world contains, that is to say, the sky and mountains and a sea, and a river and ocean, together with plants and animals —in fact everything . . . no man could tell what the material (of the image) was, for it was neither gold, nor silver, nor brass, nor stone, nor indeed any known substance, but that though not wood it most resembled a very hard wood, quite free from rot.

Coming from a fifth-century author the description is remarkable. It is striking literary evidence that the Śiva Ardhanārīśvara image existed in such an early period, especially in such advanced iconographic form, thus pushing back the age of the importance of the Śiva cult considerably. It also lends support to the view that early images being of wood later perished and only stone images have survived. This report of course would have been even more exciting if Bardesanes had actually seen the image and had described it from the viewpoint of a Westerner. But there is no doubt that we are in the presence of a remarkable, symbolic cult-image in the Indian tradition.

130. Knight, *Priapus*, pp. 14 ff.
131. Ibid.
132. Ibid., pp. 47 and 56. On the role of love in Orphism, see *supra*, note 110, and Guthrie, op. cit., p. 96.
133. Ibid., pp. 16–18 and 29. On the question that a god of light was at the source of the Orphic doctrine, see Wili, in *Mysteries*, pp. 69 ff.
134. Knight, R. P., *An Enquiry into the Symbolic Language of Ancient Art and Mythology*, London, 1818 (Society of Dilettanti reprint, 1835), pp. 1–6.
135. Knight, *Priapus*, p. 107.
136. Knight, *Symbolic Language*, p. 6. The source for the Hindu custom is the traveller Sonnerat.
137. Knight, *Priapus*, pp. 48–9.
138. Knight, *Symbolical Language*, p. 16. The same example was given in Hancarville (see *supra*, note 125).
139. Knight, *Priapus*, pp. 48–9.
140. Wilkins, C., *The Bhagvat-Geetā*, London, 1785, p. 23. Recent critical appraisal by Marshall, op. cit., pp. 192 and 5. Maréchal (*Pythagore*, III, p. 203) and Dupuis (op. cit. IV, note, p. 844) knew this great Vaiṣṇava work.
141. Knight, *Priapus*, p. 61.
142. Ibid., p. 48.
143. Manuel, op. cit., pp. 259 ff., suggests that these works had a definite pornographic purpose. Momigliano, A., 'Ancient History and the Antiquarian', *JWCI*, XIII, 1950, pp. 285–325, criticizes their scholarly limitations. It was A. Michaelis whose hostile

assessments of Hancarville's and Knight's works had influenced twentieth-century judgements. He called Hancarville's work 'a fantastic farrago of mystico-symbolical revelations and groundless hypotheses' and questioned Knight's taste in publishing *Priapus* (Michaelis, A., *Ancient Marbles in Great Britain*, Cambridge, 1882, pp. 99 and 121 ff.). Instead of judging them from a puritanical standpoint one must see them against the development of modern anthropology. The very originality and unconventionality of Knight were his undoing among contemporaries. He failed to appreciate the Elgin marbles and yet expressed sympathy for Indian art. His contribution to art criticism was not in the field of visual or aesthetic qualities but essentially in the field of meaning and iconography. It has recently been shown that he had stressed the 'associational' matters in art appreciation. For a reassessment of Knight's position and contribution see Lang, S., 'Richard Payne Knight and the Idea of Modernity', in *Concerning Architecture*, ed. Summerson, J., London, 1968, pp. 85 ff., and Pevsner, N., 'The Genesis of the Picturesque', in *Studies in Art, Architecture and Design*, I, London, 1968, pp. 124 ff.

144. Dupuis and his contemporaries had anticipated a number of Frazer's ideas about the role of fertility and sexual symbolism in primitive religion, although admittedly the ideas were not treated in a strictly scientific manner. In the modern period it was Max Müller who had employed solar symbolism for the interpretation of myths. (See Frazer, J., *The Golden Bough*, 12 vols., London, 1907–15. On Max Müller see Dorson, R. M., 'The Eclipse of Solar Mythology', in *Myth, a Symposium*, ed. Sebeok, T. A., London, 1970, pp. 25 ff.).

145. Momigliano, op. cit., p. 285.
146. Hancarville, op. cit. I, pp. 84 ff.
147. Ibid., p. 90.
148. Knight, *Priapus*, p. 60.
149. Knight, *Symbolical Language*.
150. Dupuis, op. cit. III, p. 861.
151. See *infra*, ch. iv, pp. 203 ff.
152. Manuel, op. cit., pp. 260 ff. In his essay on painting Diderot had suggested that beauty should not be divorced from sensual appeal (Diderot, D., *Essais sur la peinture*, Paris, 1795, p. 55). Manuel (loc. cit.) describes the atmosphere of radical free-thinking prevailing among the French intellectuals of the late eighteenth century. See also his introduction to *The Enlightenment*, Englewood Cliffs, N. J., 1965. pp. 1 ff.
153. Ibid., p. 262.
154. Maréchal, op. cit. I, p. 57.
155. Dupuis, op. cit. VI, pp. 45 ff., and IV, pp. 170, 491–516.
156. Knight, *Symbolical Language*, pp. 19 ff.

CHAPTER III

1. *Lettres édifiantes et curieuses* (1707–73) brought together a number of Jesuit accounts about the manners of the people of the East, including India. Hamilton (op. cit., *supra*, ch. ii, note 9) was a much read author in the eighteenth century. He had very little to add about Elephanta and provided a poor illustration of the god Gaṇeśa (p. 243).
2. Waley, A., *The Secret History of the Mongols*, London, 1963, pp. 23 ff. G. Sarton's long account of this pioneer Orientalist is quite useful, but there have been more recent works dealing with his importance (Sarton, G., 'Anquetil-Duperron', *Osiris*, III, 1937, pp. 193–223). Particularly important is Raymond Schwab's classic study (see *supra*, ch. i, note 1). In *Portraits of Linguists*, I, Bloomington, Ind., 1966, p. 53, T. A. Sebeok describes the conflict between Jones and Anquetil.
3. Schwab, op. cit., pp. 13–25 and 37 ff.
4. Waley, op. cit., p. 14.
5. Waley, loc. cit.
6. Anquetil-Duperron, A. H., *Zend-Avesta, Ouvrage de Zoroastre*, I, Paris, 1771, p. ccxxxiv.
7. Ibid., p. ccxliv. Account of Ellora occurs in pp. ccxxxiii–ccxlix.
8. Ibid., p. cccxcii.
9. Ibid., p. ccxlix. Anquetil, who was well-acquainted with the Royal Library, no doubt knew the three famous sets mentioned in ch. ii (see *supra*, ch. ii, note 80). He however makes particular mention in his notes of the fourth set, consisting of four volumes, prepared in 1758 under the direction of Porcher, commander of the French East India Company in Tanjore. The four-volume set, *Histoire et Figures des Dieux des Indiens ou Theogonie des Malabariquois* (Od. 39–39c), is listed in the old catalogue as nos. 1293–6.
10. Ibid., p. ccxlvi.

305

11. Ibid., p. ccxlix. See also *supra*, ch. II, p. 92.
12. Ibid., p. ccxxxiv.
13. Ibid., p. cccxcii.
14. Ibid., p. cccxx.
15. Ibid., p. cccxc.
16. See plan and ibid., p. cccxciv and pl. IV.
17. Ibid., p. lxxxi.
18. See plan (pl. IV), section VI, M and K.
19. Ibid., p. ccxvi. For Maréchal's comment see *supra*, p. 86.
20. An account of Niebuhr's life and work is to be found in *Lives of Eminent Persons* (Library of Useful Knowledge), London, 1833, pp. 1–33 (contributed by Sarah Austin).
21. Fourteen south Indian bronzes, including a fine Śiva Naṭarāja, at present in the ethnographic collection of the Nationalmuseet, Copenhagen, were sent by the Danish governor of Tranquebar in 1799 (Wulff, I., 'Den Dansen de Siva fra Trankebar' *Jordens Folk: Etnografisk Revy*, II, No. 4, 1966, pp. 326–7). On the Danish king's commission to William Jones, see Sebeok, op. cit. I, p. 2.
22. Niebuhr, C., *Voyage en Arabie et en d'autres pays circonvoisins*, II, Utrecht, 1779, p. 17 and pl. II (tr. by F. L. Mourier). The Danish edition of Niebuhr's travels, *Reisebeschreibung nach Arabien und andern umliegenden Ländern*, was published from Copenhagen between 1774 and 1778.
23. Ibid., p. 25.
24. Ibid., pls. III, IV–X.
25. See *supra*, ch. II, p. 89.
26. Niebuhr, op. cit., p. 26.
27. Ibid., p. 31.
28. Ibid., p. 26. On Hegel and the Indian trinity see *infra*, ch. IV, p. 218.
29. Ibid., p. 30.
30. Ibid., p. 27. Its earliest description as an Amazon is to be found *supra*, ch. I, p. 36.
31. Ibid., pp. 30–2.
32. Ibid., p. 26.
33. Ibid., pp. 34 ff.
34. Ibid., p. 36.
35. Bamboat, Z., *Les Voyageurs français dans l'Inde*, Paris, 1933, pp. 77–9.
36. Le Gentil, G. J., *Voyage dans les mers de l'Inde*, I, Paris, 1779, p. 112.
37. Ibid., p. 205. This god is compared by Le Gentil with Janus. Although at first sight the thirty-six headed god may seem to be a variant of the six-headed Kārttikeya, popularly known in the south as Subhramāniya, a closer look at the god's attributes will reveal him to be Viṣṇu. The multiple heads clearly suggest the cosmic (viśvarūpa) image of Viṣṇu. Le Gentil's thirty-six headed god is mentioned by Dupuis (*supra*, ch. II, p. 89).
38. Ibid., pp. 110–14 and 164–5.
39. Ibid., pp. 573–6.
40. Ibid., pp. 576 ff.
41. Sonnerat, P., *Voyage aux Indes Orientales et à la Chine*, 3 vols., Paris, 1782. As the illustrations served to explain the subjects dealt with in the text, they were separately published as vol. III in addition to being included in the first two. Pls. 31–60 represent various Hindu gods; the aerial view of a south Indian temple is given in pl. 61. Stylistic evidence suggests that Sonnerat's illustrations were largely based on the Sami volume in the Royal Library (see *supra*, ch. II, note 80). A comparison of his aerial view of temple (pl. 61) with pls. 57 and 94 of Sami (Od. 46) will show how similar they are. The facial types of gods, the style of painting and details like dress, reinforce the suggestion that Sonnerat used this volume. He may have, however, derived his iconographic types from Picard as well (Od. 40–41a), particularly the Ardhanārīśvara image. See Bamboat, op. cit., pp. 74–77, for an account of Sonnerat, including his interest in comparative religion.
42. Sonnerat, P., *A Voyage to the East-Indies and China*, I, Calcutta, 1788 (Eng. tr. by Francis Magnus), pp. i–vi (introduction).
43. Ibid. II, p. 120. Winckelmann was one of the most powerful spokesmen for a climatological interpretation of progress in art (see *infra*, ch. IV, p. 192).
44. Ibid., p. 121.
45. Ibid., p. 122.
46. Ibid., p. 123.
47. The description of the prevailing intellectual climate is to be found in Manuel, *The Eighteenth Century*, p. 10 and *passim*.

48. Hussey, C., *The Picturesque: studies in a point of view*, London, 1927, in discussing the problem of the huge and the gigantic in European architecture on pp. 195 ff., refers to the important work, *La Mégalomanie dans l'architecture* (Paris, 1912) by Henri Lemonnier. Unfortunately I have not been able to obtain a copy of the work.
49. See *infra*, ch. IV, p. 191.
50. Anquetil-Duperron, op. cit. I, p. ccccx.
51. Niebuhr, op. cit. II, p. vi (introduction).
52. See *supra*, ch. II, p. 89.
53. Le Gentil, op. cit. I, pp. 111 and 164.
54. Sonnerat, *A Voyage to East Indies*, I, pp. i ff. (introduction).
55. Ibid., p. 109.
56. Ibid., pp. 106 ff.
57. The changing conceptions of taste can be studied in Steegman, J. E. H., *The Rule of Taste from George I to George IV*, London, 1936; see also Venturi, L., *History of Art Criticism*, New York, 1964, ch. VIII, and especially pp. 190 ff., on the emergence of concepts of taste; cf. also Beardsley, op. cit. (*supra*, ch. I, note 107), pp. 180 ff.
58. Beardsley, op. cit., pp. 76–195. Burke's famous essay *A Philosophical Enquiry into the Origin of our Ideas of the Sublime and Beautiful* was published in 1757.
59. See Hussey, op. cit., pp. 195 ff. See also Honour, H., *Neo-Classicism*, London, 1968, pp. 53 ff.
60. Pevsner, N., 'The Genesis of the Picturesque', in *Studies in Art* (*supra*, ch. II, note 142), I, pp. 79 ff.
61. Hussey, op. cit., p. 2.
62. The best analysis of the picturesque movement is in Hussey, op. cit., but see also the important article of Pevsner's (*supra*, note 60).
63. See *supra*, ch. I, p. 36.
64. Hussey, op. cit., p. 165. The same author first showed the influence of the picturesque movement on the eighteenth-century portrayal of Indian architecture (see pp. 262 ff.). This is further developed in Archer, W. G., *Indian Painting for the British*, London, 1955, pp. 9 ff. See also Frankl, P., *The Gothic*, Princeton, N. J., 1960, pp. 428 ff.
65. A biography of Hodges is to be found in *DNB*, XXVII, 1891, p. 61; Reynolds's remarks follow on *infra*, p. 171 of this chapter.
66. Hodges, W., *Select Views in India*, London, 1786, pls. 22, 23, 45.
67. Hodges, W., *Travels in India*, London, 1793, p. iii (introduction).
68. Ibid., pp. 10 ff. and 59.
69. Ibid., pp. 62 ff.
70. Ibid., p. 64.
71. Pevsner, 'The Doric Revival', in *Studies in Art*, I, p. 200 ff.
72. Hodges, *Travels*, pp. 75 ff.
73. Ibid., pp. 152 ff.
74. Ibid., p. 153. On Townley collection see *supra*, ch. II, p. 91.
75. The most important biography of Thomas and William Daniell is by Thomas Sutton, *The Daniells*, London, 1954, on which my short biographical sketch is based.
76. Daniell, T. and W., *A Picturesque Voyage to India*, London, 1810, p. ii.
77. Sutton, op. cit., pp. 84 ff. On Malet see *infra*, p. 187. Wales, J., *Hindu Excavations in Ellora*, London, 1816. Daniell, T. and W., *Oriental Scenery*, II, part 2, Twenty-four Views of Ellora.
78. *Oriental Scenery*, I, London, 1795, pl. xxiv (Tānjore); Valentia's criticism is in Valentia, Viscount G., *Voyages and Travels to India*, I, p. 356.
79. Forbes, J., *Oriental Memoirs*, I, London, 1813, p. 423.
80. See Pinkerton, J., *A General Collection of the Best and Most Interesting Voyages and Travels*, VIII, London, 1811, pp. 150, 408, 413, 522. On Langlès see *infra*, p. 180. For the *Oriental Annual* see Sutton, op. cit., p. 139.
81. On India and British architecture the literature is extensive, but mention may be made of Sutton, op. cit., pp. 94 ff., and Hussey, op. cit., p. 165. See also Musgrave, C. W., *Royal Pavilion*, London, 1959, and Betjeman, J., 'Sezincote', *Architectural Review*, LXIX, 1931.
82. Quoted by Sutton, op. cit., p. 92. Turner wished to have the plates in his projected *Liber Studiorum* engraved like the Daniells'. Turner did several sketches on Hindu customs and manners. (See A. J. Finberg, *Complete Inventory of the Drawings of the Turner Bequest*, I, London, 1909, pp. 318 and 320.)
83. Pott, op. cit. (*supra*, ch. I, note 277), pp. 94 ff.
84. Valentia, op. cit. II, pp. 161–4. On Salt see *infra*, p. 165.
85. Ibid., pp. 194–9.
86. Valentia, op. cit. I, p. 356.

87. Ibid., p. 380.
88. Graham, M., *Journal of a Residence in India* (2nd ed.), Edinburgh, 1813, preface.
89. Ibid., p. 54. On Seely see *infra*, p. 137.
90. Ibid., pp. 56 ff.
91. Ibid., p. 64.
92. Ibid., pp. 163 ff.
93. Graham, M., *Essays Towards the History of Painting*, London, 1836, p. 19.
94. Graham, loc. cit.
95. A discussion of Southey and *The Curse of Kehama* is to be found in Bearce, G. D., *British Attitudes towards India*, London, 1961, pp. 103 ff.
96. Forbes, op. cit. I, p. 419.
97. Ibid., pp. 428 ff.
98. Ibid., p. 433; two illustrations are between pp. 454 and 455.
99. Ibid., p. 434.
100. See *infra*, p. 165.
101. Seely, J. B., *The Wonders of Elora*, London, 1824, title-page.
102. Ibid., p. 80.
103. Ibid., p. 23.
104. Ibid., pp. 103 ff.
105. Ibid., p. 108.
106. Ibid., pp. 108 ff.
107. Ibid., p. 156.
108. Ibid., p. 180.
109. Ibid., p. 275.
110. Heber, R., *Narrative of a Journey through the Upper Provinces of India (1824–25)*, II, London, 1828, p. 181.
111. Ibid. On the revised chronology for Elephanta and the identification of the Maheśa-mūrti see *infra*, p. 157.
112. Ibid., pp. 280 ff.
113. Bacon, T., *First Impressions*, London, 1837, p. 184; see also Sutton, op. cit., p. 140. In 1839 the authorship was transferred to Thomas Bacon.
114. Kittoe, M., *Illustrations of Indian Architecture*, Calcutta, 1838, pls. 9, 10, and 11.
115. See *Enc. Brit.* II (London, 1970), pp. 223 ff. A good account of the rise of archaeology is to be found in Daniel, G. E., *A Hundred Years of Archaeology*, London, 1950, p. 9.
116. Mandowsky, E., and Mitchell, C., *Pirro Ligorio's Roman Antiquities*, London, 1963.
117. The major work on the rise of classical archaeology was done by Adolf Michaelis, op. cit. (*supra*, ch. II, note 142), London, 1882, but a comprehensive and lucid account has just come out which deals in particular with the architectural aspects of Neoclassicism (Crook, J. M., *The Greek Revival*, London, 1972).
118. See James Stuart and Nicholas Revett, *The Antiquities of Athens*, I, London 1762, especially the introduction.
119. Crook, op. cit., p. 22.
120. Ibid., pp. 89 ff., discusses the relationship between primitivism and Greek art.
121. Evans, J., *A History of the Society of Antiquaries*, London, 1956, pp. 113 ff., and Daniel, op. cit., pp. 22 ff.
122. Gough, R., *A Comparative View of the Antient Monuments of India*, London, 1785. To the publisher of British antiquarian works, John Nichols, the author addressed his remarks to the effect that, while Indian antiquities were far removed from his own immediate concern with British antiquities, they were by no means unworthy of attention. Gough showed that he knew the works of Sonnerat, Mignot, Hancarville, Bailly, and Jones on India. The work contained accounts of Elephanta by Linschoten, Fryer, Ovington, J. H. Grose (1750), Anquetil, and Niebuhr, of Kānheri by Gemelli-Careri and Anquetil, and of Ellora by Anquetil. The accounts of Indian monuments in *Archaeologia* (see *infra*, p. 142) were also mentioned. On Gough's election to the directorship see Evans, op. cit., p. 135.
123. Crook, op. cit., p. 69.
124. Dalrymple, A., 'Account of a Curious Pagoda near Bombay', *Archaeologia*, VII, 1785, pp. 324–8. Dalrymple was the publisher of *Oriental Repertory* (1793–4).
125. Ibid., p. 332. On Lever's museum see *DNB*, XXXIII, 1893, p. 136. On Townley's Indian pieces see *supra*, ch. II, p. 91.
126. Lethieullier, S., 'Extract from an Account of the . . . Pagoda on the Island of Salset', *Arch.* VII, 1785, pp. 334 ff.
127. Hunter, W., 'An Account of some Artificial Caverns in the Neighbourhood of Bombay', *Arch.* VII, 1785, p. 291.

308

128. Ibid. A particularly intense awareness of the 'felt' quality or the presentation of personal emotions in art came in the wake of Romanticism (Beardsley, op. cit., pp. 247 ff.).

129. Ibid., p. 301.

130. The concept of 'The Golden Age' is discussed in Gombrich, E. H., 'The Debate on Primitivism in Ancient Rhetoric', *JWCI*, XXIX, 1966, pp. 24 ff.

131. See the new translation of Winckelmann by David Irwin, pp. 106–7, 108–9, 113 (*Winckelmann, Writings on Art*, London, 1972).

132. Slotkin, op. cit., p. 230. See also *infra*, ch. IV, p. 190.

133. Crook, op. cit., pp. 82 ff.

134. Hunter, op. cit., p. 301.

135. Reverend Gregory, 'An Account of the Caves of Cannara, Ambola and Elephanta', *Arch.* VIII, 1787, p. 252.

136. Ibid., p. 260.

137. Ibid.

138. Ibid., p. 268.

139. Ibid., p. 259.

140. Blackader, A., 'Description of the Great Pagoda of Madura' (letter to Sir Joseph Banks), *Arch.* X, 1792, pp. 449–56.

141. Among the vast literature relating to Jones the recent important studies are Mukherjee, S. N., *Sir William Jones*, Cambridge, 1968, and Marshall's (op. cit.) introduction to early texts on Hinduism. See also articles by F. Edgerton and S. K. Chatterji in Sebeok, *Portraits of Linguists*, I.

142. Willson, A. L., *A Mythical Image, The Ideal of India in German Romanticism*, Durham, N. C., 1964, p. 47 and *passim*. On Schubert's opera see *Grove's Dictionary of Music and Musicians*, ed. H. C. Colles (3rd ed.), IV, London, 1928, p. 596.

143. See Slotkin, op. cit., p. 240.

144. Jones, W., 'Desiderata', *As. Res.* IV, 1799, pp. 187 ff.

145. Jones, 'Discourse', *As. Res.* I, 1788, p. xiv.

146. Ibid., p. 428. On Rám Ráz see *infra*, p. 180.

147. Jones, 'Hymn to Sereswat', *The Asiatic Miscellany*, 1785, p. 179.

148. Jones, *As. Res.* I, pp. 221 ff.

149. Ibid., pp. 427 ff.

150. *Transactions of the Literary Society of Bombay*, I, 1819, opening address.

151. *Transactions of the Royal Asiatic Society of Gt. Britain and Ireland*, I, 1827, opening address.

152. Chambers, W., 'Some Account of the Sculptures and Ruins at Mavalipuram', *As. Res.* I, 1788, p. 149. The author was not the famous Sir William Chambers.

153. Ibid., p. 151.

154. Goldingham, J., 'Some Account of the Sculptures at Mahabalipooram', *As. Res.* V, 1799, pp. 69 ff.

155. Ibid., p. 74.

156. Babington, B. G., 'An Account of the Sculptures and Inscriptions at Mahamalaipur', *TRAS*, II, 1830, pp. 258 ff. On Heber see *supra*, p. 138.

157. Ibid., p. 261.

158. Goldingham, J., 'Some Account of the Cave in the Island of Elephanta', *As. Res.* IV, 1799, p. 414.

159. Ibid., pp. 410–17.

160. Erskine, W., 'Account of the Cave-Temple of Elephanta', *TLSB*, I, 1819, p. 198.

161. Ibid., p. 203.

162. Ibid., pp. 198–201.

163. Ibid., p. 200.

164. Ibid., p. 202.

165. Ibid., p. 203. He argued that not only in India but in the whole of South East Asia many-armed images indicated their Hindu origin. He identified Kānheri and Kārle as being Buddhist, Elephanta and Amboli (Yogeswari) as Hindu, and Ellora as both Hindu and Buddhist. In 'Observations on the Remains of the Bouddists in India', *TLSB*, III, 1823, pp. 494–541, Erskine was to establish a correct method for identifying monuments, by which means he was able to identify the various caves of Ellora. This was a very important step in Indian art history.

166. Ibid., pp. 205–6. W. Spink revised the chronology of early Indian monuments. Elephanta was begun in *c.* A.D. 540 and belongs to the sixth century. (See 'Ajanta to Ellora', *Mārg*, XX, No. 2, March 1967, pp. 9 ff.)

167. Ibid., pp. 220 ff. On Castro see *supra*, ch. I, p. 36; on Valentia see *supra*, p. 131; on Moor see *infra*, p. 178.

168. Ibid., p. 229.
169. Ibid., p. 215.
170. Ibid., pp. 209 ff.
171. Ruskin, J., 'Salsette and Elephanta', *The Works of John Ruskin* (see *infra*, ch. v, note 69), II, p. 100. The phrase 'The Dark Age' was coined by Cardinal Baronius (*Annales*, A.D. 900): see McCabe, J., *A Rationalist Encyclopaedia*, London, 1947, p. 132.
172. Erskine, op. cit., p. 212.
173. Ibid., p. 245.
174. Ibid., pp. 246–7.
175. Ibid., p. 246.
176. Ibid.
177. Malet, C., 'Description of the Caves or Excavations on the Mountain . . . eastward of the Town of Ellora', *As. Res.* VI, 1801, pp. 382–3. On Wales see *supra*, p. 127.
178. Ibid., p. 386.
179. Ibid., p. 391.
180. Ibid., p. 392.
181. Ibid., p. 393.
182. Ibid., p. 396.
183. Ibid., p. 402.
184. Ibid., pp. 404 ff.
185. Ibid., p. 421.
186. Ibid., p. 422.
187. Sykes, W. H., 'An Account of the Caves of Ellora', *TLSB*, III, 1823, pp. 265–7 and *passim*. The monuments in Ellora were finally identified by Erskine in 1823 (see *supra*, note 165).
188. Ibid., p. 292.
189. Ibid., p. 301. The suggestion is not entirely unwarranted. Recently Ronald Lewcock of Clare Hall, Cambridge, who has been working on Buddhist architecture in Ceylon and India, has found strong evidence that the *caitya* ceiling may have actually been derived from the craft of shipbuilding.
190. Ibid., p. 305.
191. Ibid., p. 319. See Colebrooke's articles on Hindu philosophy in *TRAS*, I, 1827, and II, 1830.
192. Ibid., pp. 305–8.
193. Grindlay, R. M., 'An Account of Some Sculptures in the Cave Temples of Ellora', *TRAS*, II, 1830, pp. 326 ff.
194. Ibid.
195. Grindlay, 'Observations on the Sculptures in the Cave Temples of Ellora', *TRAS*, II, p. 487.
196. Ibid., p. 488.
197. Ibid.
198. Ibid., pp. 487 ff.
199. Salt, H., 'Account of the Caves in Salsette', *TLSB*, I, 1819, pp. 43 ff.
200. Ibid., p. 46.
201. Ibid., p. 48.
202. Ibid., p. 49.
203. Alexander, J. E., 'Notice of a Visit to the Cavern Temples of Adjunta in the East Indies', *TRAS*, II, 1830, pp. 362–4. The discovery by British soldiers of Ajanta in 1819 is mentioned by Erskine in *TLSB*, III, 1823, p. 520.
204. Alexander, 'Notice of a Visit', p. 365.
205. Ibid., pp. 368 ff.
206. Ibid., p. 366. The belief that ancient Indians did not know how to construct a proper arch was a widely held view in the nineteenth century among archaeologists, some of whom discovered the 'arch' in the horse-shoe shaped façade of early Buddhist *caityas* in, for example, Ajanta, Ellora, or Bāgh. The general idea was that the Turks introduced the arch into India. This has been proved wrong since. James Harle kindly gave me the information that the radiating arch or vault built of voussoirs dates from a very early period in Nālandā, Bhitārgaon, etc. (see also Volwahsen, *Living Architecture: Indian*, Berne, 1969, pp. 174 ff.).
207. Alexander, 'Notice of a Visit', p. 370.
208. Dangerfield, F., 'Some Account of the Caves near Baug', *TLSB*, II, 1820, p. 199. Of the nine caves at Bāgh, numbers VII and IX have almost collapsed.
209. Ibid., p. 200.
210. Stirling, A., 'An Account, Geographical, Statistical and Historical, of Orissa Proper

or Cuttack, Part III' (Religion, Antiquities, Temples and Civil Architecture), *As. Res.* XV, 1825, p. 306.

211. Ibid., pp. 308 ff.
212. Ibid., p. 310.
213. Ibid., p. 315.
214. Ibid., p. 316.
215. Ibid., p. 326.
216. Ibid., pp. 330 ff.
217. Ibid., p. 332.
218. See Erskine, 'Account of Elephanta', *TLSB*, I, 1819, pp. 209 ff.
219. Reynolds, J., *Discourses on Art*, San Marino, Calif., 1959, p. 242. Discourse No. xiii. Hodges became an academician in 1787. Reynolds had acquired in *c.* 1777 a set of 43 Mogul miniatures (B.M. Ad. 18. 801).
220. Flaxman, J., *Lectures on Sculpture*, London, 1838, p. 30. He had made a number of drawings on Indian subjects from Indian miniatures, some of which were on display at the recent exhibition on Neoclassicism at the Royal Academy. The album of Indian drawings of Flaxman belongs to the Fitzwilliam Museum, Cambridge.
221. See Balston, T., *John Martin*, London, 1947, pp. 53 ff, 261, 267. *Belshazzar's Feast*, executed in 1821 and full of archaeological erudition, included Indian columns at the bottom right-hand side (appendix I, p. 261). Martin's library contained Oriental books, including those of the Daniells. He had also done an etching of Sezincote House.
222. The work belongs to Professor Michael Jaffé who kindly permitted me to reproduce the work.
223. Diderot, D., and D'Alembert, J. le R., *Encyclopédie*, VIII, Paris, 1765, p. 922.
224. Monsieur Jean Adhémar of the Dept. des Estampes, Bibl. Nat. Paris, kindly provided the following information:

A large collection illustrating the costumes and manners of the nations of the world was compiled by the Royal Library in the second part of the eighteenth century. The collection antedates by a few years the appearance of the section on dresses and professions in the *Encyclopédie*. Indian paintings were used to illustrate exotic manners and costumes (see Bibl. Nat. Cat. des Est. Od. 34–63).

225. Millin, A. L., *Dictionnaire des beaux-arts*, I, Paris, 1806, pp. 55–6. See also vol. III, pp. 185 ff. on painting. Millin mentioned that Abbé de Tersan, antiquarian and collector (1736–1819), had a beautiful collection of Indian paintings. (See under C. P. Campion in *Grande Encyclopédie*, VIII, p. 1140).
226. La Vincelle, G., de, *Recueil des monumens antiques . . . dans l'ancienne Gaule*, II, Paris, 1817, pp. 323–4.
227. Mill, J., *The History of British India*, I, London, 1817, p. 332. On James Mill see *The English Utilitarians and India* by Professor Eric Stokes (Oxford, 1959). On Sonnerat see *supra*, p. 141. See also Raynal, G. T. F., *Histoire philosophique et politique des établissemens et du commerce des européens dans les deux Indes*, 6 vols., Paris, 1770, tr. Justamond, J., *A Philosophical and Political History of the Settlements and Trade of the Europeans in the East and West Indies*, I, Dublin, 1776, pp. 32 ff.
228. Mill, op. cit. I, p. 333.
229. Ibid., p. 340.
230. Venturi, L., op. cit., p. 220.
231. Mill, op. cit. I, pp. 335 ff.
232. Ibid., p. 341.
233. See *infra*, ch. v, p. 240.
234. Mill, op. cit. I, p. 354.
235. Ibid., p. 356.
236. See *infra*, ch. iv, pp. 208 ff.
237. Robertson, W., *An Historical Disquisition concerning the Knowledge the Ancients had of India*, Edinburgh, 1786, p. 2.
238. Ibid., pp. 277–9.
239. Ibid., p. 352.
240. Ibid., p. 282.
241. Ibid.
242. Ibid., p. 362. See also *supra*, p. 115.
243. On Holwell, Dow, and Halhed see Marshall, op. cit. pp. 45, 107, 140. J. Z. Holwell's illustrations occur in his *A Review of Original Principles, Religious and Moral, of the Ancient Bramins*, London, 1779, pp. 152–3 (5 pls.). D'Anville, J. B. B., *Antiquité géographique de l'Inde*, Paris, 1775. Rennel, J., *Memoir of a Map of Hindoostan*, London, 1788.

244. Maurice, T., *Indian Antiquities*, I, London, 1800, p. 30.
245. Moor, E., *The Hindu Pantheon*, London, 1810, pl. 82.
246. See Chanda, R. P., *Mediaeval Indian Sculptures in the British Museum*, London, 1932.
247. Moor, op. cit., pls. 81 and 82.
248. Ibid., p. 29.
249. Stewart, J., and Philipp, F., *In Honour of Daryl Lindsay*, Melbourne, 1964, p. 124; see also pls. 98 and 100.
250. Moor, op. cit., pp. ix. ff.
251. Ibid., pp. 1 ff.
252. Ibid., p. 382. On Knight see *supra*, ch. II, pp. 104 ff.
253. Langlès, L., *Monuments anciens et modernes de l'Indoustan*, I, Paris, 1811, pp. 1 ff., and II, Paris, 1821, p. 69.
254. Both volumes contain profuse illustrations from the *Oriental Scenery*.
255. The Brahman Svāmī paintings are in the Dept. des Estampes, Bibl. Nat. Od. No. 46–46a.
256. Rám Ráz, *Essay on the Architecture of the Hindus*, London, 1834, pp. iii–xi.
257. Ibid., p. v.
258. Ibid., p. v., note.
259. Kugler, F. (*infra*, ch. IV, note 128), p. 114.
260. Rám Ráz, op. cit., p. 15, quoted by Jones, O., *The Grammar of Ornament*, London, 1856, ch. XIII, p. 2.
261. Rám Ráz, op. cit., p. xiii.
262. Ibid.
263. Ibid., pp. 1–14.
264. Ibid., pp. 25 ff. (pedestals), p. 28 (bases), pp. 28 ff. (columns), pp. 48 ff. (*vimānas*), pp. 60 ff. (*gopuras*).
265. Ibid., pp. 37 ff.
266. Ibid., pp. 45–9.

CHAPTER IV

1. Gombrich, *The Debate on Primitivism* (*supra*, ch. III, note 130), pp. 24 ff. See also Venturi, op. cit., pp. 152 and 213.
2. Slotkin, op. cit. (*supra*, ch. III, note 132), p. xiii.
3. Ibid., p. 228; see also Marshall, op. cit. (ch. II, note 108), p. 26.
4. Vergil, P., *De Inventoribus Rerum*, 1499, translated into English as *The Works of the Famous Antiquary, Polydore Virgil*, London, 1663, pp. 115 ff. See also Hodgen, M. T., op. cit. (*supra*, ch. I, note 2), p. 172.
5. Goguet, A. Y., *De l'origine des loix, des arts, et des sciences, et de leurs progrès chez les anciens peuples*, Paris, 1758. English translation, *The Origin of Laws, Arts, and Sciences*, I, Edinburgh, 1761, pp. 132 ff.; also Hodgen, op. cit., p. 262.
6. Irwin, op. cit., p. 106.
7. Bysshe, Sir E., *De Gentibus Indiae et Bragmanibus*, London, 1665.
8. Temple, Sir W., *Five Miscellaneous Essays*, edited by S. Holt, Ann Arbor, Mich., 1963, introduction, pp. xxiv ff. See also Slotkin, op. cit., pp. 100 ff. On the famous *querelle* see Sandys, J. E., *A History of Classical Scholarship*, II, Cambridge, 1908, pp. 403 ff.
9. Ibid., p. 45.
10. Debidour, A., 'L'Indianisme de Voltaire', *Revue de la Littérature Comparée*, IV, Jan. 1924, pp. 26–40.
11. Irwin, op. cit., pp. 53 ff. and 104–6.
12. Butterfield, H., *Man on His Past*, Cambridge, 1955, pp. 42 ff. See *New General Biographical Dictionary* by the Revd. H. J. Rose, VII, London, 1848, p. 489, for an account of Gatterer's life.
13. Irwin, op. cit., pp. 107–9, 113–14, and *passim*. On the influence of Montesquieu's *Esprit des lois* (1748) on Winckelmann, see pp. 42 ff. I have had occasion to mention the influential evolutionary doctrine which held that progress took place from the simple to the complex. The doctrine had influenced Winckelmann (see *supra*, ch. III, p. 144); it is discussed in Slotkin, op. cit., pp. 230 ff. However, the use of an organic metaphor to explain progress has a much longer tradition and is related to a cyclical conception of time. It was used, for instance, by Vasari in the context of Renaissance art to explain its progress. (This is discussed by Professor Gombrich in his unpublished paper *Nova Reperta*, pp. 13 ff.) What is interesting here is that although Winckelmann used the notion of progress it was still cyclical and old-fashioned as it looked back to Vasari. It was Hegel, as we shall see, who turned it into one of continuous progress. He replaced

cyclical time by a unilinear one. See also Winckelmann, op. cit. II, ch. IV, section III, pp. 1 ff.

14. See *infra*, ch. V, p. 240.
15. Holt, E. G., *A Documentary History of Art*, II, New York, 1958, p. 321.
16. Honour, H., op. cit., p. 45.
17. See *supra*, ch. III, p. 108.
18. Caylus, A. P., Comte de, *Recueil d'antiquités égyptiennes* etc. I, Paris, 1752, p. 95 and pl. XXXI.
19. Mignot, l'Abbé E., 'Mémoires sur les anciens philosophes de l'Inde', five articles in the 'Mémoire Littéraire' *Histoire de l'Académie Royale des Inscriptions et Belles-Lettres*, XXXI, 1761–3, pp. 81–263; on general interest in the East see issues between 1750 and 1780.
20. Caylus, *Histoire de l'Académie*, XXXI, 1763, p. 41.
21. Ibid., pp. 41 ff. Caylus read a paper on the origin of architecture at the public assembly of St. Martin in 1763. This was reproduced in summary form and in extensive quotations in the article in *Histoire de l'Académie* entitled 'Comparaison de quelques anciens monumens des diverses parties de l'Asie'.
22. Ibid., p. 43.
23. Ibid., p. 42.
24. Ibid., pp. 42 ff.
25. See *supra*, ch. III, pp. 115 ff.
26. Ibid., p. 45 and pl. III.
27. Ibid., pp. 45 ff.
28. Ibid., p. 46.
29. Ibid., p. 44.
30. Ibid., p. 47.
31. Rode, B., and Riem, A., 'De la peinture chez les anciens', in Winckelmann, *Histoire de l'art chez les anciens*, II, part II, Paris, 1803, pp. 60 ff.
32. See *supra*, note 19.
33. The correct rendering should be 'ne plus ultra', but the above form was often used in the eighteenth century (*OED*).
34. Rode and Riem, op. cit., pp. 59 ff. The assertions of the German antiquarians about Egyptian architecture were derived largely from Richard Pococke's *A Description of the East*, 2 vols, London, 1743. Pococke had paid much attention to the temple of Jupiter Amun at Karnak (vol. I, p. 90). See also I, p. 215 for his remark that Egyptian architecture represented the first essays in art in human history so that Egyptians were loath to alter Egyptian architecture's style. Similar arguments were used by Rode and Riem in the case of Indian architecture.
35. Ibid., p. 61.
36. Ibid.
37. Ibid.
38. Ibid., pp. 61 ff.
39. Ibid., p. 63. The great temple of Amun at Karnak is dated *c.* 1530–323 B.C., although the foundations go back to *c.* 2000 B.C. Pyramids were of course built right through Egyptian history but the earliest ones date from the second millennium B.C. The Gopuras of the south Indian temples belong to a late period, generally dating from about 1000 A.D.
40. Ibid., p. 74.
41. Ibid., p. 63.
42. Ibid., pp. 64 ff.
43. Ibid., p. 65. This information was based on Sonnerat.
44. Ibid., p. 66.
45. Ibid., pp. 82 ff.
46. Ibid., pp. 83 ff.
47. Willson, A. L., op. cit. (*supra*, ch. I, note 235). On Goethe see pp. 62 ff.
48. Ibid., p. 109.
49. Hegel, G. W. F., *Ästhetik* (*infra*, note 91), pp. 36 ff.
50. Momogliano, A., 'Creuzer and Greek Historiography', *JWCI*, IX, London, 1946, p. 153.
51. Cumont, F., *Recherches sur le symbolisme funéraire des Romains*, Paris, 1942, p. 13.
52. Dieckmann, L., 'Friedrich Schlegel and Romantic Concepts of the Symbol', *Germanic Review*, XXXIV, Dec. 1959, pp. 277 ff.
53. Gombrich, E. H., 'The Use of Art for the Study of Symbols', op. cit. (*supra*, ch. II, note 41), pp. 34 ff. The article discusses in detail the implications of this problem in art.

313

54. Ibid., p. 48.
55. Dieckmann, op. cit., pp. 279 ff.
56. Guigniaut, J. D., *Religions de l'antiquité du Creuzer*, I, part I, Paris, 1825, p. 139.
57. Willson, op. cit., p. 110.
58. Ibid., pp. 109 and 186–99.
59. Guigniaut, J. D., *Notice historique sur la vie et les travaux de G. F. Creuzer*, Paris, 1864, p. 22.
60. Ibid., p. 23.
61. Ibid., p. 24.
62. Guigniaut, *Religions de l'antiquité*, I, see *Avertissement pour la première livraison*, pp. 3 ff. Creuzer's introduction is on pp. 1–132; Dieckmann, op. cit., pp. 278 ff. Guigniaut's edition contains a valuable collection of cosmological pictures from diverse sources illustrating Hinduism (vol. IV, pt. 2, pls. I–XXI). In 'Flaubert and India', *JWCI*, IV, 1941, pp. 142–50, Seznec shows how important these illustrations were for Flaubert's *Temptation of St. Anthony*.
63. Guigniaut, *Religions*, I, pp. 133 ff.
64. Ibid., p. 134.
65. Ibid., p. 137.
66. Ibid., p. 135.
67. Ibid., p. 139. See also Guigniaut, *Religions*, IV, pt. 2, Paris, 1841, plates I–XXI, figures 1–116.
68. Guigniaut, *Religions*, I, p. 145.
69. Ibid., p. 141.
70. Ibid., p. 150.
71. See *supra*, ch. III, p. 157.
72. Guigniaut, *Religions*, I, p. 158.
73. Ibid., p. 155.
74. Ibid., pp. 68–72.
75. Ibid., p. 72.
76. Ibid., pp. 72 ff.
77. Ibid., p. 73.
78. See *supra*, ch. II, p. 100.
79. Guigniaut, *Religions*, I, pp. 73 ff.
80. Cumont, F., op. cit., p. 13.
81. See *infra*, p. 218. On the contribution of Idealist philosophy to aesthetics see Venturi, op. cit., pp. 187–212.
82. Venturi, op. cit., p. 188.
83. Gombrich, E. H., *In Search of Cultural History*, Oxford, 1969, pp. 6, 10.
84. Ibid., p. 6.
85. Lovejoy, A. O., *The Great Chain of Being*, Cambridge, Mass., 1936, ch. II, pp. 24–66.
86. Ibid., chs. IX-XI, pp. 242–333.
87. I have drawn extensively from an unpublished essay on Hegel by Professor Gombrich which he kindly lent me. This will be referred to as 'Hegel' in subsequent notes. For a further discussion of the problem see Gombrich, *Cultural History*, p. 7.
88. Gombrich, *Cultural History*, p. 8.
89. Gombrich, 'Hegel', p. 11.
90. Morris, G. S., *Hegel's Philosophy of the State and of History*, Chicago, 1887, ch. IV, p. 147. I have made certain alterations in the translations of Hegel used by me, where the text used somewhat archaic English which tended to obscure the actual meaning of these passages.
91. Haldane, E. S., *Lectures on the History of Philosophy*, I, London, 1892, p. 126. The translation is based on the amended 1840 edition (*Hegels Werke*, Berlin, 1832–40, vols. XIII-XV).
92. Osmaston, P. B., *The Philosophy of Fine Art*, II, London, 1920, p. 49: the translation of *Vorlesungen über die Ästhetik*, based on the collected edition of 1835 (*Werke*, vol. X).
93. Morris, op. cit., p. 147.
94. Haldane, op. cit. I, pp. 126 ff.
95. Morris, op. cit., p. 148; see also Osmaston, op. cit., II, p. 89 ff.
96. Morris, loc. cit.
97. Baillie, J. B., *The Phenomenology of Mind*, II, London, 1910, pp. 704 ff. The translation is based on the 1843 and 1907 editions.
98. Osmaston, op. cit. II, p. 64.
99. Haldane, op. cit. I, p. 90.
100. Osmaston, op. cit. II, p. 50.
101. Gombrich, *Cultural History*, p. 8; 'Hegel', p. 15.

314

102. Haldane, op. cit. I, pp. 125 ff.
103. Osmaston, op. cit. II, p. 7.
104. Ibid., pp. 49 ff.
105. Ibid., pp. 29 ff.
106. Ibid., p. 3.
107. Ibid., p. 47.
108. Ibid., p. 49.
109. Ibid., pp. 53 ff.
110. Ibid., pp. 56 ff.
111. Speirs, E. B., and Sanderson, J. B., *Lectures on the Philosophy of Religion*, II, London, 1895, pp. 9 ff. The translation is based on the 1840 edition (*Werke*, vols. XI, XII).
112. Osmaston, op. cit. II, p. 51.
113. Ibid., pp. 52 and 61.
114. Ibid., p. 10.
115. Ibid., p. 11.
116. Ibid., p. 12.
117. Ibid., p. 15.
118. Ibid., pp. 15 ff.
119. Ibid., p. 17.
120. Ibid., p. 13.
121. Ibid., pp. 14 ff.
122. Haldane, op. cit. II, pp. 136 ff.
123. Speirs and Sanderson, op. cit. II, pp. 48 ff.
124. On Hegel's knowledge of Indian religious texts see Osmaston, op. cit. II, pp. 47 ff. The important passage in Osmaston on Ellora and Salsette is not very clear. I have therefore given my own translation based on the original text (Hegel, G. W. F., *Ästhetik*, introductory essay by G. Lukács, Berlin, 1955, p. 606).
125. Ibid., p. 59.
126. Venturi, op. cit., p. 188.
127. Leitch, J., *Ancient Art and Its Remains*, London, 1850, p. 258. This is the English translation of C. O. Müller's *Handbuch der Archäologie der Kunst*, Breslau, 1830.
128. Ibid., p. 259.
129. Kugler, F., *Handbuch der Kunstgeschichte*, Stuttgart, 1842, p. 114 and *passim*.
130. Ibid., p. 119.
131. Schnaase, C., *Geschichte der bildenden Künste bei dem Alten*, I, Düsseldorf, 1843, pp. 102–24.
132. Ibid., p. 136.
133. Ibid., p. 147.
134. Ibid., pp. 154 ff.

CHAPTER V

1. Irwin, J. and Brett, K. B., *Origins of Chintz*, London, 1970.
2. The taste for Indian crafts was discussed in B. S. Allen's classic *Tides in English Taste*, I, Cambridge, Mass., 1937, chs. x and xi; and II, ch. xiii.
3. Clark, K., *The Gothic Revival*, London, 1950, pp. 3 ff.
4. Bøe, A., *From Gothic Revival to Functional Form*, Oslo, 1957, pp. 1 ff.
5. Ibid., pp. 5 ff.
6. See *infra*, p. 240.
7. Bøe, op. cit., pp. 30 ff.
8. Ibid., p. 40; see also Bell, Q., *The Schools of Design*, London, 1963, pp. 51 ff.
9. *Art Journal*, XII, 1850, p. 304.
10. *A Catalogue of the Museum of Ornamental Art*, London, 1853, pp. 116 ff.
11. Bell, op. cit., pp. 1–72.
12. Bøe, op. cit., pp. 58 ff.
13. Pevsner, *Studies in Art*, II, p. 90; Bell, op. cit., p. 245, and Boe, op. cit., pp. 44 ff.
14. Bell, op. cit., p. 215 and note.
15. Bøe, op. cit., p. 44.
16. Taylor, W. B. S., *A Manual of Fresco and Encaustic Painting*, London, 1843, p. 25.
17. Wornum, R. N., 'The Exhibition as a Lesson in Taste', *Art Journal Illustrated Catalogue* (1851), London, 1851, pp. vi ff. See also Pevsner, *Studies in Art*, II, p. 72.
18. Ibid., p. 28.
19. Seznec, J., *Flaubert à l'exposition de 1851*, Oxford, 1951, pp. 1–30.
20. Blanqui on the 1851 Exhibition, quoted by H. H. Cole, *Catalogue of the South Kensington Museum*, London, 1874, pp. 2 ff.

21. Bell, op. cit., pp. 211 ff.
22. Ibid., pp. 248 ff.
23. *Art Journal*, IV, New Series, 1852, p. 98.
24. Ibid., pp. 103 ff.
25. Ibid., p. 161.
26. Ibid., p. 227.
27. Bell, op. cit., pp. 247 ff.
28. *Art Journal*, V, New Series, 1853, p. 118.
29. *Art Journal*, VI, New Series, 1854, p. 218.
30. *Art Journal*, I, New Series, 1855, p. 59.
31. Ibid., p. 91.
32. *A Catalogue of Ornamental Art*, pp. 25 ff.
33. Ibid., p. 41.
34. Ibid., p. 41.
35. Ibid., pp. 83 ff.
36. Ibid., p. 114.
37. Ibid., pp. 116 ff.
38. Ibid.
39. Ibid.
40. Ibid.
41. Ibid.
42. Ibid.
43. Venturi, L., op. cit. (*supra*, ch. III, note 57), p. 232.
44. *Catalogue of Ornamental Art*, p. 116, note.
45. Jones, O., *The Grammar of Ornament*, London, 1856, ch. XII, p. 1.
46. Ibid.
47. Ibid., pp. 1 ff.
48. Ibid., pl. XLIX, 1, 4, 5, 6, 8, 13, 14, and 15.
49. Ibid., p. 2.
50. Ibid., pp. 2 ff.
51. Ibid., ch. IV, pp. 1 ff.
52. Ibid., ch. XIII, pp. 1 ff.
53. Ibid., ch. XIII, p. 2; on Rám Ráz see *supra*, ch. III, p. 183.
54. Ibid.
55. *Two Letters on the Industrial Arts of India*, London, 1879, pp. 1–6.
56. Ibid., p. 9.
57. Birdwood, Sir G. C. M., *The Industrial Arts of India*, London, 1880, pp. 131–43.
58. Ibid., p. 125.
59. Ibid., p. 126, On 'racial romanticism' see *infra*, ch. VI, pp. 260 ff. and note 27.
60. Ibid., p. 136.
61. Ibid., p. 142.
62. Ibid., pp. 199–201.
63. Rosenberg, J. D., *The Darkening Glass*, London, 1961, p. xi. This is one of the most perceptive critical biographies of Ruskin.
64. Bell, Q., *Ruskin*, London, 1963, pp. 4 ff. and Rosenberg, op. cit., p. 23.
65. In the early years of the Company rule in India an atmosphere of religious tolerance was rigorously maintained. There was also much interest among the administrators in Hinduism, who discouraged missionary activities on the subcontinent. Under the influence of progressivist ideas as well as the rise of more militant attitudes among Christians in Britain, India was at last opened up to the missionaries in 1813. In the middle of the previous century there was a revival of evangelism in Britain and America. In the 1730s John and Charles Wesley had founded the Methodist Society. In the same period George Whitefield was active in Britain. However, it was the Clapham Sect, an evangelical and philanthropic group, which had considerable political influence between 1790 and 1830. The leader of the anti-slavery movement, William Wilberforce, was a member. So was Charles Grant, the chairman of the Court of Directors of the East India Company, who had a large share in formulating government policy towards India. Missionary societies in India owed much to their support. The new evangelists (and members of the Clapham Sect may be taken as a typical example) combined the idea of the trusteeship of 'backward' peoples with an exalted sense of responsibility to God. The feeling of racial and religious superiority went together with the determination to interfere in Indian internal affairs, which included religion. The feeling was that India needed to be freed of superstition and idolatry. Ruskin's poem expresses these sentiments clearly. (For a study of changing attitudes of

316

the British to India, see Bearce, op. cit. (*supra*, ch. III, note 95), pp. 78 ff. For the historical background consult *Encycl. Brit.* (1970 ed.), V, p. 861; and XXIII, pp. 412 ff., 485 ff., and 504.

66. Bell, op. cit., p. 16.
67. Rosenberg, op. cit., p. 52.
68. Bell, op. cit., discusses these problems in *Ruskin*, pp. 16–51.
69. Ruskin, J., *The Works of*, eds., Cook, E. T. and Wedderburn, A., II, London, 1903, p. 94 and notes * (asterisk) and 2. The editors mention the use of Linschoten. The influence of Erskine is suggested by the use of the name Dharapori for Elephanta, also used by Erskine, whereas the correct form should be Gharapuri. See *supra*, ch. III, p. 158, for Erskine and *supra*, ch. I, p. 37 for Linschoten.
70. Bell, op. cit., p. 16. The definition of 'high art' is to be found in Bell, *Victorian Artists*, London, 1967, pp. 55 ff.
71. Bell, *Ruskin*, pp. 6 ff., on the influence of science on Ruskin.
72. Ruskin, *Modern Painters*, V, in *Works*, VII, 1905, pp. 175 ff.
73. *Modern Painters*, III, *Works*, V, 1904, p. 123.
74. Appendix V, *Ironwork of Bellinzona*, *Works*, XVI, 1905, p. 423.
75. *The Queen of the Air*, II, *Athena Keramitis*, *Works*, XIX, 1905, pp. 382 ff.
76. *Lectures on Art*, VI (Light), *Works* XX, 1905, p. 153.
77. Ibid., p. 153 ff.
78. *The Queen of the Air*, II, *Athena Keramitis*, *Works*, XIX, 1905, p. 383.
79. *Modern Painters*, V, part IX, ch. XI, 'The Hesperid Aiglé', *Works*, VII, 1905, p. 416.
80. Ibid., p. 414, note 1.
81. See a discussion of the Neoplatonic conception of symbols *supra*, ch. I, pp. 30 ff., and ch. IV, pp. 203 ff.
82. *The Stones of Venice*, I, ch. xxv, 'The Base', *Works*, IX, 1903, pp. 345 ff.
83. *The Stones of Venice*, III, ch. III, 'Grotesque Renaissance', *Works*, XI, 1904, pp. 188 ff.
84. *Lectures on Art*, II, 'The Relation of Art to Religion', *Works*, XX, 1905, pp. 60 ff.
85. *Aratra Pentelici*, VI, *Works*, XX, 1905, pp. 230 ff.
86. Ibid., p. 227.
87. *Aratra Pentelici*, V, *Works*, XX, 1905, p. 322.
88. *Aratra Pentelici*, VI, *Works*, XX, 1905, pp. 347 ff.
89. Rosenberg, op. cit., pp. 1–21.
90. *The Two Paths*, Lecture I, 'Conventional Art', *Works*, XVI, 1905, pp. 265 ff.
91. Ibid., pp. 288 ff.
92. *The Two Paths*, *Works*, XVI, 1905, pp. 310 ff.
93. Ibid., p. 311.
94. Ibid., p. 304.
95. 'A Joy for Ever' (Art School Notes), *Works*, XVI, 1905, p. 158.
96. *The Two Paths*, p. 306, note.
97. Ibid., p. 307, note.
98. Ibid., p. 261. On the 1857 rebellion in India against the British policy of expansion and Westernization, see Edwardes, M., *British India*, London, 1967, pp. 149 ff.
99. Ibid.
100. Morris, W., *The Collected Works*, with an introduction by his daughter May Morris, XXII, London, 1915, p. xxx.
101. See Pevsner, *Pioneers in Modern Movement from William Morris to Walter Gropius*, London, 1936, pp. 24 ff.; and id., *Studies in Art*, II, pp. 109 ff.
102. See *infra*, ch. VI, p. 252.
103. Morris, op. cit., p. 6.
104. See *supra*, p. 247.
105. Morris, op. cit., p. 6.
106. Ibid., p. 7.
107. Ibid., p. 35.
108. See *supra*, p. 236.
109. Morris, op. cit., p. 36.
110. Ibid.
111. Ibid., p. 37.
112. Ibid.
113. See *infra*, ch. VI, p. 278.

CHAPTER VI

1. Irwin, J., 'A Gift from William Morris', *Victoria and Albert Bulletin*, No. 1, 1965, p. 39.

2. My information is based on 'The History and Scope of the Indian Collections at the Victoria and Albert Museum' (1960, unpublished), read by Irwin at a Moscow Orientalists Conference and kindly lent to me.
3. See Chanda, R. P., op. cit. (*supra*, ch. III, note 246).
4. Barrett, D., *Sculptures from Amarāvatī in the British Museum*, London, 1954, pp. 21 ff., provides a detailed account of the discovery of the *stupa* and its subsequent fate.
5. The information is based on a visit to the Museum. See also articles by Inger Wulff, op. cit. (*supra*, ch. III, note 21), and by W. E. Calvert and K. Birket-Smith in *Ethnographic Studies* (Nationalmuseets Skrifter, Etnografisk Raekke, I), Copenhagen, 1941, pp. 29–68.
6. Cunningham's published works cover the period 1854–91. On the discovery of Gandhāra see Smith, V. A., 'Graeco-Roman Influence on the Civilization of Ancient India', *Journal of the Asiatic Society of Bengal*, Calcutta, 1889, p. 119.
7. William Rothenstein (*Men and Memories*, London, 1932) gives a lively account of growing interest among artists and critics in Indian art. One of the admirers was Geoffrey Scott. Another was Epstein as is evident from Eric Gill's letter to Rothenstein (*Letters of Eric Gill*, ed. Walter Shewring, London, 1947, p. 36). In Paris the famous restaurant Lapin Agile, frequented by Modigliani and other painters, displayed a huge Indian Buddha figure (*Modigliani*, Pierre Sichel, London, 1967, p. 104). Rodin's *paean* on Śiva Natarāja is to be found in *Sculptures Civaïtes*, by A. K. Coomaraswamy, E. B. Havell, and A. Rodin, Brussels and Paris, 1921, pp. 9 ff.
8. *Catalogue sommaire des peintres, dessins, cartons et aquarelles exposés dans les galeries du Musée Gustave Moreau*, Paris, 1926, p. 27. A recent work discusses Moreau's Alexander in connection with that artist's interest in India (see P. Jullian, *Dreamers of Decadence*, London, 1971, pp. 131 ff.). The above catalogue gives Moreau's description of the painting: Le jeune roi conquérant domine tout ce peuple captif, vaincu et rampant à ses pieds ... La petite vallée indienne ... contient l'Inde entière, les temples aux faîtes fantastiques, les idoles terribles, les lacs sacrés, les souterrains plein de mystères et de terreurs, toute cette civilisation inconnue et troublante.
9. Sastri, H. N., op. cit. (*supra*, ch. II, note 106), p. 12. In vol. X of *The Compleat Imbiber*, edited by Cyril Ray, London, 1969, p. 198, there is an illustration of *sahibs* in India wining and dining in an excavated temple which is none other than Elephanta when it was used for the 1875 banquet.
10. See *Exposition de 1900, Architecture et Sculpture*, 3e sér., published by Armand Guréinet (Paris), pl. 31.
11. See the works of F. Kugler, C. O. Müller, and C. Schnaase (*supra*, ch. IV, pp. 219 ff.).
12. See *supra*, ch. V, p. 227.
13. Cole, H. H., *Catalogue of the Objects of Indian Art*, London, 1874, p. ix.
14. Ibid., pp. 21–43 and *passim*, and pp. 57–66.
15. Ibid.
16. Ibid., p. 16.
17. Ibid., p. 15.
18. Ibid., pp. 6 ff.
19. Ibid., p. 13.
20. Ibid., pp. 13 ff. and 15.
21. Smith, loc. cit. (*supra*, note 6).
22. Cole, op. cit., p. 15.
23. Ibid., p. 16.
24. Ibid., p. 8; see also *infra*, note 28, on the Society of Arts meeting.
25. See Gombrich, *Norm and Form*, London, 1966, pp. 81 ff., for one of the most important discussions on stylistic categories in Western art and their dependence on the Vasarian norms of taste. See also the same author in *Internal Encyclopaedia of the Social Sciences*, vol. XV, 1968, pp. 352 ff. (article on Style).
26. Ibid., p. 87.
27. Frankl, P., *The Gothic*, Princeton, N. J., 1960, ch. VI, sect. 2, pp. 650 ff. and sect. 5, pp. 669 ff.
28. Fergusson, J., *On the Study of Indian Architecture*, London, 1867.
29. Fergusson, J., *The Rock-cut Temples of India*, London, 1864. See also Craig, M., 'James Fergusson' in Summerson, op. cit. (*supra*, ch. II, note 142), pp. 140 ff.
30. Craig, loc. cit.
31. Ibid., p. 142. On Fergusson and modern architecture see Pevsner, *Some Architectural Writers of the Nineteenth Century*, London, 1972, pp. 238 ff.
32. Fletcher, B., *A History of Architecture on the Comparative Method*, London, 1896.
33. Fergusson, J., *An Historical Enquiry into the true Principles of Beauty in Art*, London, 1849, p. xiii.

34. See *supra*, ch. v, pp. 229 ff.
35. Fergusson, J., *The History of Indian and Eastern Architecture*, London, 1876, p. 5.
36. Fergusson, *Principles of Beauty*, p. xiv.
37. Fergusson, *History of Architecture*, p. 6.
38. Ibid., pp. 3 ff.
39. Gombrich, *Norm and Form*, p. 84. On Winckelmann see *supra*, ch. iv, p. 192.
40. Fergusson, *History of Architecture*, p. 34.
41. Ibid., pp. 9 ff.
42. Fergusson, *On Indian Architecture*, p. 10.
43. Ibid., pp. 9 ff.
44. Ibid., p. 10.
45. Ibid., p. 9.
46. See my article, 'Western Bias in the Study of South Indian Aesthetics', *South Asian Review*, VI, No. 2, January 1973, pp. 125 ff.
47. Ibid., p. 34.
48. Ibid., p. 34.
49. Ibid., pp. 34 ff.
50. Ibid., p. 99.
51. Smith, op. cit., p. 107.
52. Ibid., p. 112.
53. Ibid., p. 173.
54. Ibid., p. 177.
55. Ibid., p. 175.
56. Ibid., p. 173.
57. Bon, G. Le., *Les Monuments de l'Inde*, Paris, 1893, p. 10.
58. Ibid., p. 16.
59. Ibid., p. 17.
60. Ibid., p. 17.
61. Ibid., p. 18.
62. Ibid., p. 18.
63. Smith, V. A., *A History of Fine Art in India and Ceylon*, Oxford, 1911, p. 2.
64. Ibid.
65. Ibid.
66. Ibid., p. 4.
67. Havell, E. B., *The Ideals of Indian Art*, London, 1911, p. xv; see also introduction.
68. Havell, E. B., *Indian Sculpture and Painting*, 1908, p. 8.
69. Havell, *Ideals*, p. xiii.
70. Ibid., p. xiv.
71. Havell, *Indian Sculpture*, p. vi.
72. Havell, *Ideals*, p. 24.
73. Havell, *Indian Sculpture*, p. 23.
74. Gombrich, *Norm and Form*, p. 87. The notion that art is concerned with an ideal world beyond that of appearances figures again and again in both Havell and Coomaraswamy as equally it figures in the works of the defenders of medieval art. The very same idea strongly influenced modern movements in art as well. The Cubists, for instance, when presenting an image from multiple viewpoints, sought to convey more clearly the 'real' nature of an object by going beyond what was visible. They were naturally the most radical opponents of Renaissance art. No wonder they attempted to relate their paintings to Kant's Idealist aesthetics and to distinguish between the 'appearance' of an object and the object itself (see J. Golding, *Cubism*, London, 1968, p. 33).
75. See Panofsky, E., *Idea*, Columbia, Ohio, 1968, for a discussion of the role of the Platonic Idea in European artistic traditions, particularly chs. 1, 2, 4, and 7.
76. Panofsky, op. cit., pp. 104–5.
77. Havell, *Indian Sculpture*, p. 24.
78. Ringbom, S., 'Art in "The Epoch of the Great Spiritual"', *JWCI*, XXIX, London, 1966, pp. 386 ff. Kandinsky held that the same spirit informed Indian and modern art (M. Seuphor, *Abstract Painting*, London, 1962, p. 44).
79. Havell, *Ideals*, p. 41.
80. Ibid., p. 5.
81. Havell, *Indian Sculpture*, pp. 41 ff.
82. Havell, *Ideals*, p. 14.
83. Ibid., pp. 6 ff.
84. Venturi, op. cit.
85. Havell, *Ideals*, p. 15.

86. Havell, *Indian Sculpture*, pp. 53 ff.
87. Havell, *Ideals*, pp. 22, 13 ff., and 18 ff.
88. Ibid., pp. 92 ff.
89. Ibid., pp. 122 ff.
90. Ibid., pp. 37 ff.
91. Ibid., p. 88.
92. Ibid., p. 103.
93. Ibid., pp. 103–4.
94. Coomaraswamy, A. K., *Mediaeval Sinhalese Art*, London, 1908, p. vi.
95. Ibid. Victorian reaction against industrialism has been discussed in a different but related context *supra*, ch. v, p. 222.
96. Ibid., pp. vi ff.
97. Ibid., pp. ix ff.
98. Ibid., p. v.
99. Coomaraswamy, *The Dance of Śiva*, London, 1924, p. 25. The comparison of Eckhart's work with the *Upaniṣads* is to be found in Coomaraswamy, *The Transformation of Nature in Art*, Cambridge, Mass., 1934, p. 61.
100. Coomaraswamy, *Transformation*, p. 62.
101. Ibid., p. 67.
102. Coomaraswamy, *Dance of Śiva*, p. 21.
103. Coomaraswamy, *Transformation*, p. 11.
104. Coomaraswamy, *Mediaeval Sinhalese Art*, p. ix.
105. Coomaraswamy, *Transformation*, p. 9.
106. Ibid., p. 11.
107. Ibid., p. 5.
108. Coomaraswamy, *Dance of Śiva*, p. 19.
109. Ibid., p. 21.
110. Coomaraswamy, *Transformation*, pp. 5 ff. This and other passages in which Coomaraswamy advances the notion that art is an 'uncaused spiritual activity' are strongly reminiscent of an early romantic, Wackenroder. In his work Wackenroder presented the act of artistic creation as a sacrament, an involuntary activity beyond reason and attainable only through feeling. The idea that art was a form of mystic communion with the divine deeply influenced romanticism. See E. G. Holt, op. cit. (*supra*, ch. IV, note 15), III, 1966, pp. 55 ff.
111. Coomaraswamy, *Transformation*, p. 6.
112. Ibid., p. 51.
113. For William Rothenstein's interest in Indian Art, see op. cit. (*supra*, note 7); for Roger Fry's interest, see his review of four books on Oriental art in *Quarterly Review*, ccxii, No. 422, London, January 1910, pp. 225 ff.
114. Havell, *Ideals*, p. 98.
115. Ibid., pp. 165 ff.
116. Coomaraswamy, *Catalogue of Indian Collection in the Museum of Fine Arts*, Boston, Mass., 1923, p. 9. On his influence on Eric Gill, see Gill's letters edited by Shewring, op. cit. (*supra*, note 7), and Gill's own *Art Nonsense and Other Essays*, London, 1927, and *Art and Love*, Bristol, 1927.

Appendix 1

A select synoptic table of major early collections of Indian art in Europe (based on present collections of Indian art in major European museums)

DENMARK (*Ethnographic collection, Nationalmuseet, Copenhagen*)

CENTURIES

17th C. Objects in Royal Cabinet of Curiosities from Tranquebar (Danish East India Co.). Christian IV (1588–1648) = ivory powder horns, arms, carved drinking vessel, ivory & wood work, inlaid boxes & cabinets, pair of mother-of-pearl sandals (room 98, cases 7–8, 10–11, & 99, cases 7–12)

1674: Indian painting (room 99, above door)

18th C. 1780: wooden Gaṇeśa & Garuḍa (room 102, case 7)

1799: 14 cola bronzes, including Naṭarāja discovered in Tranquebar and sent to Copenhagen, the earliest major collection of Hindu art in the West. Acquired for Nationalmuseet by Christian VIII (1839–48) in 1843 (room 101)

19th C. 1800: ivory miniature portrait from Tranquebar ruler to Frederick VI (1808–39) (room 99)

1823: painting = Rasmus Rusk (room 99, above door)

1825: Tranquebar granite Viṣṇu (room 101)

1849: C. A. Moller = stone Gaṇeśa & P. Hansen = Pāla Viṣṇu (room 101)

1868–75: F. Ad de Roepstorff = two Pāla pieces (room 101). Christian IX (1863–1906) = musical instrument inlaid with precious stones (room 99, case 6)

1894–1900: major collection of Hoyśala sculptures from missionary, Eduard Løventhal.

For information about collections I am indebted to the staff of Nationalmuseet, Copenhagen, Rijksmuseum and Tropenmuseum, Amsterdam, Dr. P. H. Pott of Volkenkunde Museum, Leiden, Bibliothèque Nationale, Paris (and especially to M. J. Adhémar of Dept. des Estampes), British and Victoria & Albert Museums, the India Office, London, the Bodleian Library, Oxford. For further information consult *Guides to the National Museum*, High Civilizations of Asia, Copenhagen, 1950, and articles by Inger Wulff and T. Thomsen (see Bibliography),

Dept. des Estampes, originally part of Bibl. du Roi, began in 18th century to collect illustrations of costumes and manners of peoples of the world, becoming eventually one of the largest collections. It has numerous colls. of Indian painting dating from 18th century, chief among which are colls. of Colonel Gentil treating wide-ranging subjects from Indian history to Hindu mythology (acquired by the museum in 1783), an album belonging to 18th century traveller Manucci, (acquired in 1797), an early album from missionaries (Od 38), two celebrated volumes by Sami of Indian divinities and professions (acquired in 1784), two from Adrien Picard on Indian gods (acquired in 1767) and four volumes (acquired from Porcher in 1758) dealing with south Indian theogony (Indian paintings are in section Od. 34–53). Gentil's paintings were used by Bouffon and the coll. in general was consulted by Diderot. The reserve section of Dept. des Estampes has some very fine Indian paintings.

Some of the albums of Gentil dealing with Hindu mythology and Indian history are now in the French MS. section of Bibl. Nat. The Oriental MS. section of the museum contains two illustrated MSS. from Anquetil Duperron, entitled *Ardha-Viraf-Nameh* and a volume dealing with Indian theogony (No. 100, Blochet) which must belong to a period not later than early 18th century and is similar to missionary works of late 17th and early 18th centuries.

1883: volume of Indian miniatures sold by Prisse d' Avennes to the Museum.

Benesch, O., *The Drawings of Rembrandt*, vol V, London, 1957, p 335 ff., Blochet, E., *Inventaire et Description des Miniatures à la Bibliothèque Nationale*, Paris, 1900, Stooke, H. J. & Khandala-vala, K., *The Laud Ragamala Miniatures*, Oxford, 1953, Arnold, T. W., 'The Johnson Collection in the India Office Library', *Rupam*, VI, Apr. 1921, pp. 10–14, Chanda, R. P. (see Bibliography), Barrett, D. (see Bibliography), Irwin, 'A Gift from William Morris' (see Bibliography)., and Cotton, E., "Hindoo" Stuart', *Bengal Past and Present*, XLVI, pt. 1, 1927, p. 1 ff.

HOLLAND (*Rijksmuseum & Tropenmuseum, Amsterdam, Volkenkunde Museum, Leiden*)

17th C.　paintings, jewellery & other small objects (Dutch East India Co. prohibition of large objects since monopoly held by them). Early famous collection of Indian miniatures = Rembrandt's Mogul coll. auctioned 1656–7, some of which came to Rijksmuseum in 1808.

1686: Dutch ambassador to Golconda ruler, Abul Hasan (1672–87), Laurens Pit's album of Golconda paintings, acquired by ethnographer Nicolaes Witsen, was bought by Rijksmuseum in 1728.

18th C.　Ketelaar's embassy to Mogul emperor (1711–13) brought back large coll. of paintings, now in Tropenmuseum (A 9584)

1760: *William IV coll.*: unlike private collectors, William IV, Stadholder and Director General of East India Co., received gifts of jewellery and weapons from India, which were taken by Orange family to England and brought back to Holland in 1814. J. V. Stein van Gollenesse, governor of Ceylon and later Batavia (1755), presented in 1760 to William important collection of jewellery from Surat in Gujarat made with Ceylon pearls (now in Volkenkunde Museum, Leiden). Also in William coll. were carved brass sword with gold inlay, south Indian ivory carvings & Ceylonese objects, Indian miniature paintings (Volkenkunde, Leiden).

19th C.　Royal Cabinet of Curiosities started by Orange family in the 19th century contained Jaina bronze figure (Supārśva), now in Leiden. A rich collection of Indian industrial arts acquired by Haarlem Kolonial Institut in late 19th century (now in Tropenmuseum).

ENGLAND (*British Museum, Victoria & Albert Museum,*
India Office Library, Bodleian Library, Oxford)

1640: Album of Rāgamālā Paintings presented to Bodleian by Archbishop
Laud.

Richard Johnson, in India 1770–1790, acquired enormous collection of Indian
painting on mythology, costumes, manners, history and musical modes, and
sold to East India Company over 1000 paintings in 1807 for 3000 gns, some of
which are of very fine quality (India Office Library).

Charles Townley, famous 18th century collector whose coll. of classical art
laid foundations of B.M. coll., had a number of works from India, including
the important erotic piece. The last work came to B.M. in *circa* 1805 (see
text, ch. II, p. 91)

Richard Payne Knight, famous collector and antiquarian, had a substantial
collection of Indian sculptures, many of which have only very recently been
identified as belonging to him and are in need of cataloguing (see text, ch. II,
p. 85)

The Pāla sculpture collection of Charles 'Hindoo' Stuart, part of which was
brought to Europe in 1804, was the most important collection of Hindu art
in Europe along with the Copenhagen collection, before the 20th century. It
came to the British Museum in 1872 as Stuart-Bridge collection.

After the discovery of Amarāvatī in 1796 important fragments were sent to
London in 1859 which came to B.M. in 1880, which still form one of the
major B.M. acquisitions.

1869: William Morris presented bronze Hanumān figure with the founding of
South Kensington Museum, later to become Victoria & Albert Museum.

Appendix 2

Descriptions of Elephanta and Salsette from Dom João de Castro's *Primeiro Roteiro da Costa da India desde Goa até Dio* (segundo MS. autographo, ed. Diogo Köpke, Porto, 1843, p. 65–81).

DESCRIPTION OF THE EDIFICE OF THE PAGODA (ELEPHANTA); pp. 65–69

The mountain on this island which I said was opposite the Northern region, on the one side, which is a continuous cliff, is hard natural rock. Beneath the mountain a vast temple was cut and fashioned, hollowing out the living rock, a temple of such marvellous workmanship that it seems impossible for it to have been made by human hands.[1] All the works, images, columns, reliefs,[2] workrooms, which are there are carved in the massive stone of the mountain, all of which seems to pass beyond the bounds of nature; indeed, the proportions and the symmetry with which each figure and everything else is made would be well worth the while of any painter to study, even if he were Apelles. This temple is 35 *braças*[3] long, 25 wide and about 4 high. And what greater monument to pride could men fashion than to hollow out a very hard natural rock by means of iron and sheer tenacity, and thereby to enter into such vast spaces? Oh great and foolhardy daring! Certainly if such imagination in the minds of men was not legitimate, how much less licit was it to set to work upon it and then bring it to completion. Running through the entire temple are straight rows of columns that appear to hold up the vault which is flat and very straight. There are 42 pillars in all, spaced at regular intervals. Corresponding to the place where we set the high altar in our churches, in this temple there is a square chapel. In each wall of the chapel there is a small low doorway and each of the doorways is guarded by two ferocious giants which are 21 *palmos*[4] high. Within this chapel is an altar placed in the middle, and above it is a large sphere which must represent the world. The whole temple is surrounded by 12 chapels, and in each of them there are many and various stories sculpted in unique Roman style [relief work?], all carved, as I have said, in the living rock. In one of these chapels is a man who reveals himself from the waist upwards and has three large faces and four arms. In his right hand he holds a hooded cobra by its head and in the left hand he holds a rose; in another hand he holds up the world and the last is too damaged to show the device he is holding. Concerning the stories in the other chapels I

shall say something but only a little. In one is a large man, like a giant, who has 8 arms, two of which are raised high, apparently sustaining the vault of the chapel; in the third he has a raised sword, and in the fourth he has a little bell, but in the fifth he holds a child by one foot with its head dangling downwards; then in the sixth he holds a vessel like a bowl, and inside it is wrapped up a chain of children's heads and a cobra. The last two of the eight arms are broken. In this chapel there are an infinite number of images with their hands upraised as if giving thanks to God. In another chapel is the figure of a gigantic woman, totally naked and with only the left breast, and with no sign of the right one, as is written of the Amazons. This temple has two doors, the main one and the side door. The main door and the main chapel are both orientated on an East-West axis; and the side door, like the chapel with the image with three faces, is placed on a North-South axis. And in this direction run the rows of pillars. Behind the main chapel on one side of the building is a spring of the best water I have ever seen in these parts, and nowhere in this temple is there an image which has a beard nor any that has clothing. On the left-hand side of the main doorway is another large building in the same way excavated from the living rock, set very deep down in the mountain, where there is carved out a large temple, at the back of which are large arcades and chapels and workrooms, and everywhere are carved representations of many and various stories in relief [Roman style?] of great perfection, with many giants and dwarfs, and the whole building is set 15 *braças* below the mountain, and it goes a long way in. I won't write about all its details because it would be insupportable: there are so many novelties and stories represented in it. Apart from these two buildings, on the other side of the mountain there are others, which makes me believe that the whole mountain is of carved rock. The building has no other lighting except what it receives through the temple doors.

THE PAGODE OF SALSETTE: pp. 75–81

A league and a half away from the destroyed city of Thana, among some vast mountains, there is a huge and high rock, almost spherical, inside which from the bottom right up to the top is carved out a large and noble space with many sumptuous temples and marvellous buildings. And this whole handiwork and group of dwellings is set in many rows, as in some palaces. In the whole of this building there is not a single image, column, house, portico, figure, pillar, cistern, temple, chapel or anything else which is not carved out of the very stone of this rock, a thing which certainly is not within the capability of mortals. Through many investigations, I believe this work to be so amazing that it is almost one of the seven wonders of the world, except if its worth were undermined by its seeming that men are not capable of it, and that the craft and possibility to achieve it did not lie within their understanding and power, but that it was made by spirits and diabolical art. As for me I am in no doubt of it at all. And supposing that it is so, even then it is a difficult thing to be able to believe that this skill is so powerful as to make something which nature would find difficult. I don't think that anyone could have sufficient authority that he should dare to recount the greatness and appearance of the work but

I, facing the difficulties and perils which are run by all those who describe things never before seen or heard, shall, fearfully, describe the sight of this building and the form of the rock, and even though it is so begrimed that it is difficult to understand it, let alone describe it clearly.

At the foot of the rock on each side of the path there are 7 columns, of which today only the bases remain, and they are so large in circumference and so high that one can believe that the columns were unusually large and tall. Going a little further on, one enters the first building carved inside the rock. This building is so high that anyone who sees it is full of admiration. It is full of columns and other works which are more than amazing. In the uppermost passage there is an entrance which is directed towards the interior of the rock, in which there are large workrooms and apartments. I myself didn't go into these places because of the great difficulty and the hard climb. Leaving this place one comes immediately to a large hall which is 40 *passos*[5] long and 18 wide, without a single column or other device to support it. At one end there are two chapels carved in relief [Roman work?], with a large sphere which is the shrine of adoration, and in the middle of this hall there is an inscription almost worn down with time. Passing through this portico one enters a magnificent temple, whose style and workmanship I shall describe in the best way I can, in order to satisfy any people interested in hearing about antiquities. First, outside the temple there is a large hall or patio, on which there are raised two very tall columns sculpted in marvellous relief [Roman?] work. The right-hand one has on top a wheel similar to that of St. Catherine, on which stand four lions which are very beautiful and well carved; the left-hand column has on top some men who, with their hands, hold up a large sphere, such as we use to represent the world, showing that they endure great toil through its weight. On the left-hand side there are many chapels and workrooms, placed on one side of the inner rock. Beyond this patio, before arriving at the gates of the temple, there are two more columns, each one is 4½ *braças* high, and on each one there is a large inscription in very beautiful and legible characters. In front of these columns there is a gallery on each side of which there is a very fierce and large giant 36 *palmos* high, and in his limbs one notices great conformity and proportion; and the rest of this gallery is worked in relief [Roman?] with many figures and human faces. Beyond this is the temple. This temple is very high and similar to a well-constructed vault. It is 40 *passos* long and 17 wide and 9 *braças* high. At the end there is a large altar which, like the gates and entrances, spans from East to West, and has above it the world or a round ball which is 9½ *braças* in circumference. Along the walls on each side there is a row of columns. There are 37 of them altogether, and between them and the walls on each side there is an arcade which encircles the whole temple. Above the main door there is a choir (gallery) set upon two large pillars just like the choir galleries in our churches.

Outside this temple there is a staircase which runs from the foot of the rock right up to the top, so steep that it seems almost to be going up to the heaven. When going up this path one sees on each side of it many buildings like houses, porticos, cisterns, chapels, patios, all cut into the rock; and to mention only what I counted of these things, climbing the path without straying from it,

there were 83 houses, among which I found one that was 40 *passos* long and 20 wide, and others which could have held a hundred men, and in general all the other houses were very high and spacious. As well as these houses there were 15 chapels carved in relief [Roman?] and 32 cisterns hollowed out of the rock, which held very restorative and delicate water, and 56 porticos, some of them carved in relief [Roman work?]. And in these buildings there were fifteen inscriptions which can all be clearly read. Most of these houses and apartments have halls in front of them with stone benches all around. The distance from the foot of this rock, where there are the seven columns, up to the top is 930 *passos*, and we must recall that this rock has another three paths also cut with steps, and along each of them there are many and various buildings, so that inside this rock it is doubtful if we can say that a town is built there, or rather a city, because certainly the space carved out would give ample room for 7000 men. The ascents from all sides are so steep and difficult that it is unbearable, so that in short one can say that this rock can only be called unassailable. The part facing the North is much higher than all the others, and along this side runs a stream which washes the low roots of the rock and then begins a range of crags which gradually becomes very high. This range is all of a single type of rock, and in it there are carved by means of iron many buildings which I was unable to see, lacking the time and disposition. It must be a great and magnificent sight.

NOTES TO APPENDIX 2

1. I am most grateful to Peter Dronke for his help in interpreting the awkward and archaic words in this difficult sixteenth-century text. Thanks are also due to Peter Bury for his suggestions. The first sentence in Castro is the most difficult of all and does not make sense unless slightly emended. It should be as follows:
Ho monte desta ilha que dixe estar oposto a regiam Setentrional, per huma parte, que he mossico de hum rochedo, h[e] dura pena viva. Foi cortado e feito per debaxo do monte, cavando a pena viva, hum grandissimo templo . . .
2. The word 'romanos' is taken by Peter Dronke to be relief works or *bas relief*. This of course makes sense here but I should also like to suggest an alternate meaning which I think may well reflect the widespread use of classical analogies or even the identification of Indian art and architecture as Greek or Roman. In this instance 'relief' is appropriate. Elsewhere I have put either variant, sometimes with a question mark in parentheses. The word unfortunately does not occur in standard dictionaries.
3. *Braça* or 'arms' is an ancient measure of length. It is 7 geometric feet (1 geometric foot = 33 cm.). Translated into our terms the temple is approximately 245 ft. long (35 *braças*), 175 ft. wide (25 *braças*), and 28 ft. high (4 *braças*).
4. The measure *palmo* is 22 cm. Therefore the giant is approximately 14 ft. high.
5. *Passo* is the Portuguese equivalent of the English 'pace'.

Bibliography

(A) SOURCES AND DOCUMENTS

AGOSTINI, L., *Le gemme antiche figurate*, 2 vols., Rome, 1657 and 1686 edn.

ALEXANDER, J. R., 'Notice of a Visit to the Cavern Temples of Adjunta in the East Indies', *TRAS*, II, 1832, p. 362.

ANGEL, P., *Devex Avataars* (MS. in Abdij Postel-Retie Library)

ANONYMOUS RELATION, in Moreland.

ANQUETIL-DUPERRON, A. H., *Zend-Avesta, Ouvrage de Zoroastre*, 2 vols., Paris, 1771.

Art Journal, 'Duty of Our Manufacturers at the Present Crisis', XII, 1 Oct. 1850, p. 304.

——'An Exhibition of Art and Industry', N.S. IV, 1 Feb. 1852, p. 98.

——'Mr Cole and the Schools of Design', N.S. IV, p. 103.

——'The Government School of Design', N.S. IV, p. 161.

——'School of Ornamental Art', N.S. IV, p. 227.

——'Royal Porcelain Collections', N.S. V., 1 Apr. 1853, p. 118.

——'Collection of Arms at Marlborough House', N.S. VI, 1854, p. 218.

——'The Museum of Ornamental Art', N.S. I., 1855, p. 57.

BABINGTON, B. G., 'An Account of the Sculptures and Inscriptions at Mahamalaipur', *TRAS*, II, 1830, p. 258.

BACON, T., *First Impressions and Studies from Nature in Hindostan*, 2 vols., London, 1837.

BAILLY, J. S., *Histoire de l'astronomie ancienne*, Paris, 1775.

——*Traité de l'astronomie indienne et orientale*, Paris, 1787.

BALBI, G., *Viaggio dell'Indie Orientali*, Venice, 1590, in Pinto, O., ed.

——*Viaggi di C. Federici e G. Balbi alle Indie Orientali*, Rome, 1962.

BALDAEUS, P., *Beschreibung der Ostindischen Kusten Malabar und Coromandel*, Amsterdam, 1672, tr. in Churchill, A. and J., *A Collection of Voyages and Travels*, III, London, 1703.

BARBOSA, D., *The Book of Duarte Barbosa*, tr. Dames, M. L., 2 vols., London, 1918.

BELL, J., *Bell's New Pantheon*, London, 1790.

BENEDETTO, L. F., *Il milione*, Florence, 1928.

BERNIER, F., *Voyages de François Bernier*, 2 vols., Amsterdam, 1699.

BIRDWOOD, G. C. M., *The Industrial Arts of India*, London, 1879.

BLACKADER, A., 'Description of the Great Pagoda of Madura', *Arch.* X, 1792, p. 449.

BOEMUS, J., *Omnium Gentium Mores, Leges, Ritus*, Augustae Vindelicorum, 1520, tr. Watreman, W., *The Fardle of Facions*, London, 1555.

BON, G. LE, *Les Monuments de l'Inde*, Paris, 1893.

BOULLAYE-LE-GOUZ, SIEUR F. S. DE LA, *Les Voyages et observations de Sieur F. S. de la Boullaye-le-Gouz*, Paris, 1653.

BOWREY, T., *A Geographical Account of the Countries Round the Bay of Bengal*, ed. Temple, R. C., Cambridge, 1905.

BURKE, E., *A Philosophical Enquiry into Our Ideas of the Sublime and Beautiful*, London, 1757.

BURNELL, A. C., *Linschoten*, see Linschoten.

BURNELL, J., *Bombay in the Days of Queen Anne*, ed. Sheppard, S. T., Cambridge, 1933.

BYSSHE, E., *De Gentibus Indiae et Bragmanibus*, London, 1665.

CARTARI, V., *Le vere e nove imagini degli dei delli Antichi*, ed. Pignoria, L., Padua, 1615.

CASALIUS, J. B., *Sacrae Prophaneque Religionis Vetustiora Monumenta, hoc est Symbolicus et Hieroglyphicus Aegyptiorum Cultus*, Rome, 1644–6.

CASTRO, J. DE, *Primeiro Roteiro da Costa da India: desde Goa até Dio*, ed. Köpke, D., Porto, 1843.

Catalogue of the Museum of Ornamental Art at Marlborough House, London, 1853.

Catalogue sommaire du Musée Gustave Moreau, Paris, 1926.

CAYLUS, A. P., COMTE DE, *Recueil d'antiquités égyptiennes, étrusques, grecques, romaines et gauloises*, 7 vols., Paris, 1752.

——'Comparaison de quelques anciens monumens des diverses parties de l'Asie', *Hist. de l'Académie des Inscrp.* XXXI, 1768, p. 41.

CHAMBERS, W., 'Some Account of the Sculptures and Ruins at *Mavalipuram*', *As. Res.* I, 1788, p. 145.

CHURCHILL, A. and J., *A Collection of Voyages and Travels*, 8 vols., London, 1703–53.

COLE, H. H., *Catalogue of the Objects of Indian Art Exhibited in the South Kensington Museum*, London, 1874.

COLEBROOKE H. T., 'On the Philosophy of the Hindus', *TRAS*, I, 1827, pp. 19–43, 92–118, 439–66, 549–79 and II, 1830, pp. 1–39.

CONTI, N., in Major.

COOMARASWAMY, A. K., *Medieval Sinhalese Art*, London, 1908.

——*Catalogue of Indian Collection in the Museum of Fine Arts, Boston*, Boston (Mass.), 1923.

——*The Dance of Śiva*, London, 1924.

——*The Transformation of Nature in Art*, Cambridge (Mass.), 1934.

CORSALI, A., 'Letter to Giuliano de' Medici from Cochin dated 6 June, 1515', in Ramusio, G. B., *Navigationi e viaggi*, I, 1550.

COURT DE GÉBELIN, A., *Monde primitif analysé et comparé avec le monde moderne*, 9 vols., Paris, 1773–82.

COUTO D. DO, *Decadas da Asia*, VII, bk. III, chs. X and XI, tr. Fletcher, W. K. 'Couto's Decade VII, Book III, Chapter X, of the Famous Island of Salsette etc', and 'Couto's Decade VII, Book III, Chapter XI, of the Very Remarkable . . . Pagoda of Elephanta', *JBRAS*, I, 1841–4, p. 44.

CREUZER, G. F., *Symbolik und mythologie der alten Völker*, 6 vols., Leipzig and Darmstadt, 1810–23., tr. Guigniaut, J. D., *Religions de l'antiquité*, 4 vols., Paris, 1825–41.

DALRYMPLE, A., 'Account of a Curious Pagoda near Bombay', *Arch.* VII, 1785, p. 323.

DANGERFIELD, F., 'Some Account of the Caves near Baug', *TLSB*, II, 1820, p. 194.

DANIELL, T. and W., *Oriental Scenery*, 4 vols., London, 1795–1808.

D'ANVILLE, J. B. B., *Antiquité géographique de l'Inde*, Paris, 1775.

DAPPER, O., *Asia*, Amsterdam, 1672.

DAVIES, see Olearius.

Deex Avataers, B. M. MS. Sloane 3290.

DELLA VALLE, P., *Viaggi di Pietro della Valle*, Rome, 1657–63, tr. Havers, G., and ed. Gray, E., *The Travels of Pietro della Valle in India*, 2 vols., London, 1892.

DIDEROT, D., and D'ALEMBERT, J. Le Rond, 'Isle de l'Elephante', *Encyclopédie*, VIII, Paris, 1765, p. 922.

DIDEROT, D., *Essais sur la peinture*, Paris, 1795.

DIEMERINGEN, O. von, *Johannes von Montevilla Ritter*, Strasburg, 1484.

DU JARRIC, P., *Historie des choses plus memorables advennes tant ez Indes Orientales*, 2 vols., Bordeaux, 1608.

DUPUIS, C., *Origine de tous les cultes ou religion universelle*, 7 vols., Paris, 1794–5.

DYCE, W., 'Lecture on Ornament', in *Cat. of Mus. of Ornamental Art*.

EDEN, R., 'The Navigation and Voyages of Lewes Vartomannes', in *The History of Travayle in the West and East Indies*, London, 1576.

ERSKINE, W., 'Account of the Cave-Temple of Elephanta', *TLSB*, I, 1819, p. 198.

——'Observations on the Remains of the Bouddhists in India', *TLSB*, III, 1823, p. 494.

Exposition de 1900, L'architecture et la sculpture, 3 vols. (Armand Guérinet), Paris, 1900.

EZEKIEL, *The Book of the Prophet Ezekiel*, ed. Redpath, H. A., London, 1907.

FARIA Y SOUSA, M., *The Portuguese Asia*, tr. Stevens, J., 3 vols., London, 1694–5.

FERGUSSON, J., *An Historical Enquiry into the true Principles of Beauty in Art*, London, 1849.

——*The Rock-cut Temples of India*, London, 1864.

——*On the Study of Indian Architecture*, London, 1867.

——*The History of Indian and Eastern Architecture*, London, 1876.

FINCH, W., in Foster, *Early Travels*.

FITCH, R., in Foster, *Early Travels*.

FLAXMAN, J., *Lectures on Sculpture*, London, 1838.

FLETCHER, see Couto.

FORBES, J., *Oriental Memoirs*, 4 vols., London, 1813.

FOSTER, W., *Early Travels in India*, London, 1921.

——*The Embassy of Sir Thomas Roe to India*, London, 1926.

FRAZER, J., *The Golden Bough*, 12 vols., London, 1890–1915.

FRY, R., 'Review of Four Books on Oriental Art', *Quarterly Review*, CCXII, no. 422, Jan. 1910, p. 225.

FRYER, J., *A New Account of East India and Persia*, London, 1698.

GEMELLI-CARERI, G. F., *Giro del Mondo*, Naples, 1700, tr. in Sen, S. N., *Indian Travels of Thévenot and Careri*, New Delhi, 1949.

GILL, E., *Art Nonsense and Other Essays*, London, 1927.

——*Art and Love*, Bristol, 1927.

GOGUET, A. Y., *L'Origine des lois, des arts, et des sciences et leur progrès chez les anciens*, 3 vols. in 6, Paris, 1758, tr. *The Origin of Laws, Arts, Sciences and their Progress among the most Ancient Nations*, 3 vols., Edinburgh, 1761.

GOLDINGHAM, J., 'Some Account of the Cave in the Island of Elephanta', *As. Res.* IV, 1799, p. 409.

——'Some Account of the Sculptures at Mahabalipooram', *As. Res.* V, 1799, p. 69.

Gough, R., *A Comparative View of the Antient Monuments of India*, London, 1785.

GRAHAM, M., *Journal of a Residence in India*, Edinburgh, 1813.

——*Essays towards the History of Painting*, London, 1836.

GREGORY, THE REVD., 'An Account of the Caves of *Cannara, Ambola* and *Elephanta*', *Arch.* VIII, 1787, p. 251.

GREY, see Della Valle.

GRINDLAY, R. M., 'An Account of some Sculptures in the Cave Temples of Ellora', *TRAS*, II, 1830, p. 326.

——'Observations on the Sculptures in the Cave Temples of Ellora', *TRAS*, II, 1830, p. 487.

GUIGNIAUT, *Religions*, see Creuzer.

HAMILTON, A., *A New Account of Voyages*, London, 1727.

HANCARVILLE, P. F. D', *Recherches sur l'origine, l'esprit et les progrès des arts de la Grèce*, 2 vols. and Supplement, London, 1785.

HAVELL, E. B., *Indian Sculpture and Painting*, London, 1908.

——*The Ideals of Indian Art*, London, 1911.

HEBER, R., *Narrative of a Journey through the Upper Provinces of India*, 2 vols., London, 1828.

HEGEL, G. W. F., *Vorlesungen über die Ästhetik* (Werke 10), recently published as *Ästhetik*, with introduction by Lukács, G., Berlin, 1955. English tr. Osmaston, P. B., *The Philosophy of Fine Art*, 4 vols., London, 1920.

——*Grundlinien der Philosophie der Rechts* (Werke 8) and *Vorlesungen über die Philosophie der Geschichte* (Werke 9), tr. Morris, G. S., *Hegel's Philosophy of the State and of History*, Chicago, 1887.

——*Vorlesungen über die Philosophie der Religion* (Werke 11–12) tr. Speirs, E. B., and Sanderson, J. B., *Lectures on the Philosophy of Religion*, 2 vols., London, 1895.

——*Vorlesungen über die Geschichte der Philosophie* (Werke 13–15), tr. Haldane, E. S., *Lectures on the History of Philosophy*, 2 vols., London, 1892.

——*Phänomenologie des Geistes*, tr. Baillie, J. B., *The Phenomenology of Mind*, 2 vols., London, 1910.

HERBELOT, B., D', *Bibliothèque orientale ou dictionaire universel*, Paris, 1697.

HERBERT, T., *A Relation of some Yeares Travaile*, London, 1634.

HERODOTUS, *History*, tr. Godley, A. D., *Herodotus*, 4 vols., London, 1921–4.

HODGES, W., *Select Views in India*, London, 1786.

——*Travels in India*, London, 1793.

333

HOLWELL, J. Z., *A Review of Original Principles, Religious and Moral, of the Ancient Bramins*, London, 1779.

HUNTER, W., 'An Account of some Artificial Caverns in the Neighbourhood of Bombay', *Arch.* VII, 1785, p. 286.

ISIDORE OF SEVILLE, *Etymologiarum sive Originum*, lib. XI, ch. III, tr. Sharpe, W. D., 'Isidore of Seville: The Medical Writings', *Tr. Amer. Phil. Soc.* N.S. LIV, pt. 2, 1964, p. 51.

JABLONSKI, P. E., *Pantheon Aegyptiorum*, Frankfurt, 1750.

JAMES, M. R., *Marvels of the East*, Oxford, 1929.

——*The Romance of Alexander*, Oxford, 1933.

JONES, O., 'Observations on the Collection of Indian Examples', in *Cat. Mus. of Ornamental Art*.

——*The Grammar of Ornament*, London, 1856.

JONES, J. W., see Varthema.

JONES, W., 'Hymn to Sereswat', *The Asiatic Miscellany*, 1785, p. 179.

——'The Third Discourse on the *Hindus*', *As. Res.* I, 1788, p. 415.

——'On the Gods of Greece, Italy and India', *As. Res.* I, 1788, p. 221.

——'The Preliminary Discourse', *As. Res.* I, 1788, p. ix.

——'Desiderata', *As. Res.* IV, 1799, p. 187.

JORDANUS, FRIAR, *Mirabilia Descripta*, tr. Yule, H., *The Wonders of the East*, London, 1863.

KIRCHER, A., *China Monumentis qua Sacris qua Profanis . . . illustrata*, Amsterdam, 1667.

KITTOE, M., *Illustrations of Indian Architecture*, Calcutta, 1838.

KNIGHT, R. P., *A Discourse on the Worship of Priapus*, London, 1786.

——*Two Essays on the Worship of Priapus*, London, 1865.

——*An Enquiry into the Symbolical Language of Ancient Art and Mythology*, London, 1835.

KUGLER, F., *Handbuch der Kunstgeschichte*, Stuttgart, 1842.

LA CRÉQUINIÈRE, *Conformité des coutumes des indiens orientaux avec celle des juifs*, Brussels, 1704, tr. Toland, J., *An Agreement of the Customs of the East Indians with those of the Jews*, London, 1705.

LA CROZE, M. V. DE, *Histoire du christianisme des Indes*, 2 vols., The Hague, 1724.

LAET, J. DE, *De Imperio Magni Mogolis sive India Vera*, Ex Officina Elzeviriana, Lugduni Batavorum, 1631.

LA GRUE, see Rogerius.

LAMBERT OF ST. OMER, *Liber Floridus*, facsimile ed. Dérolez, P., Ghent, 1969.

LANGLÈS, L., *Monuments anciens et modernes de l'Indostan*, 2 vols., Paris, 1821.

LANGLOIS, V., *Collection des historiens anciens et modernes de l'Arménie*, 2 vols., Paris, 1867–9.

LA VINCELLE, G. DE, *Recueil des monumens antiques . . . dans l'ancienne Gaule*, 2 vols., Paris, 1817.

LE GENTIL DE LA GALASIÈRE, G. J., *Voyage dans les mers de l'Inde*, 2 vols., Paris, 1779–81.

LETHIEULLIER, S., 'Extract from an Account of the Great Pagoda on the Island of Salset', *Arch.* VII, 1785, p. 333.

Lettres édifiantes et curieuses, vols. I–XXX, Paris, 1707–73.

Le Voyageur curieux (by Sr. le B.), François Clovsier (Publisher), Paris, 1664.

LINSCHOTEN, J. H. VAN, *Itinerario*, Amsterdam, 1596, ed. Burnell, A. C., and Tiele, P. A., *The Voyage of J. H. van Linschoten*, 2 vols., London, 1885.

LIVRE DES MERVEILLES, MS. Fr. 2810, Bibl. Nat. (Paris). Facsimile ed. by Omont, H., *Le Livre des merveilles*, Paris, 1907.

LORD, H., *A Display of two Forraigne Sects in the East Indies*, London, 1630.

LOVELL, see Thévenot

MACROBIUS, *Commentary on the Dream of Scipio*, ed. Stahl, W. H., New York, 1952.

——*Saturnalia*, ed. Davies, P. V., London, 1969.

MAFFEI, J. P., *Historiarum Indicarum libri xvi*, Florence, 1588.

MAJOR, R. H., *India in the Fifteenth Century*, London, 1857.

MALET, C., 'Description of the Caves or Excavations on the Mountain . . . eastward of the town of Ellora', *As. Res.* VI, 1801, p. 389 (and preceding letter to President of the Society, p. 382).

MANDELSLO, in Olearius.

MARÉCHAL, P. S., *Antiquités d'Herculanum*, 12 vols., Paris, 1780–1803.

——*Voyages de Pythagore en Egypte, dans la Chaldée*, 6 vols., Paris, 1799.

MATHIAS, T. J., *The Pursuits of Literature*, London, 1794.

MAURICE, T., *Indian Antiquities*, 10 vols., London, 1800.

MCKENNA, J. B., *A Spaniard in the Portuguese Indies*, Cambridge (Mass.), 1967.

METHWOLD, in Moreland.

MICHELFELD, . . ., *Sie hebt sich an das püch des Ritters herr Hannsen von Montevilla*, Augsburg, 1482.

MIGNOT, E., 'Mémoires sur les anciens philosophes de l'Inde', Mémoires de Littérature (1761–3), *Hist. de l'Acad. des Inscrp.* XXXI, 1768, pp. 81–263 (five articles).

MILL, J., *The History of British India*, 3 vols., London, 1817.

MILLIN, A. L., *Dictionnaire des beaux-arts*, 3 vols., Paris, 1806.

MONTFAUCON, B. DE, *L'Antiquité expliquée et reprentée en figures*, 10 vols., Paris, 1719–24.

MOOR, E., *The Hindu Pantheon*, London, 1810.

MORELAND, W. H., *Relations of Golconda in the Early Seventeenth Century*, London, 1931.

MORRIS, W., *The Collected Works of*, 24 vols., London, 1910–15.

MÜLLER, C. O., *Handbuch der Archäologie der Kunst*, Breslau, 1830, tr. Leitch, J., *Ancient Art and its Remains*, London, 1850.

MUNDY, P., *The Travels of*, ed. Temple, R. C., 5 vols., Cambridge, 1914–36.

MÜNSTER, S., *Cosmographae universalis*, Basle, 1550.

NIEBUHR, C., *Reisebeschreibung nach Arabien und Andern umliegenden Ländern*, 2 vols., Cophenhagen, 1778, tr. Mourier, F. L., *Voyage en Arabie et en d'autres pays circonvoisins*, 2 vols., Utrecht, 1779.

NIEUHOF, J., *See und Lantreise verscheide Gewesten von Oostindien*, tr. Churchill, A. and J., 'Mr John Nieuhoff's Remarkable Voyages', in *A Collection of Voyages*, II, 1704,

NIKITIN, A., in Major.

ODORIC OF PORDENONE, 'Travels', tr. Yule, H., in *Cathey and the Way Thither*, II (3 vols.), London, 1913.

OGILBY, J., *Asia*, London, 1673.

OLAFSSON, J., *The Life of the Icelander Jón Olafsson*, tr. Phillpotts, B., 2 vols., London, 1932.

OLEARIUS, A., *Ein Schreiben . . . in welchem en Seine des newen orientalischen Reise*, 2 pts., Schlesswig, (1645–) 1647, tr. of Mandelslo Section, Davies, J., *The Voyages and Travels of the Ambassadors*, London, 1669.

ORTA, G. DA, *Coloquios dos simples e drogas . . . da India*, Goa, 1563, tr. Markham, C., *Colloquies on the Simples and Drugs of India*, London, 1913.

OVINGTON, J., *A Voyage to Suratt in the Year 1689*, London, 1696.

PAES, D., in Sewell, R., *A Forgotten Empire*, London, 1900 (Paes's MS. Port. no. 65, Bibl. Nat., Paris, was translated by Sewell for the first time).

PHILOSTRATUS, *The Life of Apollonius of Tyana*, tr. Conybeare, F. C., London, 1912.

PICART, B., *Cérémonies et coutumes religieuses des tous les peuples du monde*, 8 vols., Amsterdam, 1723–43, tr. *The Religious Ceremonies and Customs of the Several Nations of the Known World*, 6 vols., London, 1731.

PIGNORIA, L., *Mensa Isiaca*, Amsterdam, 1669.

PINKERTON, J., *A General Collection of the Best and most Interesting Voyages*, 17 vols., London, 1811.

PLATO, *Phaedrus*, tr. Hackforth, R., London, 1952.

——*Symposium*, tr. Joyce, M., London, 1935.

POCOCKE, R., *A Description on the East*, 2 vols., London, 1743.

POLO, M., *Il milione*, tr. Yule, H., *The Book of Ser Marco Polo*, 2 vols., London, 1903. See also Benedetto.

RÁM RÁZ, *Essay on the Architecture of the Hindus*, London, 1834.

RAMUSIO, G. B., *Navigationi e viaggi*, 3 vols., Venice, 1550–9.

RAYNAL, G. T. F., *Histoire philosophique et politique des établissemens et du commerce des européens dans les deux Indes*, 6 vols., Paris, 1770.

RENNELL, J., *Memoir of a Map of Hindoostan*, London, 1788.

REYNOLDS, J., *Discourses on Art*, ed. Wark, R. R., San Marino (Calif.), 1969.

ROBERTSON, W., *An Historical Disquisition Concerning the Knowledge which the Ancients had of India*, Edinburgh, 1791.

RODE, B., and RIEM, A., 'De la peinture chez les anciens', in *Histoire de l'art chez les anciens par Winckelmann*, II, pt. 2 (3 vols.), Paris, 1803.

RODIN, A., HAVELL, E. B., and COOMARASWAMY, A. K., *Sculptures civaïtes*, Paris, 1921.

ROGERIUS, A., *De Open Deure tot het verborgen Heydendom*, Leyden, 1651, tr. Grue, T. la, *La Porte ouverte*, Amsterdam, 1676.

ROSS, A., *Pansebia*, London, 1653.

ROTHENSTEIN, W., *Men and Memories*, London, 1932.

RUSKIN, J., *The Works of*, ed. Cook, E. T., and Wedderburn, A., 39 vols., London, 1903–12.

ST. AUGUSTINE, *De Civitate Dei*, tr. Healey, J., *The City of God*, London, 1931.

SALT, H., 'Account of the Caves in Salsette', *TLSB*, I, 1819, p. 41.

SCHNAASE, C., *Geschichte der bildenden Künste*, 7 vols., Dusseldorf, 1843–64.

SCHORER, A., in Moreland.

SEELY, J. B., *The Wonders of Elora*, London, 1824.

SEN, S. N., *Indian Travels of Thévenot and Careri*, New Delhi, 1949.

SMITH, V. A., 'Greco-Roman Influence on the Civilisation of Ancient India', *JASB*, 1889, p. 119.

——*A History of Fine Art in India and Ceylon*, Oxford, 1911.

SONNERAT, P., *Voyage aux Indes Orientales et à la Chine*, 3 vols., Paris, 1782, tr. Magnus, F., *A Voyage to the East-Indies and China*, 3 vols., Calcutta, 1788.

STIRLING, A., 'An Account, Geographical, Statistical and Historical of Orissa Proper', *As. Res.* XV, 1825, p. 163.

STOBAIOS, *Physica*, 1.56, tr. in McCrindle, J. W., *Ancient India as Described in Classical Literature*, London, 1901.

STUART, J., and REVETT, N., *The Antiquities of Athens*, 4 vols., London, 1762, 1816.

SYKES, W. H., 'An Account of the Caves of Ellora', *TLSB*, III, 1823, p. 265.

TAVERNIER, J. B., *Les Six Voyages de Jean-Baptiste Tavernier*, Paris, 1676, tr. Phillips, J., and Everard, E., *Collection of Travels . . . being the Travels of Monsieur Tavernier, Bernier and other great men*, 2 pts., London, 1684.

TAYLOR, W. B. S., *A Manual of Fresco and Encaustic Painting*, London, 1843.

TEMPLE, R. C., see Mundy

TEMPLE, W., *Five Miscellaneous Essays*, ed. Monk, S. H., Ann Arbor (Mich.), 1963.

TERRY, E., in Foster, *Early Travels*.

THÉVENOT, J., *Voyages de Mr de Thévenot contenant la relation de l'Indostan*, Paris, 1684, tr. Lovell, A., *The Travels of M. Thevenot into the Indies*, London, 1687.

THÉVET, A., *La Cosmographie universelle*, 2 vols., Paris, 1575.

TOLAND, see La Créquinière.

Two Letters on the Industrial Arts of India (Victoria and Albert Museum), London, 1879.

VALENTIA, G., *Voyages and Travels to India, Ceylon, etc.*, 3 vols., London, 1809.

VALENTYN, F., *Oud en Nieuw Oost-Indiën*, 5 vols. in 8, Amsterdam, 1724–6.

VARTHEMA (BARTHEMA), L. DE, *Itinerario*, Rome, 1510, tr. Jones, J. W., *The Travels of Ludovico di Varthema*, London, 1863.

——*Die Ritterlich von Lobwirdig Raisz*, Augsburg, 1515.

VERGIL, P., *De Inventoribus Rerum*, 1499, tr. *The Works of the Famous Antiquary, Polydore Virgil*, London, 1663.

WAAGEN, G. F., in *Cat. Mus. of Ornamental Art*, p. 116.

WALES, J., *Hindu Excavations in Ellora*, London, 1816.

WESSELS, C., *Early Jesuit Travellers in Central Asia*, The Hague, 1924.

WILKINS, C., *The Bhagvat-Gēetà*, London, 1785.

WINCKELMANN, J. J., *Winckelmann: Writings on Art*, ed. Irwin, D., London, 1972.

YULE, see Polo.

YULE, *Cathey*, see Odoric.

YULE, *Wonders*, see Jordanus.

ZIEGENBALG, B., *Genealogie der Malabarischen Götter*, Madras, 1867, tr. Metzger, G. J., *Genealogy of the South Indian Gods*, Madras, 1869.

(B) STUDIES IN THE SUBJECT

AINÉ, H. R., *Herculanium et Pompéi*, Paris, 1840.

ALLEN, B. S., *Tides in English Taste*, 2 vols., Cambridge (Mass.), 1937.

ANDERSON, A., *Alexander's Gate, Gog and Magog, and the Inclosed Nations*, Cambridge (Mass.), 1932.

ARCHER, W. G., *Indian Painting for the British*, London, 1935.

AUSTIN, S., 'Niebuhr' in *Lives of Eminent Persons* (Library of Useful Knowledge), London, 1833.

BALSTON, T., *John Martin*, London, 1947.

BALTRUSAITIS, J., *Le Moyen Âge fantastique*, Paris, 1955.

BAMBOAT, Z., *Les Voyageurs français dans l'Inde*, Paris, 1933.

BARB, A. A., 'Diva Matrix', *JWCI*, XVI, 1953, p. 195.

BARRETT, D., *Sculptures from Amarāvatī in the British Museum*, London, 1954.

BEARCE, G. D., *British Attitudes towards India*, London, 1961.

BEARDSLEY, M. C., *Aesthetics from Classical Greece to the Present*, London, 1966.

BEAZLEY, C. R., *The Dawn of Modern Geography*, 2 vols., London, 1961.

BELL, Q., *Ruskin*, London, 1963.

——*The Schools of Design*, London, 1963.

——*Victorian Artists*, London, 1967.

BETJEMAN, J., 'Sezincote', *Architectural Review*, LXIX, 1931, p. 161.

BISCHOFF, B., 'Living with the Satirists', in *Classical Influences on European Culture*, ed. Bolgar, R. R., Cambridge, 1971.

BOAS, G., *Essays on Primitivism and Related Ideas in the Middle Ages*, Baltimore (Md.), 1948.

BØE, A., *From Gothic Revival to Functional Form*, Oslo, 1957.

BONNER, C., *Studies in Magical Amulets*, Ann Arbor (Mich.), 1950.

BOUSSET, W., *The Antichrist Legend*, London, 1896.

BOXER, C. R., *Three Historians of Portuguese Asia*, Macao, 1948.

BROWN, P., *Indian Architecture*, 2 vols., Bombay, 1971 (new edn.).

BUTTERFIELD, H., *Man on his Past*, Cambridge, 1955.

CARY, G., *The Medieval Alexander*, Cambridge, 1956.

CHANDA, R. P., *Medieval Indian Sculpture in the British Museum*, London, 1936.

CHARPENTIER, J., *The Livro da Seita dos Indios Orientais*, Upsala, 1933.

——'Preliminary Report on the "Livro da Seita dos Indios Orientais" ', *BSOS*, II, 1921–3, p. 731.

——'The British Museum MS. Sloane 3290, The Common Source of Baldaeus and Dapper', *BSOS*, III, 1923, p. 413.

——'The Indian Travels of Apollonius of Tyana', *Skrifter utgivna av K. Humanistiska Vetenskaps-Samfundet i Uppsala*, Upsala, 1934, p. 15.

CHATTERJI, S. K., 'Sir William Jones', in Sebeok, *Portraits of Linguists*, I.

CLARK, K., *The Gothic Revival*, London, 1950.

——*The Nude*, London, 1956.

CRAIG, M., 'James Fergusson', in *Concerning Architecture*, ed. Summerson.

CROOK, J. M., *The Greek Revival*, London, 1972.

CUMONT, F., *Recherches sur le symbolisme funéraire des romains*, Paris, 1942.

CUST, L., *History of the Society of Dilettanti*, London, 1898.

DANIEL, G. E., *A Hundred Years of Archaeology*, London, 1950.

Daniélou, A., *Hindu Polytheism*, London, 1964.

Débidour, A., 'L'Indianisme de Voltaire', *Revue de Littérature Comparée*, IV, Jan. 1924, p. 26.

Dempsey, C., 'The Classical Perception of Nature in Poussin's Earlier Works', *JWCI*, XXIX, 1966, p. 219.

Dicionárioda lingua portuguesa (ed. Cândido de Figueiredo), 2 vols., Lisbon, 1949 (14th edn.).

Dictionnaire critique et documentaire des peintres, ed. Bénézit, E., 8 vols., Paris, 1948–55 (new edn.).

Dieckmann, L., 'Friedrich Schlegel and the Romantic Concepts of the Symbol', *Germanic Review*, XXXIV, Dec. 1959, p. 276.

Dronke, P., 'The Return of Eurydice', *Classica et Mediaevalia*, XXIII, 1962, p. 206.

——'L'amor che move il sole e l'altre stelle', *Studi Medievali*, Ser. 3, 6 Jan. 1965, p. 391.

——*Medieval Latin and the Rise of European Love-Lyric*, 2 vols., Oxford, 1968.

Edgerton, F., 'Sir William Jones', in Sebeok, *Portraits of Linguists*, I.

Edwardes, M., *British India*, London, 1967.

Eliade, M., *Patterns in Comparative Religion*, London, 1971.

Encyclopaedia Britannica (new edn.), 23 vols., London, 1970.

Evans, J., *A History of the Society of Antiquaries*, London, 1956.

Farnell, L. R., *The Cults of the Greek States*, 3 vols., Oxford, 1907.

Fauth, W., 'Zagreus' in *Real-Encyclopädie der classischen Alterthumswissenschaft*, ed. Pauli, A. F. von, and Wissowa, G., 2 Reihe, Neunter Band, 1967, cols. 2221–83.

Finberg, A. J., *Complete Inventory of the Drawings of the Turner Bequest*, 2 vols., London, 1909.

Fletcher, B., *A History of Architecture on the Comparative Method*, London, 1896.

Foster, W., *The Embassy of Sir Thomas Roe to India*, London, 1926.

Frankfort, H., 'Dying God, Three Lectures', *JWCI*, XXI, 1958, p. 141.

Frankl, P., *The Gothic*, Princeton (N.J.), 1960.

Goetz, H., *The Indian and Persian Miniature Paintings in the Rijksprentenkabinet*, Amsterdam, 1958.

Golding, J., *Cubism*, London, 1968.

Gombrich, E. H., *Art and Illusion*, London, 1962.

——*Norm and Form*, London, 1968.

——*In Search of Cultural History*, Oxford, 1969.

——*Symbolic Images*, London, 1972.

——'Icones Symbolicae', *JWCI*, XI, 1948, p. 166.

——'The Use of Art for the Study of Symbols', *American Psychologist*, XX, No. 1, Jan. 1965, p. 34.

——'The Debate on Primitivism in Ancient Rhetoric', *JWCI*, XXIX, 1966, p. 24.

——'Style', in *International Encyclopaedia of the Social Sciences*, XV, 1968, p. 352.

——'Nova Reperta' (unpublished).

——'Hegel' (unpublished).

Graf, A., *Miti, leggende e superstizione del medio evo*, 2 vols., Turin, 1893.

339

——*The Story of the Devil*, London, 1931.

Grove's Dictionary of Music and Musicians, ed. Colles, H. C. (3rd ed.), 5 vols., London, 1928.

GUIGNIAUT, J. D., *Notice historique sur la vie et les travaux de Creuzer*, Paris, 1864.

GUTHRIE, W. K. C., *Orpheus and Greek Religion*, London, 1935.

HALLSTEIN, F. W. H., *German Engravings, Etchings and Woodcuts*, 7 vols., Amsterdam, 1954.

HILDBURGH, W. L., 'Images of the Human Hand as Amulets in Spain', *JWCI*, XVIII, 1955, p. 80.

HIND, A. M., *Engraving in England in the Sixteenth and Seventeenth Centuries*, 3 parts, Cambridge, 1952–64.

Hobson-Jobson, A Glossary of Anglo-Indian Words and Phrases, ed. Yule, H., and Burnell, A. C., London, 1903 (new edn.).

HODGEN, M. T., *Early Anthropology in the Sixteenth and Seventeenth Centuries*, Philadelphia (Pa.), 1964.

HOLT, E. G., *A Documentary History of Art*, 3 vols., New York, 1957–9.

HONOUR, H., *Neo-Classicism*, London, 1968.

HUGHES, R., *Heaven and Hell in Western Art*, London, 1968.

HUIZINGA, J., *Verzamelde Werken*, 9 vols., Haarlem, 1948–53.

HUSSEY, C., *The Picturesque: Studies in a Point of View*, London, 1927.

IRWIN, D., *Winckelmann: Writings on Art*, London, 1972.

IRWIN, .J, 'The History and Scope of the Indian Collections at Victoria and Albert Museum' (1960, unpublished).

——'A Gift from William Morris', *Victoria and Albert Bulletin*, No. 1, 1965, p. 39.

——and BRETT, K. B., *Origins of Chintz*, London, 1970.

IVERSEN, E., *The Myth of Egypt and its Hieroglyphs*, Copenhagen, 1961.

JULLIAN, P., *Dreamers of Decadence*, London, 1971.

KERÉNYI, C., *The Gods of the Greeks*, London, 1951.

——'The Mysteries of the Kabeiroi', in *Mysteries*.

LACH, D., *Asia in the Making of Europe*, vols. I and II (part 1), Chicago, 1965, and 1970.

La Grande Encyclopédie, 31 vols., Paris, 1886–1902.

LANG, S., 'Richard Payne Knight and the Idea of Modernity', in Summerson, *Concerning Architecture*.

LEA, H. C., *Material Toward a History of Witchcraft*, 2 vols., London, 1957.

LEMONNIER, H., *La Mégalomanie dans l'architecture*, Paris, 1912.

LETTS, M., *Sir John Mandeville, the Man and his Book*, London, 1949.

LICHT, H. (BRANDT, P.), *Sittengeschichte Griechenlands*, Dresden, Zurich, 1925, 1928, tr. Dawson, J. H., *Sexual Life in Ancient Greece*, London, 1932.

LIGHTBOWN, R. W., 'Oriental Art and the Orient in Late Renaissance and Baroque Italy', *JWCI*, XXXII, 1969, p. 228.

LOVEJOY, A. O., *The Great Chain of Being*, Cambridge (Mass.), 1936.

MANDOWSKY, E., and MITCHELL, C., *Pirro Ligorio's Roman Antiquities*, London, 1963.

MANUEL, F. E., *The Eighteenth Century Confronts the Gods*, Cambridge (Mass.), 1959.

——*The Enlightenment*, New Jersey, 1965.

MARSHALL, P. J., *The British Discovery of Hinduism*, Cambridge, 1970.

McCABE, J., *A Rationalist Encyclopaedia*, London, 1947.

McCRINDLE, J. W., *Ancient India as Described in Megasthenes and Arrian*, Calcutta, 1960 (new edn.).

MEISS, M., *French Painting in the Time of Jean de Berry*, 2 vols.: I. *The Fourteenth Century and the Patronage of the Duke*, II. *The Boucicaut Master*, London, 1967, 1968.

MICHAELIS, A., *Ancient Marbles in Great Britain*, Cambridge, 1882.

MITTER, P., 'Western Bias in the Study of South Indian Aesthetics', *South Asian Review*, VI, No. 2, Jan. 1973, p. 125.

MOMIGLIANO, A., 'Creuzer and Greek Historiography', *JWCI*, IX, 1946, p. 153.

——'Ancient History and the Antiquarian', *JWCI*, XIII, 1950, p. 285.

MUKHERJEE, S. N., *Sir William Jones*, Cambridge, 1968.

MUSGRAVE, C., *Royal Pavilion*, London, 1959.

MYLONAS, G. E., *Eleusis and the Eleusinian Mysteries*, Princeton, (N.J.), 1961.

MYSTERIES, ed. Campbell, J., tr. Manheim, R., and Hull, R. F. C., London, 1955.

New General Biographical Dictionary, ed. Rose, H. J., 7 vols., London, 1848.

NILSSON, M. P., *A History of Greek Religion*, Oxford, 1949.

——*Dionysiac Mysteries of the Hellenistic and Roman Age*, Lund, 1957.

OLSCHKI, L., *Marco Polo's Asia*, Cambridge, 1960.

OTTO, W. F., 'The Meaning of the Eleusinian Mysteries', in *Mysteries*.

PANOFSKY, E., *Idea*, Columbia (N.Y.), 1968.

PARMENTIER, L., *Recherches sur le traité d'Isis et d'Osiris de Plutarque* (Académie Royale de Belgique, Cl. des lettres, Mémoires, 2e sér., tom. XI), Brussels, 1913.

PATCH, H. R., *The Other World*, Cambridge (Mass.), 1950.

PÉPIN, J., *Mythe et allégorie*, Paris, 1958.

PEVSNER, N., *Pioneers in Modern Movement from William Morris to Walter Gropius*, London, 1936.

——*Studies in Art, Architecture and Design*, 2 vols., London, 1968.

——*Some Architectural Writers*, London, 1973.

——'Richard Payne Knight', *The Art Bulletin*, XXXI, No. 4, Dec. 1949, p. 293.

PFUHL, E., *Malerei und Zeichung der Griechen*, Munich, 1923.

POTT, P. H., *Naar Wijder Horizon*, The Hague, 1962.

RAY, C., *The Compleat Imbiber*, London, 1956–.

RINGBOM, L. I., *Paradisus Terrestris*, Helsingforsiae, 1958.

RINGBOM, S., 'Art in "The Epoch of the Great Spiritual" ', *JWCI*, XXIX, 1966, p. 386.

ROSENBERG, J. D., *The Darkening Glass*, London, 1961.

ROSS, D. J. A., *Alexander Historiatus* (Warburg Institute Surveys, I), London, 1963.

SANCEAU, E., *Knight of the Renaissance*, London, 1949.

SANDYS, J. E., *History of Classical Scholarship*, 2 vols., Cambridge, 1908.

SARTON, G., 'Anquetil-Duperron', *Osiris*, III, 1937, p. 193.

SASTRI, H. N., *A Guide to Elephanta*, Delhi, 1934.

SCHIERLITZ, E., *Die Bildlichen Darstellungen der Indischen Göttertrinität*, Hanover, 1927.

SCHURHAMMER, G., 'Desenhos Orientais do tempo de S. Fransisco Xavier', in *Gesammelte Studien*, II, Orientalia (Bibliotheca Instituti Historici, S. I., vol. XXI), Rome, 1963.

SCHWAB, R., *La Renaissance orientale*, Paris, 1950.

SCHWANBECK, E. A., *De Megasthene Rerum Indicarum Scriptore*, Bonn, 1845.

SEBEOK, T. A., *Portraits of Linguists*, 2 vols., Bloomington (Ind.), 1966.

——*Myth, A Symposium*, London, 1970.

SEUPHOR, M., *Abstract Painting from Kandinsky to the Present*, London, 1962.

SEZNEC, J., *The Survival of the Pagan Gods*, New York, 1961.

——*Flaubert à l'exposition de 1851*, Oxford, 1951.

——'Un Essai de mythologie comparée au debut du XVIIe siècle', *Mélanges d'historie et d'archéologie*, XLVIII, Rome, 1931, p. 268.

——'Flaubert and India', *JWCI*, IV, 1941, p. 142.

——'Herculaneum and Pompeii in French Literature of the Eighteenth Century', *Arch.* II, Sept. 1949, p. 151.

SHEWRING, W., *Letters of Eric Gill*, London, 1947.

SHORT, E. H., *The Revelation of St John the Divine*, London, 1928.

SICHEL, P., *Modigliani*, London, 1967.

SISAM, K., *Studies in the History of Old English Literature*, Oxford, 1953.

SLOTKIN, J. S., *Readings in Early Anthropology*, London, 1965.

SMITH, E. B., 'Jean-Sylvain Bailly, Astronomer, Mystic, Revolutionary', *Transactions of the American Philosophical Society*, XLIV, part IV, 1954, p. 498.

SPINK, W., 'Ajanta to Ellora', *Marg*, XX, No. 2, Mar. 1967, p. 9.

STEEGMAN, J. E. H., *The Rule of Taste from George I to George IV*, London, 1936.

STEVENSON, B., *Stevenson's Book of Proverbs, Maxims and Familiar Phrases*, London, 1949.

STEWART, J., and PHILLIP, F., *In Honour of Daryl Lindsay*, Melbourne, 1964.

STOKES, E. T., *The English Utilitarians and India*, Oxford, 1959.

STRAUSS, G., *Nuremberg in the Sixteenth Century*, New York, 1966.

SUMMERSON, J., *Concerning Architecture*, London, 1968.

SUTTON, T., *The Daniells*, London, 1954.

THIÉBAUX, M., 'The Mouth of the Boar as a Symbol in Medieval Literature', *Romance Philology*, XXII, No. 3, 1968, p. 281.

TURCAN, R., 'L'Oeuf orphique et les quatre éléments', *Revue de l'histoire des religions*, CLX, 1961, p. 11.

VENTURI, L., *History of Art Criticism*, New York, 1964.

VILLENEUVE, R., *Le Diable dans l'art*, Paris, 1957.

VOLWAHSEN, A., *Living Architecture: Indian*, London, 1969.

WALEY, A., *The Secret History of the Mongols*, London, 1963.

WILI, W., 'The Orphic Mysteries and the Greek Spirit', in *Mysteries*.

WILLSON, A. L., *A Mythical Image: The Ideal of India in German Romanticism*, Durham (N.C.), 1964.

WISBEY, R. A., 'Marvels of the East in the *Wiener Genesis* and in Wolfram's

Parzival', in *Essays in German and Dutch Literature*, ed. Robson-Scott, W. D., London, 1973.

WITTKOWER, R., *Architectural Principles in the Age of Humanism*, London, 1952.

——'Marvels of the East', *JWCI*, 1942, p. 159.

WRIGHT, J. K., *The Geographical Lore of the Time of the Crusades*, New York, 1965.

WULFF, I., 'Den dansen de Siva fra Trankebar', *Jordens Folk: Etnografisk Revy*, II, No. 4, 1966, p. 327.

Index

References to footnotes are treated as follows: chapter number (roman numeral), and letter n. followed by footnote number (arabic numeral). The number within square brackets refers to plate in text.

345

119, 190 ff.; religious customs of, 56, 79 ff., 86, 91, 101, 112, 115, 119 ff.
Elephanta, 25 ff., 34 ff., 47, 54, 89 ff., 96, 99, 103, 108, 112, 133, 136 ff., 144 ff., 154, 158, 168, 171, 177, 326; sketch by Niebuhr, 109 [52]; antiquity of, 119; object of wonder, 123; visited by the Daniells, 127; visited by the Biks, 130 [66]; Pyke's account, 142; banquet held at, 253
Ellora, 25, 41 [20], 120, 127, 133, 137, 162, 165, 171, 177, 201, 208, 218, 220, 260; seen by Anquetil-Duperron, 92, 107 ff.; measured in 1801, 159; compared with the Notre Dame, 108; compared by Seely with Blenheim, Fonthill Abbey, the Pantheon, the Parthenon, St. Paul's and St. Peter's, 138
Elstrack, R., illustrator, 72
Eleusis, mysteries at, 94 ff., 97, 99
Enlightenment, The, 84 ff., 104
Erskine, W., 154 ff., III, n. 165
Euripides, 83, II, n. 84
Eusebius, 79
L'Exposition Universelle (1900), Indian architecture at, 253
Ezekiel, vision of, 30

Fenicio, Father J., 50, 57 ff., I, n. 277
Fenicio-Baldaeus, Baldaeus's plagiarism of Fenicio, 106, 115
Fergusson, J., architectural historian, 256, 258, 260 ff., 262–7; early use of camera to document architecture, 260
Ferroverde, engraver, 28
Figueroa, C. de, 42
Figueroa, M. F. de, 19
Finch, W., 20 ff., 43
Fitch, R., 20, 43; on zoolatry, 50
Flaubert, G., 225
Flaxman, J., 133, 171 ff. [92], III, n. 220
Fletcher, Sir B., architectural historian, 261
Fontenelle, B.-L.-B., 19
Forbes, Sir C., collector, 162
Forbes, J., 127 ff., 133 ff., 136 ff.
Fores, L., Jesuit, 28
Foucher, A., on Gandhāra, 274
Frazer, Sir J., anthropologist, 84
Frederick the Great, 86
Fry, R., art critic, 283
Fryer, Dr. J., traveller, 26, 40, 46, 142

Gandhāra, 252, 258, 267 ff., 271; art derived from the West, 274 ff.
Gandy, J., artist, 172 [94]
Gaṇeśa, 50, 60, 64, 110; phallic Gaṇeśa, 78; called Gaves, 39; called Ganissone, 28; called Ganescio, 29
Gaṅgā, as the devil, 55
Garuḍa, 53 ff.
Gasper, Father, Jesuit, 34
Gatterer, J. C., historian and leader of Göttingen School of Universal History, 192
Gaurnātha, as the devil, 55
Gébelin, A. C. de, 88

Gemelli-Careri, G. F., traveller, 40
George IV, 149
Gill, Major, Ajanta paintings copied, 253
Gill, E., artist, 284
Goa, 28 ff., 34, 41, 43, 51, 87, 108
god, Indian, 2 ff., 16, 26, and passim (Chs. I and II); Greco-Roman, 75, 77, 79, 83 and passim (Ch. II); pagan, and medieval image of, 9, 17; as demons, I, n. 24; Mexican and Japanese, 28; Indian symbolic deity described by ancient Westerner, 100, 207, II, n. 129; thirty-six armed deity, 113; Indian god compared with ancient Greek hero, 46
Goethe, 85, 147, 202
Goguet, A. Y., 190
Goldingham, J., 150, 154
Gopasvāmī (Kṛṣṇa), 75
gopura, comparison with ancient Egyptian pyramids, 115 ff., 194 ff.
Gough, R., director of Society of Antiquaries (1771), 141
Govinda Deva, temple of, 44 ff. [21]
Graham, Maria, 131 ff., 133, 151, 172
Grand Tour, the, 105, 123
Great Exhibition, the, 224; Indian section at, in Jones's Grammar, 231
Griffiths, J., 233, 253
Grindlay, R. M., 162

Halhed, N. B., 177
Hamann, J. G., 202
Hamilton, A., 75, 106
Hancarville, P. F. d', antiquarian, 84 ff., 87, 89, 90, 92, 94 ff., 97, 99, 101 ff., 109 ff., 120, 206, II, n. 143
Havell, E. B., art historian, 256, 270–7; appreciation of specific examples of Indian art, 283
Haydon, B., 224
Hayton, early traveller, 3
Heber, R., 138 ff., 151
Hegel, G. F., 104, 112, 177, 203 ff., 208–19, 238, 243, 260; on Indian art in Ästhetik, 212 ff.; Indian art as expression of Neoplatonic symbolism, 215 ff.; specific examples of Indian art in Ästhetik, 218; knowledge of Indian religious texts, 218, IV, n. 124
Herbert, Sir T., 22 ff., 49, 60, 72
Herculaneum, 80, 84, 86, 98, 193; and Pompeii discovered, 140
Herder, J. G., 147, 205
Herodotus, 6, 48, 194; Bacchus equated with Osiris in, 79
Hesiod, 30
hieroglyph, 27, 31, 40, 46, 57, 98, 103, 159, 205
Hindu worship, early serious accounts, 53
Hodges, W., artist, 123 ff., 127, 171 ff.
Holwell, J. Z., 177, 192
Homer, 30
Hrabanus Maurus, description of monsters in, 10

347

Medici, G. de', 34
medieval, 5 ff., 18, 22, 24, 27, 30, 33, 74, 108, 123, 125, 249, 259, 272, 279 ff.; traditions of earthly paradise, 13; traditions of the devil, 17 ff.; psychology of sin, I, n. 23
Megasthenes, 6, 83
Megenberg, German translator of *De Naturis Rerum*, 9
Melampus, 79
Melchet Park, 129
Menipe (god), 64
Mensa Isiaca (Isiac table), 79
Merta, 43
methodology, for studying Indian architecture, 144; for distinguishing different styles of Indian architecture, 154 ff.; of Coomaraswamy, 278
Methwold, W., 49 ff.
Michelangelo, 145, 165
Michelfeld, German translator of Mandeville (1482), I, n. 38
Mignot, Abbé, 194, 198
Mill, J., 173 ff.
Millin, A. L., 172
Mithra, 75
Modigliani, A., VI, n. 7
Mondriaan, P., 274
monster, 2 ff., 21 ff., 30 ff., 37, 46, 57, 68, 73, 75, 103, 155, 208, 237, 243 ff., 245; gastrocephalic, 22; definition of, 7 ff.
Montesquieu, Baron de, climatic determinism, 192
Moor, E., author, *The Hindu Pantheon*, 157, 172, 178 ff.
Moreau, G., painter, 253 [117]
Morris, W., 230, 236, 238 ff., 248 ff., 274; gift of Indian sculpture to South Kensington Museum, 252
Müller, C. O., 219
Mundy, P., 45 ff., 75
Münster, S., author, *Cosmographae universalis*, 14, 27
Museum of Ornamental Art, 228 ff.
myth, about the age of Elephanta, 123
mythology, Indian, 2, 48, 50 ff., 58, 83, 107, 109 ff., 126, 148, 154, 157, 162, 177 ff., 206, 237; Western, 8, 27, 56, 74, 80, 82 ff., 84, 98, 102; comparative, 28 ff., 73, and *passim* (Ch. II)

Nagapatan, 25
Nagarkot, 43
Nandi, 53 ff.
Nash, J., designer of the Brighton Royal Pavilion, 129 ff.
Nature, according to Ruskin, 245 ff.; in Indian art according to Coomaraswamy, 281
De Naturis Rerum of Thomas of Cantimpré, 9
Neoplatonism, interpretation of images, 28, 30, 83, 203, 242; Neoplatonists, 27, 31, 56, 77, 82, 94, 273
Newton, Sir I., 190

Niebuhr, C., traveller, 96, 99, 106, 108 ff., 119 ff., 133, 145, 178
Nieuhof, J., 25, 45, 49
Nikitin, A., 74
Noord en Oost Tartarye, 72
Northcote, Stafford, Secretary of Board of Trade, Britain, 227
Nude, in art, 32, 74 ff., 104, 207, 244, I, n. 111
Nuremberg Chronicle, 4, 9, 14

Odoric of Pordenone, early traveller, 3, 10 ff., 32 ff.; on zoolatry, 50
Ólafsson, J., 50
Old Testament subjects, 52 ff., 77 ff., 84, 119; view of history in, 189 ff.
Olearius, A., 24
Oriental Annual, of Caunter, 129, 139
origin, of societies, 119; of the arts, 189 ff.
Orme, R., 177
Orphic cult, 82 ff., 97 ff., II, nn. 94, 102, and 111
Orta, G. da, 35, 38, 40
Osiris, 31, 79, 83, 100 ff., 205
Ovid, 100
Ovington, J., 25 ff., 39 ff.

Padmanava, Brahman fugitive, collaborator of Rogerius, 51 ff.
Paes, D., 42
Pagoda (Pagod or Pagode) as image, 21 ff.; as temple, 22, 24 ff., 34 ff., 38 ff., 42 ff., 53, 55, 58 ff., 74, 90, 101, 118, 120, 150, 166, 201; definition of, I, n. 56
Palladius, texts on Brahmans in the Middle Ages, 49
Palmyra, 140
Pan, 9, 78
Parliamentary Committee (1835), 223 ff.
Pārśvanātha, 108
Pārvatī (Durgā), 18
Peiresc, C. F. de, collector, 28, 56, 75 ff.
Perrault, C., 191
Persephone, 94 ff.
Phaedrus, of Plato, 97
phallic cults and objects, 75 ff., 84, 86, 88, 92, 94 ff., 99 ff., 108, 178, 215, 277, II, n. 39
Phanes-Eros, 97 ff., 100
Picart B., engraver and author, *Cérémonies et coutumes religieuses des tous les peuples du monde*, 64, 68, 78
picturesque, 21, 85, 120 ff., 126, 131, 136, 141 ff.
Pignoria, L., 28 ff., 37, 50 ff., 56, 73, 76, 79 ff.
Pindar, 103
Pinkerton, J., 129
Piranesi, G. B., 122
Plato, 30, 49, 52, 97, 191, 209, 272; on the Idea, 272 ff.
Pliny, 6 ff.
Plutarch, 79, 82 ff.
Pococke, R., traveller, 198 ff.

349

351